FROM THE REVIEWS

'It is a work of meticulous and wide-ranging research to which has been added the author's own considerable experience of Asian countries . . . Well written and attractively produced, it will be worthy of a place on the library shelves, not only for the Asian specialist but also for the general reader . . . It does for Australian visual artists what *Japonisme* by Siegfried Wichmann did for Europeans a decade ago.'

Richard Austin, *Courier-Mail*

'As I understand it, this is the first and certainly the most comprehensive survey of its kind undertaken in this country. And may I say at once that I have been enormously impressed by the breadth of Alison's scholarship, the elegance of her writing, and the persuasiveness with which she has argued her views. I am quite sure . . . that it will become an indispensable reference book for all who take an interest in Australia's relations with our Asian and Pacific neighbours — and who can afford not to, these days?

H.E. Mr Bill Hayden, Governor-General of Australia,
Adelaide Writers Festival, March 1992

'This exhaustive and insightful survey carries the reader along with its sense of urgency . . . It is the work of one who has grown to love Asia and wants others to share the sense of discovery she and a large number of other Australian artists have made in examining cultures which too few of us have taken seriously.'

John Graham, *Canberra Times*

'This is a beautiful book . . . It is also much more than that. As a pioneer study of Australia's artistic and literary response towards a variety of Asian cultures for more than 200 years, it challenges many hoary assumptions. It deserves to be widely read. I hope its theme and commentaries will also be hotly debated.'

Wang Gungwu, *Sydney Morning Herald*

'*The Yellow Lady* is so up to date that it includes references . . . to the ABC mini-series *Children of the Dragon* and other contemporary issues. This is as impressive as the author's encyclopaedic command of her subject. The phrase "lavishly illustrated" was invented for books like this.'

Linda Jaivin, *Modern Times*

'Racism, as Alison Broinowski reveals in this superbly illustrated history of Australian aesthetic responses to Asia, lies poisonously at the heart of Australian nationalism . . . It will be up to future scholars to build upon what would once have been called . . . a "pioneering" work.'

Robin Gerster, *Age*

The
YELLOW
LADY

Australian
impressions of Asia

Alison Broinowski

Melbourne

OXFORD UNIVERSITY PRESS

Oxford Auckland New York

OXFORD UNIVERSITY PRESS AUSTRALIA

Oxford New York Toronto
Delhi Bombay Calcutta Madras Karachi
Kuala Lumpur Singapore Hong Kong Tokyo
Nairobi Dar es Salaam Cape Town
Melbourne Auckland

and associated companies in
Berlin Ibadan

OXFORD is a trade mark of Oxford University Press

National Library of Australia
Cataloguing-in-Publication data:

Broinowski, Alison.
 The yellow lady: Australian impressions of Asia.

 Bibliography.
 Includes index.
 ISBN 0 19 553452 2.

 1. Arts, Australian—Asian influences.
 I. Title.

700.994

Edited by Beverly Barnes
Designed by Sandra Nobes
Typeset by Solo Typesetting, South Australia
Printed by Impact Printing Victoria Pty Ltd
Published by Oxford University Press,
253 Normanby Road, South Melbourne, Australia

Research was assisted by special purpose grants
from the Australia Council, the Federal
Government's arts funding and advisory body

Title page
W. Hardy Wilson, cover design, *Grecian and Chinese Architecture* (1937).
The bat and peach, Chinese symbols of happiness and long life, enclosed
within the circle of the world, became Wilson's personal emblems. (National
Library of Australia.)

WHY HAVE AUSTRALIANS remained so tenaciously Euro-centric and oblivious to the challenges and opportunities presented to us by our proximity to so many Asian countries? Alison Broinowski concludes her survey of the relatively few serious artistic and intellectual interchanges between Australia and Asia by observing that 'from the first, only those . . . who were specially imaginative, disaffected or eccentric thought the chance of East-West fusion worth investigating . . . Politics . . . sided with history against geography . . . to the detriment of economics.'

Economic and intellectual forces should not always be the decisive considerations in matters of this kind, but in this case they happen to be unusually overwhelming ones. In the 1990s, communal opportunities are dragging Australia into close collaboration with Asians more than ever before, yet almost always in our language, not theirs, and on terms and conditions derived from our (Western) laws, commercial practices and business cultures. Few Australians yet see that if these exchanges are to become meaningful this will have to change. Soon, very soon, we will have to be capable of meeting them on their terms, to comprehend their very different business cultures and the philosophical tradition behind them, to recognise that Australia is an off-shore island in an Asia-Pacific world of very dynamic and fast-growing societies and civilisations. If we continue to turn our backs on them on the grounds that our historical and cultural roots are basically European, we are doomed to isolation and insignificance as a nation.

Alison Broinowski's book is a passionate, path-breaking, and indeed visionary contribution towards our better understanding of this problem—and of ourselves in relation to it. It is not just a survey of the conspicuously few Australian artists, writers, travellers and others who have been 'switched on' by their experiences in Asian countries. It also raises a wide range of broader issues about the ways in which Australian images of Asia and Asians have been shaped over the last 200 years.

Our isolation from our Asian neighbours may be slowly changing at long last, as we enter the 1990s, since more and more Australians are beginning to realise that it is the expanding business oppor-tunities opening up to us in various Asian countries that should now be uppermost in our minds, not the largely mythical threats and apprehensions that have so preoccupied us in the past. Oppor-tunities for trade, investment and even jobs are emerging almost obviously in Japan and the fast growth countries of Southeast and East Asia, also in India to a lesser extent, as well as opportunities for selling and buying educational services, film, music and the arts, or even spiritual enlightenment, according to one's tastes or capacities. No longer is Europe or the USA the sole source or market for such things, as we have so long assumed.

Since it is now increasingly recognised that Australia's national destiny is becoming ever more closely intertwined with the destinies of various Asian countries in our region, it is worth reflecting briefly on the reasons why it has taken us so long to adjust to that simple and basic fact. After all, a few far-sighted Australians have been conscious of the tension between our geography and our

Foreword

history since well before World War II—and many more have become so since then. One reason, of course, is that the cultural roots and emotional ties of the white Australians—at a time when the Aboriginal Australians were largely ignored—were initally with Britain (or, later, with other European countries also) and hardly at all with any Asian countries until long after that war. Another was that until quite recently only a handful of Australians had much experience or knowledge of Asian countries and their languages and cultures, apart from a few former British army officers or planters from India, or other outposts of the British Empire, steeped in the Kipling tradition, let alone any conception that Australia might benefit by closer contact with them. Above all, the prevailing stereotype of 'Asia' meant coolie labour or the threat of 'Asian hordes' pouring in to threaten our living standards or racial purity in the days of the White Australia Policy. Visionaries foretelling a shared future with any Asian countries have never been likely to strike a very responsive chord in Australia, until very recently.

Early in this book, Ms Broinowski juxtaposes the responses of the eminent painter, Sir Arthur Streeton, and the less well-known architect, Hardy Wilson, to their experiences of travel in the East. For Streeton, 'my instinct is English' and in favour of British supremacy, as was the case for most Australian artists, writers, scholars and businessmen in the early years of the twentieth century, whereas for Hardy Wilson 'the Orient was full of a life force which would stiffen up Australian culture'. His enthusiasm for it could hardly have been further removed from Streeton's more conventionally 'Orientalist' view (in Edward Said's sense of that word) that 'the Orient' was dangerously 'enervating, feminine, passive, a seductive place where Western masculinity might go limp'. Hardy Wilson was the first Australian of significance to envisage some kind of fusion of the civilisation Australians had inherited from Europe with the good things they might discover in China and Japan. He emerges from this story as a real pioneer, a man who brought to his work both a vision and some depth of knowledge about the civilisations by which he was inspired, a rare combination in this country hitherto.

The juxtaposition of Streeton and Hardy Wilson epitomises the basic theme of 'our history versus our geography' which runs right through this book. That topic can easily degenerate into hackneyed and empty clichés if it is not handled deftly, but here it is treated with great skill and subtlety, neither overworked nor presented in a sentimental mode. The author clearly does not lack passionate views on the subject, even provocative ones in some instances, but she has presented them coolly and sensibly. Above all, however, her book is extraordinarily comprehensive and authoritative in its coverage of so many Australian artists, writers, musicians and others who have been influenced in some degree by Asian cultures, or responded creatively to them, or written about them. Not that she exaggerates the extent of those influences. In fact she confesses very frankly at the outset that she initially expected to find, and *wanted* to find, that Australians have made

greater use than in fact they have of their unique opportunities to 'take advantage of the ancient cultures, innovative modernity and growing economies in their region'. But that, she admits, would be a premature conclusion. What she has found instead is 'how powerful images are, and once received, how resistant to change'. So she has shown us also how Australian popular images of Asia and particular Asian countries and peoples have developed over the years, in response to various kinds of contacts with them or perceptions of them. Hence we can see the interplay of the crudest red-neck prejudices and some quite sensitive and appreciative reactions by creative artists or others to the finer points of various Asian civilisations, a picture that is often illuminating, albeit profoundly depressing and even embarrassing at times. But it should certainly help us to know ourselves better.

Ms Broinowski does not idealise or romanticise Asia as either a monolithic entity endowed with some superior wisdom, which some foreigners have done, or as a place of cultural pilgrimage towards which all Australians should bow their heads. She simply tells us how various talented and sensitive Australians have had their horizons expanded there and found much that has enriched their work or their lives. But the great strength of her book, in my opinion, resides in the fact that she has done far more than just compile a catalogue of names of artists, writers and others who have transmitted various Asian cultural influences from there to here. She has set these within a much broader context of how Australian impressions of Asia have been formed, shaped and changed over the last two hundred years. Without a full appreciation of the latter, the former makes little sense. The appalling crudity and ignorance that characterised so much Australian image-making about Asians in the press or in parliamentary rhetoric throughout the era of the White Australia Policy has not only overshadowed the efforts of the more enlightened individuals to describe and explain more accurately why they behaved as they did, but has in important respects both shaped and constrained those efforts. That has to be taken into account if we are to understand why popular attitudes have changed so slowly.

Above all, this book should provoke us into rethinking a lot of almost unconscious attitudes to things Asian and alien, along with the reasons shaping our perceptions of them, which have rarely been exposed to the light of day for serious scrutiny. The value of Alison Broinowski's book is that it is the first comprehensive treatment of such matters. It should become an indispensable work of reference in our schools, universities and public libraries, as well as a work of inspiration to all who prefer the Hardy Wilson vision of Asian countries and cultures to Streeton's or J. D. B. Miller's, as cited here in. Above all, it provides a wealth of information which should render untenable the view which was advanced when she first proposed this subject for research at the ANU in the mid-1980s: 'Asian influences on Australian culture? It's not worth doing. There aren't any.'

Jamie Mackie
October 1991

to Richard

Contents

THIS IS A study of impressions of Asia in Australia, and of how they have been formed, reflected, and changed throughout Australia's history by the arts.

Only recently have many Australians, apart from the artists considered here, noticed that Asia has relevance to their culture. Some still deny it. Asia, on other than a technical or professional level, 'has little to offer us,' predicted an Australian professor of international relations in 1967, adding: 'It is a mistake to think that Australians will take to traditional Japanese or Indian or Chinese customs in any more than a touristy way.'

Proliferating European and American accounts of their perceptions of Asia, and the influence of Asia on their culture, suggested to me that the same phenomena existed in Australia. For me, as much as for any of the Australians considered here, a Western exemplar was what pointed to the Asian presence.

At the outset, I had expected to reach a more optimistic conclusion than I do. I had expected to find—I *wanted* to find— that Australians, uniquely placed to take advantage of the stimulation of the ancient cultures, innovative modernity, and growing economies in their region, and to become a centre of expertise about their neighbours, in the 1990s are well on the way to doing so, and in large numbers. While that conclusion is true of some scholars, business people, and Australians working in the arts, it would be premature as a generalisation about all Australians. To the extent that it is true, the artists are largely responsible, and the credit is theirs.

What this study taught me is how powerful images are and, once received, how resistant to change. Asian images of Australia may be equally inflexible.

I followed the lead of artists themselves—by which I mean people working in the visual, performing, literary and design arts— in concentrating more on some art-forms and some countries than others. Japan, China, Indonesia, and India receive more attention than other countries in the region, simply because they are the cultures more Australian artists have used as sources.

At some points the scope widens to include Papua New Guinea and the South Pacific, not in great detail, but to point to contrasts between Australian perceptions of Asian countries and Pacific ones, and of themselves in relation to each.

I selected certain artists for greater attention than others, not necessarily because of the relative merit of their work, but because of its contribution to my purpose. For the same reason I emphasise the Asian elements in their work. My intention as a non-specialist is to suggest an outline. Others may remedy my omissions by exploring in more detail.

The difficulty of finding the material and identifying the linkages has been compounded by the difficulty of defining *Asia*, of saying where it begins and ends and, if it exists at all, what its characteristics are. It becomes clear that they are so few, and so inapplicable to all the region's people, that 'Asia' should always be read as if written between quotation marks. *South, East,* and *Southeast Asia* are used to refer respectively to three groups of

Preface

countries: India, Sri Lanka, and Burma; China, Japan, Korea, and Hong Kong; and the ASEAN and Indochina countries. The *Asia-Pacific hemisphere* is recognised as a specific area. But it is inappropriate for Australians in the 1990s to perpetuate anachronistic and inadequate generalisations about Asia as a whole.

The same reasoning applies to *race*, *black*, *white*, *yellow*, and similar words, which I do not regard as meaningful categories of humans. If *race* can be used in so many ways—the 'British race', the 'Aryan race', the 'white race', and even the 'human race'—it clearly lacks specificity; the colour words lack accuracy. My use of them, and my citations from others, carry that reservation.

This book begins with an account of the unquestioned generalisations of the past about 'Asia', as a single, all-inclusive European idea, and considers how some of them have been perpetuated to this day. The chronological core of the study traces the progressive fragmentation of 'Asia' into many conflicting and disputable impressions of various countries and millions of individual humans. In each period in the chronology, certain artists and works are selected for concentration against the background of a general survey. As far as possible, living artists were asked for comments, and their responses are the basis for my judgments, whether directly cited or not.

I do not set out to compare mutual images held by Australians of Asians with those held by Asians of Australians, nor do I examine racism in Asian countries in any detail; separate examinations of those would be illuminating. Nor is this a history of Asian and Pacific studies in Australia. It does not claim to be a critique of Australian foreign policy or of Australian relations with Asian countries; nor is it an analysis of immigration policy, multiculturalism, or cultural exchange. All of these provide the setting in which the creative artists, whose work is my primary source, were and are active. The work of cultural and oral historians, critics, musicologists, performers, and interpreters of each of the art-forms is important, but to do it justice would double the size of the book. The same applies to the contribution of collectors, curators, translators, documentary filmmakers, journalists, and broadcasters.

I have made a practice of transcribing quotations literally into the text with their authors' original capitalisation, occasional errors, and style of transliteration of Asian words. In my own text, family names are given first where that is national usage, except for individuals who have adopted the reverse order. Romanisation of Chinese is official Hanyu pinyin except where sources quoted use the Wade-Giles style, or where names predate 1949. Alternative versions are given in brackets. In the case of 'Tao', which has derivatives in English like 'Taoism', and which is used by all the artists cited, I have not used 'Dao' in my own text. Romanisation of Japanese follows Kenkyusha's *New Japanese–English Dictionary*, with a macron indicating a long vowel. Common placenames are given without the macron, and in the version appropriate to the period: for example, Edo or Tokyo, Peking or Beijing, Ceylon or Sri Lanka.

Acknowledgements

IN MY OWN explorations over a decade, I have had the support of those who knew Australian cultural history had another side. I am particularly grateful to all the artists who answered my questions; to Professors J. A. C. Mackie, Wang Gung-wu, R. G. Ward, Nancy Viviani, John Ingleson, David Walker, and Colin Mackerras; to Dr Jos Jordens and Ann-Mari Jordens, Dr Choe-Wall Yang-hee, Dr Julia Meech, Dr Joan Grant, Jim Jamieson, Helen Musa, Peter Fitzpatrick, Jeremy Eccles, Gary Kildea, Janet Mansfield, Peter Rushforth, Jackie Menzies, Len Radic, Ken Scarlett, and Simon Patton; to Jenny McGregor, Neil Manton, Michael Liffman, and to my research assistant in Canberra, Kay Walsh; to staff of the Australian Music Centre and the Australian Film Commission, to John Thompson and the staff of the Petherick Room of the National Library of Australia, and of the State Library of Victoria, and to Heather Reid, who until her death in August 1991 was ABC reference librarian in Melbourne. Professors Mackie, Mackerras, and Viviani, Margaret Kartomi, and Judith Brine read the draft and offered valuable suggestions, as did Peter Timms, Alison Carroll, and Katharine Brisbane. Peter Rose, Sonja Chalmers, Jane O'Donnell, Sandra Nobes, and Beverley Barnes shaped the project for publication with tact and assurance. Colin Golvan's legal advice was indispensable.

I acknowledge with appreciation the cooperation of the Department of Foreign Affairs and Trade, which allowed me time for research, and which since 1965 has sent me to live in five Asian countries; research grants from the Australian Academy of the Humanities, the Australia-Japan Foundation, the Australia-China Council and the Korea Research Foundation; special-purpose grants from the Literature Board and the Visual Arts and Crafts Board of the Australia Council, the federal Government's arts funding and advisory body; a visiting fellowship at the Asian History Centre and the Research School of Pacific Studies, Australian National University; a readership at the National Library of Australia and a research associateship at the Institute of East and West Studies at Yonsei University in Seoul; special support from the Myer Foundation to Asialink to assist the project; and the Japan Foundation for financial support towards the publication of this book.

Richard Broinowski's patience, generous support, and partnership provided me with a better working environment than most writers dream of.

The history of every country is, to a great extent, determined by its geography

C. P. FitzGerald, 1935

I
Introduction: Australia's New World

WHEN EUROPEANS EXPROPRIATED the last available continent from its Aboriginal people in the late eighteenth century, they set about establishing Australia as the only Western society, apart from New Zealand, in the Asia-Pacific hemisphere.

In the process, if they so decided, they could jettison the European imperial practice of exploiting colonised people. They could reject Orientalism: the European vision of all Eastern peoples as exotic, remote, inferior, and subject to the political, military, economic, cultural, and sexual dominance of the West.

It didn't happen, as we know. Why not, for couldn't Australia and Asia-Pacific countries alike have expected to benefit greatly from such a redefinition of their shared hemisphere? In these introductory chapters, some answers will be suggested by identifying the impressions, preconceived and acquired, which conditioned settler Australians' response to the region. In tracing their effect on succeeding generations, we will give several of them labels for convenience.

There was no lack of interest from the region. Early in the life of the Australian colonies, Indians arrived to become waiters and itinerant pedlars, Chinese to be coolies and shepherds, Ceylonese, Javanese and South Pacific kanakas to work on plantations, and Afghans to be cameleers. Plans were prepared in Adelaide for Japanese farmers to take up land, particularly in the Northern Territory.

> Malagasian tribesmen, Bessarabian communists, Patagonian Welshmen, Garibaldi's redshirts were but a few of the people attracted.

In the 1850s free Chinese immigrants from Canton and Shanghai joined the gold rushes, and some stayed on to found families, to run trading houses, restaurants, laundries, to work on railway construction, and to grow vegetables. Even before the Japanese government lifted its ban on travel in 1878, Japanese arrived in Australia as entertainers and prostitutes; they were followed by pearl divers, and by traders seeking to maximise the complementarity between their industrialising country and Australia as a producer of raw materials.

The ideal of Australian-Asian intercourse had been put forward as early as 1783 by James Mario Matra in his proposal for the colonisation of New South Wales. Matra saw Australia as a vantage point for the development of trade with China, Japan and Korea. In 1784 Sir George Young, wishing to avoid the experience of the fractious American colonies, thought Chinese, American loyalists, and settlers from the Loyalty Islands, east of New Caledonia, would be ideal for Australia. Edward Gibbon Wakefield, writing from Sydney in 1829, saw Australia as better placed than 'any country without exception' to deal with the numerous and industrious people of Asia. He proposed that Australians should build 'a free bridge between the settlements and those numerous over-populated countries by which they are, as it were, surrounded.'

In 1888 the Reverend James Jefferis foresaw in Australia a land where the best characteristics of many peoples — French, Germans, and Anglo-Saxons as well as Chinese, Japanese, and 'Hindoo' —

1
Australasians

*Choices for a new world —
'Asian' labour — idealists,
imperialists, and chauvinists —
early encounters — varieties of
Orientalism — history and
geography*

could be united. In the same year, Cardinal Moran had even more elevated hopes, for Australia to become a centre of civilisation for all nations of the East, and particularly to produce missionaries to go there.

No less idealistic, the poet Bernard O'Dowd declared that it was in the interests of Australian democracy and the labour movement to do away with the myth of inferior races: 'Whatever his colour may be, we must take our fellow man in Africa, in Asia and in Europe by the hand as a man and as a brother'. O'Dowd was attracted to Theosophy and to 'Buddha's shining path'. From the 1880s, small but growing numbers of Australian Theosophists and Buddhists found in Asian religious philosophy a source of superior wisdom close at hand.

Unaware that in Japan his contemporaries were also contemplating an 'Asiatic Mediterranean', the novelist Marcus Clarke in 1877 envisaged 'Australasia', a vast archipelago stretching from Malacca and Singapore to New Zealand, in which the best of tropical and Mediterranean civilisations would flourish side by side. A healthy national 'type' would develop with the benefits of good food, education, and climate. Unless Australians recruited fresh stock from other nations, Clarke warned, the 'breed' would become extinct. He knew, however, that settler Australians were unlikely to throw wide the doors of the workingman's paradise and that Australasian idealism was often a front for those who wanted cheap labour to replace the convicts.

The failure of 'Australasia' to develop in harmonious partnership with its region was thus not for lack of interest or vision. The visionaries, however, included neo-imperialists who took it to be their right, as British Australians, to have an empire too. Proposals for 'Australasia' as a series of flourishing colonies in the South Pacific began in the early 1800s, and at the end of the century the future Prime Minister, Alfred Deakin, promised: 'We intend to be masters of the Pacific by and by.'

Long after the ideal of 'Australasia' had faded from reality— either as a region merging the best of nationalities, or as a channel for trade, or as a means of saving souls, or as a focus of enlightenment—it persisted as an anachronistic affectation by companies and learned societies and as a reminder of what might have been before it shrank to denote only Australia and New Zealand.

But 'Australasian' idealists were always a small minority. To say that most settler Australians did not welcome Asians as neighbours is an understatement. Their European education gave them little preparation for dealing with the region. They were hostile to anyone who shared their territorial ambitions. They feared Asia's teeming millions might take the empty land from them as easily as they had taken it from the Aborigines. They were protective of their gold, of their jobs and working conditions, and of 'their' women, and again it was Asians who were assumed to want them. Fear, ignorance, and bigotry fomented hostility and drove the colonial governments to abandon their liberal schemes and adopt a succession of discriminatory exclusion measures aganst Asians, which the federal Parliament in 1901 endorsed among its first Acts.

Europeans had become settler Australians, but Australians had failed to become 'Australasians'. In 1901 the Australian Federation was held together not by the 'Australasia' ideal but by anti-Asianism. As Humphrey McQueen points out: 'Australian nationalism is the chauvinism of British imperialism, intensified by its geographic proximity to Asia'.

But while Australians' self-image was still fluid, there remained a chance that experience of their Asia-Pacific new world might change their ideas. As it happened, the earliest contacts by people from the Australian settlements were of a different kind from those the idealists hoped for: escaped convicts reached Batavia, Japan, and China; whalers were shipwrecked in Hokkaido; and blackbirders and sandalwood traders plied their illegal trade in the South Pacific.

Even before the establishment in the 1850s of the Australasian Steam Navigation Company, Australians became frequent travellers to Asia, some as traders and miners, others in transit to other parts of the British Empire. If they travelled in their thousands to Hong Kong, China, and Japan with Thomas Cook, and to the South Pacific with Burns Philp, they went in their tens of thousands to Singapore and Colombo and on to Europe with Blue Funnel and P & O. Their route was the thin red line in reverse, from the 'Far East' to the 'Middle East' and 'Near East.' Familiarity increased, rather than diminished, each time they left port—from Batavia, Singapore, Colombo, Madras, Bombay, and Aden, to London and 'Home'. For many, the wogs *ended* at Calais. The Suez route, opened in 1869, was spoken of as Australia's lifeline.

'All are Orientals here,' wrote Arthur Streeton rather superfluously from Egypt, where he stayed for three months, and where he, his friend Tom Roberts, and other Australian artists painted 'Oriental' street scenes for the London market. In 1905 the architect William Hardy Wilson made the same first contact with the East by sailing west. He too painted, comparing Colombo's rich colour to 'an Orient poster by Brangwyn'. He was delighted by the crowds and found even in dirty, ramshackle Port Said 'a world unlike anything [he] had ever seen'.

The difference between them was more than generational. Wilson was an Australasian, who saw his fellow countrymen as a declining remnant of Europe 'planted in Oriental soil', enervated by the climate, and ideally placed to revitalise themselves by contact with Asia, particularly with China. Streeton, on the other hand, regarded himself as British, the Suez Canal as umbilical, and imperial might as right. At the time of the Boxer Uprising he wrote:

But damme—my instinct is English, and if I have any political feeling—it is in favour of British supremacy. Once we lose the sea, canal, and Mediterranean—we are done—we take a subordinate place like Italy—we shrivel up into a 2nd or 3rd rate power . . .
But we evidently may run short of men—unless we set to work picking out the best stock and breeding people specifically for war purposes.

For Wilson the Orient contained the life-force that would stiffen up Australian culture. For Streeton the Orient was enervating, feminine, passive, a seductive place where Western masculinity might go limp. He warned Roberts about it in 1907, comparing the civilisation of Melbourne with the 'luxurious langour' of Sydney, which he said was 'semi-Eastern'. Streeton believed the Orient was to be resisted and dominated: ex occidente lex. Wilson wanted it to be studied and emulated: ex oriente lux.

Australians were not the first to perceive the East-West difference in gender terms. It had been a theme of European Orientalists for centuries. More remarkable was for how long they were to go on doing so. In 1968 the architect Robin Boyd was still distinguishing traditional Japanese buildings — slender, minimal, light, subtle, poetic, intuitive, visual, and *feminine* — from modern, western-influenced ones — heavy, sometimes coarse, logical, intellectual, aggressively *masculine*.

A divergence had emerged early and would persist between those settler Australians for whom *geography* was dominant, who wanted to become Australasians, part of the Asia-Pacific hemisphere, and those for whom *history*, and their British identity, dominated all else. Thus how Australians defined themselves determined their view of Asia.

FOR MORE THAN a century most settler Australians defined Asia not as many diverse countries but as one and as a generalised source of threat. While they had inherited other enemies—Russians, Germans, French, even Americans—from their British identity, Asia seemed peculiarly their own. 'The Far East is our far-North,' George Pearce declared in 1922; and in picking up his expression John Latham in 1934 and Robert Menzies in 1939 both endowed Australia's geography with sinister qualities, calling it the 'near north'. Healthy, lazy Australia, the expression suggested, was exposed to Asian plagues and predators; underpopulated, well-paid Australia was seen as a vacuum, ready to suck in the cheap labouring masses of Asia; democratic Australia was an undefended target for atheistical Asian communists; gravity would cause a yellow tide to rush towards Australia, red paint to run down, floodgates to burst and dominoes to fall in succession. Even Wallace's Line, the border between Asian flora and fauna and those of Australia, lent Darwinian respectability to the demarcation. Pseudo-science created an image of Asia which, simply because of where it was on the map, was a perpetual menace to Australia.

Not until the mid-1960s were these Antipodean images widely challenged. In the more radical 1970s Prime Minister Gough Whitlam reversed Labor tradition by declaring that Australia no longer saw its neighbourhood as a frontier rimmed with nameless Asian enemies. The poet Judith Wright rebelled against the way the world map seemed to impend over Australia, and looked forward to the day when Europe would be seen as Australia's Antipodes. In 1971 Robin Boyd drew an inverted Australia in the middle of the north Atlantic. A 'Universal Corrective Map' was published with Australia in the upper centre (with Tasmania on top) as the Desliens world map had done in 1542. Some dismissed it as a joke; others liked the upstart challenge which the map represented to Australia's historical images of domination and threat. Some went so far as to say Australia was part of Asia; others reasoned that Asia, being a construct of the European imagination, did not exist, and hence there was no threat.

By 1975, however, the forces of history had reasserted themselves over those of geography, and again the globe provided the images. A report to the conservative Fraser government re-declared Australia part of the West, a European outpost in an alien sea, a 'Western nation located in the Asia-Pacific region far from the traditional centres of Western power'. Once again, images of exposure and loneliness came from the atlas. Distance within Australia and distance from Europe were seen by an influential historian as a 'tyranny' imposed by geography. After two centuries of settler Australians' presence in the region, it remained the official view that Australia had no 'natural allies' there, and suffered from isolation—in a hemisphere that included two-thirds of the world's people.

2
Whites Only

Images of Asian threats—
Antipodeanism—born
fighting—the yellow peril in
films, cartoons, poetry, novels,
plays—politics of race—
national types

IN 1800, EUROPEANS in Australia numbered less than 6000, and only one in ten was a free settler. In the years that followed,

many more went to Australia because they too were dissenters from, or dispelled from, or dissatisfied with Europe. Hostility and defensiveness were only to be expected in a 'nation of bastards' founded by people who bore class and sectarian grudges like birthmarks. Imbued with the mediaeval myth of the Antipodes, they ingested a self-image of weirdness, loneliness, and absurdity, of being underfoot and beneath contempt, an immature satire of a Western society. Australian cartoonists after 1901 often used the Little Boy from Manly to represent the young nation, vulnerable, unsophisticated, confused, innocent, and surrounded by enemies.

Australia was born fighting. Well before Federation in 1901, men from the Australian colonies had already been involved in eight armed excursions, against Zulus, Russians, Indians, Union Americans, Maoris, Sudanese, Boers, and Chinese Boxers, whose uprising coincided with Federation. As a nation, they would take part in seven more wars by 1991, and only once directly in their own defence. Australia had soldiers to send away to war a century before it had its own diplomatic service. In every one of the wars Australians were present as supporters of their Imperial masters, or their Commonwealth partners, or their American friends or allies, and in eight of them the enemy was Asian. Thus of the images Australians formed of Asians and some still hold, many were engraved on their minds in actual war or by war propaganda.

Although they fought so often to defend British interests and felt betrayed by Britain's inadequacy in defending theirs, Australians' hostility to their colonial neighbours—particularly the French, Dutch, and Germans—nevertheless derived from their perception of themselves as British at a time when Britain was supreme. Their historical associations, in effect, made their geographical environment a threat. If cartoons and novels of the three decades spanning Federation are a guide to popular opinion, settler Australians, aware of how they had displaced the defenceless Aborigines, were fearful of being displaced in their turn by Asians, who might be the tools of European enemies. The popular image-makers projected their own motives onto Asians. They did not reflect on why, if Chinese or Japanese wanted to take over Australia, they had not done so before 1788. Political leaders soon recognised that a foreign threat, particularly from Asia, was one of the three issues around which their quarrelsome constituents would unite: the others being the protective tariff and the White Australia policy.

'Wake, Australia! Wake' (1888). Under an open window labelled South Australia, thinly screened by Anti-Chinese Legislation, sleeping Australia under her digger's blanket is about to be ravished by Chinese Invasion. (Latrobe Collection, State Library of Victoria.)

IMAGES OF THE ASIAN threat were purveyed by the powerful medium of silent film. The earliest films made in Australia included accounts of military departures—such as mounted troops going to the Boer War, and the New South Wales contingent departing for China in 1900—and military arrivals. Many had opposed Britain's alliance with Japan in 1902, fearing Australia would be forced to relax its exclusion laws, but an early documentary, *Welcome to Our Gallant Allies—the Japanese*, duly recorded the Japanese naval visit of 1906. Australians observed Japan's moves towards industrialisation, its success in the Sino-Japanese war in 1893–95, and its

defeat of the Russians at Shimonoseki in 1905, and many were convinced it had designs on Australia. So although some complained of the United States' imperialism in the Pacific, the majority welcomed the American Great White Fleet in 1908 more warmly than they had the Japanese, as sending 'notice to the yellow races that they will have to stop in Asia'. The *Sydney Morning Herald* believed America might provide the first line of defence, not just against Japan, but against Asia as a whole.

Whiteness, Alfred Deakin pointed out just before an election in 1909, was Australia's strongest link to the United States. In spite of their imperial adventures in North Asia and the Philippines, the Americans had shown with their own exclusion acts that they were more antagonistic to 'the yellow race' than the British. Deakin's sense of kinship with those who feared 'the Yellow Peril to Caucasian civilization, creeds and politics' apparently overrode his Theosophical beliefs. Not the least of these three, for Deakin's purposes, (as for his Prime Ministerial predecessor, Parkes), was politics. The nationalist playwright Louis Esson agreed, and in 1908, after a visit to Japan and other countries, he wrote a series of articles on the 'Asiatic menace' and the 'many dangers for the white race of the Pacific' for *The Lone Hand*. His warnings against Japanese expansionism were generalised to include any or all Asians:

> I feel sure Australia must be kept white, and have severe immigration laws . . . We'll have to find out what races will blend and prohibit all the rest.

If it was characteristic of settler Australians to invest fears of one particular Asian country in Asia as a whole, the film industry perpetuated the habit. In 1913 Raymond Longford's film *Australia Calls* warned Australians to 'beware the yellow peril'. It suggested that the Asian invaders were Japanese, though in deference to the Anglo-Japanese alliance it called them Mongolians. The film included attacks on local *Chinese* by settler and Aboriginal Australians, and extras to play the enemy were recruited from Sydney's

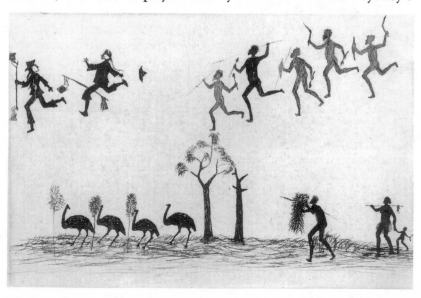

Tommy McCrae, Aborigines chasing Chinese, *sketch (n.d.). A drawing by a nineteenth-century Aboriginal artist suggests that settler Australians were not the only ones who harassed Chinese workers in northern Australia. (Museum of Victoria.)*

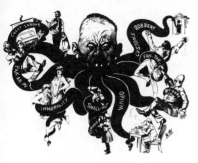

Phil May, The Mongolian Octopus—His Grip on Australia *(1888). The Asian presence in Australia was depicted as a source of gambling, disease, drugs, and corruption, but principally as presenting competition for good jobs and white women. (*The Bulletin, *1888.)*

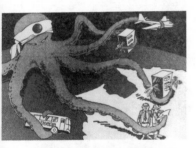

Beware the Octopus Takeover *(1989). By 1989 the Asian octopus was seen as Japanese, holding airlines, hotels and condominiums, construction projects, and tourism in its clutches. (*The Australian, *1989.)*

Chinatown. What's more, film of the *American* fleet's visit provided the footage to simulate a *Japanese* invasion. The theme of anti-Asian hostility was still current in 1928, when Phil Walsh made *The Birth of White Australia*, recreating the 1860–61 massacre of Chinese at Lambing Flat and using extras with stockings over their faces to make them appear Chinese.

Cartoons and illustrations were equally potent purveyors of Asian images. Many Australian artists survived by doing black and white sketches for *The Bulletin*, the bushman's Bible, whose policy was 'Australia for the Australians'. From 1905 to 1961, when Donald Horne removed it, the masthead read 'Australia for the White Man'—which, it was said, implied China for the Chows. For all their patriotic concern, not many of the cartoonists were even Australian-born. But they duly produced for *The Bulletin* (and other publications) images of Asians as a pestiferous insect plague, an Oriental dragon, or a Mongolian octopus whose tentacles wormed into every hallowed Australian institution, a venal usurper of Australians' jobs, and a creeping threat to their wives and daughters. As late as 1952 R. G. Casey, as Minister for External Affairs, would again liken China to an octopus, and in 1989, the octopus cartoon reappeared, this time representing Japanese 'mafia' in Australia.

The images Eugene von Guérard drew of Chinese who were his 'nearest neighbours' on the Ballarat goldfields in 1853 were benign and realistic by contrast with those of the cartoonists. In the *Melbourne Punch* in 1865 Chevalier sketched newly-rich Chinese acting as though they owned the place. A cartoon image of a Chinese posing as A. B. Paterson's comic bushman, Mulga Bill, reflected the perennial fear that lazy Australians would have the tables turned on them, and that they would become the 'poor white trash of Asia'. In a Vincent cartoon the Little Boy from Manly faced a host of aggressors: a Bismarckian German, a treacherous Indian, a ruthless Japanese, and an ageing but still inscrutable Chinese. In 1902 Hop managed in black and white to suggest the awful polychrome possibilities of intermarriage with Asians and others. A not-dissimilar sketch would be circulated in 1988 by the Perth-based Australian Nationalists Movement for White Australia, and in the same bicentennial year a pastiche Chinese in a coolie hat, with a drooping moustache, would appear in Qantas publicity, before being withdrawn.

Visions of Asian hordes acquired a semblance of historical validity in Australian minds from the Mongols who had ravaged the very borders of Europe under Genghis Khan. Sensational travellers' tales and missionary accounts of barbaric 'heathen' practices seemed to confirm images of China as a place where, as the poet Richard Stewart suggested, 'the ancient Dragon flaming biddeth forth the Yellow man.' In the 1850s the *Age* warned of an invading army of Chinese. What Australians read in letters and newspapers and heard in church provided a seed-bed for threatening images of Asia, as did the poetry most schoolchildren recited. Riding and marching rhythms went with Australians to work and to war, particularly those of Rudyard Kipling (who wrote of 'lesser breeds without the Law'), Banjo Paterson, and Henry Lawson.

Lawson exhorted Australians in 1905, just after Japan had won the first Asian victory against a European power, to defend the 'Outpost of the White'. He was not the only nationalist who believed that Jews wanted to take over Australia, using Japanese as a front. Yet he was just as concerned, eight years later, about the Chinese who had no such capacity: 'You have builded a wall, O China! *Let them see that it keep you in!*' Walls and floodgates were to remain the stock stuff of Australian cartoons for at least another sixty years.

Alf Vincent, The Relative Sizes of Chairs *(1913). The Little Boy from Manly, symbolising the young Australian nation, occupies a chair too big for him upon which Chinese, Germans, Japanese, and Indians have designs.*

Livingstone Hopkins, Piebald Possibilities—a Little Australian Christmas Family Party of the Future *(1902). Liberal advocates of 'Australasia' exposed the country to the dreadful consequences of interracial marriage, in Hop's view. (*The Bulletin, *1902.)*

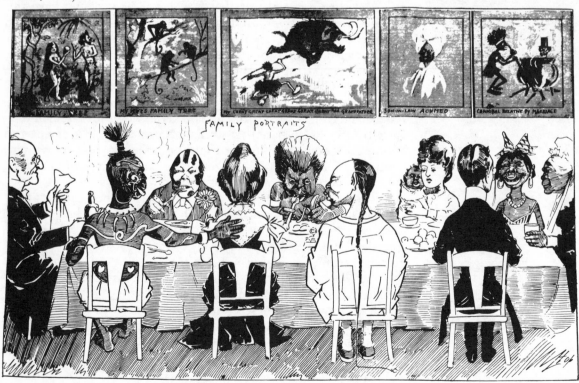

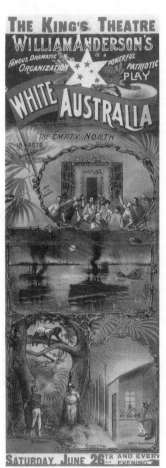

White Australia, or, The Empty North *(1909). The poster for Randolph Bedford's play had everything: a fight in a Chinese joss-house, a Chinese attacking a telegraph operator, settler Australians tied to trees with a simian black man in the branches, and Japanese battleships. (State Library of Victoria.)*

Novelists and short-story writers—many of whom, like the cartoonists, earned their keep from *The Bulletin*—were equally prone to generalise fears of Asians or yellow men. In the 1890s, as prosperity waned, writers developed an obsession with skin colour. Novels called *The Yellow Wave*, *Yellow and White*, *The Yellow Man*, and *White or Yellow?* glutted the market. The Queensland magazine *Figaro* in 1883 began a 'Yellow Agony' column, and Joseph Furphy used the expression liberally in his novel *Such is Life* (1896, 1903). In 1922 the poet Hugh McCrae and his artist-author friend Norman Lindsay kept the fixation alive with *The Yellow Lady*. Edward Dyson referred collectively to the Chinese in his 1929 story 'A Golden Shanty' as 'Celestials' and 'the Yellow Agony'. The obsession was still current as late as 1934 in Ion Idriess' story, 'The Yellow Joss' and in 1942 in W. T. Stewart's novel, *Yellow Spies*. Not until 1965 would 'White Australia' be dropped from the platform of the Australian Labor Party.

'Invasion fiction' was as popular with Victorian Australians as science fiction is today. Incursions by 'every Chink and Jap under the sun' were anticipated in Aldridge Evelyn's typical invasion novel of 1909; by Chinese, called Mongols, in *The Yellow Wave* (1895); and by Japanese in *The Coloured Conquest* (1903). Japan, or China, was merely the topical expression of the yellow peril. *The Bulletin* saw Chinese and Japanese as equally threatening, but in 1895 it was somewhat confused about their colour: 'the little brown men come leaping over our north-eastern and north-western border by scores and hundreds.' The colour change to brown was necessary because they were being compared to a plague of rabbits.

Popular stage shows were equally colour-conscious. In 1909 fear of a kanaka invasion was the theme of Bland Holt's *The Great Rescue*. And Japan and China vied for possession of Australia in Randolph Bedford's play *White Australia: or, The Empty North*. The play's poster showed Chinese and 'blacks' as the enemy, together with Japanese battleships. In Jo Smith's *The Girl of the Never-never* (1910), stage directions called for 'a turbulent stream of yellow water rushing towards the footlights'. Australia, the hero declares, must not become piebald: 'We're going to keep this country and we're going to keep it white.' In *My Mate* (Edmund Duggan, 1911), a bush drama sympathetic to Aborigines, the hero nonetheless announces that if he had his way, he'd give 'the coloured races' twenty-four hours to get out.

Humanitarian and eugenic suggestions that a mixture of races might benefit Australia elicited a passionate response from the writer Jack Lindsay, Norman's son. Australia, he believed, must not repeat other countries' mistakes. 'Of all the mass imbecilities which have demoralized mankind,' Lindsay thundered, 'this of racial equality between peoples, white, black, red and yellow, is the most inane.' Skin colour remained the underlying criterion for immigration and hence for images of Asians in Australia until the late 1960s, as the minister responsible, A. A. Calwell, made clear. He resorted to the language of the invasion fiction writers with which he had grown up: 'We have twenty-five years at most to populate this country before the yellow races are down on us.'

Mulga Bill of the Future—A Yellow Fancy. *Cartoonists and writers of the 1880s and later were obsessed with the idea of the yellow man reversing the 'natural order' by becoming the white man's master.*

IT WAS IMPOSSIBLE, Donald Horne discovered as editor in the 1960s, to find positive images of 'coloured' people in *The Bulletin*'s back numbers. For more than sixty years the magazine's Australian readers had only to see a short, bespectacled Japanese, a smiling Chinese or an athletic African for familiar corollaries to suggest themselves: evil, cunning, depravity, bestiality. This was because

> All the Japs in *The Bulletin* were evil, if stunted and myopic. All the Chinese and other grinning Orientals were cunning and/or depraved. All the buck niggers were animals. You need to know little more than its iconography to understand much of what the White Australia policy was about.

These images, clothed as all images are in shreds of fact, for years plausibly filled the gaps in most Australians' education and experience.

Travel, for many Australians, confirmed their preconceptions about Asia. They pronounced in sweeping generalisations either on the diligence and attractive appearance of Asians at their various ports of call, or on their laziness and ugliness. The filth or cleanliness of Asians, at a time when many Australians, newly aware of bacterial infection, had a hygiene fetish, was constantly remarked upon. A piece of glass bought at a jewel's price could be taken as proof of the dishonesty of all Ceylonese. Boys diving for pennies in Bombay pointed an object lesson about the impoverished millions of Asia which it would be perilous to ignore. Assertions of Asian deviousness were matched by triumphant claims to have discovered the 'real India', or 'the Orient at last', as if they had been cunningly concealed, and by 'untold' stories and revelations of lands 'behind the veil'. Equally popular were 'quests' to remote interiors never before visited by white men. These were standard themes of Western writers about travel in Eastern countries and as part of Orientalist discourse it hardly mattered whether what they said was fact or fiction, consistent or not.

Anti-Asian prejudice began, as all racism does, with attributing certain characteristics to all Oriental people and, when that became unsustainable, to certain 'types'. The travel writer J. Hingston in 1880 created a typology of his own in *The Australian Abroad*. He found the British less racially degenerate than the Dutch, and described the Malays as having 'no gratitude, no energy, no industry, no manners of any kind'. But the Japanese, currently in favour in Europe, he described as ingenious, artistic, delightful, childlike little people from whom 'we may learn all'. After study of the subject as an Australian prisoner of the Japanese in Changi, W. S. Kent Hughes informed his readers as late as 1946 that

> The Oriental with his simple soul
> Finds harmony with nature as a whole.

In 1952, Australians could still learn from Russell Braddon that Indians lacked moral fibre, Koreans were detestable, Sikhs homosexual rapists, Malays indolent, Chinese hysterical, and that Indonesians, along with most other Asians, were unable to bear pain in

silence. The Japanese, moreover, were leading a hundred years' war of 'Asia against the white man.'

Kipling was not so sure. He was puzzled by Japan's evident superiority over China, the older civilisation, and what that might mean for the hierarchy of types: 'the Chinaman's a native . . . but the Jap isn't a native, and he isn't a sahib either.' In 1900 Kipling memorably declared: 'the Jap has no business savvy.'

A future Australian Ambassador to China was no more prescient. In an article called 'White Australia' Frederic Eggleston explained in 1921 how, in the course of European industrialisation, only the most suitable 'types' survived. The 'Asiatic' was not capable of taking any effective part in complex industrial society. One unskilled Englishman could do as much work as three Japanese, not merely because of his strength, but because of his 'greater fortitude and endurance, educated intelligence and the ability to consume and utilise more food . . .'

Japan, in fact, presented the phrenologists, social Darwinians, Spencerians, and taxonomists with their worst problems, some of which still puzzle observers today. In London *The Times* was concerned in 1904 that it was a mistake to trivialise Japan as a nation of pretty dolls dressed in flowered silks living in paper houses the size of matchboxes, when it already had a bigger navy than Britain's in the Pacific and half a million men in arms.

The paradox of Japan, as child or monster, enemy or ally, concerned Australians too. Victorian parliamentarian Dr William Maloney, who was an international socialist, a fervent republican and vociferously anti-Asian, proposed that Australia ally itself with India against Japan, whose military expansion he forecast in his *Flashlights on Japan and the Far East* (1905). He was a friend of the artists Tom Roberts and John Peter Russell, and a vociferous Cassandra on the subject of Japan to his fellow politicians and their indolent constituents. But the expatriate artist Mortimer Menpes could observe Japan in the same period without alarm. 'Japan', he wrote, 'is not being Westernised in the smallest degree: she is merely picking our brains.' Then, as now, whether you found in Japan an enemy or friend depended on what your expectations were.

The first two professors of Japanese at the University of Sydney, James Murdoch and A. L. Sadler, warned against delusory images, both positive and negative. Sadler sought to explain that what appeared to be an East-West duality in the Japanese character, a paradoxical conflict between passivity and aggression, sensitivity and brutality, was due to the West's limited understanding of Japan. Murdoch, in his 1919 Oriental Studies inaugural lecture, recognised the importance of China but predicted that Japan would become the 'natural leader' of the region because of its rapid adoption of Western methods. Those methods included military imperialism. In the same year, E. L. Piesse, a Japan-literate Commonwealth official, warned that Australia's racial discrimination would strengthen the hand of imperialists in Tokyo. The roads to Pearl Harbor, and in both directions, were paved with racist intentions.

INSTEAD OF BECOMING the best informed of English-speaking peoples about the Asia-Pacific region, as they were well placed to do, settler Australians sheltered from the challenge, accepting Europe's Orientalist constructs as substitutes for knowledge.

Because they failed to identify with their geography, Australians accepted that their own region was the Antipodes, and that the West (the 'podes') was the centre from which the East was 'far'. They adopted the Spice Islands, Tartary, Barbary, Serendip, Shangri-La, and Xanadu as places on imaginary maps as Europeans did. Cathay was the fantasy land of silk and porcelain; Zipangu was the land of lacquer; and the unpinpointable Indies had the same 'impossible picturesqueness' for literate Australians as for Europeans. The Australian bush inspired Orientalist nostalgia in the poets Henry Kendall and Adam Lindsay Gordon. Orientalism for Europeans was about the exotic, the long ago and far away; and in the Australian imagination it became linked with the Antipodean notion that civilised life was always somewhere else. The absurdity was that the real Orient was another great source of civilisation, closer to them than Europe. And in 1901, more than 30 000 Chinese were living side by side with other Australians.

China, it had always been said, was so remote that by digging straight down and deep enough, an Englishman could get there. Australians, in their Antipodean way, repeated this, and retained the image of China being as distant from them as it was from England. Some of the convicts who tried to escape from the penal colony thought they might get to China, even overland, for Botany Bay too, they knew, was at the end of the earth. The image was still recognised in Australian fiction in 1991, more than two centuries later:

> Some people said the holes went right down into the centre of the earth, and even through to China itself! China—a place where men wore pigtails, where everyone trotted along under straw hats . . . where there are so many people that the government stacks them, standing up, into big rooms to sleep at night.

Kipling had instilled in Australians the impression that Mandalay was in an unnamed country 'somewhere east of Suez', and also that, as Peter Dawson resonantly sang, China was ''cross the bay' from it. To get to China, an American popular song later confirmed, took a long time in a slow boat. A remote area of sand dunes, eroding peaks, and saltbush around dried-up Lake Mungo in New South Wales, was named The Walls of China. For the poet Christopher Brennan, China was much more foreign than Europe, his intellectual home; the artist George Bell spoke to his students as if China was *any remote place*; in Alma de Groen's 1986 play, Katharine Mansfield's mother longs to be an explorer anywhere far away—China will do. Australian soldiers in Vietnam, according to a novel by one of them, still thought China was 'the whole of South East Asia and everybody in that part of the world was Chinese.'

China in their minds was a pastiche, derived from the European eighteenth-century image of Cathay, a Utopia of benevolent

3
Neo-Orientalists

China as any remote place—the Far East Fallacy—chinoiserie—the vogue of India—the Great Reflex Movement—japonisme and japonaiserie—opposite extremes in 1888

dictators and harmonious workers, the nineteenth-century one of Chinese heathen tyranny, opiated decadence and mass poverty, and the twentieth-century one of China lost, first to Japanese domination and then to communism.

Because European history remained a much more important component of their national identity than their Asia-Pacific geography had ever been, many Australians accepted not only that China was any remote place, but that all of Asia was more distant and exotic than Europe. They perpetuated the West's view of the 'Far East', and constructed a kind of neo-Orientalist framework for Asia. This we will call Australia's Far East Fallacy.

Australians were late-comers to the European vogue for exotic cultures, having become wealthy enough and leisured enough for such things well after the 'turquerie' phase of Middle Eastern Orientalism in Europe (which followed Napoleon's conquest of Egypt in 1798) was over, and when the chinoiserie movement, which held sway in Europe for more than a century, was giving way to a brief craze for things Indian, coinciding with the apogée of the British raj. Then, in the latter half of the nineteenth century, Japanese artifacts outshone Chinese displays in the great international fairs beginning with London's Crystal Palace Exhibition in 1851, a succession in which Sydney took part in 1879 and Melbourne in 1880 and again in 1888.

As China was declining, Japan was coming to the fore and establishing its culture and identity in the West, and Australia was setting about defining its own. The difference was that Australians were not concerned to seek matching acceptance in or understanding of the East.

The complex cultural exchange between Britain and India, which had been in train since the eighteenth century, flowed out to other British colonies, washing up on their shores the artifacts and tastes that produced new growths in Asia and in Australia, but was based on practical commerce and administrative control. The archdiocese of Calcutta, for example, included Australia until 1835. From the 1850s, international exhibitions reinforced the power of the imperial metropolis, inculcated images and stimulated demand. By means of these displays, for example, the chintz style and the paisley design became part of Australians' early perceptions of India. In addition, Australia's first ballet audience in 1835 saw *The Indian Maid*; and Pavlova in the 1920s brought the young Uday Shankar to Australia and performed with him in *Oriental Impressions*. Australians who read Arnold's *The Light of Asia* were probably outnumbered by those who knew the name as a brand of tea. Loan-words from India—including the familiar 'verandah', 'bungalow', and 'gunny' sack and the less-familiar quli (coolie) and bundook (musket)—arrived by way of the thin red line. The snakecharmer Chunder Loo was introduced to Australia by Kipling, Norman Lindsay, and Cobra boot polish, and his name became rhyming slang for 'spew'.

Chinoiserie, no less than the vogue for things Turkish or Indian, was an amalgam of ideas which had been ingested back into China and re-exported over several centuries. Chinoiserie in designs

of Doulton, Worcester and Minton china particularly impinged on settler Australians who bought pieces or saw them on display. The ubiquitous willow pattern was accepted to represent China, in spite of being entirely a European invention. The British China trade gave settler Australians direct access to silverware and ceramics from Canton, and table mats, baskets, furniture, and paintings in oils, watercolours, and on glass, all produced for Western chinoiserie tastes. As well, export goods reached Australia having been ordered by settler Chinese.

At the exhibitions, and in the shops that sold products of the 'Chinese and Japanese empires', the two countries were sometimes confused. Advertisements, accounts by critics, and the makers of the objects themselves, often lumped the two together. A yellow Minton teapot, for example, owned by the South Australian Gallery since 1904, decoratively combines a Chinese figure and a Japanese Nō mask.

Japan sent its first display to the Paris exhibition in 1867 and took part in all its international successors, including those in Sydney and Melbourne. Deliberately promoting their capacities in the West, and their superiority over China, the Japanese purveyed an image of artistry and integrity in which Europeans and Australians alike found a pre-industrial, childlike innocence. The Melbourne art critic James Smith borrowed such terms from British writers in describing the Japanese court at the 1880 exhibition. It seemed to surprise Smith, considering Japan from his position of inherited Anglo-superiority, that the invasion of Japan by the West in 1854 had set off a reciprocal invasion of the West by Japan—'a great reflex movement'—as a result of which Japan had come to 'profoundly affect the artistic productions of Europe and America.' This movement came to be known as Japonisme.

On a more superficial, fashionable level, as enthusiasm for chinoiserie waned, newly prosperous Australians filled their houses with japanalia or japonaiseries: fans, waxed-paper umbrellas, woodblock prints, cloisonné vases, peacock feathers, 'Jap' silk, and 'Jap' pincushions. The Western obsession with Japan outdid its Chinese predecessor, in content as well as in extent. In England it quickly gave rise to Aestheticism, and its stylish accoutrements were exported to the colonies by Liberty's shop in London. In Melbourne by 1888, Tom Roberts' studio decor included a Japanese fan, a paper lantern, an Oriental cane chair, screens, bowls, and muslin draperies—a setting copied from Whistler in London and described as 'thoroughly and fashionably Aesthetic'. Both Aestheticism and the Arts and Crafts movement, which had grown in England out of the ideas of William Morris, thrived on a Japanese diet. Oriental prints had been shown in Sydney as early as 1857; books and magazines on Japanese art were rapidly shipped to the colonies; and prints and other Japanese objects collected by the architect John Smedley, by Felix Myer, George Verdon, and L. Bernard Hall were exhibited in the 1880s and 1890s.

1888 in Australia was annus mirabilis. Japan was in the ascendancy. In that year *Artistic Japan*, the English translation of Samuel Bing's *Le Japon artistique*, went on sale in Australia, and Mortimer

Menpes' articles about Japan appeared in the *Magazine of Art*; Tom Roberts painted Mrs Louis Abrahams in his aesthetic studio, and Charles Conder created his japoniste *Bronte Beach* and *A Holiday at Mentone*; at the Centennial Exhibition in Melbourne, Japanese goods were widely admired and bought; Japanese gymnasts performed in Sydney; the new Japanese house was in the public eye in Brisbane. In the same year Pierre Loti published his influential popular novel *Madame Chrysanthème*, an account of a sailor's stay in Japan upon which *Madam Butterfly* would be based, and which epitomised Japan for Van Gogh as it did for the Australian artist John Peter Russell and novelist Hal Porter. The Reverend James Jefferis advocated uniting the best of Asian and Pacific capacities in Australia, and Cardinal Moran spoke of Australia as the future centre of civilisation in Asia. In the South Australian *Lantern*, Leo's celebrity portrait featured Mr Y. S. W. Lee, a respected local Chinese identity.

But China was out of popular favour. The same centennial year was marked by riots outside Sydney's Parliament House against Chinese migrants on board *Afghan*, who had been refused permission to land in Melbourne. Delegates to an intercolonial conference resolved to restrict Chinese entry and movement, restrictions which in 1896 would be extended to all 'coloured' races. In 1888 *The Boomerang* carried William Lane's serialised Asian invasion novel *White or yellow? A Story of the Race War of AD 1908*. In cartoons in *The Bulletin*, an Australian worker battled a Chinese on a building site marked 'room for one only'; a baby shaped up to an Oriental dragon invading his cot; and a 'yellow rogue elephant' with fans for ears and a pigtail for a trunk was beaten off by settler Australians. In 1888 *The Bulletin* ran a special 'anti-Chinaman' issue, and, by 1895, was fulminating against the Japanese as well.

Those who found in Japanese, Chinese and all Asians the undifferentiated incarnation of their worst fears, were poles apart from those who idealised Japanese industriousness and artistry, Chinese civilisation and Indian philosophy; but they were alike in their selective use of information. Between the poles were a few Australians who offered wiser counsel, but who were usually derided or shouted down. When Sadler and Murdoch urged Australians to learn more about China and Japan they were, on the whole, ignored. When a lone Senator offered the view, in 1905, that

> Japan, successful as she has been on the battlefield, is much more anxious to be recognised as the exponent of peace and civilisation, than of war and conquest . . . though originally Asiatic, the Japanese . . . are now no more Asiatic than they are European,

and proposed a treaty with Japan, he was castigated by the Defence Minister, who asserted that the Japanese were inherently aggressive and must be kept out of Australia. Those who sought to trade with Japan were described as traitors by *The Bulletin*.

The bicentenary in 1988 inspired the slogan 'One Australia', which meant the same as the 'room for one only' calls of 1888. In 1990 a popular Sydney radio announcer was suspended for three

Turandot (1928). In the Australian premiere of Puccini's opera, leading roles were sung by Italians, wearing costumes which had more to do with European chinoiserie than with China. (Gyger, 1990.)

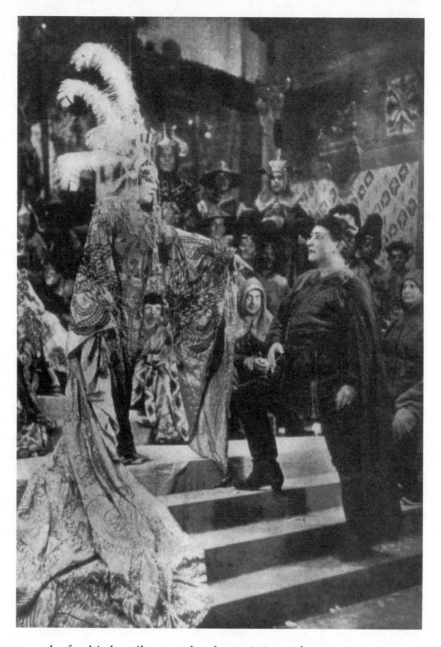

months for his hostile remarks about Asian refugees. He returned to the airwaves in 1991 with the suggestion that boat people be stamped on the forehead with an 'Australian reject' sign and deported. No action was taken against him by the Australian Broadcasting Tribunal.

The judgments we make depend largely on the way we view things in the first place

Rodney Hall, 1988

II
The Circular Route: Prehistory to 1945

WHEN WILLIAM WESTALL, a young artist on Matthew Flinders' voyage of 1801–03, painted *Malay Bay from Pobassos Island* and *The Island of Timor*, he may have made the earliest images of Asia seen from Australia by Europeans. But Aboriginal impressions of Asia preceded them.

What would have challenged Australian settlers' image of their country as an isolated outpost in a hostile neighbourhood, had they known about it, was the long story of contact between Aborigines in the north and visitors from Asia. Great Chinese fleets cruised close to Australia on their way to the coast of Africa in the fifteenth century, and Japanese traded in Southeast Asian waters in the sixteenth century. Sailors may actually have landed. Aborigines spoke of contacts with pale-skinned people they called Baijini who, it is speculated, may have been Chinese.

Well before 1700, fishermen from Macassar in the Celebes began to visit the coast of Arnhem Land with the northwest monsoon at the end of each year, to gather and cure trepang (bêche-de-mer) which was much in demand by Chinese as an aphrodisiac.

Eloquent corroboration of centuries of this Aboriginal-Asian contact, which occurred as a result of the visits of Macassan and Malayan traders, appears in painted wooden figures and paintings in rock shelters in the northern coastal regions. Aboriginal artists differentiated the sailing boats used by Macassans from those used by Bugis; they recorded the Indonesian kris (daggers), and the smokehouses made of bamboo and rattan; they drew decorative motifs like those of the Macassans; and they made the earliest image of Australian travel abroad, a rock painting of a monkey, apparently seen by Marege Aborigines who are believed to have joined the crews on their voyage back to Indonesia. In northeast Arnhem Land, stones were arranged on Aboriginal sacred ground in the shape of the sailing prau and representations of houses, seen in Macassar by the Aborigines.

Old Aboriginal men in the 1970s recalled the pearl-fishing industry in Cape York, and the Chinese, Malays, Japanese, and South Pacific divers who, in the 1880s and after, cohabited and worked there in reasonable harmony. They remembered a number of Japanese words, songs and dances and the use of chopsticks.

After the Macassans' visits ceased, the Aborigines continued to use rock and bark painting, as they had always done, as a way of recording and interpreting news from elsewhere. In the Arnhem Land rock galleries they gave visual accounts of a railway line under construction, of the Chinese labourers (who built it) being chased, of the port of Darwin, and of a house there on stilts.

AN EARLY OBSERVER of life on the north coast, in Torres Strait, and in Papua and New Guinea was the photographer and filmmaker Frank Hurley. He found the white society of Port Moresby distasteful and the Torres Strait islanders deplorably missionised; he trenchantly described polyglot Thursday Island as a satire on the White Australia policy. As John Harcourt, a former

4
Image-makers

Aborigines and Macassans— film and fiction on Oceania— architecture—childhood images—popular perceptions from Chu Chin Chow *to* The Mikado—*food, wine and females—attacks on pigtails— gap-crossers in China, Japan, and India—the Adventure Zone—Illicit Space*

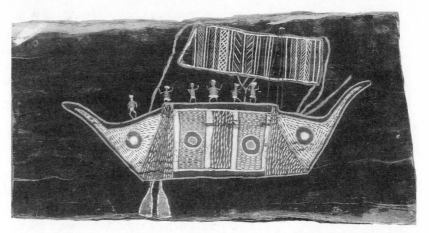

Minimini Mamarika, The Malay Prau *(c. 1948). Paintings on rock and images on sand recording the annual visits of Macassan trepang fishermen were Aboriginal artists' first images of Asians. (Art Gallery of South Australia, Adelaide.)*

pearl fisherman, pointed out in his novel, the White Australia policy became inexpedient when labour was needed for difficult or dangerous work.

Suspended in geographic limbo between Asia and what some called Oceania, in what might have been Australasia, New Guinea had been thought from the time of the earliest European settlement to be in Australia's sphere of influence. In the 1870s the coastline of New Guinea had been only partly charted, and little was known of its interior. To some Australians it seemed a land of mystery and promise, less dry and dispiriting than Australia, and with more colourful and interesting inhabitants. Some were concerned to save heathen souls there, and others to improve ignorant minds, while others again sought to line their pockets, particularly after gold was discovered.

Many Australians projected the Antipodean fantasies brought from Europe onto this unknown country beyond their own, imagining it either as another El Dorado or as Ultissima Thule. If New Guinea was Australians' Further Antipodes, they could also, it seemed, assume spiritual, political, economic and cultural dominance over it, just as Europe maintained dominance over colonial Australia. But while it attracted them, New Guinea would over the years confront settler Australians with unwelcome questions about their identity and their place in the region. Were they colonised or colonisers, dominated or dominant? What had they to give New Guinea that was not second-hand European?

New Guinea could not be dealt with by any accepted European formula; it required Australians to devise a new one. They had failed to create 'Australasia'; New Guinea would throw back at them the unresolved Australian dichotomies between history and geography, black and white, East and West, egalitarianism and authority, law and enlightenment.

Simpler verities attracted Australian silent-film-makers, for whom Papua and New Guinea were convenient sources of exotic, thrilling and salacious images close at hand, uniquely theirs to exploit. From 1915, Jack Ward shot his travels in Papua and used them as background in *Australia's Own* (1919), a film about the adventures of an Australian girl among 'naked tribes of head-hunters, cannibals, giants and dwarfs of a trackless country'.

Ward's *Death Devils in a Papuan Paradise*, similarly playing up the attractions of Eden and Hades, appeared in 1924. Old footage shot by pioneering Australians would be reused by Bob Connally and Robin Anderson in their *First Contact* (1983) to examine first impressions of New Guineans and Australians of each other in the central highlands in the 1920s and 1930s.

Ward's efforts were followed by the 'travelogue entertainments' of Frank Hurley, who did in fact make, and film, first contact with tribes on the Fly River and at Lake Murray. His *Pearls and Savages* (1921) was advertised as offering 'a mile and a half of film embracing black men, pearlers, cannibals, strange birds, savage headhunters, and the goblin dens of the wild men of the Papuan interior'. Hurley found there was a market for colourful accounts of the region and went on to make *With the Headhunters in Papua* (1923) and *The Hound of the Deep* (1926), shot on location on Thursday Island. Hurley had to make *Jungle Woman* (1926) in Dutch New Guinea, because Australian authorities said it would be 'harmful to show whites and blacks together'. Although Hurley avoided the stock cast of planters, missionaries, adventurers, and native women in blackface, he had no New Guineans in significant roles, and many of his white cast were British.

Norman Dawn followed Hurley's lead, making *The Adorable Outcast* (1928) in Fiji, and several other island romances. Jack Bruce and Noel Monkman extracted a bit more mileage from the formula of pearlers, crocodiles, opium smugglers and bloodthirsty 'natives' in *Typhoon Treasure* (1938). The genre was still alive in 1954 with *King of the Coral Sea* (Lee Robinson), in which an Australian pearler discovers an illegal immigration racket involving Yusep, his half-caste crewman.

The Devil's Playground (Victor Bindley, 1928), filmed on Sydney beaches and in the Mosman town hall, purported to show the 'fetish and cannibal rites' of rebellious natives and the 'wild doings' of Europeans in the Trobriand Islands. Settler Australians in blackface played the islanders—just as they wore stocking faces to play Chinese in *The Birth of White Australia* (Phil Walsh, 1928) for which the citizens of Lambing Flat (now Young, New South Wales), provided both the extras and the finance. Audiences were, it seemed, expected to accept that any black person, or any Asian, was interchangeable with any other.

Fascination with Australia's north continued into the sound film era, with *Isle of Intrigue* (A. R. Harwood, 1931), *The Unsleeping Eye* (Alexander Macdonald, 1927), and *Mystery Island* (1937). In *Lovers and Luggers* (Ken Hall, 1937), footage shot by Frank Hurley on Thursday Island was incorporated, with background projection, in the Sydney production. The cast included an American in the lead role, settler Australians as Chinese, and a Chinese actor from Hong Kong, Charles Chang, billed as 'Australia's Charlie Chan' in the role of a Japanese diver called Kishimuni. This represented some progress, if only to the extent that an Asian from one country (if not the right country) was in the cast.

One of the last silent films made in Australia, *In New Guinea Wilds* (William Jackson, 1929), was a documentary promoted as

Livingstone Hopkins, Annexation—Carrying the Blessings of Civilisation into New Guinea *(1883). Queensland, which needed plantation labour, sought to annex south-eastern New Guinea in 1883, before Germany colonised the north-eastern part in 1884. (*The Bulletin, *1883.)*

E. W. Cole, Human Beings with Tails *(1873). In a fictional traveller's account, the publisher of Cole's Funny Picture Books satirised Australian ignorance of New Guinea and challenged images of its barbarity. (State Library of Victoria.)*

having no staged or faked effects. Realism in films set in Oceania was difficult to achieve, however, for so long as censorship banned nudity. Charles Chauvel had to battle with the censors to bring in film from Tahiti that included bare-breasted dancers for *In the Wake of the Bounty* (1933). Later, on-screen nudity by natives was permitted while it was prohibited for whites; as the censors well knew, an interest in history and anthropology could mask the audience's appetite for the salacious.

AUSTRALIANS FELT THAT if there was one part of the world about which they had a stronger claim to write novels than British or American writers had, it was Papua and New Guinea and the South Pacific, or Oceania. This did not necessarily mean their fiction was highly original. They had read Herman Melville, Robert Louis Stevenson, and Joseph Conrad on the Pacific in general, but for themes they looked to others who wrote about adventures in places nowhere near Australia. Like the filmmakers, they then projected onto a South Pacific island background a romance or adventure story whose original model might be Defoe, Swift, or Fenimore Cooper. Heirs, as they saw themselves to be, of the early explorers and of Captain Cook, and aware of the fates that befell many of those men, the earliest Australian Oceania novelists were confident of a market in Australia and in England—where most of them were published—for bizarre accounts about lands that they and their readers might not have seen. The result was 'a mixture of Aztec splendour and Dyak barbarity'. New Guinea was fictional open slather: it was open to H. M. C. Watson to exaggerate its exoticism and savagery; to E. W. Cole to satirise Australian ignorance of New Guinea while himself compounding it; and to C. A. W. Monckton to tell how he meted out white man's justice in a country which he found to be a 'weird compound of comic opera and tragedy, with a narrow margin between them'.

Fact hardly needed embellishment by fantasy, as a long succession of real-life adventurers showed. Sir Hubert Murray, Ivan Champion, Frank Hurley, and Mick Leahy were written of as if they were Ulysses or Columbus in Australia's new world. Jack McLaren wrote up his own wandering life in Papua, New Guinea, and Thursday Island, the Solomons, and north Queensland for *The Bulletin*, and later became a writer and broadcaster in London. There, from the 1920s to the 1940s, he produced over twenty books of formula fiction about what he called 'the British Empire's tropical outposts'. Louis Becke had a similar career, but with added realism, having been shipwrecked, arrested for piracy and acquitted. J. M. Walsh was another chain-writer, addicted to beginning a new novel about his own experiences as soon as he had stubbed out the last. He too moved to Britain and continued his habit after 1929.

The most famous and hence the most influential of the Oceania image-makers was Errol Flynn, whose misspent youth included four years sailing, trading, tobacco planting, and blackbirding in New Guinea from 1927. In the seven stories he wrote for *The Bulletin* he did not mention that he suffered from malaria and

Michael Leahy *(1934). Leahy, a prospector, and his three brothers were the real-life epitome of white adventurers in Oceania fiction, making first contact with and living among tribespeople in the PNG highlands.* (Hemisphere, *1984.*)

gonorrhoea as a result of his experiences. 'I have killed!' was the title of one of his Oceania stories, published in America.

Others involved in the industry of 'Strange South Seas' fiction included the adventurers Beatrice Grimshaw, Ion Idriess, and Frank Clune. Grimshaw, a Barbara Cartland precursor of the 'cannibal islands,' as she called them, based her tales of tourism, adventure, and romance on personal experience. Idriess wrote of Aborigines with a mixture of disparagement and admiration, yet he deplored the damage that colonial settlers were doing to New Guineans, whose society was generally held to be a step up from that of Aborigines. Other writers who shared his concern were Alys Brown and G. Munro Turnbull. J. M. Walsh, on the other hand, borrowed such epithets from British colonial fiction as 'insubordinate', 'impertinent', and 'treacherous'. His advice was never to relinquish colonial dominance:

> Once shake the black's belief in the white's ability to rule and continue ruling, and anything can and may happen.

Although some might regret the 'fatal impact' of Europeans, there was no doubt in these Australian writers' minds about whose side they were on, or who in the South Pacific were 'we' and who were 'they'. Eleanor Dark might send an idealistic doctor to regain Eden by establishing a Utopian community on a Pacific island (*Prelude to Christopher*, 1934), but her standpoint remained the same: Australians were still inheritors of the white man's burden to enlighten and improve the natives.

Vance Palmer, with *The Outpost* (1924), led the way for many more novels by young Australians who were patrol officers in Papua and New Guinea: bearers of the burden in the further Antipodes, the very last of empire's outposts. The 'niggers' are referred to as 'cheeky brutes', and a locally brought-up Australian woman's wild impulses are suspected of resulting from 'dark blood'. Palmer's Resident Magistrate prides himself on reforming

'primitive' behaviour, but he questions the value of making the 'dark people' dependent on Australia.

Doubt surfaced during the Second World War when New Guineans witnessed the white men's retreat and humiliation before an Asian enemy, and proved that they themselves had the toughness and local knowledge their former overlords needed to survive in the jungle. Australians who had feared at the beginning of the war that New Guineans, or indeed Aborigines, might side with the Japanese 'liberators', now worked shoulder to shoulder with them and often owed them their lives. There would be no going back to racial supremacism in New Guinea after such an experience, the novelists George Johnston and T. A. G. Hungerford believed: although Hungerford noticed that the diggers did not always apply their egalitarian principles to their native carriers. Even so, the visual images of New Guineans and of Papuans, in keeping with Australians' newfound gratitude, changed from exotic savagery to gentleness and heroism, as Damien Parer's photographs, William Dargie's paintings, George Allen's sculpture, and documentary films such as *Angels of War* and *Tidikawa and Friends*, later demonstrated.

The Adelaide poet Francis Webb had never been to New Guinea or the South Pacific islands, unlike the vagabond real-life chain-novelists. But he broke new ground in his poem 'A Drum for Ben Boyd' (1945), by giving a voice to a Papuan victim of one of Boyd's notorious blackbirding raids of the 1840s, and by reversing the simian stereotype to describe Boyd as a 'dressed-up ape with a patronising stick'. For Australian writers, filmmakers and artists after the Pacific war, the simple images with which they had been brought up would no longer be adequate, either for the region or for themselves.

IN ARCHITECTURE, COLONIAL dominance found its most tangible expression. Buildings, as Ruskin said, are documents embedded in time, and those in Delhi, Bombay, Rangoon, Penang, Singapore, Hong Kong, Suva, Melbourne, and Sydney were massive monuments to British imperial power. Queen Victoria had become empress of India in 1877, and a spate of Indianesque and Moorish Victoriana paid her opulent homage. All over Australia, hotels, railway stations, banks and museums played back the theme of the empire upon which the sun never set. These buildings endured long after the eclipse.

More modest buildings took Australian conditions and materials into account, and their designers might even adapt ideas from Asia and the Pacific. The bungalow was evolved by the British in India, from more distant antecedents. The design was adapted to the basic Georgian structures in southern Australia and became the verandahed homestead and cottage, while in Queensland it rose on stilts (like its cousins in Fiji) and acquired jalousies, venetian blinds, and ceiling fans. With its simple frame construction, its hipped corrugated-iron roof and spreading verandah, the house looked like someone wearing a digger's broadbrimmed hat: the

George H. Allen, Papuan Carrier *(1947). When Australians realised they owed their survival in the jungle war to Papuans and New Guineans, images of them became more benign and heroic and less barbarous. (Australian War Memorial.)*

25

Antipodean. 'We mould our buildings, and then our buildings mould us,' as Churchill said.

An 'Australasian' vision for Australian cities was put forward by a retired servant of the East India Company, who recommended devoting whole streets to various architectural styles: Grecian, Italian, Mauresque (Moorish), Gothic, Egyptian, 'the Hindoo and even the Chinese'. Instead of that, Australians, devoted as they were to imported style manuals, eclectically reproduced whatever they liked in *every* street. Until David Saunders and Brian Lewis drew attention to it in the 1960s, little respect was paid to the legacy of Chinese builders and furniture makers in Australia, and still less was taught about their work to students of architecture.

About forty-five temples (often called 'joss houses') were built by Chinese in Australia, but very few remain today. Temples repeatedly bore the brunt of anti-Chinese feeling, in fiction and fact. In Idriess' story 'The Yellow Joss' (1934), the 'pagan idol' becomes a target of vindictiveness. Half the cast of Bedford's play *White Australia* (1909) meet their end in a fight in Darwin's Chinatown. In 1916 Brisbane's main 'joss house', which had been attacked several times since its erection in 1886, was looted by vandals. After the First World War, the press revealed that a Melbourne mob had broken the windows of the Chinese club in 1914 when war was declared; on Armistice Night in 1918, they broke them again.

The main Darwin temple was closed during the Second World War, but three others at nearby Pine Creek were looted by Allied troops stationed there, apparently in disregard of the fact that Chinese were both Australians and allies. The incident was veiled in obscurity by historians, but in John Romeril's play *Top End* (1988), locals in Darwin say there is an old Chinese man who bears

Melbourne Joss House. *Chinese temples, called joss-houses, were subject to particular hostility in wartime, although Chinese were not the enemy. Reports of attacks on local Chinese establishments in Darwin and Melbourne during the Second World War were suppressed. (Latrobe Collection, State Library of Victoria.)*

Japanese House at New Farm
*(1887). A Brisbane judge had a
house built for him by a
Japanese architect and Japanese
workmen, from Japanese
materials.* The Boomerang's
*writer thought the Japanese,
'this peculiar but interesting
people' could help solve the
problem of semi-tropical
architecture. (*The Boomerang,
1887.)

the scars of an 'anti-Asian rampage'. Given the pattern of Australians' xenophobic tendencies erupting into violence in wartime, it is more likely to have occurred than not. It was the noble Anzacs of 1914–18 whose

> assumption of racial superiority and . . . callous contempt for non-European cultures . . . granted the diggers *carte blanche* to run amok among the 'Gyppos' en route to Europe and to terrorize the hapless 'niggers' of Colombo on the way home.

Such architectural links with Asia as existed in the early settlement period, or which survived it, had more to do with Australia's colonial identity than with an interest in Asian traditions. Prefabricated houses were imported from India, China, and Singapore to meet the need in Australia, especially during the gold rushes. In 1853 nearly 16 000 houses arrived, most of them prefabricated to British design in other colonies in local materials. 'St Ninians', a house still standing in the Melbourne suburb of Brighton, was built in 1841 for G. W. Cole using Singapore teak.

Although Australians saw Japanese carpenters assemble teahouses before their eyes at international exhibitions, they generally failed to consider any application for such exotic architecture to their own needs. Japanese prints were widely known by the 1870s, and photographs of Japan had begun to appear at the end of the nineteenth century, showing the detail of buildings and interiors, and the relationship of inside to outside space, but they largely failed to kindle in Australia the spark of interest that was already burning in the West. A Japanese house built in Queensland in 1909 was considered by Addison, a Brisbane architect, 'eminently suitable for the Brisbane climate but quite impractical for the Australian way of living'. Judge G. W. Paul of the Brisbane District Court, who had visited Japan, brought materials, carpenters, and artists to build a Japanese house at New Farm, which he filled with his collection of Japanese art objects. Even the anti-Japanese magazine *The Boomerang* was impressed, in 1887, with the detailed artistry of the house and its wall panel painting of 'Fugi Yamna'. But, the critic warned, it would not do for Australian families and for their 'refractory colonial children'.

A critic for the English art magazine *The Studio* was taken with the style in which Mortimer Menpes had furnished his London house in 1899, but equally dubious about whether it would suit Western living. Menpes was an Adelaide-born artist who studied under E. J. Poynter and then with the American impressionist J. A. McN. Whistler in London, from whom he acquired a taste for things Japanese. Menpes went to Japan twice, in 1887 and again in 1896, lectured in Australia, and produced an impressive array of paintings, prints and books based on his travels, many of them engraved and printed at his own press.

On his second visit, Menpes stayed long enough in Kyoto to have fittings made for his house in Cadogan Gardens, Chelsea, which had been designed in the japoniste arts and crafts style by Arthur Mackmurdo. As a follower of William Morris, he preferred

The Inner Hall at No. 25 Cadogan Gardens *(1899). The expatriate artist Mortimer Menpes brought fittings for his London house back from Japan. English critics, like Australians, doubted the suitability of Japanese design to a western lifestyle. (*The Studio, *1899.)*

the company of Japanese carpenters and artisans to that of the foreigners in Tokyo and Yokohama, who seemed to him to spend their time abusing Japan and everything Japanese. 'Strange', he remarked, 'that a colony of such unrefined, uneducated people should presume to criticise these artists.'

Menpes was unusual among Australian artists of his time—though less so among Americans—in elevating Japan above Europe and in going to Japan to acquire the perquisites of an elegant life. Australian architects generally expected to have foreign styles mediated to them by Europe or, in the case of Japanese design, increasingly by the United States. They waited while Mackmurdo and Dresser, Greene and Greene, Frank Lloyd Wright in his way and the Bauhaus in theirs adapted Japanese design. A critical response greeted Walter Burley Griffin and Marion Mahony Griffin when they gave expression to these ideas in Australia in the 1920s and 1930s. Mahony had worked in Wright's studio in the 1890s and 1900s, designing furniture, light fittings, and glass mosaics in keeping with his houses, and making perspective drawings 'filled with the spirit of Japonisme'. Hardy Wilson's advocacy of Chinese architecture was all but ignored. Modernist buildings appeared in

the late 1930s, but few Australians saw the architecture of the countries closest to them as playing a part in modernism or as having anything relevant to offer.

FAR FROM EXPECTING to find models for themselves in neighbouring countries, settler Australians were conditioned by their European contacts to perceive Asians as people to be instructed, not to seek instruction from; to be patronised, not to be equal with. China might have a long tradition and an impressive list of inventions to its credit but the Chinese were thought in the West, and hence in Australia, to have become dissolute. The popular images commonly attached to them were of coolies, eunuchs, gnomes, dwarfs, or opium-crazed sex maniacs. Japanese had shown they were clever imitators but they were still the 'near relations' of the Chinese, and were seen in the more flattering of Western descriptions as 'harmless little folks' who lived in paper boxes or rabbit hutches and made tawdry products. Americans in the Philippines called Filipinos their 'little brown brothers' once they were colonised—and before that they were said to be gorillas and savages. It was common for Indonesians to be referred to by the Dutch as monkeys and by the British as 'nig-nogs.' Images of insect pests and monkeys were commonly used to reinforce distaste for whichever Asian people were out of imperial favour. By the time of the Korean War, a cartoon showed a communist spider making its web across all of Asia to Australia, where such internationally-accepted ideas were not disputed.

The power of these images, and the authority of their Western origins, is revealed in recollections of Australian childhood. Indians were visible in Australia, often as 'Afghan' hawkers or 'lascar' seamen; and from *The Bulletin* magazine, children knew Kipling's verse about the itinerant snakecharmer Chunder Loo of Akim Foo. The less-visible Indians, the ones who were

> Far away in Sunny India
> Where the Idol Temples stand,

were presented in threatening terms to Sydney children during the Indian mutiny:

> . . . cruel pagans tried to murder
> All the Christians in the land . . .
> Yes, if you had been in India
> Perhaps they would have murdered you.

Early contacts with Chinese were more frequent than with Indians and were vividly remembered by writers. Henry Handel Richardson had a powerful childhood vision of 'Chinamen' as 'fearsome bodies (who) corresponded to the swart-faced, white-eyed chimneysweeps of the English nursery'. Tom Hungerford recalled the Chinese market gardeners in south Perth who, everyone knew, played fantan and conducted orgies on Saturday nights. An Australian girl in one of his stories is thrown out of her family

Velly Good Lettucee. *Many Australian writers and artists recalled their first impressions of Chinese as market gardeners and vegetable hawkers. (Engraving from a photograph,* Centennial Magazine, *1889.)*

Lionel Lindsay, The Five Years that Possibly Remain *(1910). Australians and Japanese cooperated as allies of Britain in the First World War. The Little Boy From Manly fears the deluge of Japanese samurai militarism which may follow expiry of the treaty in 1915. (*The Bulletin, *1910.)*

Oscar Asche in Chu Chin Chow *(1931). Wearing an authentic robe, the German-born Australian actor-manager made an international success of his role as the evil Abu Hassan disguised as a Chinese grandee. (Performing Arts Museum, Melbourne.)*

when she marries one. (As late as the 1930s a custody case could be brought against a girl for 'associating' with a Chinese man.) In a 1967 poem Hungerford admitted he had only to encounter a smiling Chinese boy for 'all the old lies', missionary horror stories, and the Chinese menace to revive in his memory. Charmian Clift recalled the same dual image of Chinese as both whimsical and sinister, and the superstitious saying: 'You must have crossed a Chinaman.' Sali Herman painted a *Chinaman's Garden*, still a familiar sight in 1948. In the 1980s the Sydney journalist Ron Saw would recall how Australians between the two world wars saw Chinese: 'Ching-Chong-Chinamen who worked the vegetable gardens; comic coolies'. The Christopher Koch would ingest from old copies of the British boys' magazine *Chums* the impression that 'Chinamen' were sinister. And the poet Fay Zwicky, visiting Beijing, recalled childhood games of Chinese Torture and Chinese Burns.

Australian writers, like their Western counterparts, perpetuated condescending antipathy to Chinese in the way they transliterated names and represented Chinese spoken English. On the early Australian stage, Chinese were often the comic characters, with such names as Hang Hi, Hang Lo, Ar So, Ar Filth, and Ah Sin. Cartoonists invented Bung-Hi and Ah Hop. Writers of invasion fiction called their Chinese villains or their fall guys Cow Far, Sin Fat, Sir Wong, Charlie, or John Chinaman. In his novel *The Mandarin* (1899) Carlton Dawe recorded a servant's warning to a foreign traveller in China in a way that makes the well-meaning local man, not the ignorant visitor, seem foolish: 'Blidge slippee slippee'. In Edward Sorenson's tale, the boss, Murphy, calls his Chinese cook a 'gibbering idiot', and to Edward Dyson's ears, the Chinese on the goldfields spoke a 'babble of grotesque gibberish'.

Just as Chinese became more avuncular in cartoons when the Japanese became more threatening, Chinese fictional characters magically became taller and more articulate as Japan replaced China as the Asian enemy. Lionel Lindsay sketched a large, menacing samurai looking down at tiny Australia while waiting for the dam of the Anglo-Japanese alliance to break in 1915—the very alliance that Australians had opposed in 1902. But in *Chu Chin Chow* (1921), Oscar Asche disguised his villain as a 'dignified and sonorous' Chinese prince, whose opening words the drama historian Leslie Rees remembered from his youth: 'I am Chu Chin Chow of China'. A Japanese scene in a 1934 marionette revue, *All Aboard for Happiness*, was later dropped and a Chinese one inserted. In 1947, two years before Mao's revolution, the Melbourne Puppet Guild created a benign fairytale China in *The Emperor's Nightingale*, perpetuating the Far East Fallacy in the minds of young Australians.

The European puppet tradition had for centuries included Oriental pastiche figures, and at the height of the vogue for chinoiserie, a version of shadow-puppetry was known as ombres chinoises. When Thai and Cambodian dancers were taken to France in 1900 and 1906, and when Japanese dancers, jugglers and acrobats performed at the international expositions, they seemed to Western observers, as they did to Australians, like puppets come to life. A Japanese troupe visited Australia as early as 1867.

Katsushika Hokusai, Samurai in the Rain, *from* Manga *(1812). Hokusai's small figures of humans and animals in natural poses fascinated European artists. (State Library of Victoria.)*

The Geisha, a British musical comedy, had forty-two performances at the Princess Theatre in Melbourne in 1898. Japanese performers were painted from life in Melbourne by Nicholas Chevalier in 1873, drawn in Sydney by Phil May, Arthur Collingridge, and Constance Roth in 1886–87, and painted in Paris in the early 1900s by Rupert Bunny. Another group, performing in Hyde Park in London, and said by Collingridge to be superior to Sydney's Japanese Village in number and quality, provided Gilbert and Sullivan with first-hand material for *The Mikado* (1885).

When pert little figures of fun called Yum-Yum, Nanki-Poo, Pitti-Sing and so on appeared in *The Mikado*, few in the audience were likely to quibble that these sounded, if anything, more like Chinese than Japanese names. They represented the doll-people, petty villains, pompous officials, and brocaded potentates, whom Europeans had come to know well from centuries of reports from both China and Japan, countries which were sometimes confused in their minds.

Mikado-mania quickly reached Australia. Its imagery was still current in 1907, when the artist Margaret Preston went to a Mikado party in Melbourne under Japanese umbrellas. Women's magazines offered ideas for decor and arrangements for such occasions. A Mikado Bazaar opened in Sydney. The Japanese house at New Farm was described as 'a perfect dream of Mikado-land, where the harmony of the decoration and the perfection of colour and outline is as perfect in its way as was that of the Greeks in theirs'. Fans and umbrellas became the emblems of the Mikado-land dream, and when they turned up in paintings by Streeton, Menpes, Bunny, Bell, Charles Conder, Thea Proctor, Ethel Spowers, and Roy de Maistre, it was always with the suggestion of exotic, stylish aestheticism but often, also, of childishness. *The Mikado* was still being put on in Adelaide in the 1960s, as the writer

Roy de Maistre, Woman with Parasol at Palm Beach *(1927). Even after japonisme had been succeeded by other modern movements, an umbrella, here one of several intersecting circles, continued to be a metaphor for exoticism, ease, and aestheticism. (Art Gallery of New South Wales.)*

Nicholas Jose would recall in 1987, with cherry-blossom sets and school-children giggling at the mention of Titipu and the singing of 'Tit-willow'.

On the eve of the Second World War, the Sydney book fancier Percy Neville Barnett was still writing lyrically of the imaginary Japan, with its

> dainty, winning maidens in their gay kimonos, and all the simple folk unspoilt by the corroding influence of people with ways alien to their own.

Rohan Rivett went to the opposite extreme, recalling that the stature and general appearance of the Japanese made them a joke in Western eyes. Both images were trivialisations, and both would be swept away by the war.

As the reality of modern Japan asserted itself, some Australians, instead of reassessing their image of Mikado-land, blamed Japan for its betrayal of their childhood dream. Tom Hungerford and Hal Porter would both be disappointed when paper lanterns and irises were less in evidence in post-war Japan than they expected. Porter was preconditioned to love Mikado-land, he said, by producing G&S at Prince Alfred College in Adelaide and at the Hobart Repertory, by the prints in the National Gallery of Victoria, by Japanese objects in Melbourne antique shops, by reading Loti, Hearn and haiku, and by teaching Japanese as a 'fill-in' subject at Hutchins School in Tasmania. He was predisposed, on the other hand, to hate 'New Japan' by associating it with cheap export products, 'gimcrack, jerry-built, trumpery', and by having been left behind in Australia during the Pacific war, to attend garden parties where guests diverted themselves by smashing Japanese crockery at stalls set up for the purpose. Nor was Porter's schizophrenia about Japan unique to him.

Ethel Spowers, Wet Afternoon *(c. 1930). Spowers' design sense was based on Japanese prints, mediated through the Grosvenor School of Modern Art in London. (Art Gallery of New South Wales.)*

THE JAPONISTE AESTHETES invited satire. In France the Société Japon du Jing-lar was a group of artists and writers who met for dinners at which only chopsticks were used and only sake was drunk. Whistler, who carried japonisme to England in 1859, was known to buy worthless blue and white export ware and pass it off at teatime as priceless Japanese porcelain. And it was said that what the young English artist in Sydney, Charles Conder, drank from a friend's Japanese tea service was hot water with straw floating in it.

Even Australian artists as impassioned about things Japanese as Mortimer Menpes drew the line at the food and wine. In the 1901 account of his visit he complained

> . . . although the repast was of the very best quality, it was after all Japanese, which statement speaks for itself, as everyone knows that Japanese food does not by any means commend itself to the British palate. . . . As for the Sake, it tasted like bad sherry.

More than sixty years later, Hal Porter, on his second visit to Japan, still could not bear raw fish, aubergines, 'blood-warm rice', or the smell of pickled radish. The average foreigner, he declared, found Japanese food unsatisfying, savourless, lament-

able, repugnant: this, in the very years when French chefs were taking ideas from Japan and China to establish nouvelle cuisine. Chinese food, on the other hand, was 'perhaps, in an all-over way, the world's best,' Porter thought.

Hungerford, who was also in occupied post-war Japan, did not distinguish between the two cuisines. Like Australians with their hygiene fetish, he had learned undifferentiated distaste for Asian-grown vegetables as a child. During his year in Kure, Hungerford wrote, he found it hard to reconcile himself to the fact that

> in Japan nightsoil was the name of the farming game. It was something else completely foreign to our Australian background—although when we were kids we used to tell each other: *Don't eat cabbages from Wong Chu's, they piddle on them to make them grow!*

Later Australian writers, such as Harold Stewart and Robert Brissenden, proving that you are what you eat, would accept and enjoy the food of Japan in one case and Thailand in the other, just as they accepted and enjoyed the societies themselves.

If tastes differed about the food of Asian countries, visiting male writers were even less in agreement on the subject of women, a favourite topic in accounts of eastern travels, and not only those by Australians. Reports of mixed bathing and of the attentions and talents of geisha aroused popular curiosity about Japanese women. Dutch observers sent detailed descriptions of bare-breasted women in Bali, which became an Australian tourist destination early in the twentieth century. But the Australian journalist G. E. 'Chinese' Morrison, who talked about women a lot, preferred a Chinese smile to that of the 'mis-shapen little dot with black teeth that we are asked to admire as a Japanese beauty.' Long after teeth-blackening was out of style in Japan, Porter was repelled by 'simian women with the raw-fish halitosis of seagulls'. Yet these same women, for the American Lafcadio Hearn, who married one, were the country's 'most wonderful aesthetic product'. Douglas Sladen, who travelled between Australia and Japan at the turn of the century, deigned to admit that 'Japanese girls can be very pretty, even to the European eye', and A. G. Hales allowed for both views in his 1904 novel by distinguishing subtle, deep, farseeing Japanese women from those who were 'servile, cringing, of poor fibre, both mentally and morally'. Nicholas Chevalier, whose cartoons of male Chinese in Australia were grotesquely ugly, was capable of painting a Japanese woman as quite pretty and a Filipina as a classical beauty.

In the matter of what might be called cultural appetite, some men, who could not stomach things Japanese, could swallow China whole; and vice versa. The same, had they known it, applied to the reactions of Chinese, Japanese, and other Asians to them. What appealed to Australian women was another question, not often asked.

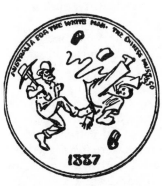

A Jubilee Medal *(1887). Queen Victoria's jubilee was suggested as an opportune time to kick Chinese out of Australia. Anti-Chinese feeling reached a peak in 1888.*

THE APPROVED AUSTRALIAN male response to threats by Asians against their jobs or 'their' women, as suggested in cartoons, poetry, and fiction, was violence. The reasoning followed

a quasi-logical progression, beginning with images of scab labour who undercut Australian workers, particularly the shearers. So to Banjo Paterson's horror:

> I looked along the shearing-board afore I turned to go—
> There was eight or ten dashed Chinamen a-shearing in a row.

Shearers and diggers from the goldfields found common cause in their determination to deal with this threat, and by common means, which Mary Gilmore recorded in her poem about Lambing Flat:

> Fourteen men
> Chinamen they were
> Hanging on the trees
> In their pig-tailed hair.

From there it was a short step further to accounts of assault by pigtail and even, as in the *Figaro*'s 'Yellow Agony' column, to helpful recommendations

> to take each individual Celestial by the queue and swing him to the depths of the Pacific if he won't clear out for the asking.

Then followed the results, the spoils of the unequal contest. In Edward Dyson's story 'A Golden Shanty' (1887), Doyle the publican sets his dog onto the Chinese, and he brings back

> trophies, a boot, a scrap of blue trousers, half a pigtail, a yellow ear, and a large part of a partially-shaved scalp.

Doyle sees the Chinese as 'pestiferous heathen', whom he suspects of using the 'quaint dialogue of the Mongol' to flatter and seduce his wife. Punishment by pigtail castration seemed to fit the crime of seduction. Women in the colonies had been a scarce commodity from the outset. Governments sought, by keeping Asian women and children out, and by restraining intermarriage, to prevent the Chinese, Indians, Japanese, and others already living in Australia from multiplying. In 1859, when only 8 per cent of Australia's total population was Chinese, they comprised 20 per cent of males in Victoria. The visible presence of large numbers of Asian bachelors presented competition for a scarce commodity, and thus a threat to Australian settler society from within, against which males instinctively felt they had to be on guard.

Because Australia was thought of as an empty continent, a vacuum, logic seemed to dictate that 'sturdy, healthy, energetic Europeans' must either be attracted or bred to fill it first, before Asians did. So generations of Australian women were instructed to 'populate or perish' and warned that in an Asian invasion of an Australia that they had failed to fill with sons, they and their daughters would be the first to suffer unspeakable fates. At a time when Australian women were beginning to practise contraception, male image-makers exaggerated the lasciviousness and ugliness of Asians and the moral evils of spinsterhood, childlessness, illegitimacy, and miscegenation. Women who went to China as mission-

Pigtail Cutting *(1856). Chinese in Australia were commonly attacked by drunken mobs, their homes looted, their shops and clubs vandalised. Queues and scalps were favourite targets of attack in real life as well as in fiction and cartoons. (Melbourne Punch, 1856.)*

Alf Vincent, The Modern Mercia and the Sirens: The Maid and the Mongol *(1898). Three women missionaries from Melbourne are seen as facing treachery, disease, deceit, and immorality in China. (Mahood, 1973.)*

aries in 1898 were depicted by the cartoonist Alf Vincent as risking disease, treachery, and immorality, as well as being misled by religious hysteria, as they walked into the slavering jaws of a Mongol. In promoting the tall, tanned, tough, laconic bushman as the national ideal, a male subagenda was operating to ensure that settler Australians were preferable to Asians as lovers, husbands, and sons.

Thus novels by men about encounters between Australians and Asians tended to play up the gallantry of the one and the dastardliness of the other. Carleton Dawe's Oxford-educated gentleman in *The Mandarin* shapes up to the lascivious Wang who has presumed to approach Rose, the daughter of his host in 'Quang-Tong' (Guangdong) province. Wang, who is described as having a yellow, oily smile, and horrid little eyes like a grinning monkey, according to the logic deserves all he gets:

> . . . my hand coming into contact with his queue, I caught it and jerked him violently against the wall, which he struck with a dull thud.

Struggling women in the clutches of 'Mongols' were standard in invasion fiction and cartoons. In Kenneth Mackay's *The Yellow Wave* the invaders 'thrust their bayonets into the passing trucks, and dragged back struggling women by the hair from the still open doors.' Pigtails and bayonets could be penis-substitutes even for pre-Freudian writers.

The logic was further complicated by Australian men's lascivious interest in Asian and Oceanian women who, assumed in Orientalist discourse to be morally lax, were all the more tempting because affairs with them were illicit. James Murdoch, in his journalistic *From Australia and Japan* (1892), wrote in one story of a Western male defending Japanese female honour, and eventually winning her from a Japanese rival, and in another of the charms of an 'Oriental seductress'. Among the attractions of Japan for foreign men were 'hot baths and a few others that [he] had rather not mention' which he said were available dirt cheap. He also warned of the social disaster which befell white men who admitted to affairs with Japanese women.

Carlton Dawe enunciated a variation on this double standard in his *Kakemonos: Tales of the Far East* (1897):

> So-called men of honour are notoriously dishonourable where women are concerned. As man to man they savour much of self-sufficiency; as man to woman they wear another coat. But in the Far East such things matter little, and the native woman doesn't count. Heaven knows, her own men think little enough of her: we think less.

A worrying possibility was that, if Australian men treated their wives badly, Asians might lure them away. The Reverend Francis Hopkins spelled this out in less than clerical terms in 1882:

> The difference is that a Chinaman's Anglo-Saxon wife is almost his God, a European's is his slave. This is the reason why so many girls transfer their affections to the almond-eyed Celestials. Now you have it. Chin chin.

As if to prove the point, the Australian heroine of Rosa Campbell Praed's *Madam Izan* (1899), having decided while visiting Japan that it is 'a country and a people to be taken seriously', finds she prefers Kencho, the subtle, cultivated guide who explains Japan's history and destiny, to the big white Australian squatter who is her suitor. Kencho 'might almost be a gentleman from Bond Street, so well was he tailored, and so little was there distinctively Japanese in his gait and manner,' Madam Izan explains.

Praed was another chain-novelist, whose stories often involved Australian women fleeing detested men. In *Fugitive Anne* (1903), escape to a superior Asian civilisation is once again the heroine's preference. Praed's contemporary Ada Cambridge was equally at odds with mainstream male opinion in holding sympathetic views about Asians. In her autobiography she praised the Chinese in Australia, and deplored the policy of 'Australia for the Australians now in it'. These would not be the last Australian women artists to empathise with Asians.

Another male double standard sanctioned violent retribution against females who capitulated to Asian lovers. William Lane, a few years after his 1888 serialised novel about the rape and murder of an Australian, Miss Saxby, by a lascivious Chinese merchant in Queensland, maintained his fervour; he would rather, he said, see his own daughter dead in her coffin than kissing a 'coloured' man or nursing a 'little coffee-coloured brat'. The fate in fiction of Asian women compromised by white men was even worse, as we shall see.

WHEN AUSTRALIANS CROSSED the gap to live in Asian countries, they narrowed the distance between themselves and Asians and exposed their prejudices to the challenge of reality. One of the earliest and most celebrated of the 'gap-crossers' was 'Chinese' Morrison who, as a young medical student turned journalist and adventurer, in 1894 arrived from Japan in Shanghai, 'a cosmopolitan hell-hole then as now, a mart of merchandise and misery, festering with intrigues of commerce, politics and vice', as an Australian novelist described it fifty years later. In Chinese dress, which he found made living cheaper and more comfortable, he set out in 1894 on foot across China to Burma, and in 1907 walked from Peking to Hanoi. On the way he discarded most of the prejudices of his contemporaries in Australia:

> I went to China possessed of the strong racial antipathy to the Chinese common to my countrymen, but that has long since given way to one of lively sympathy and gratitude.

As late as the 1920s it was believed by foreigners that those who learned Chinese went mad. While Morrison was reporting for *The Times* and advising Yuan Shih-k'ai (Yuan Shikai), the first President of the Republic, another Australian, William Henry Donald, 'Donald of China', was doing the same for London and New York papers and was an adviser to Chang Hsueh-liang (Zhang Xueliang) in Manchuria and to Madam Chiang K'ai-shek (Jiang Kaishek) in

Shanghai. But because Morrison and Donald sent their dispatches from China to the West, many of their pearls reached Australians only by being sent half-way round the world twice. Morrison, whom Clune claimed as 'Our Correspondent', was hardly that.

Partly because of the precarious state of Australia—Japan relations and partly because few Australians had established an international reputation, no more than a handful of Australians is thought to have been invited as yatoi (foreign experts), to advise Japan in pursuit of its policy of 'quitting Asia, looking to the West'. Australia, of course, had no intention to 'quit the West, look to Asia'. Thus, an opportunity for influential contact with Japan was lost to Americans and Europeans, and negative images remained unchallenged in the minds of many Australians.

The notion that an Asian culture should be appreciated at first hand by crossing the gap and living in it in the local style, as the American yatoi Sturgis Bigelow, Lafcadio Hearn, and Ernest Fenollosa did, was rather novel. One gap-crosser who was not a yatoi and was only tenuously Australian, but who could claim to know Japan better than any of his foreign contemporaries, was Henry James Black. Born in Adelaide in 1858, he was five when his Scottish parents—his father, John Reddie Black, was a newspaperman—went to Japan. Henry Black became a popular orator and a famous performer of rakugo, popular narration which combined elements of philosophy, politics and bawdy jokes. (Yet the Japanese, it was said among foreigners on the Yokohama bluff, and was still said by an Australian writer in 1945, had no sense of humour.) Black became the first representative of the London Gramophone Company and recorded his own performances and those of other rakugo-ka on wax discs.

Only two years before his death, Black held forth to his Tokyo audience about the unimportance of racial differences: 'After all,' he said, 'human feelings are universal and everybody has the same heart.' Similar sentiments had been expressed in 1903 by *The Queenslander*, but many politicians were committed to different views, both in Australia and in Japan.

An Australian who may be counted as a yatoi, because he taught architecture and drawing at Tokyo University in the late 1870s, and designed western buildings, pavilions for public occasions, and stage sets in Tokyo and Yokohama, was John Smedley. He spent three periods of several years in Japan, and like Fenollosa on his return organised displays of Japanese art at the Sydney Intercolonial Exhibition in 1877, and showed his own oils at the Art Society of NSW in 1880–81 and at the Centennial Exhibition in Melbourne in 1888. A critic found these 'rich with the splendour and the havoc of the East in their blending of grotesque figures, uncouth architecture, and brilliant colouring'. In 1889 he showed at the Art Society what critics considered a 'correct and quaint representation of a Japanese theatre'. Quaint but grotesque, brilliant but uncouth: many Australians were in two minds about Japan, then and later.

Other early image-makers crossed the gap from Australia to India. One was John George Lang, whose grandmother had been a

Strange Foreigner. *Henry Black, born in Adelaide in 1858, became an itinerant narrator in Japan, wearing Japanese clothes, using a Japanese name, and taking Japanese citizenship. At the peak of his career he led a troupe of twenty or thirty performers. (Kato Collection, courtesy Ian McArthur.)*

convict. Lang wrote fiction about colonial days in Sydney, became a barrister, was involved in a scandal, and left for India in 1842, where he was successful as a lawyer and newspaper owner. His novels satirised pre-Kipling British social life and generally took a non-lordly view of the British raj's Indian subjects. They included *The Weatherbys* (1853) and *The Ex-wife* (1858). Another, almost a century later, was the Australian dancer Louise Lightfoot, who studied Kathkali dance in India from 1937, and returned ten years later to present performances by her master, Shivaram.

For as long as imperialism underpinned the connections between Australia and India, and for some time afterwards — because of the magnetic amalgam of cricket, Kipling, tea, the sea route to Europe, a succession of state governors, the British Missionary Society, and the Theosophical Society (TS) — India remained a significant presence in the Australian imagination. By the 1920s Theosophy was at its peak in Australia. In 1922, the young TS World Leader Krishnamurti was greeted with ridicule and racist taunts in the streets of Sydney; he returned to address his followers in the Star amphitheatre built for the purpose at Sydney's Balmoral Beach in 1925. Like most of the Indian gurus who succeeded him, Krishnamurti was not Australia's discovery: he was introduced to Australians by Americans.

TRAVEL YARNS AND thriller fiction about Asian countries, by British and American writers as much as by Australians, reinforced images in the minds of Australian readers. Even before Sax Rohmer began his Fu Manchu series in 1913 (the last of which appeared in 1959), and before his rivals Charlie Chan and Mr Moto appeared in the 1920s and 1930s, the Australian chain-novelist Guy Boothby had created a 'Tibetan' prototype of the inscrutable Oriental in his magician Dr Nikola. Hume Nisbet based his detective, Wung-ti, on an Australian-born Chinese he met in Melbourne. A detective in the pay of Chiang K'ai-shek (Jiang Jieshi) in W. T. Stewart's *Yellow Spies* (1942) is Gaff Lee, a Chinese woman who is both calculating and ruthless. From the 1920s to the 1970s Dale Collins, Frederick Thwaites, Richard Moorhead, and Frank Clune produced fiction that lent authority to the image of Asia, particularly the British southern and eastern parts of it, as an Adventure Zone for white men.

Katharine Susannah Prichard admitted that her *Moon of Desire* (1941) was 'a rotten book', written in hopes of a money-making film. The story, set in 'exotic Asia', was no more improbable than novels by men in the Asian adventure genre, but Prichard the communist missed a timely fictional opportunity to challenge Australians' views of their oppressed neighbours.

Well after the Pacific war, Asia would continue to attract Australian writers of exotic adventure stories. Geoff Pike, Jon Cleary, and James Clavell, all Australian-born, carried on the chain-novel tradition. Hong Kong, said Clavell, 'is a colourful, rich, exotic, sensual area'. The region was still ripe, apparently, for profitable exploitation by Westerners such as James Michener, who described Tahiti on Bastille Day as the most erotic place on

earth. Shanghai was internationally nicknamed 'the Whore of the Orient'. In the 1950s the American film industry would give the world Bali-Hai, an erotic island created by the reports of anthropologists and GIs, in *South Pacific* and *The Road to Bali*. In the 1990s the Australian James McQueen, an admirer of Hemingway, Conrad, and Kipling, would still be writing of men encountering seduction and moral challenges in the tropics.

As much of their writing showed, Australians took with them into the Adventure Zone of Asia, as part of their race-memory, the British boys' stories of *Chums* and *Boys' Own*, *Kim*, *The Jungle Book* and *King Solomon's Mines*. They identified with Britain and the empire by cringing from making their heroes Australians. In colonial adventure fiction, the hero was male, superior, authoritative, and hence, mostly British. He had to be presented as the bringer of enlightenment and the setter of examples, because the alternative was to admit the possibility of his being a ruthless exploiter and a white supremacist. It followed that, if colonised people were the villains, their immorality, treachery, and savagery had to be exaggerated. If not villains, then they were white men's loyal helpers, childlike in their simplicity, dependence, or stupidity. And in all adventure narratives about Asia, according to Rana Kabbani (writing in 1986),

> there was a deliberate stress on those qualities which made the east different from the west, exiled it into an unretrievable state of 'otherness'.

Once the concept of otherness had been accepted, the whole of Asia could be consigned to what Kabbani has called 'illicit space', an Adventure Zone for adults in which civilised norms of Western male behaviour could be abandoned and taboos breached. It also became a place where the white adventurer could be tempted in ways unknown at home, and could do unheard-of things. So the response to Illicit Space always involved a combination of allure and repugnance, assumed superiority and guilt. But while for Westerners the Illicit Space of Asia was far distant, fanciful, and escapable, for Australians it was proximate, problematic, permanent, and real. So the image Australians held of the people who were closer to them than any others was at odds with their image of themselves.

Of course, Australians held no monopoly on racism or xenophobia. Waiguoren, weiguk, gaijin, ferang, feringee, putih, da bidze (dabizi), mat salleh: these were and remain 'outsider' words in Asian languages, used with contempt for foreigners and connoting barbarians, monsters and devils. In Asian languages as in English there are further terms of abuse for those who do not belong to your own communal or religious group. Japanese distinguishes two classes of foreigner: those admired and those condescended to. In 1991 Humphrey McQueen would conclude after two years in Japan that Australia was not the most racist and sexist nation on earth. Australians would learn from the 1960s civil rights movement in the United States to develop a conscience about white supremacism, while their Asian neighbours' racism remained little changed.

ON HIS RETURN to London from his first visit to Japan in 1887, Mortimer Menpes enthusiastically described to Whistler the technique of the painter Kawanabe Kyōsai, who had been Hokusai's pupil. The Master—as Whistler liked to be known—declared the Japanese artist's use of flat tones was the same as his own. By then the East-West 'cultural reflex', which *The Argus* art critic observed in 1881, had been under way for nearly thirty years. No artist in the West was unaware of Japanese art, and many had absorbed its influence. The same, in reverse, applied to their counterparts in Japan, where Katsushika Hokusai and Andō Hiroshige knew of Western perspective from the Dutch and had adapted it well before their own work was discovered in the West, and where other Western techniques were widely used from the 1880s.

Kyōsai—Western artists who flocked to Japan called him by his given name—acted as Menpes' drawbridge to the Japanese cultural castle. Kyōsai was one of the 'interface' Japanese who, by dealing with foreigners, sometimes came to be assumed by them to be pre-eminent in their field in Japan. Other 'interface' people who played an important part in the creation of an image of Japan abroad included the art dealer Hayashi Tadamasa, based in Paris, and his partner Wakai Kensaburo, who began exporting prints to Melbourne in the 1870s.

Japan's defeat of the Russian fleet in 1904–5 made it the first Asian nation to overcome a European power. It was also the first whose culture some Europeans accepted as equal, or superior, to their own. Whistler and the brothers Goncourt referred to Japanese art in the same breath as that of classical Greece. Menpes accepted the view of an unnamed authority that the only living art of the day was the art of Japan; and he returned from 'that lovely land of the Far East' convinced that 'every Jap is an artist at heart'. Menpes had made the Expatriate Shift, as Lafcadio Hearn did, to seeing Western behaviour as though with Japanese eyes, and finding it embarrassing.

As a young man, John Peter Russell visited Tahiti, Japan and China in 1874–75 and brought back to Sydney what must have been one of the earliest collections by an Australian of Japanese art. He was ahead of Smedley by a year, and Lucien Henry followed them both: yet this was twenty years after both the French etcher Felix Bracquemond's discovery of Hokusai, and the first exhibition of Japanese art in London. But Russell was ahead of other Australian artists, including Menpes, in seeking Japanese material direct from its source. He decided, rather than work in his family's prosperous iron foundry, to go to Paris and study art in 1881. Russell met Tom Roberts on the voyage, and joined him and his parliamentary friend Dr Maloney on the now-famous walking tour of France and Spain, during which they learned from two Spanish artists about *plein air* painting and French impressionism.

Russell, who had been described as 'tough, spirited, and unspiritual' as a boy, and who had a reputation at Cormon's academy in Paris as an outstanding boxer, shared his friends' japoniste taste for seascapes, trees in blossom, and women in kimono. He read Pierre Loti, invited Monet to his house in Brittany, painted Van Gogh's portrait, and placed a kakemono

5
Emulators

Japonistes and impressionists— the Expatriate Shift— aesthetes—printmakers— potters

Utagawa Toyokuni, Tsukushi-no-Gonroku played by Sawamura Gennosuke. *Dramatic poses like those of Kabuki actors and areas of solid back were adopted by western artists from Japanese prints. (National Gallery of Victoria.)*

(hanging scroll), perhaps with ironic intent, behind the anti-Japanese Dr Maloney who sat for him. But he never waxed eloquent about the ideal Japan as Van Gogh did. The most fulsome known acknowledgement of his debt to Japanese art was Russell's gruff compliment, in 1877, in a letter to Roberts, pairing 'Jap artisan art' with that of the Italian Renaissance.

In Europe the kimono, with its silken freedom from stays and bustles, had become an emblem of modernity and aestheticism. It suggested the abandoned delights of the ukiyo, the Japanese floating world of actors and courtesans and their erotic arts, which the Goncourts had discovered in prints in the 1860s. 'Even the way the fashionable Parisienne stood and moved', Wichmann records, 'between 1860 and 1900 was, so to speak, imported from Japan.' Whistler, Monet, Toulouse-Lautrec and many others painted japonaises — Western women in kimono. In keeping with fashion, Russell and John Longstaff who visited him at Belle-Ile in Brittany in 1889, painted their wives à la japonaise, in what may be the same kimono. Rupert Bunny, who lived in France from 1886, also painted his French wife and other European women posed on balconies in the manner of Kitagawa Utamaro and of Whistler. As well, he exhibited three kimono paintings, more realistic and less languid, of a Japanese actress who performed in Paris.

The floating world from which European and Australian artists derived these images was by no means the everyday Japan: Yoshiwara, for Japanese themselves, was like an Edo theme park, popularised by print artists and kabuki actors. In London and Paris artists constructed a japoniste fantasy around the kimono, but in Australia the response was more restrained. In G. W. Lambert's *The Three Kimonos* (1903), three Australians in London amuse themselves in Gilbertian style, playing at being Japanese; in Australia in 1889, Girolamo Nerli exhibited a japonaise, of sorts, in *The Sitting*; and Janet Cumbrae Stewart blandly painted what she called *The Pink Kimona* in 1918.

These were costume diversions, a form of Orientalism for which any exotic style might serve as well as another. The novelist Tasma (Jessie Couvreur) was photographed in Oriental finery; Ada Cambridge in 1903 recalled the fun of dressing in 'China silk'; in a Nora Heysen portrait of 1938 the model wears Chinese dress; Bernard Hall's nude study with assorted Asian objects, *Toilet à la Chinoise* (1918) appeared to be based on Firmin Girard's *Toilette japonaise* (1873); and Max Meldrum painted a gaudy *Chinoiseries* (1928), of which his model later said: 'It was a habit of that time for men and women to play at times, dressing up'. Rupert Bunny, who painted Parisiennes in loose, flowing tea-gowns, explained their attraction in Orientalist terms.

> It gives a man a sort of luxurious feel of being an Oriental Pasha, as he lies in his chair, smoking . . . to see himself surrounded by graceful houris clad in gauze and gorgeous draperies, shimmering . . .

Tom Roberts returned from London and Paris in 1885 'primed with whatever was the latest in art'. The latest was *plein air* impressionism and japoniste Aestheticism. These ideas informed the work of the group of young painters he formed the following

PAINTINGS AND DRAWINGS OF JAPAN BY MORTIMER MENPES ARE NOW ON VIEW AT THE DOWDESWELL GALLERIES 160 NEW BOND STREET

Mortimer Menpes, Poster for the Artist's Exhibition in London *(1888). Although he used the techniques and themes of japonisme, Menpes' images of Japan were taken from first-hand observation. (Musée de la Publicité, Paris.)*

M. Napier Waller, The Man in
Black *(c. 1928). This image
recalls Manet's* Theodore
Duret *(1868). In both,
japonisme suggested elegance
and modernity. (National
Gallery of Victoria.)*

Max Meldrum, Chinoiseries
*(1928). By the late 1920s, the
vogue of things Chinese had
declined to pastiche. Meldrum's
daughter borrowed this brilliant
blue and yellow silk costume
from an American girl in Paris,
adding red slippers and a purple
embroidered robe to 'feel
Chinese'. (National Gallery of
Victoria.)*

year at Box Hill, Eaglemont, and Heidelberg near Melbourne,
though in the anti-Asian political atmosphere of Australia in the
1880s and 1890s they made much of the Australian landscape and
little or nothing of their debt, through France, and through
Whistler, to Japan. It would not have occurred to the Heidelberg
painters, led by the 'socially acceptable Bohemian' Roberts, to
write in Melbourne, as Van Gogh did at Arles, 'here I am in Japan'.
Emanuel Phillips Fox would hardly have described his painting of a
French ferry in 1910–11, as Van Gogh did of his *Barges on the
Rhone* (1888), as 'pure Hokusai', even though it was equally
japoniste. In their experiments with light, colour, and spontaneity,
with ordinary people moving freely in natural settings in the
country, on the beach, and in the city, the Australian impressionists
made their distinctly Australian vision explicit, and left its japoniste
derivation implicit, for reasons that seem to reflect the political
culture of the period.

Yet in doing so they displayed the very 'independence of all
clap-trap' which Whistler considered the essence of Japanese art.
Japoniste allusions were too prevalent in the work of the Heidelberg
painters, in the narrow formats, the angling of streets, coasts and
quays, the cropping of objects, the use of solid black, of empty
space and high horizons, the scattering of spontaneous moving
figures, the purple shadows, and the use of blue, green and yellow,
with red accents, to be coincidental.

For the 9x5 Impressions Exhibition that Roberts and his
friends Conder, Streeton, Frederick McCubbin, and others
mounted in Melbourne in 1889, a year after Menpes' articles about
Japan, the themes, techniques, materials, and decoration came
directly from Whistler (whose exhibition Roberts had seen in
London in 1884) and thus indirectly from Japanese art. Conder
designed the cover of the 9x5 catalogue with some japoniste cherry
blossom and a statue of outraged Convention: similar illustrations
were used for other Japanese displays, including the one at the
Boston Foreign Exhibition in 1884. The critical reception that
greeted the 9x5s showed that, like their precursors in Paris and
London, they too had succeeded in shocking the conservatives;
they were accused of 'Whistlerism'. Yet not even the criticism was
new; James Smith's terms in *The Argus* were lifted from Ruskin's
attack on Whistler in 1878.

The Heidelberg painters claimed they were seeking to avoid 'a
repetition of what others have done before us'. In the sense that
they were breaking new ground for Australian art, that was true; in
the sense that they were continuing what Europeans had begun
twenty years earlier, and Japanese earlier still, it was not. But
japonisme was a fusion of ideas from many sources, and once
japoniste modernity was unleashed, it pervaded Western art. Some
of the Australians' paintings seemed even to have their *successors* in
works by Pissarro, Dufy, and Bonnard.

Charles Conder's feeling for japonisme was stronger than could
be expected of even a precocious artist imitating European trends
with Roberts as mentor. One relative provided Conder with a job
in Sydney, another with funds to study painting in Paris in 1890,
and another, Josiah Conder, who had lived in Japan since 1877,

Andō Hiroshige, Evening
Scene in Saruwaka chō
*(c. 1857). Hiroshige incorpor-
ated Western elements of
perspective and shadows in this
street scene in the pleasure
quarters. Kabuki theatres are
on the right and teahouses on
the left.*

Camille Pissarro, Boulevard
Montmartre *(1897). Pissarro's
angled, wet streets, high view-
points, and hurrying people had
precursors as well as followers
in the work of Tom Roberts,
Arthur Streeton, Girolamo
Nerli, and Charles Conder.
(National Gallery of Victoria.)*

Tom Roberts, Bourke Street,
Melbourne, Allegro Con Brio
*(c. 1886). In the anti-Japanese
political climate of the 1880s,
Roberts did not explicitly
acknowledge his debt, through
Whistler, to Japanese art.
(National Library of
Australia.)*

may well have supplied him with Japanese art. If so, he would have
been as well placed as Russell or Roberts, even though he had
arrived in Sydney in 1883 at barely sixteen, and in Melbourne at
nineteen, to make connections of his own between impressionism
and Japanese art, which were evident in several of the paintings
from his few years in Australia. Josiah Conder was a yatoi architect,
retained by the Japanese Ministry of Technology to teach at Tokyo
University. As well as designing some important Meiji buildings,
including one for the 1880 Tokyo exhibition, he wrote books on
Japanese gardens and on flower arrangement, and was taught
painting by the ubiquitous Kyōsai. Given their tastes in common,
it is hard to imagine that the Conder cousins would not have
corresponded, and that prints, at least, and perhaps fans, would

not have been sought by Charles and sent to Australia by Josiah. If so, Conder would have had more to draw on than reproductions, glimpses of others' collections, and Roberts' advice.

Conder's wide artistic acquaintance included not only the Heidelberg painters but Nerli, Roth, the cartoonist Phil May and the art teacher and painter Blamire Young, all of whom brought the latest news of the Aesthetic movement from Europe. May sketched the Japanese Village troupe in Sydney in 1886. Young favoured Whistlerian decor and a Japanese hanko signature, interpreted Australian gumtrees in an Art Nouveau manner and drew on Hokusai, probably his *Nagakubo*, from his Kisokaidō series, in *Pastoral Symphony* (c.1920) and *The Bridge* (c.1927).

The stream of japonisme branched into the fan designs and watercolours on silk in which Conder specialised in Europe and in which Thea Proctor, Russell's cousin, followed him. It branched again into her strong, innovative woodcuts, linocuts and watercolours. Another current surfaced in the aesthetic paintings of David Davies, Sydney Long, and Murray Griffin, the watercolours and colour woodcuts of A. B. Webb, and the design sense and solid blacks of M. Napier Waller. The leisured ladies of Proctor, Bunny, George Bell, Phillips Fox, Ethel Carrick Fox, and Agnes Goodsir were a further diversion and so, as a Chinese-inspired variant, were the animal and flower prints of Lionel Lindsay.

In 1931 Jessie Traill made a series of etchings, *Building the Harbour Bridge*, in which the high span of the arch, the exaggeratedly low shoreline, the barge, and the slender verticals inventively recall Whistler, Monet, and Hiroshige. Her friend Constance Coleman also made japoniste linocuts in the 1930s. Goodsir's women bathing and dressing, and those of Carrick Fox and Adelaide Perry have their antecedents in Suzuki Harunobu, Utamaro, and Mary Cassat, who was making aquatints of similar subjects in Paris while Goodsir was a student there from 1900 to 1927. The pattern was similar for Violet Teague, whose references to Hokusai's

Andō Hiroshige, Nagakubo *from the* Sixty-nine Stages of the Kisokaidō. *Japanese bridges inspired many western artists, including Monet, who had one built over his lily pond. (National Gallery of Victoria.)*

Blamire Young, The Bridge *(c. 1927). Silhouettes and arcs were elements of Aesthetic design, enabling an interpretation of Australian landscape with stylistic reference to Japanese prints. (Australian National Gallery, Canberra.)*

Andō Hiroshige, Kyōbashi, *from* One Hundred Views of Edo *(c. 1857). The high curve of the bridge, cutting the picture, the boat passing under it along a cluttered shoreline, and the evening light all reappeared in Whistler's* Nocturne in Blue and Gold: Old Battersea Bridge *(c. 1872–75).*

Jessie Traill, Building the Harbour Bridge V: Going Up *(1930). Many Australian artists painted Sydney's bridge under construction. In her series of etchings Traill wittily referred to Hiroshige and Whistler, substituting cables for pylons, a barge for the boat, and making the arch all but disappear. (Art Gallery of South Australia, Adelaide.)*

Manga resulted from study with Herkomer in London; for Ethel Spowers, who was guided in Japanese technique by Bracquemond, Manet, C. R. W. Levinson, and Morley Fletcher; and for the accomplished printmakers Dorrit Black and Eirene Mort, who brought Japan to Australia through study in Paris and London. Ethleen Palmer, who had early exposure to Chinese and Japanese prints in her mother's collection, pioneered serigraph and colour linocut in Sydney, and as her *Spindrift* (1939) shows, was conscious of Hokusai. But Russell, Menpes, Lionel Lindsay, and Eveline Syme were among the very few Australian artists of the day who, in addition to their study of Japanese or Chinese art in Europe, took the shorter route to East Asia to see it in its original location.

As Australian art sank into the sands of convention, Orientalist accoutrements displaced the modernist energy of japonisme. Paintings by Bernard Hall, Florence Rodway, Bess Norriss, and Sybil Craig reflected mere exoticism and Australian stultification. 'Local colour' paintings of artists' travels rode on a wave of 1930s Pacific Orientalism, which included Elioth Gruner's *Chinese Junks*, Mary Edwards' Samoans, Tahitians, New Caledonians, and Javanese, Adrian Feint's fanciful *The Offering—Bali* (1941), Oceanian woodcuts like Kenneth Wallace Crabbe's *Kava* (1936), and the Balinese, Samoan, and Fijian paintings of Aletta Lewis, J. Rickard Schjelderup, and Harold Herbert. Lewis, who also wrote fiction based on her travels, articulated the Expatriate Shift with an artist's vision:

> In the beginning you saw the people as a type; now they are each intensely individual. You no longer have a general impression of the country, but you have intimate associations with little spots you hardly noticed at first.

In Victorian Australia and later, 'arts and crafts' were thought more fitting for women than oil painting, large portraiture, or landscape. Studying art abroad, almost always in Europe, was an acceptable way for women who could afford it to escape from or at least delay the obligations and restraints of marriage and motherhood. It may also partly explain why, in the female-dominated arts and crafts sphere, Asian culture generally, but Japanese in particular, gained ground more quickly than it did in male preserves such as film, drama, and invasion fiction.

The process for Australian printmakers was the same, however, as for Australian painters: they travelled half-way round the world to learn from Europeans about art that had originated in their own hemisphere. Whatever it was that inhibited them from making the direct crossing to Asia, Australian artists continued for decades to take the longer, circular route.

AUSTRALIAN ARTIST POTTERS became aware of Asian ceramics and adapted what they learned to their own work in a way that, in its circularity and its acceptance of the authority of Europe, closely resembled what happened in the visual arts in Australia in the period, except that fewer of the early potters travelled.

45

In Britain, William Morris and John Ruskin asserted the aesthetic superiority of work of the artist-craftsman over that of the factory, and the idea became the core of the Arts and Crafts ethic. Until the 1920s, the question of whether pottery was the work of an individual or a production line was unimportant to most Australians, with the significant exception of Merric Boyd, who thought of it as 'art for all'.

When the Arts and Crafts Movement gained momentum in Australia in the 1920s, it attracted not only relief printers, batik printers, and basket weavers, but also china painters and hobby potters, many of whom were women excluded from paid work, or disabled servicemen. Nationalist idealisation of the bush, expressed in gumleaf and wildflower decorations, was the Australian potters' version of the English romantic obsession with a lost pre-industrial landscape, but they did not generally pose a challenge or offer an alternative to the ceramics industry. Such interest as china painters had in Asia was expressed in chinoiserie decoration or japoniste motifs derived from English models—butterflies, fans, peacocks, bridges, willows, storks, fishermen, iris, and cherry-blossoms—and later, in the stylish Art Nouveau and Art Deco derivatives of japonisme.

Chinese forms and glazes, which were to be seen in Sydney's display of Doulton ware, in international exhibitions and in the collection of the National Gallery of Victoria from 1921, attracted several potters to make trial-and-error emulations of the qualities that interested them. These pioneers included Ernest Finlay and his brother Alan, Klytie Pate, Allan Lowe, Harry Lindeman, Irene Beetson, L. J. Harvey, Harold Hughan, Violet Mace, and Norah Godlee. The last two had worked in artware studios in England and as early as the 1920s knew of the East Asian interests of the British potter Bernard Leach and his Japanese friends. Pate, Jack Castle Harris, and Marguerite Mahood adopted the Chinese dragon or its English-style legitimation as a decoration for their work, while Finlay and Godlee transformed it into an Australian lizard. In either form, references to Asia were minimal, and benign, not threatening. Moreover, Finlay, Lowe, Beetson, Harvey, and Mace were among the early artist potters who, seeking a new national artistic synthesis for Australia, combined an interest in Chinese tradition and technique with adaptations of Aboriginal art.

The transition from earthenware to stoneware is usually taken as the Rubicon of East Asian influence. Beyond what some Australians learned from the English potter Joliffe's (F. E. Cox) *Pottery* and from C. F. Binns' *The Potter's Craft*, little technical advice was available in print. Merric Boyd used high firing as early as 1911, Finlay experimented with stoneware the 1920s, and Mrs Behan did so in the 1930s. In the 1940s Lowe would begin to make minimally decorated pots based on the Chinese ginger jar, but still in earthenware. In 1950 Hughan, taking Leach's *A Potter's Book* (1940) as his guide, would show stoneware that marked the beginning of japonisme in Australian ceramic art. Yet half a century after japonisme's impact on Australian painters and printmakers, the habit of reliance on an English mentor persisted.

NOT ALL AUSTRALIANS' first impressions of Asia were negative. The Japanese performance groups that toured Western countries, and Australia, from the 1880s were commercial enterprises as well as part of the Japanese national purpose of propagating a positive image abroad. Percy Grainger remembered a visit to Melbourne by such a group, and its effect on him. He was greatly impressed by music he heard in 1888 as a boy of six in Melbourne's Chinatown. As well, he recalled 'marrow-curdling Maori rhythms' chanted to him by an English botanist, A. E. Aldis, who was a boarder in the Grainger house for a time.

These experiences alerted the young Grainger to the fact that not all music had to sound like Bach, Beethoven, or Brahms, and that it could come from places other than Europe. By the age of sixteen, as his biographer John Bird has pointed out, he was committed to a battle against western European musical dominance, in which his compositions were to be his weapons.

Educated and taught to play the piano by his dedicated mother, Rose, with whom he lived until her death by suicide when he was 40, Grainger was an unselfconscious eccentric, with an unconventional lifestyle, an 'unbalanced genius', in the view of his British musical contemporaries. He learned several minor languages and adopted his own 'blue-eyed' form of English based on Anglo-Saxon; he invented various musical machines, including something resembling the modern synthesiser; and he devised an innovative form of musical expression which he called 'Free Music', without the limitations of time and pitch intervals.

Menpes, Sadler, Russell, Proctor, Bunny, Lionel Lindsay, Hardy Wilson, and Margaret Preston were all enthusiastic collectors of books, artifacts and furniture, much of it from Asia. Like them, Grainger amassed a vast collection, which included musical instruments, compositions, and recordings from Indonesia and the South Pacific. 'Some of the world's most exquisite music is found in this area,' he wrote of the region generally in 1955. As well, he collected masses of material from the 'Nordic group' of composers, which he thought of as British, Irish, American, Scandinavian and settler Australian. Although he spent most of his life from the age of thirteen outside Australia, first studying in Frankfurt, and from 1914 living in the United States, where he became an American citizen, Grainger always considered himself an Australian.

One of the stated aims of the Grainger Museum, which Percy established at the University of Melbourne, was the preservation and study of the folk-music of the English-speaking world and the 'art-musics and primitive musics of countries adjacent to Australia (the South Seas, Java, etc.)'. Grainger travelled widely and explored music wherever he went. He deplored the fact that early European and 'Asiatic' music were so little known. He pointed also to the value of recordings of Aboriginal music made by E. H. Davies of the University of Adelaide—tunes, he said, 'as lithe and graceful as snakes, and highly complex in their rhythmic irregularities'. His appreciation of Aboriginal music placed him ahead of most contemporary opinion, which considered Aboriginal culture generally as primitive. Why, Grainger asked further, if Chinese and

6
Internationalists

Percy Grainger—Norman Lindsay—Hardy Wilson— national types—Margaret Preston

Japanese art objects are highly regarded by 'most of us', should the music of these and other Asian countries be neglected? He led the way for Australian composers, and for some writers and visual artists, to see the rejection of Europe as the basis for Australian national identity and to accept in its place a wide range of non-Europeanness.

Although he never visited Indonesia, Grainger encountered at the Paris Exposition of 1900, and at the Ethnographical Museum in Leyden in 1912, Javanese instruments which he knew had been a source of modernity for Debussy. In 1918 he arranged Debussy's *Pagodes* for his own 'tuneful percussion'. In 1944 he repeated the experiment with Ravel's *La Vallée des Cloches* as well as with Javanese and Balinese gamelan pieces themselves.

With modern technology available to widen musical knowledge, Grainger could find no excuse for the public's ignorance of 'the great art-musics of Asia'. He saw polymelodic Javanese music as being ahead of Western tradition because it was further advanced towards his ideal of 'free music' in which melody, rhythm and harmony 'will not be hampered by each other'. He praised the comparative freedom from rhythm which he found in Chinese and Japanese folksongs. One of his piano pieces, *Arrival Platform Humlet*, is based on a Japanese melody, while another, *Beautiful Fresh Flower*, has Chinese origins.

It seemed to Grainger only fitting that Australia should become the centre of Asia-Pacific musical studies: it was a 'proud Australian task to adequately study these exquisite native musics adjacent to Australia and present them to the world'. Australia, he thought, being a leader in social experimentation, should also lead the way in 'musical go-ahead-ness'. Yet Grainger believed Australia should not become detached from its Western musical heritage. Australians' identity—by which he meant their racial type—was different from that of their neighbours. Australians' fundamental focus should therefore not be in the Pacific, but in the world of innovative composers in Europe, Scandinavia, and the United States, what he called the 'white man's world'.

Grainger's capacity to face East and face West at the same time was part of his eccentricity. His views on race are, in fact, less difficult to explain than some of the other puzzles about him. Rose Grainger instilled in her son a deep veneration for the supposed Nordic inheritance of her side of the family, with which went her accumulated amateur mythology about the virtues inherent in fair hair, blue eyes, pale skin, and Viking-like endurance of physical pain. She peroxided his hair to keep it blonde, a practice he continued for some years after her death. He liked best the parts of his early works which were soul-revealing—passages he described as 'truly Nordic, truly British, truly new-world, truly Australian'. Among these were settings he wrote for Kipling's poems, especially those from *The Jungle Book*, which his father had given him in 1897 and which, Grainger said, was the basis of his sense of patriotism and racial consciousness. He commemorated his own mountain-climbing exploits in his settings of Kipling's *Hill Songs*, which must often have pounded in his mind as he walked and ran. The main

difference between Grainger and the many Australians of his day who believed in racial types was that he took an informed interest in the people of other 'breeds' and urged others to do the same.

Grainger was perfectly capable of advocating universality in music without any integration of races. He strongly disapproved of Queensland in 1903–04, which he found

> full of Chinese, Kanakas, and worse still ½ breeds, & chaps likening Colombo Eurasians. And the whites too, all bung-faced, sallow, puffy, sloppy-built, undersized; no look of pride, uprightness, or toughness . . . Folk must be clean mad . . . to beckon in coloured & lower-race work into a land that as yet has no race-hatreds or wars within itself & need have none.

The 'race-hatred' Grainger was reflecting, because he shared it, had been present in Australia and in the United States for over a century and had caused a sort of 'war within itself' against Chinese in both countries. Like other Australians who thought of themselves as humane, he adopted the rationalisation that 'coloured' people *caused* racial strife. He shared the pseudo-scientific belief in a hierarchy of types with his type at the top, which would be weakened by the presence of lower races. Others commonly pointed to America, as Grainger did to Queensland, as an example to be avoided. It was Australia's right, according to the orthodoxy, to study their neighbours' culture and to offer them aid and education, but they were unfit to live in Australia because they would *introduce* 'race-hatred'. At the time of Grainger's death, Australian government representatives were still advancing this line in Southeast Asia and expecting it to be accepted.

Grainger's dream of Australia as a centre for the study of music of the Asia-Pacific region was not realised in his lifetime, and he died with a sense of defeat. 'I have . . . felt and acted,' he wrote,

> upon my feelings, that art should be one of the meeting places of all races, without racial, national or local prejudices, jealousies or smallnesses.

He sincerely believed he was free of these prejudices himself, yet his vision did not allow of Australia becoming such a meeting place.

Although Grainger spent little of his life in Australia, his ideas became signposts for Australian composers: Peggy Glanville-Hicks, who abandoned the straitjacket of European rhythm and the diatonic scale; Peter Sculthorpe, who was advised by Grainger to 'look to the islands', and would later do so; and Anne Boyd, who recalled his words on the wall of the museum, urging young composers to acquaint themselves with the music of Asia and the Pacific, which she did.

PERCY GRAINGER WAS an admirer of the fleshy, Bacchanalian drawings of Norman Lindsay. Both adopted the national myth: 'temper democratic, bias offensively Australian'. Both were eccentrics and vitalists, but their nationalism was of the mainstream.

They differed to some extent in their attitude to Asia, but neither wanted Asians in Australia.

Largely self-taught, like Grainger, and widely read in translations of the European classics, Lindsay drew in his youthful work on reproductions of the Pre-Raphaelite works of Millais and Sandys, and of Whistler, which he found in such English journals as the *Cornhill Magazine* and *Good Words*. Art Nouveau techniques, derived from Japanese prints by Aubrey Beardsley and posters by the Beggarstaff brothers, appeared in his drawings in the form of solid black foreground shadow and foliage, contrasting with areas of white, often the white of naked female flesh. After his return from London and Paris, sickened by the carnage of the First World War, he retreated into his own form of vitalist spiritualism and into embattled defiance of Australian prudery. For *The Bulletin* he produced propaganda cartoons and posters which became increasingly anti-Japanese.

The poet Hugh McCrae shared Lindsay's vitalist enthusiasms, as well as his belief that the classical past was closer to the life force than was Australia of their day. His vision of antiquity included the fantasy land of Zipangu where, in his poem 'The Mimshi Maiden' (n.d.), an apparently Japanese princess is abducted by a tiger, whose amorous attentions she prefers to those of Zipangese men. In Zipangu, McCrae suggested, anything was possible, with no gratification of the senses barred. It was his Xanadu or Cathay, the white man's dream of the Orient, the fallacious Far East.

Lindsay as illustrator and McCrae as poet were mutually inspired by each other's work. At his own press Lindsay published McCrae's *Idyllia* in 1922, which included his poem 'The Yellow Lady'. Lindsay made an accompanying etching of her, almond-eyed, enigmatic, with pointed fingers and toes, seated like a Buddha on a lotus, and wearing nothing but a headdress of peacock feathers. The moonlight of fanciful antiquity, the glow of candles and smoke from the nostrils of a sinuous dragon obscured and distanced the opinions McCrae and Lindsay held of real, contemporary Asians.

Neither the poet nor the artist had first-hand knowledge of Japan or China; what they knew about from the Orientalist discourse of their Western heritage was what went on in Illicit Space. Lindsay, in addition to despising uncouth Australians, characterised Chinese and Japanese as sinister simian invaders, Jews as pawnbrokers, and Aborigines as clowns. While he warned in his cartoons against the depredations of 'yellow men' on Australian women, his own lascivious fantasy of a Chinese 'yellow lady' was veiled in acceptability by Orientalism and the double standard.

In Lindsay's etching and McCrae's poem, the image had to be Asian: no white lady, no matter how idealised by mediaevalism or mythology, could be posed like Cheefoo. The lewd posture, the diminutive feet (bound in the poem, though not in the picture), the long, salacious nails, are exotic trappings to evoke prurient fantasy. The Gilbertian, chinoiserie name is borrowed from Chefoo, the place where Morrison and Paterson met during the Boxer Uprising, chosen with Western authors' usual smirking disregard

Norman Lindsay, Balinese Dancer or Oriental Woman *(1920s). Lindsay, who believed in a hierarchy of racial types, reflected European Orientalist assumptions about the instinctuality and moral laxity of Eastern women. (Norman Lindsay Gallery and Museum, Springwood.)*

Tina Wentcher, Two Balinese Girl Dancers *(1930s). This Austrian-born sculptor observed Indonesian life at first-hand for several years before she arrived in Australia. (McClelland Art Gallery, Langwarrin.)*

for accuracy about Chinese names and places. Into both the poem and the etching Australians in the 1920s would have read suggestions of a lotus land in the Adventure Zone, where women without shame indulged males whose appetites were sharpened by the guilt of miscegenation.

Lindsay knew little about Indonesia, either, but that did not inhibit him, in about 1927, from creating a cement sculpture fantasy, *Balinese Dancer or Oriental Woman*. A comparison with two images created by Australian women artists points to the difference in their fantasies: Ch'a Fa, the Chinese concubine brought to 1850s Sydney in Helen Heney's novel of 1950 is a doll-like figure but not a voracious sex-fiend; and the two Balinese dancers sculpted by Tina Wentcher when she was living in Indonesia in the 1930s, have such innocence and tentative grace that they might be of another species.

LIKE MANY YOUNG men of his day who showed a capacity to draw, William Hardy Wilson was articled to a firm of architects in Sydney. He conceived an early and strong dislike for the neo-Gothic and Renaissance public buildings then in vogue and dreamed of a uniquely Australian national architecture. His travels in Europe from 1905 to 1909 convinced him that this was not where the future of Australian architecture lay. In America he admired the faded neo-Hellenic buildings of the Old South, and on his return to Australia he was among the first to urge the preservation of early colonial buildings west and south of Sydney and in Tasmania.

In 1922 he went to China, perhaps at the suggestion of Lionel Lindsay, who was his neighbour for a time from 1916. A visit of three months was long enough for him to conceive a new architecture to take the place of declining Western ideas, and to be based on a union of East and West, China and Greece. He thought it natural that Australia, having 'Oriental soil', should be the birthplace of this new style, 'a true fruit of the womb of Geography and not a passing fashion'. His first attempt to put his theory into

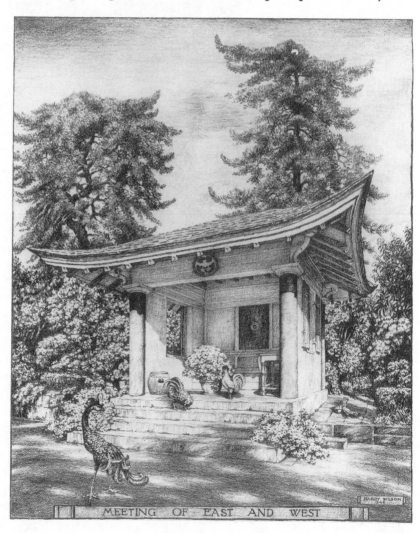

W. Hardy Wilson, Meeting of East and West, *(1924). The tennis pavilion designed for Professor Waterhouse near Sydney was the only one of Wilson's Grecian-Chinese projects to be realised. (National Library of Australia.)*

MEETING OF EAST AND WEST

practice was the only one of his East-West, Chinese-Grecian designs ever constructed: a teahouse (1924) beside the tennis court at 'Eryldene', the residence he had designed in 1914 for his friend Professor E. G. Waterhouse. The teahouse was painted in Chinese vermilion, with upturned eaves, Doric caps in gold, and the peach and bat motif signifying happiness and long life, which was his personal emblem.

Wilson repeated ideas from the 'Eryldene' pavilion in his western gateway for 'Celestion', a proposed residence for himself, which was to be part of a group in his mixed classical and Oriental manner at Pymble, north of Sydney. The east-facing entrance was to lead into a Chinese-style courtyard, with the south side allocated to service areas, the west opening to the garden, and the north used for informal living and a studio. There were to be vermilion columns, an Oriental frieze, upturned eaves, and a pantile roof. It seemed eminently livable, but was never built.

In 1938 Wilson proposed to Prime Minister Lyons that a start be made on a national collection of Oriental art, to be housed in a small gallery of his design. He was disappointed, as he had been a few years earlier when Menzies, then Attorney-General, intervened to prevent Wilson, a Sinophile and eccentric, being appointed director of the Victorian State gallery. He planned an ideal city, named Kurrajong, complete with encircling avenues with Chinese temple structures as public buildings, but by the 1950s, when the design was finished, Wilson had long given up hope of seeing it built. He vented his despair of finding clients to share his vision of uniting East and West by writing an autobiographical novel (1929). 'To adventure forth in quest of a new style was beyond the imagination of his people,' concludes his hero, Richard Le Measurer, although he realises on leaving Peking that it will take even him more than a lifetime to master the culture of China.

Wilson's distaste for war was as strong as Grainger's and Norman Lindsay's, and he articulated it in essays: *Grecian and Chinese Architecture* (1937) and *Atomic Civilization* (1949). Wilson used 'atomic' more with fusion than fission in mind, and he even adopted the mushroom cloud as a beneficent symbol in a couple of his designs. He believed that China, far from being a sleeping dragon about to wake, rush out, and savage Australians, was a peaceful giant arising, refreshed from slumber, to a new creative period. But when the long-awaited Asian dragon turned out to be Japanese, Wilson's hopes of infusing Oriental forms into Australian houses in his lifetime were doomed, 'discredited once and for all after Pearl Harbour'—or so it seemed to Robin Boyd.

ARTHUR STREETON, Norman Lindsay, and Percy Grainger were as enthusiastic as Hardy Wilson for vital energy and the life force, though each had different ideas about what should be done to prevent them declining in Australia. Streeton, his days as a japoniste iconoclast behind him, advocated breeding more white fighting men; Lindsay expressed his distaste for men of all 'coloured races' and hated 'all negroes, with no exception'; Grainger decried

all prejudices yet at the same time saw Australia as belonging to the 'white man's world', married a 'Nordic princess', and cultivated a Scandinavian appearance. Wilson advocated China's ancient civilisation for the renewal of Australia, though by 1945 he was warning that China would have to pass through a communist period first. Yet even Wilson was a believer, like the others, in national types. He wrote to those fellow believers, Hitler and Mussolini, recommending New Guinea become a country of exile for Jews.

All four artists struggled to define an Australian national character by reconciling the conflicting claims of history and geography, without systematic logic, and with no methodical education in the history and cultures of Asian countries. They had little but their own images, stuck like papier mâché over a base of prejudice, to guide them. For Streeton and Lindsay, these images were formed from such limited observations of Asia as could be made from inside Australia, or from the voyage to England and back.

Such images were not confined to eccentric Australians. Wilson's rival for the National Gallery directorship, J. S. MacDonald, like Streeton was a supporter of the Australian Academy, set up as part of Menzies' design for a conservative, empire-loyalist Australia. MacDonald's brand of nationalism was sustained by his enthusiasm for racial purity of Australia: 'the last of the pastoralists', 'thoroughbred Aryans', 'not a nation but a race', whose imagery was expressed by its 'independent-minded sons'.

Streeton, Grainger, Lindsay and Wilson were by no means the only Australian artists who sympathised with these views, written in 1931 as Hitler rose in Germany and as the militarists overcame their opponents in Japan. One of Australia's independent-minded daughters, however, would have greeted them with a snort of derision.

WITH DRIVING DETERMINATION, Margaret McPherson Preston became adept in the full range of graphic techniques and wrote as prolifically as she painted, printed, and designed. An iconoclast from her youth, she articulated in art journals her disgust with the atrophy of Australian art between the two world wars. She was among the few Australian artists of her day who became independent enough of Europe—where she spent two periods of study (1904–07 and 1912–19)—to scorn filial piety to 'Grandpa G. Britain'. After her marriage to a prosperous businessman, she was also independent enough financially to travel widely to non-Western countries in search of ideas.

Her efforts to understand what the Nabis (led by Pierre Bonnard), post-impressionists, and secessionists in Europe were about led her to study one of their sources, Japanese art, at the Musée Guimet in Paris in 1912, under a person she didn't name but who she said was 'one of the leading teachers of design in Paris'. From 1915, during her second visit to Europe, she began collecting books on Japanese art, including Fenollosa's *Epochs of Chinese and Japanese Art* (1912) and using others recommended by his fellow-

Katsushika Hokusai, Puppies *from* Manga *(1814–1878), vol. 14. (State Library of Victoria.)*

Paul Gauguin, Still-life with Three Puppies *(1888). An active borrower from many artistic traditions, Gauguin transposed three puppies from* Manga *in the same year as he based the wrestling figures in his* Vision After the Sermon *on another motif of Hokusai. (The Museum of Modern Art, New York.)*

Margaret Preston, Implement Blue *(1927). In the 1920s, Preston sought to use Japanese art, Post-impressionism, and Aboriginal art to forge a national art for Australia. Gauguin was one of her guides to all three sources. (Art Gallery of New South Wales.)*

American protégé, Arthur Wesley Dow, the author of the leading guide to japoniste technique, *Composition* (1899). From that time her work became more radically stylised, with simpler forms and purer colours, and with space structured in a more deliberately decorative manner.

Preston left clues to her use of Japanese art in the marginal sketches she made in her books, in some cases abandoning the original subjects completely and substituting her own. The genesis of her painting *Implement Blue* (1927) is traceable through Gauguin to Hokusai, and her oil paintings of the Shoalhaven region combine ideas from Aboriginal design and Chinese painting.

Never satisfied for long with any one idea or environment, Preston kept on travelling, moving house often, and touring other countries. Her journeys from 1923 to 1934 included New Caledonia and the New Hebrides (1923), Macassar, Bali, Singapore, Bangkok, Angkor, Macao, and Hong Kong (1924–5), Tonkin, Hong Kong, and Bali again (1926), New Zealand (1930), Tahiti, and other South Pacific islands (1932). She consciously followed in Gauguin's steps to Tahiti to observe the Polynesian environment, and decorated her article 'New Caledonia and the New Hebrides' in *The Home* with masks. Visits to China, Korea, and Japan followed (1934). During the war years the Prestons concentrated on travel within Australia, particularly in pursuit of Aboriginal art, but they resumed their overseas visits in 1950, going to Ceylon, India, and Nepal in 1956.

Preston used the books and objects she brought back in her work, including a copious collection from China and Japan. In Kyoto, by her own account, she studied woodblock printing from a son of Hiroshige, though whom she meant is not certain. Her visit to the Bunraku puppet theatre inspired prints of *The Bad Lady Puppet* and *The Usurer Puppet* (both 1934), the latter being based on a reproduction in a Japanese book on puppets, *Poupées japonaises*. Her series of 'Aboriginal paintings' owed much to Chinese and Korean landscape art. Her admiration for Chinese painting grew, as Japan waned in her estimation, in the 1940s.

For all her interest in tradition, Preston's eye was firmly fixed on the present. She found a place in her art for a personal, cartoon-like comment on the war against modern Japan in *Tank Traps* (1943), and *General Post Office* (1942). The Australian sailor guarding the remnants of the Japanese midget submarine captured in Sydney Harbour stands head down, feet apart, much like Preston's Bunraku usurer puppet, both of them with the narrowed eyes and, perhaps, the closed minds that controlled societies, or those at war, produce.

In her determination to hack a national art for Australia out of the rock face of public indifference and conservatism, ignorance of Asia, and condescension to Aborigines, Preston lacked the guidance of perceptive art historians and formal education. Her arguments could contain both self-contradiction and foresight. Well before the end of the Pacific war, Preston was looking forward to what she called the 'Orientation' of art in the Pacific and advocating the abandonment of Australians' habit of going only West to study. The post-war Australian would have to 'hunt for his masters in strange places,' she wrote, 'and learn from his own intuition how to understand them.' The result would be genuine national awareness, an 'open vision of what his country is really like'.

Like her fellow internationalists Grainger and Hardy Wilson, Preston expressed her views on national identity in the form of a redrawn world map. In her diagram,

> Australia will find herself at a corner of a triangle; the East, as represented by China, India and Japan, will be at one point, and the other will have the United States of America representing the West.

Like other Australians, Preston hoped for an Australian renaissance, but not through a return to the old bush nationalism, to Europe, or to the past. She was drawn to geography, not cowed by history. America, Asia, and the Aboriginal spirit were the stimuli of the future.

*Because nearly everyone had a stake in the
existing world, few voted for a new world*

Ross Terrill, 1987

III
Across the
Diameter:
1945 to 1968

ACCORDING TO OFFICIAL accounts of Australia's wars, those who served were motivated by a sense of patriotic duty to defend their freedom, families, country, monarch, and God—none of which was, until 1941, demonstrably in direct danger as far as Australia was concerned. But by their own accounts, what impelled each generation of young Australians to go to war, at least as much as a sense of duty or a desire to emulate past heroes, was the desire to get away, to go with the others, and to sow their wild oats before retreating to live 'the ole tame life' in the buttoned-up respectability of urban Australia or the enormous silence of the bush. As the novelist Tom Hungerford wrote:

> There's nothing like a few years in the army to shake you apart from your preconceived notions about life, and to set you off on a vagabondage of body and mind and spirit.

Japan's imperial ambitions now not only ran parallel with those of the West but collided with them. In response, cartoons and newsreel films took the lead as image-makers. In Australia, Norman Lindsay was still an influential iconographer, transforming mediaeval images of ogres into Huns and Nips. A king hit into the Pacific remained the cartoonists' favoured means of repelling the 'Jap' menace. The Department of Information (DOI), set up within a week after the outbreak of war, ran a 'hate Japan' series of advertisements proposing that artistic Japanese concealed a brutal alter ego, and concluding: 'We've always despised them—now we must smash them.'

Bean, the war historian, objected that this was 'un-Australian sort of stuff'. Rohan Rivett, Deakin's grandson, a war correspondent, and prisoner on the Burma railway, recalled that at first Australians were sceptical of anti-Japanese propaganda; but later, they learned 'his ability, tenacity, ruthlessness and fanaticism'.

General Blamey seemed to have ingested his epithets straight from DOI, the cartoons, and the newsreels. The Japanese enemy—always in the singular—was a primeval, subhuman beast, subject only to the jungle law of tooth and claw. He was, said Blamey in 1942, 'a curious race—a cross between the human being and the ape . . . But he is inferior to you, and you know it . . .' Australian soldiers were fighting to preserve civilisation against what Blamey called little barbarians, 'these things'. Out of the nineteenth-century image of the 'Chow pest' he created a Japanese hybrid, calling them 'vermin' which must be exterminated. The image would still be current in 1987, when an Australian writer equated the Viet Cong with leeches and mosquitoes.

The success of this sort of indoctrination was reflected in Rivett's image of the Japanese as a 'naked beast beneath the thin civilised veneer which he had so recently assumed'. In his war diary, written in New Guinea, the young artist Clifton Pugh wondered: 'Are these [Japanese] human beings? . . . They are the worst brought out of man and animal.' Pugh, later a fervent opponent of the Vietnam War, recounted with approval how Australians treated Japanese as the animals they were. In a 1955 account of the Pacific war, Japanese were still described as little, grinning, and 'mustard-

7
Enemies

Antipodean heroes—war cartoonists, poets, artists, novelists—various enemies—war correspondents—the case of Hungerford and Statler—war drama—Cowra—Korea

coloured', and as 'animals . . . Apes with pants on'. As late as 1980 an ex-serviceman expressed his view in rhyme that the 'ap' in Japan lacked an 'e'.

The more serious poets wrote less hostile verse. Tom Inglis Moore celebrated the valour of ordinary Australian soldiers in poetry and radio drama. Kent Hughes, with the resources of the 'Changi library' at his command, managed to produce 50 000 words of verse on twenty pages of tissue paper, the idiosyncratic epic *Slaves of the Samurai*, which rhymed 'diarrhoea' with 'fear', and 'malarias' with 'swampy areas.' In what he called the 'tragic drama of Japan's Great Flop' he combined accounts of Japanese atrocities with warnings that Australians must learn tolerance of Asians:

> Australia, last and smallest continent
> is situated in the Orient . .
> She never bothered, much to her disgrace
> to teach her children how her neighbours live
> or what is owed to them for what they give.
> In culture, commerce, art and in defence,
> much has been given, but with insolence.
> Australians with the west pre-occupied
> like football-barrackers, have been one-eyed.
> This leads to danger as they cannot be
> smug isolationists and yet be free.

Describing the experience in war historians' grandiose terms as an 'Australian Odyssey', Kent Hughes nevertheless paid a degree of respect remarkable in the circumstances to Asian culture and philosophy, commending Taoism at length as the Way for Australians to follow if they wanted to survive in the Pacific. Inglis Moore, who had idealised a Filipino Achilles in fiction in 1935, similarly looked to a more 'Australasian' future.

What Australians learned about Asia in several wars, and expressed in what they wrote, painted, and filmed, reveals that, for some, the experience served to engrave more deeply the preconceived image they held of Asians and of Japanese in particular, while for others, exposure for the first time to the reality of Asia led them to question it. In the less angry writing there was often a sense of the stupidity of war and of the universality of humankind; the xenophobic racism of the Australian nationalist poets had shrunk to a shadow. War's horror was equal for both sides.

WHILE NEWSREEL FILMS, war cartoons, and posters bristled with hostile epithets and images, most Australian war art did not. Artists were recruited to record the experience of war, and perhaps to ennoble it, but not to create propaganda against the enemy. War service gave artists a degree of paid leisure to put into the creative process, even under trying conditions, which had not come their way in Australia in the 1920s and 1930s, and many did not hesitate to accept it. War produced work based on first-hand observation of Asia and the Pacific from artists as diverse as Ivor Hele, Nora Heysen, William Dargie, Roy and Frank Hodgkinson, Sybil Craig,

Stella Bowen, James Flett, Donald Friend, Murray Griffin, Sali Herman, Eric Thake, Harold Abbott, John Coburn, Frank Norton, J. Richard Ashton, William Martin, and John Goodchild.

Ray Crooke began painting while serving as a soldier, rather than as a war artist, in Borneo, Thursday Island, and Cape York. He stayed in the north after his discharge, returning to Thursday Island and working there as a labourer, cook, and driver while he observed the lives of the island people. He also visited New Guinea, Fiji, and Tahiti and painted Australian Aborigines on Mornington Island. Reminiscences of Gauguin were consciously part of Crooke's still, calmly posed, often silhouetted figures. But these were Melanesians whose way of life seemed not to have been so dislocated by the missionaries and the colonialists; even his wistful Tahiti figures were relaxed. They were not the dramatic, sensuous, despairing Polynesians whom Gauguin painted.

Service as war artists offered Australians colours and textures they had never seen, and they revised their palettes as much as they did their preconceptions about native people. Dargie's stretcher bearers, for example, were not threatening savages but gentle, rather pale-skinned people, modestly clad, with crosses around their necks and flowers in their hair. Hele set aside dignified portraiture and painted raw jungle, tropical efflorescence and decay. Dobell's post-war New Guineans inspired a new range of skin colours, ebony, blue, red and yellow.

The Director of the Australian War Memorial kept an open mind about the work of young war artists even when it did not appeal to his own taste. Lieutenant-Colonel Treloar commented on Donald Friend:

> my feeling is that he is going very well, and . . . I have no doubt that his war pictures will be of great interest to those who admire his work. Although it has pleased our critics to inveigh against bureaucratic control of artists, this in fact does not exist and has never existed. No-one—except the critics—has ever told the artists what they should paint.

Donald Friend had studied art in Sydney and in London. He abandoned his hereditary acres in New South Wales and left home at seventeen. Discovering a preference for company other than white Australians, he lived in Malay town in Cairns, worked from Thursday Island on the luggers with Timorese, and in London frequented jazz bars full of Africans. He spent two years as an adviser to the Ogogo of Ikerre in Nigeria. After witnessing the Japanese submarine attack on Sydney Harbour in 1942 he enlisted as a gunner but was by his own account a 'hopelessly inept soldier'. He became an official war artist in 1945, recording and illustrating his experiences in *A Gunner's Diary* (1943) and *A Painter's Journal* (1946).

Friend set out to record not the noble events or splendid vistas of war, but human oddities, individual acts and foibles. He preferred to portray the lives of unsophisticated people with none of the ethnic or rank distinctions between them so dear to the military

Scorfield, The Red River
*(1954). The old imagery of
undifferentiated Asian hordes
advancing on Australia gained
a new semblance of validity
when the cold war years
brought fears of international
communism. (*The Bulletin,
1954.)

mind. Friend's war works were part of an unbroken progression
from the company he kept in his early years, to Sri Lanka where he
lived during the 1950s and 1960s, and Bali, which was his home for
thirteen years from 1966.

Albert Tucker went to Japan for more than three months in
1947, not as a war artist but as an art correspondent in the British
Commonwealth Occupation Forces. He photographed devastated
parts of Kure and did paintings of Hiroshima which he called
'fairly straight watercolours'. He had been anticipated by James
Cant who imagined the moment of impact in *The Bomb* (1945).
These were shocking images for those who had thought of Japan as
a picturesque fantasy land, and the currently fashionable techniques
of abstraction were not required to increase their impact. Tucker
also sketched or made oil portraits of a Japanese girl and of several
Japanese war artists. One was Fujita, a Western-style painter who
lived mainly in Paris. He fascinated Tucker, as Kyōsai had fascinated
Menpes, and they exchanged work.

Fujita hardly presented an enemy-image to Tucker, any more
than the sad-faced soldiers in *The Face of Japan* series (1945) did to
Eric Thake. Sali Herman painted a stiffly surrendering officer
(1945), Clifton Pugh recorded *Japanese Surrendering their Guns
NG 1945*, and Friend's *Searching Japanese Prisoners* was somewhat
farcical, but the enemy was rarely present in the war paintings, and
the enemy as demon even less so. In very little of the Australian art
of the Pacific war, in fact, was there a visible enemy. The Japanese
whom the war artists recorded were, most often, dead: dolls flung
into heaps with the stuffing coming out, as in George Browning's
New Guinea painting of 1943. The strutting, menacing Jap of
cartoons and propaganda, and of some contemporary American
painting, rarely appeared.

The lifting of wartime travel restrictions gave Tucker his first
chance to get away. What he most wanted to see was not Asia but
Europe. 'I was in the grip of the romantic image of Paris and had to
see it,' he said later. Leaving for London in 1947, his journey was
the reverse of the exodus from Europe; he thought of himself as a
'refugee from Australian culture'. Japan was merely a six-months'
foray before the 'real' journey.

Clifton Pugh, on the other hand, joined the occupation force in
Japan, where he had time to paint posters for the anti-VD campaign
and to spend the proceeds on three prostitutes—geisha, as he
called them—for himself and his friends. But he also studied
Japanese art, and wrote to his mother: 'I'm sure now that this
Japanese art is going to influence my work very much. I wish to
achieve their mastery in simplicity and design—it already is starting
to show.' John Coburn also took the opportunity of studying the
arts of countries where he served: India, Burma, and Japan.

Travelling in the opposite direction, a refugee from Russia in
the 1920s, Danila Ivanovich Vassilief had reached Australia by way
of Armenia, Persia, India, Burma, Shanghai, and Hong Kong and
had settled there in 1935. In about 1952 he too produced a painting
of Hiroshima. After the war, artists who had been too young to
fight would respond in new ways to the touring exhibition of the

Hiroshima Panels, which for many dispelled the Mikado-land fantasy once and for all.

Damien Parer made his name, and lost his life, as a war filmmaker and photographer in the Middle East and in New Guinea. His documentary films, *Moresby under the Blitz*, *Kokoda Front Line*, *Sons of the ANZACs*, and *Jungle Warfare on the Kokoda Front*, gave many Australians their first impressions of war in New Guinea. Already known from his work as 'a man apart', Parer was killed in the American landing at Peleliu. He, Frank Hurley, and Max Dupain had between them established an Australian art-form — 'the creative treatment of actuality', as Dupain called it. In 1948, just before the cold war made Asians enemies again, Sydney wharf workers and Peter Finch collaborated with the Dutch film-maker Joris Ivens in *Indonesia Calling*, a documentary about Australians' refusal to load ships with arms to be used against nationalist Indonesians. Other Australians, like Neil Davis, David Bradbury, John Darling, Dennis O'Rourke, Solrun Hoaas, and Curtis Levy would carry on the documentary tradition in Asian and Pacific locations, with low-key, unpretentious dedication to the job. Their interpretation of contemporary Asian societies presented the positive face of Antipodeanism.

NOVELS OF THE Pacific war told a different story. A spate of first-hand accounts of the suffering of Australians at the hands of sadistic Japanese and Koreans began with such books as Rohan Rivett's *Behind Bamboo* (1945, 1991) and Graeme McCabe's *Pacific Sunset* (1946), and continued with Roy Whitecross' *Slaves of the Son of Heaven* (1951, 1988), John McGregor's *Blood on the Rising Sun* (1953, 1980), Russell Braddon's *The Naked island* (1952), and the American Douglas Valentine's account of Australian POWs in Leyte, *The Hotel Tacloban* (1984). The output of novels such as these had not ended fifty years after the war.

While none of the Australian writers were in doubt about the need to confront and resist the enemy, his image varied, and he was not always generalisable, male, or even Japanese.

War poets such as David Campbell, Kenneth Slessor, Russel Harte, Peter Middleton, and later, Randolph Stow discovered a common humanity with the enemy, and there were moments in the New Guinea jungle when war novelists did the same. In Hunger-ford's *The Ridge and the River* (1952) a sudden encounter with the enemy dispels the propaganda image the Australians have had instilled into them:

> It was the first time he had seen a Japanese unarmed, undressed, helpless, playing, and he was afraid with a strange new fear. The Jap he had been used to seeing was always cruel, foreign — a remote face and a shapeless figure half-screened by the cover of an ambush position, or a waddling ape who might have raped European women in Hong Kong and would like to do the same in Perth or Sydney . . .

It was this moment, when the image of the enemy collapsed and turned into a human being, that all who wanted wars had always

had cause to fear. War, as Hal Porter remarked, was a short-cut to admiration of and affection for an enemy.

The enemy, on the other hand, could be your own allies. Russell Braddon, who was sent from Changi to the Thailand-Burma railway, was almost as vitriolic about the British in Singapore, and their failure to see what Australians had predicted was coming for fifty years, as he was about the Japanese. The British-born communist writer Eric Lambert used his war novels, as did Jon Cleary used *The Climate of Courage* (1954), to express contempt for the British traditions of the officer class, for the military's waste and delay, for civilian profiteers, and the pointlessness of much of the Australians' suffering. These, and particularly anti-Britishness, had been the themes of many Australian writers of the First World War, and they would carry over to the Vietnam War. The tone, perpetuated from one war to another, was truculently Antipodean, 'bitterly anti-war, anti-officer, anti-army, anti-civilian' and, by the 1960s, it would become less anti-British, and more anti-American.

The enemy could even include your mates. The Pacific war, like all wars before and since, sorted out those who were survivors from those who were not. Among the survivors were some whose aim was purely survival, while others managed to make something out of either the system, or their experiences, or their comrades. One of the latter was the hero of James Clavell's first novel, *King Rat* (1974). Both Clavell and the Rat were prisoners at Changi: one in fact, as a junior British officer captured in Java; and the other in fiction, as the prison's American black-market king, anticipating other such entrepreneurial heroes in *Catch 22* and *Empire of the Sun*. Clavell fell foul of members of the Australian Returned Servicemen's League who denied that gallant Australian prisoners of war were involved in profiteering. Clavell had been away from Australia too long to know that modest achievements, or exemplary failures, were more admired in Australia than material success which, since the convict days, had been seen as a mark of exploitation of your mates. But he did catch the Antipodeanism of the Australian prisoners, the truculent cynicism that sprang from their powerlessness to control what was happening, even while they resented and accepted it.

The enemy could also be the country you were fighting over. Australian war novels had not been set in jungles before, and for some writers the New Guinea vegetation itself, by making the enemy invisible, became their enemy. It was, as one historian put it, 'not a good place to fight a war'. Osmar White made the same point in *Green Armour* (1945). His own survival as a lone intelligence scout pitted against the jungle became the young Peter Ryan's sole objective in *Fear Drive My Feet* (1959). The jungle was described as a wet sponge which could absorb and deaden the effects of weapons, both by David Forrest in *The Last Blue Sea* (1959) and by Hungerford in *The Ridge and the River*. It made for what George Johnston's *New Guinea Diary* (1944) said was the 'toughest fighting in the world'. Norman Bartlett, in *Island Victory* (1955), asserted that jungle warfare was unsuited to the Australian

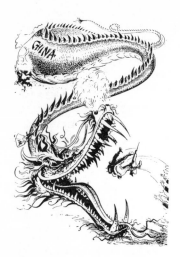

Heth, Recognition? *(1961).*
Australia's Asian enemies, often
portrayed as dragons, acquired
more benign images when they
became allies. China and Japan
went through several image-
changes.

temperament, whose free and easy adventurousness came from the dry, open spaces. His belief that the terrain gave the Japanese an advantage was apparently inspired less by any great familiarity with conditions in Japan at that time, than by propaganda about 'Asiatics' and monkeys, who were at home in jungles. Conveniently forgotten since the fall of Singapore were Japanese night-blindness, webbed feet and near-sightedness, which had been made so much of by DOI. The enemy's image had changed. Now, General Slim decided, the Japanese were the 'super-bogeymen of the jungle'.

Enmity could be dissipated by time. For Nevil Shute (N. S. Norway) in *A Town like Alice* (1950), the sentimental yearning for a simple life in outback Australia was stronger than hatred of the enemy. His Australian soldier, Joe Harmon, shares this preoccupation. Joe survives Japanese barbarities and symbolically re-establishes normalcy and decency and the nuclear family with a young Englishwoman, another heroic survivor of Malaya, whose wanderings with other European women and children were based on the real experience of a Dutch group. Shute's couple do not hate the Japanese, observing human strength and weakness among friends and enemies alike. In other accounts of women's war experiences, however, Japanese lived up to their barbarous image: Betty Jeffrey's *White Coolies* (1954) and, in the same year, Jessie Simons' *While History Passed* (*In Japanese Hands*, 1985) were among them.

Enmity could be temporary. As late as 1990, *Blood Oath* (Stephen Wallace), a film that studiously sought to present Japanese and Australians involved in war-crimes trials on Ambon Island as individuals, with a fairly even distribution of venality and virtue, would accurately reflect Australians' resentment of the Americans' haste to forgive Japanese who were clearly responsible for war crimes, and the United States' eagerness to make Japan into an ally against the new enemy, communism. Australians tended to remain as faithful to their enmity against Japan, as Americans did later to theirs against Vietnam. But Russell Braddon, whose sequel to *The Naked Island* was called *The End of a Hate* (1958), by the 1980s would be writing a japanegyric book, with renewed warnings, like those of the invasion writers a century before, of the plan of the 'new master race' to displace lazy Australians and avenge its defeat. Were he not Australian, Braddon declared, he'd 'like to be a Nip'.

Enmity could be a matter of opinion. Australian war diarists and those who produced fictional accounts or oral histories of their experiences tended to divide into two broad groups. Those who saw the Japanese as individuals, including both good and bad like themselves, included Ray Parkin (*Out of the Smoke*, 1960, *Into the Smother*, 1963, and *The Sword and the Blossom*, 1968), Stan Arneil (*One Man's War*, 1981), John Lane, (*Summer Will Come Again*, 1987), Kenneth Harrison (*The Brave Japanese*, 1966, republished as *Road to Hiroshima*, 1983), Hugh Clarke (*Last Stop Nagasaki!*, 1984), and John Brown (*Zaibatsu*, 1983). By the time David Malouf wrote *The Great World* (1990), he was able to present the Japanese and Korean guards on the Thailand–Burma railway as equal victims who, like the Australians, simply did what they had to to survive.

But the enemy as traditionally constructed was always identifiable. Those who made much of the savagery of the Japanese soldiers, and found in it proof of pre-existing assumptions about *all* Japanese, included the official war historian Henry Gullett, who described the Japanese in his memoir, *Not as a Duty Only* (1976), as 'clever animals with certain human characteristics', reviving Blamey's propaganda image. Australian writers who had been prisoners of war certainly had what Gerster calls a 'rich cast of oriental villains' to choose from, and many met the expectations of their readers by representing all Japanese either as homicidal maniacs or as simian buffoons, even without being paid by DOI to do so. Along with this familiar imagery went a sense that the natural order was reversed: being 'coolies' of the arrogant, egotistical Japanese was much more humiliating than being captured by the Germans, whom these Australians thought of as their racial equals. And the Japanese, well aware that Western nations thought them culturally trivial and racially inferior, sought to teach their prisoners otherwise in ways they would not forget. As Norman Carter recalled:

> To be a prisoner-of-war was nothing to be proud of at the best of times, but it was especially galling to surrender to a race who . . . had been regarded as a simple-minded people, politely bowing their way through life amid a shower of cherry-blossoms . . . a nation of geishas and house-boys. Now Honourable Houseboy had become dishonourable conqueror.

Enmity could simply be xenophobia. The official Australian historian of the First World War declared that the Digger 'knew only one social horizon, that of race'. And Tom Hungerford seemed to confirm this in his novel of the occupation of Japan, *Sowers of the Wind* (1954). While even some of his more civilised Australians use terms straight out of early issues of *The Bulletin* for the Japanese—'bloody coolies,' 'apes', 'stinking yellow bastards', and 'slant-eyed golliwogs'—and refer to 'slitted eyes', 'gabbled conversation', and the 'stocky, ugly shortness of the bandy Japanese', they are equally hostile to Australia's 'coloured' allies, the Indian contingent and black American servicemen at Kure. Racist hostility extends even to two fellow Australians, Weisman and Lefevre who, a central character, Sergeant McNaughton, declares, 'could spend a lifetime in Australia and . . . never be anything but what you started as—wogs. Bloody foreigners'.

The enemy in Australian war fiction, with his many faces, could also be female. Australian women in Albert Tucker's paintings of *Victory Girls*, he seemed to suggest, by consorting with the Americans who had invaded Australia, were in effect giving aid and comfort to the enemy. Xavier Herbert made similar allegations in his novel *Soldiers' Women* (1963). Australian males, as his fellow novelist Jon Cleary pointed out, and as the writers of invasion fiction in the nineteenth century had feared, did not always present great competition to foreign rivals. This did not deter enlisted Australians from hoping for sexual conquests abroad. Drinking, whoring, and scrounging (in that order) were listed by 'Turk'

Bennet in Richard Beilby's *No Medals for Aphrodite* (1970) as the preoccupations of his comrades; and war, in Eric Lambert's *The Twenty Thousand Thieves* (1951) 'seemed to have licensed drunkenness and the pursuit of women'. In wartime, everywhere a soldier went became Illicit Space.

Yet Australians' sexual conquests as represented in the novels of the Second World War were mainly, and significantly, confined to the Middle East and to Europe. Affairs were had with Greek, Jewish, and English women, and even with a French-Egyptian: but the literature was uneasy about Asian lovers. Japanese war-brides of Australians were not admitted to Australia until 1952 and could not become Australians until 1957. In Jon Cleary's *A Very Private War*, written in 1980, when such things were more acceptable, still the lady is a doctor and a half-caste and thus more nearly the Australian's equal. Revealingly, 'she was a physical woman who responded to the physical side of men; had she been totally white she might have been promiscuous.'

That such heroes as the Anzacs should themselves commit war crimes was unmentionable. That they should retreat from 'Japs' seemed inconceivable. Yet on what Xavier Herbert was to call the 'Day of Shame' in *Poor Fellow My Country* (1975), a 'Rabble Fled the Test of Nationhood'. Just as the invasion novelists had predicted, the government secretly discussed with the Americans abandoning everything north of the 'Brisbane line' to the Japanese. Frank Kellaway's poem 'They came with work to do' repeated the grasshopper image of Australians, their summer idleness swept away. Darwin could be gone, just like that. Images of the 'leering sea', 'sprawled wrecks', 'screaming women', and 'demon laughter', came direct from the 'Asian plague' literature, as did the conclusion: 'Here a new irony is forced upon us . . .' The irony was of image-inversion.

THE ALLIED OCCUPATION of Japan was like a repetition of Commander Perry's arrival in 1853. Once again Americans were quick to exploit peace-time opportunities by becoming the new Japan experts, in business, education, and culture. Few Australians in the occupation spoke enough Japanese to compete with them, and few thought of learning it. The case of Tom Hungerford and his American double illustrates how Australians lost the peace.

Oliver Statler was born in 1915, the same year as Hungerford. Both served in New Guinea, and then in Japan on the quartermaster's staff of their respective occupation forces. Hungerford thought 'a year or so with a foot on the neck of a prostrate Japan seemed like a pleasing proposition'; Statler, who was familiar with the Japanese print collections of Hearn and Frank Lloyd Wright at the Art Institute of Chicago, wanted to explore Japanese culture.

Both defied army restrictions and got away to the countryside, taking imported food for Japanese they had met. Hungerford, recalling Asian fertiliser, missed out on the fresh fruit and vegetables that Statler enjoyed at the inn at Okitsu, which he was to commemorate as the 'Mizoguchi-ya' in his *Japanese Inn* (1982). Statler had a friend, Uchima Ansei, to help him understand the history of

Eric Thake, The Face of Japan no. 10 (Japanese P.O.W.)—Koepang, October 1945. *With defeat, images of Japanese changed again. Several war artists presented them sympathetically as fellow humans and fellow victims. (Australian War Memorial.)*

the inn and the generations that had run it; Hungerford echoed the chronic complaint of the Australian occupation forces that they were short of interpreters. As far as studying the language was concerned, he set his sights low:

> We got to know our way about Kure, established black-market routes, and learned the elementary but necessary Japanese vocabulary for work, business and love. In no time at all, I felt as if I'd been there all my life.

Hungerford met a Japanese former teacher of English who had read Furphy's *Such is Life* and who introduced him to haiku:

> Of course, I'd never heard of them ... how could I have at a time when all we wanted to know about the Japanese was that they were a lot of half-blind, sex-crazed midgets who lived on raw fish and seaweed? He said *haiku* were very traditional and very old (wasn't every bloody thing in Japan? I wondered) and were arranged in exactly seventeen syllables in three lines of five, seven and five.

While Statler knew in advance what he wanted to explore in Japan, Hungerford had Mikado-land expectations that were doomed to disappointment because they were based on ignorance. The wharf at Kure had dirty, battered galvanised iron sheds, just like Fremantle, he reported in surprise.

> I'd expected something a bit more exotic, perhaps bamboo and rice-paper ornamented with storks and irises, as on the Japanese tea-caddy I'd stared at on the kitchen mantleshelf, all through my childhood.

In Kyoto, which American scholars of Japanese had managed to have spared from fire-bombing, that very inflammable Japan was preserved, but almost nowhere else. Statler, however, found in the 'Mizoguchi-ya', which had survived many fires and rebuildings, an enduring, renewable Japanese aesthetic, because he knew how to recognise it and where to look for it.

At the end of the year Hungerford went back to Australia to build a career as a novelist. Statler stayed in Japan for eleven years, revisiting his friends at the inn, collecting prints, working as an art critic for a Tokyo newspaper, and walking the circumference of Shikoku, like the Buddhist sage Kōbō Daishi, for research on his second book, *Japanese Pilgrimage* (1983).

Hungerford's experience of Japan was limited by his culturally impoverished inheritance. His *Sowers of the Wind*, like most of the war writing, and like later novels by Hal Porter and Elizabeth Kata, was littered with errors in Japanese. But in its day, *Sowers of the Wind* was thought daring for its sympathetic presentation of the Japanese, and this was the reason given for delaying its publication for six years.

THE POET KENNETH SLESSOR, after writing for the cause in the Middle East and in New Guinea, resigned as a war correspondent rather than sustain the impressions required by the

Albert Tucker, Hiroshima *(1947). Australians brought up on the Mikado-land fantasy found post-war Japan nothing like their expectations. (Australian National Gallery, Canberra.)*

Australian authorities. George Johnston, the first accredited Australian 'warco', stayed on, and his syndicated accounts from New Guinea, China, Burma, and India brought these places to life in the minds of many Australians who had scarcely heard of them—more than his official dispatches, which tended to contribute to the camouflage effort. Other warcos of the Pacific war included Pat Burgess and Alan Moorehead; and Jon Cleary later wrote as a war historian. Denis Warner, who prefigured the Vietnam debacle in *The Last Confucian* (1963), and Wilfred Burchett, who operated behind communist lines in Korea and Vietnam, gave Australians unstereotyped accounts of successive wars.

Like them, George Johnston went on travelling and writing in Asia after the war. In *High Valley* (with Charmian Clift, 1949), based on a detailed observation of Tibet (with no Western presence), a young Chinese-Tibetan questions both new and traditional authoritarianism. Johnston was one of the early few to perceive the farce of Western policy in China, which he brought out in fictional form in *The Far Road* (1964). His earlier novel, *The Moon at Perigee* (1948), was a classic pre-independence story in which the ex-soldier Casey, an Irishman, is torn between his reluctance to leave India and his failure to understand the newly emerging nation. Casey, like Johnston, finally leaves for China.

Johnston reported the last days of the Kuomintang (Guomindang) for the Australian press, and witnessed the evacuation of Kweilin (Guilin). Meredith, the seasoned Australian correspondent in *The Far Road* who is Johnston's alter ego, can see that the core of the system is rotten. The novel was a harbinger of post-war, post-imperial uncertainties. Meredith's fellow-correspondent, Conover, a young, efficient, pragmatic Chinese-speaker, who provides the jeep and the K-rations, and saves Meredith's life, is an American. It is he who wins the girl in the red cheong sam, suggestively called You May. The departure of the last train from

Kiuchow (Jiuzhou) anticipates scenes at the fall of Saigon; the scenes in the interior of China, along roads littered with bodies, prefigure the Cambodian killing fields; the Australian is newly dependent on the American; both despise their corrupt allies in China, as they would in Vietnam.

In his prefatory note to the book, which was republished in 1987, Johnston reflected bitterly on Australia's interchangeable alliances and enmities. The Japanese had been musical-comedy figures at the turn of the century, he wrote, allies in the First World War, ogres and apes in the Second World War, and tamed monkeys in the occupation. The Chinese had been vermin during the gold rushes, coolies in the canefields, and allies in the Pacific war. Chinese communists had joined Australians in resisting the Japanese, but they would be enemies again in Malaya, Korea, and Vietnam. The Indonesians had been enemies of the Dutch, allies against the Japanese, friends against the Dutch in 1945, enemies against Malaysia, Papua New Guinea, and Fretilin (in East Timor). Johnston's response to such absurdities was to become increasingly opposed to war and cynical about journalists who reported it. In what passes for Meredith's moment of illumination, he exclaims: 'What phony shits we all are!'

Johnston has Meredith realise that war depends on the implantation of images of the enemy as inhuman or subhuman in the minds of your own people, for these images give permission for inhuman acts against theirs. Johnston and Meredith, as journalistic image-makers, were both implicated in the process of making and unmaking enemies. The post-war years would see the Soviet Union become an enemy, and Japan become a friend, joined later by China; and in 1989 the USSR and China would almost change places again. These image substitutions, which Australians accepted, no longer made by the British, were now performed by the United States.

WHEN THEATRE IN Australia began awakening to a life of its own in the post-war years, the war experience came in for questioning and reinterpretation and gave playwrights a new theme, an alternative to the 'Sydney or the bush' tradition, but one that nevertheless represented a further effort to define the national character.

In *Rusty Bugles* (1948), Sumner Locke Elliott drew on his experience as a bored private in an ordnance camp at Mataranka in the Northern Territory. The play's vernacular realism, and its implied challenge to the heroic myth, were given added daring by Alan Seymour in *The One Day of the Year* (1960), a dialogue about war across the generation gap between the 1940s and the 1960s; nothing symbolised the gap better than young Hughie's covert smoking of marijuana on Anzac Day—another first for the Australian stage. Such local Australian barricades had to be breached before any reassessment of the image of the enemy could be thought of.

In Seymour's play, the old generation, Alf and Wacka, whinge about 'Poms and wogs and bloody Ey-ties' invading Australia:

'New Au-bloody-stralians. Jabber, jabber, jabber.' This was how foreign languages, particularly Asian ones, had been described in Australian fiction for a century. Whether spoken by Malays, Filipinos, Pakistanis, or Japanese, the sound would seem the same to John Hooker's hero in Korea in *Standing Orders* (1986), to John Lee's ocker Alan in Malaysia in *Sarong Aussies* (1979), and to John Romeril's Les in *The Floating World* (1974). Vietnamese as 'yammer' would later join the list.

For Australians like Alf and Wacka, the arrival of a million American servicemen during the Pacific war constituted an invasion, more than the Japanese one which failed. Young Hughie's questions would become the agenda for a reassessment of the American alliance, Australian attitudes to Japan, Asian migration, and (inescapably) Australians' view of their own identity. Yet other dramatists were slow to take it up until Romeril did so in *The Floating World*.

COWRA WAS AN earlier focus for this sort of questioning. The story of the outbreak of Japanese prisoners, suppressed until after the war, has continued to fascinate Australian writers and filmmakers. Kenneth Mackenzie's novel, *Dead Men Rising* (1951), based on the incident, which he witnessed, was banned in Australia until 1969; the reassessment of the enemy, whose image had taken a century to build up, was a slow process in Australia. But the book sidestepped the problem of the motives and psychology of the Japanese, sticking to the predictable themes of an all-Australian love affair and the boredom of the garrison, most of whom were unfit for active service. It even avoided naming Cowra, calling the place Shotley.

In 1978 Harry Gordon in *Die Like the Carp* would try to reconstruct events that had not all come to light twenty years earlier. He recounted the capture of the prisoners who were to become the ring leaders of the breakout, their conspiracy in the camp, the suicide of two of them, the secret court of inquiry which followed, and the trial of the main surviving organiser. Without debating too far the degree of blame that should fall on Australian officers for not taking seriously either a Korean prisoner's warning six weeks before the breakout, or a similar attempt in New Zealand, or for not understanding the consequences of separating Japanese NCOs from their men, the oyabun-kobun system of loyalty and protection, bushidō and Emperor-worship, Gordon pointed to the same widespread ignorance about Japan as had hampered most Australians during the occupation.

Curtis Levy's interviews with some 800 Japanese for his documentary film *Breakout* (1987) produced responses across much the same range of views as those recorded by Hank Nelson and Tim Bowden in conversations with Australian former prisoners of the Japanese: from stiff-necked, unforgiving suspicion to wry, regretful friendliness, honest admissions of fear and a wish to survive. At about the same time, Kennedy-Miller fictionalised the story as *The Cowra Breakout* (Chris Noonan, Phil Noyce, directors, 1986), for

an Australian television series with Hiroyanagi Susumu. And the writers of *Blood Oath* were at work, in 1991, on yet another version of the breakout, *Giants at Dawn*. By then, the inferior-superior relationship had been reversed: Japan was the world's leading economy, and Australia was back in its customary subservience.

In 1981 Roger Pulvers would follow his surrealistic masked drama about the Japanese general, *Yamashita* (1970), and his puppet play, *General MacArthur in Australia* (1978), with a novel, *The Death of Urashima Taro*. As he explained, the name of this fictional character, known to every Japanese child, was used by prisoners to conceal their identity and appears, solemnly engraved, on a gravestone in the Japanese war cemetery at Cowra. (It was as if an Australian grave bore the name Ginger Meggs). In Pulvers' novel a young ABC reporter, a Japanese speaker, goes to Japan to discover who the real Urashima Taro was. He encounters a series of uniquely Japanese obstructions, from inscrutability to outright racial prejudice.

> 'Don't mind my wife,' says Inomata Shuji. 'She hates foreigners. It's not personal. To be fair to her, she hates Koreans and Chinese more than whites. With whites it's just a complex from the war. Her family had a bit of a bad time after the war. It was only the Americans really. She may be a bit of a racist, but she's nice to other Japanese . . .'

VERY LITTLE FICTION in English was produced about the Korean war, by Australians or anyone else. Korea had an image in the West as the 'hermit kingdom', having effectively been a Japanese colony for the whole of living memory. If Australians had much to learn about China and Japan, their ignorance about Korea was profound, and, apart from a few missionaries, widespread. Frank Clune's sketchy *Korean Diary* (1955) did little to dispel it. Nor did the kids' comics, Australian and imported American, whose proliferation coincided with the cold war period.

A. M. Harris' *The Tall Man* (1958) and John Hooker's *Standing Orders* bridged a gap between two kinds of war: the war in which Australia was in actual danger of invasion and the one in which it was not, the war whose purpose was clear to Australians fighting in it and the one whose purpose was in dispute.

Harris' tall man, never named, is a *Boys' Own* sort of hero, who at the end lies dying on 'the harsh Korean earth for which, for some strange reason, he had fought'. Though he may not know the reason, the story suggests it: the tall man is there to represent Australia's loyalty to its Western allies. The United Nations as a fig-leaf combatant is never mentioned. Only the white, English-speaking participants in UNCOK are presented as the Australian's 'natural' friends. Canadians, British, Americans and one New Zealander are drawn true to type; representatives of the other eleven participating countries might as well not have been there.

The tall man is cast as big brother to the Koreans under his command. The personal lives of his three loyal Koreans are recorded in flashbacks which reveal familiarity with Korean geography and society—up to the point, at least, at which they are given Japanese

Scorfield, The Almost-unknown Soldier *(1953). Australians fought in the Korean War, in an almost unknown country, with an ill-defined enemy, to reach a stalemate. The government said a 'communist challenge to the Western democracies' called for Australian participation. (*The Bulletin, *1953.)*

to speak, and inaccurately transcribed Japanese at that. A cook is straight-facedly named Kimchi.

In the approved *Boys' Own* manner, the tall man makes a great effort to save the loyal South Korean, Pak, 'as he might a younger brother'. He respects the bravery of the Chinese soldiers. But the North Koreans he categorises as 'bitter in defeat and casual in cruelty', without explaining why communism alone should make them so different from their southern blood brothers.

Hooker, born in New Zealand, had not fought in Korea himself but went there to research material for the novel and a historical account of the war. In *Standing Orders* he pointed to Australian ignorance about its causes and public indifference to its outcome. His hero, David Andersen, is a grazier's son from the western district of Victoria—the green corner of southeastern Australia, whose Englishness is stressed throughout. As a boy he asks his grandfather:

'Where's Korea?'
'I don't know. Somewhere between Japan and China.'

David's family, his upbringing, education, and values are all at odds with Korea, where he goes as a professional army officer. A background in Biggles, *Kim*, Melbourne Grammar, Wellington, and Sandhurst gives him instant rapport with the British officer with whom he is captured, but teaches neither of them anything about 'Asiatics'. David is presented as superior to his men, not because of his greater knowledge of Korea or China, but because he has been to a public school. On David's first encounter with North Koreans, he observes that they all look alike. To some of the men under his command, Koreans are 'gooks' and 'vermin' who, anticipating Vietnam, are said to wear black 'pyjamas'.

David realised that he had not spoken to any Korean, except to shout at porters. He knew lots about the French and the Germans, but nothing about Asiatics at all.

Back in the western district after the war, most Australians think nothing has changed. The hoofbeats of the approaching Vietnam apocalypse are heard, far off still, and muffled by loyal Australian trumpetings for the Queen's coronation and the conquest of Everest. One man suggests to David that Korea is a 'new kind of war' which the Americans have got wrong, as the French got Indochina wrong: but this is news to David.

Hooker's novel closely resembles Fred Thwaites' *Sky Full of Thunder* (1968), in which a young Australian gentleman farmer has the doubts of a soixant-huitard about obeying his superiors' inhumane orders in Vietnam, but still describes the enemy in 1888 terms: 'an incredibly ugly man, very thin and short . . . his black eyes never lost their furtive expression . . . pyorrhea-riddled gums . . . badly eroded teeth . . . fanatical Viet Cong'. He develops friendly contact with a token child, who is conveniently English-speaking and anti-VC; he performs heroically in the end and

emerges, scarred, for a romantic ending. In fiction, as in fact, aspects of the two wars and their images were interchangeable.

Korea epitomised what an expatriate Australian academic would call the 'Australian numbness to history' in its numbest manifestation. Three lonely exceptions were Judith Wright, who during the war years wrote *The Two Fires* (1955), anticipating and warning against the nuclear holocaust that nearly occurred; fellow poet John Tranter, who after the event wrote a sonnet on the 'terrible new war'; and novelist Katharine Susannah Prichard, an opponent of capitalism, conscription, censorship, and Japan, whose concern in her last novel, *Subtle Flame* (1967), matched that of her protagonist, an aging newspaper editor, for world peace and nuclear disarmament. He sees the war as 'a crisis faked to serve the interests of United States foreign policy'. Apart from them, few writers and artists in Australia—unlike their counterparts in eastern Europe—considered it their responsibility to explore international political issues or through their art to offer the people alternatives to the government's image of Asia.

In the 1950s and 1960s, Australians found themselves engaged in Malaya against communists with whom they had formerly resisted the Japanese, and against Indonesians whom they had supported in ejecting both the Japanese and the Dutch. Western ideology, once again, overrode Asia-Pacific empathy. Neither the Emergency nor Confrontation attracted much interest from Australians in the arts. Bruce Dawe's comment after serving at Butterworth in Malaysia during the period showed how deficient Australian image-making was: 'Many Australians thought that the local people have come down out of the trees only recently.'

BETWEEN THE WARS, refugee artists had arrived in Australia from Europe, bringing a transfusion of new ideas. More would come after 1945. Among them were some who knew considerably more about Asia than most Australians did. Later they would be joined by returning Australian expatriates, the backwash of the generational diaspora of Australians who had fled conservatism and philistinism. A few of them, though still only a relatively small number, returned with first-hand experience of Asian cultures.

Paul Haefliger, who would become well known in his role as an art critic and exponent of European art in Sydney, was a German-Swiss who first arrived in Australia in 1930. Rather than gratify his mother by becoming a sheep farmer, he took printing classes under Thea Proctor at the Sydney Art School. In 1932–33 he went to Japan to study with the woodblock print artist Watanabe, then to China and India, and after travelling to London, returned to Sydney in 1939, bringing back an extensive collection of East Asian art to support his knowledge of its history and his application of it, particularly in his early work. Haefliger used Hokusai and Hiroshige, as his European colleagues had done much earlier, and Toyonobu and Sharaku as well, as sources for prints. On the eve of war with Japan, these literal references ceased, although Japan remained in his mind as a stylistic stimulus to modernity.

Buddhist art and philosophy were among the interests that Desiderius Orban brought to Australia in 1939 from his native Hungary, having first become aware of them in Paris in 1906. Although he did not visit Japan and Hong Kong until 1961, he was prepared by his knowledge of the masters of Zen painting for the encounter with nature as a felt experience. But it was after reading Alan W. Watts' *The Way of Zen* in 1967 that he attained what he recognised as his second enlightenment: art, he realised, achieves its own spirituality when the artist 'forgets that it is he who is handling the brush'. Among Orban's works which most obviously demonstrated what he gained from his East Asian absorption were his *Kabuki Backdrop* (1962), *Sunrise in Hongkong* (1966), and *Thousand Buddhas* (1975). The little Chinese Buddha figures in their niches would also attract Sidney Nolan as a subject, apparently suggesting the format of his great mural in 1620 rectangular segments, *Snake* (1970–72).

John Passmore left for Europe in 1933 and did not return to Australia until 1950, bringing with him ideas derived from his studies in Europe. He imparted his admiration for Hokusai, as well as Rembrandt and Cezanne, to his students. For others, the contact with Asian countries would be of more central importance, and would be direct. They included Nolan, Friend, Godfrey Miller, and Ian Fairweather.

Godfrey Miller was born in New Zealand but lived most of his life in Sydney. He graduated in architecture and then made a long visit to the Philippines, China, and Japan in 1919, before moving to Melbourne. At the Slade school in London in 1933, French mathematics, Chinese ceramics, and Ajanta Buddhist cave paintings displaced his earlier interest in cubism and abstraction. He worked, he said, by geometry and the stars, seeking to demonstrate in his

8
Travellers

Diaspora and influx of visual artists — post-war potters — architects — composers

art the interconnectedness of all things in the universe: 'Not the Slade or Cezanne, but Indian philosophy gave me the key'. Miller became a Theosophist, adopting a meditative approach to his paintings, which he gradually and painstakingly constructed over long periods. The art historian Bernard Smith called his method mystical, and another critic said it was pantheistic: certainly Miller, like Buddhist scholars, sought to know the essential stillness behind the prismatic surface, and the unity of the cosmos.

Like Miller, Ian Fairweather was not born in Australia, but ended his life in Queensland as an artistic hermit. He too served in Europe in the First World War, and in prison camps. By the time he reached Melbourne in 1934 he had lived in Holland, Germany, Canada, and Bali for short periods, and in China for three years; he had read Hearn, and Fenollosa's *Epochs of Japanese and Chinese Art*, and had studied both languages. He soon resumed his wanderings, in the Philippines, China again, Singapore, and India. He returned to Australia in 1943, and left again; in 1952 he made his famous attempt to get to Bali from Darwin on a raft. From the mid-1950s he lived on Bribie Island, near Brisbane. Perennially poor, Fairweather was often on the brink of starvation and sometimes ill, paying irritated attention to his health only when it threatened his capacity to paint. In his hut among the mangroves, he retraced each experience in memory from country to country.

In spite of his orthodox grounding in art school in London, Fairweather's wanderings kept him aloof from developments in the international art world, and this freed his mind to concentrate on Chinese and Japanese art, on Buddhism, Taoism, Christianity, Aboriginal culture, and primitive mythology, and allowed his eye to take in the varied fresco of jungles, mangroves, temples, carvings and people past which his life moved. He was hardly typical of foreigners in the 1930s in China, being uninterested in politics, commerce, collecting treasures, the promotion of Christianity, or his own material comfort. He was able to make the Expatriate Shift, to see the Chinese as though he were one of them, a 'sort of honourary Chinese', and the foreigners as waiguoren:

> I took on, unconsciously I believe, many Chinese attitudes and when I met a European I found his appearance slightly distasteful—his features coarse-grained by comparison with the delicacy of the Chinese bone-structure. Above all, I shrank from the European's aggressive individuality.

Donald Friend and Harold Stewart would later have the same reaction to foreigners in Bali and Kyoto respectively. But image-reversal in Asia was something few Australians, apart from the prisoners of war who had it thrust upon them, contemplated in the early post-war years.

The fact that Fairweather finally came to rest in Australia did not mean he regarded himself as Australian, though he is claimed as an Australian artist. Nationality was unimportant to him. He believed anyone should be allowed to live in Australia, and loathed the Anglo-Saxon inbreeding which he saw as an outcome of the White Australia policy.

Ian Fairweather, Perjinnan (Persimmon) *(1951). During the Second World War, Fairweather enlisted in the British army and was assigned to Bangalore in India. He dated this painting in Chinese, and signed it and others with variants on the Chinese character for 'if' [若]. (National Gallery of Victoria.)*

Throughout Fairweather's long life, he dwelt nostalgically on China, which offered him lasting and varied resources. He particularly admired the great traditional Chinese calligraphies. Many of his paintings are signed and dated in Chinese; Fairweather read his Chinese dictionary as a diversion, until it fell apart. In 1961 he translated *The Life of the Great Ch'an Master Tao-chi* (Chan, Daoji), based on tales of a Buddhist saint who lived in Chekiang (Zhejiang) province in the thirteenth century and whose wanderings were no less picaresque than his own. It was published as *The Drunken Buddha* (1965).

When the young photographer Hedda Hammer left Germany to become the manager of Hartung's photo studio in Peking, she threw overboard the pistol and umbrella her parents thought necessary for such a place. She lived in China from 1933, through the Japanese occupation, to 1946, making a photographic record not only of daily life in the capital but also of the western hills, the bandit-ridden 'lost tribe' country, and Ch'u Fu (Qufu), the birthplace of Confucius where, staying in temples as she often did, she was nursed by nuns through an attack of scarlet fever. She married Alastair Morrison (a son of G. E. Morrison), who was an officer in the British army, and went with him after the war to Kuching in Sarawak, where she added Malay to her fluent Chinese; they also lived in India and Indonesia before moving to Canberra in 1967. Hedda Morrison published several volumes of her work, including *Sarawak* (1957), *Life in a Longhouse* (1962: with text in English, Chinese, Malayan and Iban), and *A Photographer in Old Peking* (1987). She revisited China twice, welcoming the decline of the grinding poverty of fifty years before, but deploring the pollution that industrialisation had brought to Beijing.

Tina Haim Wentcher was born in what was then Constantinople, grew up in Vienna and studied in Berlin and Paris. In 1931, with tickets won at a ball in Berlin, she sailed with her husband Julius, a painter, to Ceylon, Java, China, Hong Kong, Cambodia, Thailand, Singapore, and Malaya, where she stayed from 1936 to 1940. The Wentchers then left for Australia, where they were interned as enemy aliens for a year. Her sculptures, in wood, bronze, marble, pewter, plaster, and Chinese modelling wax, included many portrait heads and busts, but also figures of Chinese and Balinese done from observation in the countries she visited. She also made relief sculptures of Malay scenes and exhibited them in Australia, where they were thought exotic by the critics.

Donald Friend's duties as a war artist, far from thwarting his development, gave him more of the opportunities he sought to observe the male form at rest and in movement, usually naked. Often these figures appeared in intricate, perspectiveless tropical settings, which seemed to move right up to and in amongst the figures, in the manner of Balinese painting and batik and Ceylonese relief sculpture. Friend shared with Gauguin and Rousseau the European Orientalist fantasy—the idea of escape to a distant island, a tropical Eden of sensual beauty. 'In the Orient,' he wrote,

> distinctions blur in the drifting smoke of dim lanterns and evening fires. Brown and lissom graces, liquid eyes and the smooth skins of both sexes lose the edges of difference. And so do attitudes of mind.

But in spite of his claim that he wanted 'a sort of tropical, exotic, romantic life', Friend never took himself or exoticism too seriously and always diluted the tropical syrup with a measure of detachment and ironic amusement. In the Torres Strait, in Ceylon from 1957, and in Bali from 1966 to 1980—years which, in the view of his retrospective curator, were the salvation of his art—Friend found Asia and the Pacific, not the Orient. Writing autobiographically of his exploits on various islands in *Save Me From the Shark* (1973),

Friend made tolerant fun of the pretensions of native and foreigner
alike. 'The proto-Sanskrit euphuism *Varniyapringoswatinattya-
vastrya,*' he confided,

> expresses the unique sound made by the silver filigree nostril-ring of
> an ambergris-vendor who has sneezed after taking snuff from the
> fingers of a person of superior caste.

By 1985, Western borrowing from Chinese, Japanese and Balinese
art would become such a cliché that Friend could mock it, along
with artists' coteries and critics' ignorance, in his *Art in a Classless
Society and Vice Versa.*

During his idyllic years in Bali, Friend wrote and painted,

observed local events, and formed associations with other painters and his neighbours which were as important to his work as the landscape, and recorded his life in a film, *Tamu* (the guest). He wrote with distaste of intrusive foreigners as if he were not one himself. He was repelled by their white, maggot-like bodies even more than by their stupid questions. He particularly resented being asked to predict 'how long it will be before the forces *they* represent will demolish an entire, complete, small civilization.' Although he was following the beaten track of Walter Spies, Colin McPhee, and others, it was the 'highly sophisticated innocence of [the Balinese] world' that attracted him, he wrote, rather than artistic primitivism; not the gloss placed on Bali by its foreign interpreters, nor the money or fame that could be made out of it. In his ironic resignation, living in the present, and the absence of 'culture-heroism', Friend reflected the Buddhism of Sri Lanka and the Hinduism of Bali.

Friend would lose his paradise when he returned to Australia in 1980, paying for youthful excesses with diabetes, emphysema and a stroke which crippled his left side, and his painting arm, in 1987. Wistfully recalling his moat-encircled house in Bali, and his twenty-five houseboys, Friend felt he had lost his status: 'I was a really great man in Bali, here I'm not.' Moreover, he had given away much of his collection of Indonesian art and many of his own paintings. Yet approaching the end of his life, he would deny that changing countries was the answer, much as he would love to be back in Bali. The man who had once written 'If I do not find love today I shall scream, SCREAM, SCREAM', who had been called Tuan Raksasa (Lord Devil), by his household, had spent some of his life in countries where painting naked boys did not present the problem it would have done then in Australia.

In the post-war years, like Tucker, Sidney Nolan got away to Europe as quickly as he could. Not until the 1960s, when his art was securely established in international critical esteem, did it begin to reflect an interest in Asia. He had already become an artist-tourist, with explorations of Greece, Turkey, India, Cambodia (1956), Japan and Mexico (1957), the Australian desert, Antarctica, and Africa behind him. In 1965 he managed to get into China—then officially impossible for an Australian—by way of Indonesia, Pakistan, and Afghanistan. This, during the Cultural Revolution, was the first of seven visits which produced an intermittent series of paintings. The first was a set of small works in mixed media, which understated the impression China had made on Nolan.

Since his first encounter with the left intelligentsia in Melbourne in his early twenties, Nolan had been fascinated with the long march of Mao Tse-tung (Mao Zedong). Now the silk routes from China to the Middle East, through the Gobi Desert, where he had seen what remained of great Buddhist frescoes, also lured him. He sought a creative link between Chinese images of great military leaders, on the one hand, and Aboriginal cave paintings on the other. The results would gestate slowly, and appear late in the 1980s.

Five years after the war William Dobell found new colour,

lushness, eroticism, and spirituality in New Guinea, continuing to visit the island until 1953 to make landscapes, genre paintings and portraits. He observed the repetition of landscape forms in patterns of human activity and delighted in new juxtapositions of complementary colours. He and the writer Colin Simpson observed a kanana, courtship ritual, which Dobell painted as a frieze of haloed, translucent, entomological figures. In retreat from censorious Australia, for four years Dobell renewed himself by painting little but the unabashed 'primitives' of New Guinea. In the same years Ray Crooke was applying a more lyrical, expressionist vision to Australia's tropical north and to the islands, and one that was closer to the daily lives of the people.

Tony Tuckson extended Australian recognition of the diversity of Papua New Guinea from 1965 with his first collecting expedition along the Sepik River (as Andrew Sibley had done a few years earlier), the results of which he shared with the Art Gallery of New South Wales and the National Gallery of Victoria. Among those who followed him to the Sepik in search of a new vision in the 1970s and 1980s were Shay Docking, Alun Leach-Jones, and Paul Greenaway. Frank Hodgkinson, another of those artists who could not wait to get back to Europe in the diaspora of 1947, continued to move backwards and forwards between figurative and abstract painting, between bright, pretty colours and heavy, primal ones, as he did between Europe and Australia. In 1984 he would bring out his *Sepik Diary*, a large book of drawings, paintings, and photographs, with a hand-written journal compiled during a 500-mile journey he had made in March 1977 by dugout canoe through country he had seen during the war but had never been able to explore. By 1989 he would be exhibiting paintings of the Himalayas and Kashmir which were as concerned with the textures of local screens and fabrics and with the mountain light as with Muslim responses to the death of General Zia, which occurred during his visit.

In the 1960s, in no organised or premeditated fashion, some artists were looking towards Asia and the Pacific with new individuality and assurance. Most had done the mandatory period of study abroad, usually in Europe; some had visited Asian countries, and some had not; many were now able to see work that interested them in exhibitions, collections, books, and films; admiration in the West for primitive art and abstract expressionism gave them permission. Barriers of many kinds had fallen, not least those in their minds. They included Robert Juniper, Fred Williams, Barry Gazzard, Robert Grieve, John Olsen, and George Baldessin.

Robert Juniper filled his canvases with the empty spaces of Western Australia, doing so with an awareness of Japanese technique, which came to the surface in some of his trees and their shadows, filled black or ultramarine stencils recalling the aesthetes' japoniste posters and Japanese katagami, dyers' stencils. But like Preston he owed as much to Cezanne as to Japanese art. Looking out of his window was, he said, 'like seeing Cubism on the ground'. Juniper admitted raiding his images from wherever he could find them—from Byzantine, Renaissance, Persian and Oriental art.

The vantage point for Juniper, and for the growing number of Australian artists who were discovering the potential of the desert, was looking down on it from the air. His salt lake paintings were done in this way, and Lake Austin in particular suggested a Chinese landscape to him.

> The blinding white salt lake, 80 kilometres long, has small islands jutting from its surface like the exaggerated Chinese mountains with trees on top which rise from a milky mist . . .

Elsewhere he noted that he liked to use the Oriental technique of 'making the space as significant as the objects placed in it'. An example of this appeared on the uniform, bleached background of Juniper's diptych, *River Dies in January* (1977), suggesting a further debt to byōbu, folding screens, in which mountains and landscapes disappear behind lozenges of cloud.

Juniper's work shared roots and resonances with the oils and gouaches of Fred Williams, one of the most admired of Australian painters. Williams returned from art schools in England accomplished as an etcher but deeply interested as well in tonal relationships and disciplined forms. His landscapes became progressively more simplified, like musical scores with the staves and bar lines blotted out, and only minimal notations left. He used what one critic called 'a personal calligraphy which is immediately legible to those who know his subject'. Another said he had 'the ability to suggest a totally expressive shape with the minimum mark'. Such an approach went back through Seurat and Van Gogh to Hokkei, Hokusai, and the Zen painters, and his sparse dots of paint on a flat, luminous ground suggested the shadowless space of ukiyo-e.

Williams used the screen and panel format, both vertically and horizontally, in many paintings, recalling Conder's and Streeton's hashira-e. The potency of his tree and rock shapes derives from the infinite care that he and his Japanese and Chinese predecessors devoted to placement and significance of objects. Horizons for Williams—so high as to be only just visible, or daringly angled and curved—were visual jokes suggesting admiration for Hokusai and Hiroshige. But the contemplative mind is drawn to Fred Williams' landscapes as to the visual illusions of the garden at Ryōanji. He

> makes us reassess things we had taken for granted for so long that they merely passed through the eye on their way to limbo.

Williams called some of his work of the 1960s 'Chinese', less because of any visual resonance with Chinese painting or landscape, than because it suggested, as Chinese painters sought to do, a state of being in which trees, mountains, earth, and heaven became continuous. In 1976, searching as always for new directions, Fred Williams went to China for three weeks. In his *China Sketchbook* he produced a remarkable set of charcoal drawings, seeing Chinese landscape as though with a Chinese eye, hinting broadly at Chinese calligraphy but, as Fairweather did, integrating it with his own idiom. Williams derived much more excitement from China than

from his 1976 visit to Europe. A growing interest in Asia and a general opening-up of his art to new experience characterised his work during the 1970s.

Buddhist philosophy, though not Zen in particular, was and would remain an essential element in the work of Barry Gazzard. For his graduation thesis at the Chelsea Art School in London in 1962, Gazzard chose as his subject the influence of Zen Buddhism on ink painting, knowing nothing about either. In what he later described as one of 'those Innocent Abroad experiences', and having seen only one example, a Japanese kakemono shown him by a Frenchman, a lecturer at the school, he immersed imself in the British Museum's collection.

In 1964 Gazzard went to Japan for a year, and stayed for ten. He was able to study Japanese aesthetics at Kyoto Geijutsu Daigaku under Professor Masuda and to improve his knowledge of Japanese to the point where he could translate for his professors. He formed friendships with Japanese craftspeople, one of whom was the wood craftsman Kunoda Tatsuyuki, a living national treasure in his field. Gazzard studied at the Koyasan monastery, where the priests and scholars led him away from Zen towards the esoteric or tantric philosophy known in Japan as mikkyō, secret teaching, linked with Tibetan Buddhism. He was fascinated by the symbolism and iconography of paintings which were themselves diagrams of rituals, with the deities arranged to represent the cosmos: mandalas are classic examples. As well as his studies in Kyoto, from which Gazzard emerged qualified as a Shingon priest, he also travelled widely, visiting Taiwan, Cambodia, Thailand, Hong Kong and Korea, and spending nine months in India.

In Gazzard's work, Chinese and Japanese influences, though seminal, were not superficially discernible. He stuck to 'determinedly western oil paints and there isn't an obvious stylistic influence'. He studied the Nihon-ga technique in Japan but was not interested in applying it to his own work. He preferred making lithographs and etchings to relief prints in the Japanese tradition. It was at the level of ideas, not of style or technique, that the transition between cultures took place for Gazzard. 'I think ch'an or zen is true cultural transmission', he wrote. 'The idea or conception is Indian, the style, language etc. is purely Chinese.' For Australia, he believed, political and economic contacts with Asian countries were a means to widen cultural awareness as well, opening the narrow doors of Australian perceptions.

Another painter and printmaker to take advantage of the widening doorway was Robert Grieve, who lived in Japan in 1962 and 1964, was married to a Japanese, and exhibited there. His work, which has been described as achieving harmonious fusion of Japanese and modernist European influences, included the use of embossed handmade paper, and collage of fragments of minute Japanese newsprint, overlaid with crass roman capitals. Some paintings demonstrated his admiration for Japanese contemporary artists Saito and Wakita, whose works he owned. As Grieve pointed out, even in the early 1960s Japan was less isolated from the latest American and European art than Australia was. Later,

John Olsen, Improvisations on
Bashō's Frog *(1976). Olsen in
the 1950s was one of the first
Australian artists to appreciate
haiku, especially Bashō's
famous verse about the frog's
splashdown. (Parliament House
Collection, Canberra.)*

Grieve would add the New Guinea rainforest to his sources of
improvisatory stimulus.

Widely-travelled Sydney Ball progressed in the 1950s and 1960s
through the hardest of hard-edge painting and spattered spon-
taneity. In 1975 he visited islands in the South Pacific, and in the
1980s his art moved on to figurative meditations on Oceanian and
Aboriginal cultures in juxtaposition, not always harmonious, with
those of Western Europe. A painter of landscapes and mandala,
Lawrence Daws traversed the outback from Adelaide and travelled
in New Guinea as a geologist on field trips, developing an animistic
and mystical sense of both countries which he applied in his work
in the form of mandalas floating over a desolate, chaotic world.

But it was John Olsen who, more than any others, found in the
Australian desert the animistic link between Aboriginal and Chinese
culture, what he called 'a certain mystical throbbing throughout
nature'. Olsen had studied under John Passmore in the 1950s. His
enthusiasm for Passmore's ideas about total experience and his

admiration for Cezanne led him in turn to Dylan Thomas, Gerard Manley Hopkins, and T. S. Eliot. He began to look east as well, to Hindu philosophy, and to Zen; Suzuki's *Zen and Japanese Culture* was given him by Haefliger. After Olsen's return from Europe in 1960, his series 'Journey into the You Beaut Country' represented his own search for a new significance in the 'dry salvages' of the desert, a new linkage between Australia's inherited historical culture and its immanent geographic one. 'The landscape is in me,' as he put it, 'and I am in the landscape.' The spirit of the land seemed to well up and confront him with moments of memorable illumination, moments in which the linkage between Aboriginal and Asian tradition was apparent.

In 1973–74 Lake Eyre, a huge saltpan in central Australia, filled with water and suddenly seethed with wildlife, wildflowers, and spectators, including Olsen. Wondering at the luxuriant life that had briefly sprung from the dead lake, Olsen visited and revisited Lake Eyre, simplifying his lines and colours, yet following where they led. His treefrogs were consciously Chinese in execution, Japanese in intent. Olsen wanted the spectator to hear the maniacal cry of the kamikaze frog before it hit the water: the sound immortalised by Bashō in the seventeenth century. As well, the paradox of the dry, but flooded lake was a powerful revelation of Tao in nature, and an expression of the insignificance of human hopes and fears.

Olsen, a printmaker as much as a painter, contributed to the reawakening of printing as an art after its thirty-year hibernation. The reconstruction period in Japan was, as we have seen, like the opening of Japan to the West a century earlier, and the reflexive adoption of Japanese and Western ideas. This time the reflex was at work in Western abstract expressionism and modern Japanese printmaking. American collectors discovered Munakata, Hagiawa, Kidokoro, Isode, Hatagau, and others. Tate Adams led a wave of similar enthusiasm in Australia. Four exhibitions from Japan—of contemporary art (1958–59), of modern prints (1962–63), of the *Hiroshima Panels* of Maruki Iri and Akamatsu Toshiko (1958), and of contemporary calligraphy (1965)—were sent to Australia as part of Japan's second conscious effort to remake its image. Reciprocal showings of Australian art gave some Australian artists their first look at Japan. At the inaugural exhibition at his Crossley Gallery in 1966, Tate Adams brought together work by ten printmakers, five Australian and five Japanese. One of them was George Baldessin, whom Adams encouraged to go to Japan in 1966.

Baldessin exemplified the new breed of Australian artist, but his early death in 1978 in a road accident left open the question of what directions his talent would have taken. The son of an Italian migrant family, he worked as a waiter before studying at the Royal Melbourne Institute of Technology, where Tate Adams headed the print department. The young Baldessin was culturally eclectic; his interests ranged from the abstract expressionism of Charles Reddington, the American who taught him for a year, to Goya, twentieth-century Italian art, British sculpture, and the *Hiroshima Panels*, all of which he saw exhibited in Melbourne. Baldessin

PLATE 1 *Nicholas Chevalier*, Japanese Musicians *(1873) oil on canvas 61.0 × 91.5 cm. From 1867, troupes of Japanese entertainers visited Australia promoting their culture. Responses to them in Sydney and Melbourne ranged from admiration to scorn. (Art Galley of Western Australia.)*

PLATE 2 *Sam Byrne*, Mt. Robe Silver Mine 1896 *(1964) oil on board, 23.5×30 ins. Cameleers said to be Afghans were among early workers in Australia. A train from Adelaide to Alice Springs was called 'The Ghan' after them. (University of Texas at Austin.)*

PLATE 3 *J. C. F. Johnson*, Euchre in the Bush *(c. 1867) oil on canvas, 42.0×60.2 cm. Chinese men arrived in Australia in 1848 as indentured workers to replace convict labour, and in the 1850s many more joined the gold rushes. The black man in this cross-cultural card game is thought to be not an Aboriginal Australian but an American. (Ballarat Fine Art Gallery.)*

PLATE 4 *John Peter Russell,*
Portrait of Dr Maloney *(1887)*
oil on canvas, 48.3×37.2 cm.
William Maloney, a friend of
Russell and Tom Roberts, from
1905 onwards warned
Australians against the rise of
Japanese militarism. The
kakemono in the background
may have been from Russell's
collection. (National Gallery of
Victoria.)

PLATE 5 *Tom Roberts,* Mrs
L. A. Abrahams *(1888) oil on*
canvas, 40.8×35.9 cm. Roberts
decorated his studio with the
Oriental accoutrements of
Aesthetic taste. Mrs Abrahams'
husband, also an artist,
provided Roberts and his group
with cedar panels from his
family's cigar business for their
exhibition of 9×5 Impressions
in 1889. (National Gallery of
Victoria.)

PLATE 6 *Girolmo Nerli,*
The Sitting *(1888) oil on*
canvas, 119×77 cm.
Photographs or paintings of
women posing or reclining in
Oriental finery implied luxury,
fantasy, exoticism, and
amusement. (Robert Holmes à
Court Collection.)

worked his passage to London in 1962 to study printmaking. At the Brera academy in Milan in 1962–63, his fellow students brought together ideas from a rapidly contracting art world: Japanese, Germans, Americans, and others.

Baldessin intended to use an award that he won in 1966 to stay in Japan for two years, but visa difficulties made him cut his visit down to two weeks. In that time he met Hagiwara Hideo but not Munakata Shiko, whose work he greatly admired and emulated. He never returned to Japan, but maintained his interest in modern Japanese prints and in Utamaro. He imported large, high-quality Torinoko paper for his own work.

By 1968, the Italian-Australian Baldessin had begun to use both Japanese and European resources for his own development as an Australian artist; Graham Kuo, born in China in 1949, who had arrived in Australia in 1962 and studied printmaking, was exhibiting his abstract screenprints in Australia and in North America; Ruth Faerber, born into a Jewish family in Sydney in 1922, was studying at the Pratt centre for contemporary printmaking in New York and would return to produce work which included *China Passage* and *Oriental Variations*; and Tay Kok Wee, born in Malaysia in 1942, another printmaker, was exhibiting at Crossley and, like Kuo, was one among many Australians interpreting their Asian ancestry in new surroundings. The change that had occurred in formerly Anglo-dominant Australia was nothing short of tidal.

IN 1962 THE British potter Bernard Leach visited Australia, where by then he had a large following as a result of his *A Potter's Book* and of his tour of America in 1953 with the potter Hamada Shoji and the Mingeikai theorist Dr Yanagi Soetsu. In both countries, his arrival coincided with the advent of abstract expressionism in visual art.

Surface decoration with multi-coloured, lustrous commercial glazes had already been rejected by artist potters in Australia, and stoneware was displacing low-fired work. The earthy colours and textural interest of the bush were so much in harmony with the mingei aesthetic that Australian potters were readily converted, while Japanese potters took to the 'abundant nature' of Australia with enthusiasm. Hamada lectured to packed audiences in 1965. Pottery in the 1960s was exceptional among the arts in Australia, in that a reciprocal exchange got under way rapidly and with ease — Japanese potters visiting Australia and in some cases living there for long periods, and Australian potters visiting China, Korea, and most of all Japan, and studying with Japanese masters.

Although it was Leach — once again the Western mentor — who had shown Australian potters the way to what was on Australia's doorstep, he still represented one connection with English ceramics, while the refined 'new modern look' which Lucy Rie and Hans Coper had introduced to British ceramics in the 1950s represented another, and one that offered Mollie Douglas, Marea Gazzard, and later Australian potters an alternative to the Japanese aesthetic.

Three Australian potters of contrasting styles who, like the writers and visual artists of the Pacific war period, might not have been exposed to the East Asian tradition but for the war, were Ivan McMeekin, Carl McConnell and Peter Rushforth.

McMeekin recalled first becoming aware of Asia in 1937, in his final year at school, when he had to write a report on the Japanese invasion of Manchuria.

> I became very involved [he said later] and from that time on have always seen China as the central civilising force among the Asian communities.

His distaste for Japan, in contrast, was strengthened by service in the Australian navy, when he realised the need for Australia to become an independent, Pacific nation. China seemed to him about to displace Britain as 'the most powerful influence on our lives'.

In 1943 McMeekin had seen the catalogue of a Chinese art exhibition held in London in 1935, and the tiny photographs, particularly of the ceramics, 'changed his life'. So in 1946 he went to work for four years as a seaman on the Chinese coast with the China Navigation Company. He was able to see Chinese ceramics at first hand because the captain of his ship and some of the line's passengers were collectors. He hoped to study in China, then in the throes of civil war; reluctantly he went to Europe where he found he detested contemporary French pottery. He studied instead for more than three years with Michael Cardew, a 'most English of English potters', who shared McMeekin's preference for Chinese over Japanese ceramics. The link with Australia became clear in McMeekin's mind:

> A salient feature of the early Chinese ceramics — Tang and Sung — is
> that [they] were very local — each particular $\begin{cases} \text{ware} \\ \text{idiom} \end{cases}$ grew out of the

long use of local materials by local people and presumably at first for the local market. So on my return home to Australia this was my central, basic, idea: to develop an Australian idiom based on the nature of our Australian materials, & as far as possible on those that were close by.

In this, McMeekin's ideas were close to those of the pioneers Merric Boyd, Ernest Finlay and H. R. Hughan. But now there were many who shared them. Back in Australia, McMeekin established the Sturt pottery workshop at Mittagong in New South Wales. His *Notes for Potters* (1967) became the handbook for a new generation of Australian ceramists. His successor at Sturt in 1959 was Les Blakebrough, who remained there until 1972, and who brought many Japanese to Mittagong. With the help of Kawai Takeiichi, he built a large noborigama, climbing kiln, in 1964.

McMeekin went on to establish other studios in New South Wales, in Darwin, and on Bathurst Island, where he worked with Aboriginal potters. In 1975 he led a delegation of Australian potters to China to visit provincial potteries. Although he added to his own work ideas from Korean ceramics of the Yi dynasty and Thai wares from Sawankhalok and Sukhothai, as well as Annamese blue and white porcelain, he still felt, in 1985, that he had not 'moved on very far from the Chinese beginning'.

Japanese pottery he regarded (with some exceptions) as suffering, rather as some Australian ware did, from self-conscious imitation of its Chinese and Korean masters. The development of an Australian idiom, however, he was sure would take more than one generation—a reflection with which the Chinese and Japanese alike would have agreed.

American-born Carl McConnell was another potter who studied the ceramics of all three major East Asian countries, and visited Japan many times. He had been a young sculptor in the United States at the Art Institute of Chicago in 1935–39, and in 1943–46 service in the US Navy enabled him to visit China and Japan. He married an Australian and in 1948 settled in Queensland. He first read Leach's *A Potter's Book* in 1946 and at once found a new direction: he began woodfiring, using plant and wood ashes in glazes, and made the transition from earthenware to stoneware and later to porcelain, becoming skilled in a remarkable variety of styles, clays, and glazes: celadon, Ming blue and white, white Ting, Shino, raku, Shigaraki, Bizen, old Seto, carved stoneware, and neriage (inlaid and layered coloured clays). His son, Phillip McConnell, studied in Mashiko with Shimaōka Tatsuzo, a pupil of Hamada, and in Bizen with the Fujiwara family, before establishing a pottery in 1975 in Toowoomba.

Peter Rushforth was a twenty-year-old soldier when Singapore fell. As a prisoner of the Japanese, whenever he could he sketched, carved chess sets and, like Kent Hughes, made use of the copious Changi library, some of which found its way to Thailand when the POWs were moved, Rushforth among them. Working on the notorious Thailand–Burma railway, he resolved, if he survived, to take up a constructive rather than a destructive occupation, and on his return to Australia, he met the pioneer potters Allan Lowe,

Klytie Pate, Harold Hughan, and his son Robert Hughan. In the Victorian gallery he studied the Oriental ceramics collection.

The prisoner-of-war experience made some Australians anti-Japanese for life. But Peter Rushforth's perception of the Japanese was different from theirs, and from McMeekin's. On his first visit to Japan in 1963, he 'got flak for going from some Australian RSL types', but he was impressed with the hospitality and kindness of the Japanese potters. Having, as he said later, only seen Japanese from behind barbed wire, he had initial difficulty in reconciling that image with these gentle craftsmen. In 1964 he worked at Mashiko, northeast of Tokyo, at Koishiwara in Kyushu, and at Kyoto Geidai. Later, in the Blue Mountains west of Sydney, Rushforth built two kilns, an anagama and a noborigama, both fired with pinewood. He noticed the difference: in Japan there was an equal division of labour between throwers, glazers, claymakers, kiln-builders and so on. 'Australians', he said sadly, 'end up doing everything for themselves.'

In the 1960s, a succession of Japanese potters visited Rushforth in Australia, among them Leach's friends Kawai Kanjiro, his nephew Kawai Takeiichi, and Hamada Shoji; Fujiwara Yu, Shimaōka Tatsuzo and Shiga Shigeo. Shiga remained in Australia for fifteen years. From these contacts many more followed. There was a sense of mutual discovery, which included, for Rushforth, the realisation that pottery politics were at least as complicated in Japan as in Australia:

> I went along thinking this was a happy country with happy potters but they have the same values or lack of values as we do—envy, jealousy, squabbles—worse than here.

Rushforth saw Japanese pottery as much more than the descendant of the Chinese and Korean traditions. He found in it qualities he believed to be unique, resulting from kiln types, materials and firing techniques as much as from the Japanese aesthetic. But he did not dismiss the English ceramic tradition which went back to the middle ages, and would not advise Australian potters to model their work exclusively either on it or on Leach and the Japanese.

> Most of us realise that we don't want [to] import a culture per se, that is the result of another and different environment to our own. Rather it is a heritage from which we can draw for our own work.

Writing in 1958 Rushforth saw Australia's late emergence as an artist-potter's country as having some advantages: Australians could draw from many sources in a common heritage and adopt whatever they wished.

It is characteristic of potters to care little for nationalism and to communicate readily, with or without language, with craftspeople from other cultures. This may be because those who fire with wood and dig their own clay must live far from large cities, as farmers or in farmlike surroundings, frequently opening their homes to visitors and welcoming fellow potters who stay for the

extended periods needed to complete the whole cycle of pottery-making up to the final firing. In Australia it had always been possible for what was only an ideal in other countries, of the artist-craftsperson living close to nature, to be realised. Pottery has been called the most human of arts, and it may be the most universal. That several of Australia's leading potters were indirectly led to take up this peaceful art by war in Asia lends encouraging support to the claim.

No list can do justice to all the Australian potters for whom contact with Asia became a stimulus. Approximate contemporaries of Rushforth were Les Blakebrough and Milton Moon, who followed Leach's lead to Japan and who studied the work of the potters who had led the mingei revival. Moon had served in the navy in New Guinea and in Japan, and found Japanese ceramics and landscape then; they remained his starting point, he declared in 1986. Col Levy, a close associate of Shiga, developed his interest in Sung celadons and Japanese tea wares entirely in Australia. All learned the technical discipline that the Japanese masters believed must precede inspired individual work. Each found his own point of fusion where the Japanese Zen aesthetic, with its spontaneity, quietude, and simplicity, the English clay discipline and usage of objects, and the Australian vision and identification with the bush could meet.

Levy, Moon, and Blakebrough were so firm in their belief that useful wares enhance daily life, and so sure of the essential validity of their Japan-based aesthetic, that they saw the reaction against 'trad-Jap-crap' by younger potters in the 1970s and 1980s as a transient phase. 'This trend towards expression without technique — it's mere fashion,' Levy said in 1973. Peter Rushforth alluded to the contest between function and fashion when he remarked, 'I don't think the proximity of Australia and Asia is that important — I think it is rather the philosophic concepts that could inject some values into our work that are important.'

Ware believed to be utilitarian, which showed its origins in natural materials and in the chance effects of firing, and which combined spontaneity and restraint, continued as an Australian, as much as an East Asian preoccupation, even though the modest practice of attributing work to the kiln, not to its maker, had for long been abandoned in Japan and had never been relevant among individual potters in Australia. In both countries, a pot that was a named art object had a different value, collectability, and price, and was unlikely to be in daily use. In Australia as in Japan, humble ceramics once supposed to be art by and for the people, mingei, were so only in a sentimental sense. Practicality was at risk of becoming illusory, and utility a pretence. Yet Rushforth maintained that expressive work such as pottery would lead to a more integrated life for the individual and the community. He argued further that a pot was functional even if only for its colour, glaze, form, and occasional use.

Young Australians continued to be introduced to Japanese masters. Andrew Halford, a student of Shiga and Blakebrough, worked in Japan with Shimada in Shimane and for three years in

Mashiko with Shimaōka, a potter who patiently trained one Australian after another. In 1986 his latest deshi, apprentice, would be the young Sydney potter Richard Ballinger, who by 1990 was exhibiting solo in Tokyo. The Japanese method of minarai, having students learn slowly by seeing rather than by direct instruction, required some adjustment to be made by the Australians. In ceramics, as in much else, the Japanese tendency has been to turn simplicity into an art form, with its own rules about what constitutes simplicity, and the time required to learn the rules.

Among the many others who had followed a similar path of learning and practice were Janet Barriskill, Audrey Stockwin, Jan Barrow, Peter Rose, Brian Kemp, Ian McKay, Cecily Gibson, Gillian Broinowski, Neil Whitford and Stewart Holland. Some visited Japan several times. Wanda Garnsey and her successor as editor of the influential magazine *Pottery in Australia*, the Sydney potter Janet Mansfield, did much to strengthen the flow of technical and aesthetic communication between potters, while remaining active in their own workshops. Mansfield trained a succession of apprentices, many of them young women who went on to study in Japan, where she exhibited several times. Marea Gazzard also promoted the cause of Australian ceramics, and its recognition in Japan, through national and international organisations.

There was still room for pottery that was not derived from the East Asian aesthetic, or not exclusively so. Rod Bamford studied at the Bhadrawati Village Pottery in India and became fascinated not by perfect products of the kiln but by shards and fragments; Alan Peascod concentrated on the Middle Eastern tradition and amphorae, curlicues, gold lustre and cobalt glazes, which characterised his work; Beverly Dunphy's and Joan Campbell's large, handbuilt globular vases and Vic Greenaway's elegant relation of shape to decoration reflected their individuality as well as an underlying East Asian aesthetic. Bruce Nuske drew on Chinese forms and colours. The Adelaide potter Jeff Mincham added elements of Nigerian, early Japanese Jōmon, Korean Silla and Peruvian ceramics to his work, in reaction to what he saw as a 'mountain of ghastly junk' being produced in raku by foreign beginners trying to be Japanese. Raku, indeed, in the 1960s had become as international as yoga or jūdō. Although at times he consciously tried to exclude all Asian influence, Mincham found it pervasive:

> Somehow it would keep surfacing. I would think . . . I had come up with a new solution to an idea only to find it a common device in some form of Oriental art.

Heja Chong, Tsubo *(1988). After arriving in Australia in 1975, Chong returned to Japan for periods of study at Mashiko, Kyōmizu and Bizen before building her own Bizen style kiln near Melbourne. (Artist's collection.)*

Joan Campbell spoke for many (and not only potters) when she proposed that Australians should not imitate Asian tradition but use it to 'get to be ourselves'.

Two years after Shiga, in 1968, Hiroe Takebe Swen arrived in Australia, and in 1970 she and her husband, the Dutch-born graphic designer Cornel Swen, established the Pastoral Gallery and their studio near Canberra, a location that gave her distance from

pottery politics and commercialisation, Australian and Japanese. She integrated into her large sculptural pots the bark textures, leaves, patterned rocks, and fossils she found in the bush, but in a way which recalled Korean inlay techniques and Japanese textiles. Chinese-born Cheng Ng worked in Adelaide in stoneware and majolica. Heja Chong, born in Kobe of Korean parents and educated in Korea and Japan, arrived in Australia in 1975 and studied ceramics in Melbourne, returning like other Australians to the Japanese potters in Mashiko and Bizen to complete her training. She built a modified noborigama of four chambers near Melbourne in 1984, from which she produced the small dark or reddish pots of the Bizen style, with straw packing and ash deposits of the kiln contributing their own decorative effect. Chong, like Hiroe Swen, would find better opportunites for women potters in Australia than in Japan and believed that her work could make a contribution to the broader society that by the 1980s would be growing in Australia.

BY THE 1950s, the principles of Japanese design, as adapted by Gropius, van der Rohe, Taut, Breuer, and others in the United States, were belatedly acknowledged in Australian universities, and Harry Seidler, who had studied under Gropius and Albers, arrived and began to build elemental, white houses in Australia. Peter Muller acquired the other, organic, side of japonisme from Frank Lloyd Wright, passing it in turn to fellow Australians Bert Read and Adrian Snodgrass. From the 1950s on, a few Australian architects had been using ideas from other Asia-Pacific sources in their domestic work and in landscape design: Donald Friend's Balinese house was designed by the Australian architect Geoffrey Bawa, who had lived in Sri Lanka.

In the 1960s the prevailing taste in Australia moved towards a revaluing of the natural environment, and by the end of the decade the word 'ecology' had entered the vernacular. Now it was the folk tradition and the aesthetic of Japanese farmhouses—rather than aristocratic culture, or the art of the floating world —that, by reflecting an appreciation of nature, became the new source of modernity. This was the inspiration for the 'nuts and berries' Sydney school of architects of the 1960s: Ken Woolley, Phillip Cox, Philip Johnson, and others.

Disinclined as many Australian architects still were to be the originators of radically new approaches, or to study the primary regional sources for themselves, some did in the 1960s begin to reinterpret the relationship between the landscape and Australian family life. They began to use open plan, uncluttered white walls, and large windows opening onto wooden decks with pergolas that suggested continuity with the natural landscape. Bruce Rickards, Ian McKay, Ross Thorne, Peter Muller, and others used low horizontal lines and extended beams beyond the joint, as prescribed by Frank Lloyd Wright's japonisme. Such houses were made more affordable when they were designed in 'project' series for middle-income people.

It was not essential that the debt to Japan of Sydney Ancher, Neville Gruzman, Roy Grounds, or the partners Pettit and Sevitt be direct, or even be acknowledged. Nevertheless the emotional quality of the Japanese house was one that they tried hard to capture in their work. The simplicity and straightforwardness of the construction, the revelation rather than disguising of the nature of the materials, and the play of dark grey tiled roofs, white rectangles and plain dark lines formed by squared dark timber invited architects to put into practice the first principles of good design that were much talked about. The houses produced were far from being copies of Japanese houses. They were soundly conceived, thoroughly understood, and well worked out to suit local conditions: they were Australian through and through. The initial stimulus had come from Japan, with American endorsement.

Yet the change did not penetrate the whole culture. In spite of the new aesthetic and the return to natural materials in domestic buildings, a Sydney architecture academic wrote despairingly in 1977 on her return from Japan: 'For the most part, the Japanese arts are regarded as remote and irrelevant—to be valued primarily for their novelty.'

It was Robin Boyd who, having often complained about the ugliness of Australian architecture, its fondness for featuristic decoration, and its lack of critical theory, sought to remedy that through studying the work of Tange Kenzo and his colleagues Mayekawa, Murata, Maki, and others. Boyd thought they owed all to Le Corbusier, but in fact they represented in architecture the same Great Reflex Movement as had taken place in other art-forms: the Japanese went to Europe and the United States to study, while Le Corbusier, De Stijl, the Bauhaus, and the Chicago School each took Japanese architecture as their starting point, whether the end result was the pared-down 'international style' or the 'organic architecture' favoured by Frank Lloyd Wright.

So Tange led Japanese architects in emulation of modern European architecture, a modernity that Europeans and Americans had in large part derived from Japan, and were now finding again in Tange. Australians belatedly joined the Reflex process, once again with American and Japanese gap-crossers as their guides.

Robin Boyd was less critical of the mish-mash of modern Tokyo than Hal Porter was, and more prepared to excuse Japan's ugliness than Australia's. Boyd found in Tokyo the 'mad visual trivia of our last 60 years', all the 'gigantic trivia, the gewgaws and the gimmicks, all the visual idiocy of the 20th century', the very things he found featuristic in Australia. He interpreted these as reflections of the 'great incompatibles', of the divergence between Eastern and Western culture, with Australia dithering between the two.

> The Featurist wants to belong, but where can he? In eighteenth-century England, nineteenth-century Australia, twentieth-century America, or twenty-first century Asia?

He shared Tange's view that it was the task of architects and city planners to bridge the gap: to unite tradition with progress and

creativity, individuality with universality, the human with the superhuman scale, and technology with humanity. By the late 1960s he believed younger Japanese had already put the East–West gap behind them.

Richard le Plastrier studied drawing with Lloyd Rees at the University of Sydney School of Architecture and in the 1960s worked on the Sydney Opera House with Joern Utzon. In 1966 he went to Kyoto to study with Professor Masuda Tomoya and then worked in Tange's office. On his return to practice and teaching in Sydney, he adapted the Japanese relationship between designer and builder, buying timber himself, intervening and helping in construction. The result, by the 1980s, was a series of finely detailed, carefully crafted houses, combining European masonry and sailcraft, the carpentry tradition of Japan, and the Australian environment. Together with some japoniste houses by Peter Muller, this was belated evidence from the Australian side of the closure of the East–West gap.

THE AUSTRALIAN PATTERN of delayed reaction to the Great Reflex Movement had become evident in all the arts. In music there were two minor deviations from the pattern: one being the prominence of Indonesia as a source in addition to Japan, and the other, the desire of some Australian composers to go further and to say 'to hell with Europe!' altogether. But even these inclinations were shared with, and sometimes learned from, avant garde composers in the United States, in England, and in Europe itself.

Music in Australia, Peter Maxwell Davies would write in 1972, 'has a sad history of conservatism, understandably due to its extreme isolation'. In that, music was no different from the other art-forms or from Australian post-war society as a whole. But Australia, as we have seen, was only isolated if Australians saw themselves as Antipodeans, and behaved as though they had no identity with or interest in their populous region.

By the 1960s, 'New' music was being commissioned and performed in Australia and heard on ABC radio; international bodies were encouraging young Australian composers with conferences and grants; technology reduced the 'tyranny of distance' by bringing high-quality recorded music, copies of scores, and broadcasts of concerts from all over the world rapidly within Australians' reach. When New music burst upon the Australian scene, composers realised that innovative Europeans and Americans had been at work for more than sixty years, almost without Australians' knowledge. Webern, Berg, Busoni, Stravinsky, Schoenberg, and more were waiting to be 'gone through, weighed, used or ignored', something which the Chinese-born Australian composer Larry Sitsky saw as being to Australians' advantage.

George Dreyfus, in spite of his German origins, exemplified the new mood when, on his return from a Unesco fellowship, he advised his fellow musicians to reject European works: 'I believe we should play their music only when they play our music.' But

Boulez, Messiaen, and Stockhausen were looking East for new musical ideas, as Debussy and Ravel had done before them. American admiration of Zen as interpreted by D. T. Suzuki had infected John Cage and Charles Ives, who were adapting it to their music, or to its absence. Since these would also be the sources of modernity for Australians, they were following the Western model yet again.

One of the first composers after Percy Grainger to start out from Australia in a new direction was Peggy Glanville-Hicks. She won scholarships to study in Melbourne, London, Vienna, and Paris. In 1938 she was the first Australian composer to be represented at a festival of the International Society for Contemporary Music. In 1942 Glanville-Hicks moved to America from Europe and remained there until 1959, becoming an American citizen. After a further period of eighteen years in Greece and India, she returned to Australia in 1975 where she died in 1990.

Glanville-Hicks' works were considered experimental in their time. The search for new ideas led her, as it did Grainger, to investigate many kinds of non-Western music: Hispanic, Scandinavian, Eastern European, Greek, and Indian. She considered the percussive element as the real basis of music; therefore a melodic and rhythmic structure should replace a harmonic one. This new, 'natural' orchestration, deriving from non-Western music, and abandoning the predictable elements of Western music, led Glanville-Hicks to set up a new basic structure of three equal choirs, strings, winds, and percussion, which turned out to resemble those of Indian and Greek music. But she sought to reduce her work to a fundamental and timeless essence whose national origins ceased to be important.

Glanville-Hicks also rejected the diatonic in favour of modal scales, consciously following Vaughan Williams' use of the church modes. It was not until the early 1960s that she came to realise that with their similarity to the Hindu raga, the modal scales represented a 'substitute for the decadent Western system', and that scale itself was the clue to what should follow the decline and fall of the diatonic. She found what she called 'an incredible minimum row of sounds' in raga, and set out to build on that. But Glanville-Hicks had no particular interest in Indonesian, Chinese or Japanese music, convinced as she was that the basis of music was the raga tala system, and that there was no limit to what could be done with it.

She was introduced to Indian music by her friend Narayana Menon, a fellow student in London, and it reminded her of the instruments she had heard when she was nineteen, on a brief stopover on the voyage to Europe. Her interest grew with visits to India. In her 1958 opera *The Transposed Heads*, Glanville-Hicks set a Thomas Mann novella based on the Baghavad Gita to music in a way that was consciously revolutionary. Yet her use of Asian themes was not imitative or appropriational; she sought to avoid 'doing any violence to their unique character'.

Glanville-Hicks saw European civilisation as being in a decline that would lead to an apocalypse at the end of the century. From this, she believed, the new English-speaking countries — America, India, and Australia — would emerge in a triangular nexus of

influence. The west coast of the United States was more Asian than Western; India had the creative wisdom of antiquity and yet was the new force of the twentieth century; Australia in a few short years had produced more first-class composers and more lively and exciting compositions than any other country.

Peter Sculthorpe, who was to turn the ears of young Australian composers away from Europe, acknowledged Grainger and Glanville-Hicks as visionaries, 'people to look towards'. At nine, Sculthorpe was impressed by Grainger, whom he met after a performance in Melbourne. 'You must look forth to the islands,' Grainger told him, on hearing that he wanted to compose music. Later he worked with Grainger on the construction of the Grainger Museum in Melbourne. Like Grainger, Sculthorpe vividly remembered his first experience of Eastern music: an impromptu band of Chinese market gardeners in Launceston, Tasmania. His first taste of Western classical music, by contrast, was a disappointment; he found an orchestral concert stiff and lifeless.

As a child studying piano in Launceston, Sculthorpe felt an early distaste for what he saw as the worn-out ideas of Beethoven, preferring Debussy and Delius. He began to compose atonal music, without key signatures or bar lines. As a student at the University of Melbourne Conservatorium he alternated between experiments with serialism and twelve-tone composition, and reversion to 'banging the kerosene tin', being aggressively Australian.

Study at Oxford in 1958 exposed him to the influence of Egon Wellesz and Edmund Rubbra, the one a pupil of Schoenberg and the other an exponent of Oriental music and philosophy. Through Wilfred Lehmann he discovered the Japanese court music piece, *Etenraku*; Wilfrid Mellers introduced him to Charles Ives, John Cage, Harry Partch, and Aaron Copland. Contact with these composers and distance from Australia reassured him that he was one among a select band who had freed themselves of the tradition of Western Europe.

Sculthorpe found himself comparing the old world attitudes of the Oxford scholars around him with the new world he was learning about: the *Oxford History of Music* referred reverentially to the 'achievements of the Western world' but slightingly to the 'contributions made by Eastern civilisations and primitive societies', and made no reference to any Australian music. Sculthorpe spoke to a conference in Kyoto in 1968 of how modern western composers had 'turned not only to the music of the machine, but also to rock music and to the music of Africa, India, Indonesia and Japan'. Yet some of the Asians in his audience, and many of the Japanese, were by then reflexively engaged with the *Western* avant garde. An Australian's assurance of solidarity with their traditions may not have generated the response he expected.

Sculthorpe maintained the interest in Buddhism that had been stimulated by Rubbra, Cage, and the Zen writings of Alan Watts. At Teryuji in Kyoto in 1968, he learned about the practice and notation of shōmyō, Buddhist chant. He found the artistic abundance and broader humanism of the local Shintō shrine more

amenable than the austerities of Zen. There the abbot, who was a poet, painter, musician, and philosopher, communicated to him the principles of Japanese taste, traditional music, and instruments, as well as ancient Shintō melodies which he would use in later works. His friendship with the abbot was, as he later described it, like the end of a pilgrimage he had begun as a boy.

In 1969, Sculthorpe introduced classes in ethnomusicology and 'world music' at the University of Sydney, as Mellers had done in England. Professor Donald Peart had purchased a set of Balinese gamelan metallophones for the music department. Sculthorpe's interest in the gamelan and Javanese gongan, and the added dimension they could give to music, both in sound and rhythm, was stimulated by his contact with the American Colin McPhee, whose *Music in Bali* was published in 1966 while Sculthorpe was composer in residence at Yale, and who in turn owed much to Walter Spies and Jaap Kunst. He also devoured McPhee's *A House in Bali* (1947), an account of Sayan in central Bali, and the building of McPhee's house there.

Contact with Willem Adriaansz, who worked at Berkeley on Japanese koto music, and with Sculthorpe's Australian colleague, Richard Meale, who had studied at the Institute of Ethnomusicology at UCLA, were further sources of stimulation. Both Meale and Sculthorpe, in keeping with the delayed reaction pattern, first had Asian music mediated to them through English or American composers and were tentative about directly approaching its sources for several years.

In Sculthorpe's *Sun Music* series, begun in 1965, he sought to develop his interest in both Japanese and Indonesian music while evoking the spirit of outback Australia. The public was unready for it, and one critic called *Sun Music III* 'Suzie Wong music'. Bernard Heinz, the conductor, called it 'elephant music'. His *Sonata for Viola and Percussion* (1960) had become known as the 'Asian threat concerto'. Sculthorpe realised he had a task ahead of him, and broadening Australian minds by 'opening their ears to Asia' was part of it. Beginning with *Sun Music I*, which itself owed much to Penderecki's *Threnody for the Victims of Hiroshima* (1961), Sculthorpe used Japanese and Indonesian melodies and instruments in this way. *Haiku* (1966), for example, was as suggestive and brief as the name implied; *Images* (1966) was based on nagauta, the 'long songs' often interpolated into Kabuki drama. *Sun Music III* (1967) and the chamber work for wind quintet and percussion, *Tabuh Tabuhan* (1968) were almost entirely based on the sound of the gamelan and the orchestration of the gender Wayang, while *Sun Music I* and *Sun Music IV* reflected the nagauta style of Nō. The dynamic rhythmic patterns in *Ketjak*, renamed *Sun Music II* (1969), were inspired by the Balinese monkey-dance. A similar rhythm would appear, along with elements of Tibetan religious music, in *Music for Japan* (1970), commissioned for performance by the Australian Youth Orchestra at Expo 70 in Osaka. Sculthorpe's music would continue to use Indonesian and Japanese sources in this way for two decades.

Takemitsu Tōru was the contemporary Japanese composer most acclaimed in the West in the 1960s, and Sculthorpe invited him to visit Australia. Sculthorpe, like Australians in other art-forms, had found his Japanese mentor in a professional inter-nationalist. Music, like Japanese printmaking, pottery, and archi-tecture of the same period, had entered modern universal culture.

Although he had begun to draw on Japanese music several years before his first visit to Japan in 1968, and would continue to do so after it, Sculthorpe was disturbed by the disjunction between the Japan he had imagined and the Japan he found. Others too had seen the apparent contradictions in Japanese culture: the courtesy and politeness in personal manners, contrasted with the brutality in films and comics and in Japan's war record; the reverence for nature contrasted with its distortion and miniaturisation in the name of art. In 1987 Sculthorpe would describe his 'Japanese period' — his idealisation of Japan — as having come to an end well before he first visited Japan, adding that the same applied also to his 'Balinese period'.

He did not reach Bali until 1973, when he went with a film crew to make a documentary about traditional music. Disappointed at finding something less than McPhee's Balinese paradise, he abandoned his plan of taking a house there and reverted to Australian sources and Aboriginal transcriptions. He would revisit Bali in 1982, and tiring of the Hindu artefacts collected on his first visit, he found a new passion: Chinese ceramics. By 1987, looking back on his love affairs with Japan and Bali, the one more lasting than the other, Sculthorpe thought he had all along been 'using both as surrogates for Australia'.

While Peter Sculthorpe was absorbed with his *Sun Musics*, Richard Meale had also set out to explore, but more as the 'lonely voyager, the intellectual, the moon-watcher'. Encouraged, as Grainger and Sculthorpe had been, by a mother who appreciated music, he too encountered Asian music and developed an enduring fascination for it as a child: but he made his discovery by means of short-wave radio. After nine years at the Sydney Conservatorium, he earned a living in the mid-1950s as a buyer in retail record shops, where long-playing records were then coming onto the market. The entrepreneur Clifford Hocking was introducing Ravi Shankar and Akbar Khan to Australia. Meale came across music that he had not encountered in the limited range of the Conservatorium, Indian music in particular.

Study at UCLA in 1960 gave Meale his first exposure to research and performance of non-Western music: Balinese, Javanese, Indian, Japanese, and Persian. UCLA had a gamelan group, made up of tutors and students, as the University of Sydney would have under Sculthorpe's leadership nine years later. After his return to Australia by way of France and Spain, the first of Meale's works to make use of his study of Asian music was *Images (Nagauta)* (1966), which drew on the traditional structure of Gagaku, Japanese court music, and in which the textures were inspired, Meale said, by the Japanese sho, a vertical pipe organ played with the mouth. At the

University of Adelaide from 1969 Meale composed three orchestral settings of haiku by Bashō, which he had read in the newly available Penguin edition.

Japanese tradition in poetry and music, no matter how ancient, seemed to Meale refreshing and stimulating. 'We had to get out of Europe,' he said. In addition, Japanese music posed a musical challenge which Western forms did not.

> In all my Asian studies I was confronted with two factors: the inspection of the rhythm—much more complex than the Greek—and free play, where it is impossible to notate a fragment. You had to learn to play it.

This he found particularly applied to gamelan music, in which the fourth beat, rather than the first, is accented. Until he learned to do this by playing it, Meale found that it did not sound authentic. The energy in the music seemed to find its proper release in the fourth beat.

Meale's music, more than Sculthorpe's, grew out of a synthesis of ideas that had nothing to do with national origins. Influences from Japan, Spain, and Indonesia, from Messiaen, Stockhausen, and Xenakis were completely absorbed and metabolised into a body of work in which Japanese, Indonesian, or European listeners might not recognise their presence.

In 1988, Meale would move his world again, resigning his teaching job in Adelaide and devoting himself to full-time composition for the first time, secluded in the bush in northern New South Wales from all but a small group of empathetic people. The technology of music by then would be such that even there, he could hear any work he wished from anywhere in the world. He had never been to Japan or Bali, and felt no need to go. Although Larry Sitsky already had cause to caution against fashionable claims of Asian inspiration for a work simply on account of its use of folksong, pentatonic scale, exotic percussion, or an Asian title, the direct approach to Asia was what would distinguish the newer, diametric wave of Australian composers from their older, circumferential predecessors, and it would be backed by technological innovation.

9

Exiles and Aliens

Fringe writers—the Hearn Syndrome—Porter's Schizophrenia—the Butterfly Phenomenon—poets in exile: Stewart, Stow, Judith Wright —Papua New Guinea at independence

WHILE IT HAD come to seem proper or even mandatory that Australian painters, potters, and composers should be at home with Asian cultures, Australian *writers* in the post-war period tended to be less certain about where their natural sphere of influence was. The minds of many remained in the English reading and publishing world, in the other hemisphere, and their knowledge of Asian history, literatures, and languages remained almost non-existent. As a result their vision was narrowed, their tolerance was diminished, and their image of themselves was distorted.

Among the post-war writers who did take an interest in Asia, as distinct from Asia *at war*, fringe people predominated: women, migrants, expatriates, communists, pacifists, spiritual aliens, and physical or intellectual exiles.

Ethel Anderson was married to a British Indian Army officer and lived in India until 1926, where she wrote stories of Indians as individuals, with curiosity, an eye for detail and some humour. *Indian Tales* (1959) and *The Little Ghosts* (1948) included pre-war anecdotes of the north of India and Persia (Iran). In her 'Mrs James Greene', a young English widow is wooed—significantly not seduced—and won, by a Punjabi at the time of the mutiny.

Elizabeth Kata, who married the son of a wealthy and influential Japanese family in 1937, spent much of the war in the mountain village of Karuizawa in central Honshu, or teaching in universities and colleges—'except', as she said, 'when the bombing got too bad'. The Americans and Japanese in her novel, *Someone Will Conquer Them* (1962, 1978) were 'blends of good and evil' like people everywhere, and her theme was the universal one of the futility of war. Japan had confirmed many Australians' worst expectations, and Japanese wives of Australian soldiers were often ostracised. Although Japanese, too, were critical of 'kimono marriages' to foreigners, Elizabeth Kata was accepted and cared for by her Japanese family. 'I sometimes think', she said, echoing others who had made the Expatriate Shift, 'that I am more Japanese than I am anything else.' None of her characters is Australian; apart from the army, few Japanese at the time knew where Australia was, she said.

Kata, by the 1980s living in Sydney, would return to her Japanese experience in 1989 with *Kagami*, the first of a two-part family saga based on diaries in English kept by her Japanese relations from 1845, before Commodore Perry's arrival. Her intimate knowledge of these people provided a varied cast of characters and a sensitive understanding of the effects of Westernisation on their society. Kata's method in *Kagami* was so like that of *The Good Earth* on China, and of *The Patriot* (1939) on Japan, that the title 'Australia's Pearl Buck' may have occurred to her. Her admiration for the values of a bygone age, however, left her with a degree of respect for hereditary class which verged on reverential. As well, like other Australian auto-didacts, she could not transliterate Japanese words correctly.

Although there had been Asian students in Australia since 1904, and their numbers had grown rapidly under the post-war Colombo Plan, Australian-born writers of Asian background were

still a rarity. Mena Abdullah was an early example. Many of her stories concerned the life of Indian families in Australia, the pain of self-exile, and the discrimination suffered by children. They and their creator, in *Time of the Peacock* (1955) were outsiders within Australian society. In 'High Maharajah' (1965) the children are absorbed in kite-flying games derived from India, which is their distant fantasy-land, their Orient. These rituals are impenetrable to their well-meaning Australian neighbour, though not to the local Chinese storekeeper who saves special kite-paper for them.

After the war when a retreat from Asia into 'normal' life was what many writers and readers preferred, Hugh Atkinson, who had been a conscientious objector but had served in the RAAF, spent four years in India and later remained away from Australia for years at a time. In his first novel, *The Pink and the Brown* (1957), an Australian working for a British advertising company in post-independence India faces the same conflicts as beset George Johnston's protagonist; he has to decide whether to stand up for his Indian friends or be loyal to his company and his 'kind'. It was an old theme of the raj, but now it was an Australian dilemma too. History or geography, European roots or Asian region?

Richard Beilby spent his childhood in Malacca and went to Western Australia in 1929. In his novel *The Bitter Lotus* (1978), Mason, an Australian writer, returns to Sri Lanka, which he knew during the war. He has two quests: a physical search for David Coleman, whom he believes to be his nephew or his son; and a spiritual search for his own lost youth and idealism. Beilby anticipated the younger journalist-novelists whose first experience of Asia came a decade later than his, and shared with them the stock themes of turn-of-the-century travellers in Asia: the shock of arrival, the smells, crowds, colours; the local guide or mentor; the quest; the journey to the interior and the climb to a mountaintop; enlightenment of a sort; a transitory love affair with a foreign woman; departure for home. Mason's lost nephew, in faded red sarong, bare feet and beard, who has found The Way, is a sign of things to come. So is a young Japanese woman journalist, one of the 'Super Japs' whose emergence he believes is the result of General MacArthur's post-war generosity, in whom Mason sees 'an ageless, Oriental woman' of superior understanding.

Len Fox, a relative of the impressionist artists Emanuel Phillips Fox and Ethel Carrick Fox, worked on left-wing newspapers during and after the war and went with his wife, Mona Brand, to live in Hanoi in 1956–57. Fox's verse and prose writing after his return from Vietnam drew on his observation of ordinary life there and the history of the Australian Aborigines. Mona Brand also wrote poems, novellas, and plays which presented Malays and Vietnamese in a sympathetic light and was critical of American intervention in Indochina long before other Australians knew about it.

David Martin arrived in Australia in 1949 by way of Holland, Spain, England, and India, where he was the *Daily Express* correspondent in 1948–49, the year of independence. Some of his Indian experiences were recorded in *Stories of Bombay* (1949). As a

Hungarian Jew, brought up in Germany, who had led a wandering life, was fluent in several languages, was culturally eclectic and, as well, was a member (until 1956) of the communist party, Martin was out of place in conventional Australia. His novels, verse, and plays, however, with their universalist view of humankind, opened eyes and minds. He was the first of several Australian novelists to write about Laos or Cambodia, in *The King Between* (1966). Martin was equally capable of genial satire on Australian small-town life, including its local Chinese, in *The Hero of Too* (1965).

A characteristic of expatriate writers is that they tend to preserve an impression of their own country as it was when they left. One such creator of images in aspic was Desmond O'Grady, a former literary editor of *The Bulletin* who, with an ideology diametrically opposed to Martin's, Brand's, or Fox's, lived in Rome from 1962. His stories of Australians in Papua New Guinea and in Asia, in *Valid for All Countries*, published in 1979, reflected Australian attitudes of much earlier years. In one of them, an Australian tourist in Thailand, in culture-shock, who is presented as being a woman of intelligence and sensitivity above the ordinary, at the climax of the story actually visualises a foreign man as 'white' and a Thai as 'black'.

Christina Stead left Australia in 1928 and spent the rest of her life in France, the United States, and England. In the 'Letters to Malaya' episode of her semi-autobiographical novel, *The Man Who Loved Children* (1940), Louie tells her little brothers and sisters thrilling tales of the jungle exploits of their father Sam Pollitt, a scientist on a Smithsonian expedition. Sam, as the American in Singapore, however, is condescending to his Indian and Chinese colleagues and to the 'childhearted people' who he believes 'took him for something next to a god'. Proud of his blondness, Sam compliments the cultivated Nader on being an 'Ebonized Aryan' and speculates that there must be a black god and a white god, one for each of them. Pollitt has fantasies about impregnating Malay, Chinese, Indian, 'Cingalese', and pygmy women, but doubts that they should share his polygamous pleasures by having poly-androus mates themselves.

Written before the fall of Singapore, through which she had passed on the voyage to London, Stead's novel anticipated the coming changes in Asian societies as little other Australian writing had. Her implicit criticism of Sam was that, with his racial supremacism and his exploitative sexual fantasies, he was, even then, an anachronism.

Helen Heney, in *The Chinese Camellia* (1950), reversed the familiar theme of the outsider in Australian society by making a young Chinese woman the still, silent pivot on which the story balances. Ch'a Fa has been sent as a gift-concubine to a self-made Sydney merchant, Nathan Bent, in the 1850s. From her secluded garden-house she wordlessly affects the lives of the Bent family, who respond to her variously as a threat, a scandal, a sex object, and a piece of chinoiserie. The Bents' pompous, secretly lascivious, Jane Austenesque son-in-law sees Ch'a Fa in missionary terms: 'she was China, the heathen, the mission field'. Apart from him,

and in spite of the anti-Chinese atmosphere of Australia in the 1850s, the Theosophist Heney created a family relatively free of prejudice. Bent even knows a little Mandarin, picked up on a visit to China. But his son Michael, faced with the well-known Western dilemma of how to cope with an Asian lover, eventually resolves it by the unusual means of sailing with Ch'a Fa to the Antarctic Ocean and there drowning her.

This bizarre fantasy was significant because of the questions it posed about what was coming: Asians as Australians; the Asian woman as a commodity; and what could happen to Asians across the lust frontier. The expatriate Australian writer Janette Turner Hospital would raise these issues again in another location in *The Ivory Swing* (1983), in which a Canadian couple working in southern India are caught up in sexual/social complications leading to the death of Yashoda, an Indian widow trapped by a system they cannot comprehend.

WE HAVE SEEN how, in the early years of the twentieth century, study and travel abroad offered an escape for some Australian women writers and artists from a society that expected them to become full-time mothers and housewives. Equally, for men unsuited by taste or temperament for marriage and fatherhood, writing or painting abroad was an escape, as much from the rigid social conventions of Australia in the 1950s as from its cultural isolation. The search for a more amenable personal environment was at least as important a factor in some Australian men's self-exile in Asian countries—though few publicly admitted it—as their interest in Asian cultures themselves.

Hal Porter grew up in Melbourne and in Victorian country towns, spending much of his later life in the Gippsland region. Porter's dominant mother, whom he later described as an 'unexorcizable ghost', had an enduring influence on him. Like Grainger he was preoccupied during much of his adult life by nostalgia for a time he saw as ordered, harmonious, and sinless, which had ended, corrupted, with puberty. Grainger walked and ran, flagellated and plunged into icy streams, composed and performed his energetic, innovative music. Porter sharpened his verbal daggers and wrote and over-wrote stories of a kind new to Australia, which made free with such words as 'bugger', took short cuts with syntax, and were strewn with word-play, puns, and paradoxes, as well as grotesqueries, murders, disfigurements, maimings, perversions, and suicides.

Briefly and unsuccessfully married, Porter's misogyny was evident early in his story 'The Room' (1939), in which he wrote of the aesthete's ideal studio: 'You decide the room ascetic, a room woman must never enter'. It would gain vehemence in Porter's stories about Japanese women—which sounded like the views of Henry Adams and G. E. Morrison half a century earlier.

> Japanese girls are very plain; she was by many points the plainest . . .
> she dropped a broken-winged paper sunshade and giggled repulsively.

A traffic accident in 1939 put Porter in hospital and out of the Pacific war. So while other young men were joining up and escaping from Australia, Porter was left like an exile in his own country, writing of his personal search for someone 'less alien than the others'. This was a search upon which Patrick White and Randolph Stow were also embarking. In their novels, the protagonists are often sensitive, perceptive men exiled to the fringes of heterosexual Australian society.

In his autobiography Porter wrote that his fascination with Japan was a result of the japonaiserie he had seen in childhood, the art collections he had seen as an adult, and his reading of Japanese literature. But arriving in occupied Japan to take up a job teaching the children of Allied forces in 1949, an experience he recorded in the novel *A Handful of Pennies* (1958), Porter and his protagonist, Major Everard-Hopkins, were as disappointed with what they found as Hungerford had been in *Sowers of the Wind*. Instead of pagodas, lacquer, wistaria, and 'girl-high irises', there were ashes, smells of squid, and 'human manure'.

What Porter was addicted to before going to Japan was a fantasy Mikado-land. He was not sorry to leave at the end of his year in the real Japan, yet his experiences 'did less than they should have to break the addiction'. Porter idealised Japan and at the same time execrated it for not meeting his expectations. 'Blindly passionate as I am about the place, I have no deep regrets,' he wrote on leaving in 1950. Like Hearn, he had ingested an image of Japan that was part propaganda, part wish-fulfilment. Any slip from this idealised perfection would bring disillusionment, as indeed it did for Hearn. The phenomenon became known as the Hearn Syndrome.

Confused, contradictory feelings were still with Porter at the time of his second visit in 1967, which followed what he called his 'infatuated' writing about Japan. The result was *The Actors* (1968). Porter had no praise for Japan's efforts to recover from the war, or for its miraculous modernisation; all this he described as duplicitous posturing, play-acting, a 'frightful game' which the Japanese had no right to play. He accused them of having abandoned the very Japanese traditions he execrated as being contrived and contorted. He mocked their aping of the very Western manners by which he measured civilisation. He pointed to primitive carnality, ugliness, and smelliness, never considering whether he was more entitled to apply his hygiene fetish to Japanese than they were to him and other foreigners. He was unable to decide whether the Japanese would suit his taste if they were more, or less, like Europeans, or like the Australians he derided in his fiction. This aggravated form of the Hearn Syndrome might be termed Porter's Schizophrenia.

Porter's books were widely admired by his Australian contemporaries, and apart from the usual sorts of people being offended by the usual sorts of words, little outrage was expressed at his portrayal of the Japanese. Porter did not see Australians as faultless, 'but only from his point of view as preferable'. The basis of this preference was explicitly racial. In *The Paper Chase* (1966), seeking

to 'dig down to the true centre of [his] revulsion for people of other races', Porter focused on the European's sea-route to the East:

> A similar revulsion, sometimes weaker and sometimes stronger, is aroused in me by such places as Panama, Colombo, Djakarta, Bombay, Singapore and Aden.

Australian soprano Amy Castles.

In his fiction, Porter's range of Japanese acquaintance was limited mainly to male students and housegirl/prostitutes. They speak wretched Japlish, often wrongly transliterated, so they sound like comic-opera characters or near-idiots. For the mass of Japanese, Porter did not disguise his contempt; when he gave them some credit it was for sexual attractiveness combined with a fitting sense of loyalty and deference—qualities displayed by the maid and the student in his play, *The Professor* (1966), and their counterpart characters in *A Handful of Pennies*.

Porter's literary strategies protected a complex personal vulnerability, and seemed to reassure him of his superiority. His Orientalist fantasy of Japan as Mikado-land was one of these strategies; his Hearnish infatuation with Japanese culture during the occupation, when young Japanese were still in their assigned, subservient roles, was another. But by the late 1960s the Japanese were challenging the West, outstripping Australia, and no longer knew their place, and he had no strategy to deal with that. So Porter called them bad actors because they rejected the parts in which he had cast them, in a scenario he had devised himself.

OPERA ALWAYS DEALT with exotic fantasies, and so often located them in the Orient that it created a genre in the European imagination, of which Gilbert and Sullivan's efforts were a comic pastiche. Stories similar to those told by Scheherazade on the one thousand and one nights during when she had to divert an 'Arabian' potentate to save her own life, both confirmed and created images of Oriental tyranny, luxury, artistry, and sensuality.

These images arrived in Australia in successive shipments of European cultural baggage and lodged in the Australian imagination, along with such fantasies as *The Abduction from the Seraglio*, *The Italian Girl in Algiers*, *Semiramide*, *The Pearl Fishers*, *Aida*, and *Salome*. As operatic fashion moved from the Middle East to the Far East, China and Japan were exploited as settings for *The Land of Smiles* (Lehar), *Lakme* (Delibes), *Iris* (Mascagni), and above all *Madame Butterfly* and *Turandot* (Puccini).

It was no accident that most of these operas—and there were ballets as well—were named after Oriental heroines, almost all of whom met tragic fates. The Italian imagination had for centuries been attracted to male dominance and female sacrifice, and the Asian or Middle Eastern woman as victim proved to have international appeal. Reasons for this have already been identified in Australian invasion literature and the war novels: they include the fantasy of Asia as Illicit Space, alluring and repugnant, where moral

French mezzo-soprano Bel Sorel.

Madam Butterfly in Australia. *When Puccini's opera had its first season in Australia in 1910, Mikado-mania, a vogue of things Japanese, was already at its height. It coexisted with mistrust and fear of industrialising Japan. (Gyger, 1990.)*

restraints on violence and sex can be abandoned; the hierarchy of races, and of males over females, which is threatened by miscegenation; and the division of the world into East and West, identifying one as female, emotional, instinctive, subservient, and exploitable, and the other as male, pragmatic, rational, and dominant. As Rana Kabbani points out,

> These responses to other peoples were an intrinsic part of the imperial world-view. To perceive the East as a sexual domain and to perceive the East as a domain to be colonised were complementary aspirations. This kind of narrative did not only reflect strong 'racial' bias—it reflected deep-seated misogyny as well. Eastern women were described as objects which promised endless congress and provoked endless contempt.

Italian soprano Maria Pampari.

The fascinating revelations that reached Europe about Japanese men and women taking baths together, and about carryings-on in the Yoshiwara, and allegations that the Japanese had no word for 'chastity'—against which Lafcadio Hearn argued strenuously—were interpreted as open invitations to Western men to exploit the situation. The fact that many of the earliest Japanese women to arrive in the West were entertainers and prostitutes lent the image of *all* Japanese women its requisite factual validation.

The arrival of Townsend Harris, the first United States consul, at Shimoda in 1854, in itself represented a shotgun wedding between Japan and the West. Harris was the epitome of Puccini's naval officer Pinkerton, and his exploits were probably the basis of the *Madame Butterfly* story. Butterfly, defined by her name as exotic, beautiful, and transient, is misled to believe that she can marry Pinkerton, leave Japan with their baby and become an American. According to the double standard this is impossible, unimaginable. An Eastern woman may be delightful, but she cannot become a Western wife, and her child is a half-breed. After her day in the sun with her lover, Chō chō san will pay the price of pleasure: her wings will fade, and she will perish. She is a fragile art object, but also a cheap, replaceable commodity.

The resilience of the Butterfly Phenomenon shows how enduring an appeal it had for Australians. Similar situations occur in Carlton Dawe's stories, and predate Puccini—as do Murdoch's *From Australia and Japan*, and Lang's 1859 story 'The Mahommedan Mother'. In Hurley's 1926 film, *The Jungle Woman*, Hurana nurses the wounded hero Martin South, they become lovers, and she helps him escape hostile tribes, only to die of snakebite, whereupon Martin goes back to his Australian sweetheart. The Aboriginal heroine in Prichard's *Coonardoo* (1928) is rewarded with death for miscegenation, having borne a squatter's child. The fate of *The Chinese Camellia*, Ch'a Fa, in Helen Heney's novel, who is drowned by her Australian lover, anticipates that of Asian women in several of Cleary's and Clavell's novels, who are never introduced into Western society, and seldom survive. Butterflies must die, china dolls get broken, and dragon ladies burn. Then you buy another one.

The Ceylonese woman left pregnant by Richard Beilby's ex-soldier, Mason, in *The Bitter Lotus*, has died in childbirth before he gets back. In Kata's *Someone will Conquer Them*, when Mike's fiancée Yuriko is killed by a truck driven by a GI, 'it was as though a butterfly had fluttered across the road'. The Tall Man in A. M. Harris' novel about the Korean War, after asserting that 'all soldiers lust after women', proposes that cruelty to Asian women is excusable:

> In the East, perhaps because in the main they have not yet learned to tread with men on an equal footing of brutality, of avarice, and of cunning, women are naturally counted among the spoils of war, to be taken at the will of men and savaged.

Tom Hungerford's Australians in the occupation rapidly lose their

illusions about silken geisha when they reach Kure. Confronted, like Porter, with real Japanese women, they decide that the 'one fine day' image is 'bulldust'. But that does not prevent them from having their day in the sun. Before long, Porter recorded scornfully, the occupation was 'increasingly burdened with the agonizings of small-time Cho-Cho-sans left high and dry by rough-as-guts Aussie Pinkertons.'

Although some of them might deny it, Australians had been imbued, as part of their colonial heritage, with the East–West, male-female double standard, and their expectations were moulded by Puccini. Right on cue, Hungerford's Sergeant McNaughton leaves his pregnant girlfriend.

> I lowered the curtain on my Japforce bloke [Hungerford recalled] as he sailed out of Kure Bay, leaving behind him, Pinkerton-like, his broken-hearted Japanese girl.

The Australian even catches himself humming 'One Fine Day'.

> *Baby life of mine, little orange-blossom* . . . Oh Christ, what bulldust! . . . *So as not to die* . . . the soaring notes of the aria beat in his brain as the girl flung herself against him.

Among Hal Porter's unprepossessing cast of Australian characters in Japan, several are affected by the Butterfly Phenomenon. The insensitive Captain Truscott in *A Handful of Pennies* has a Pinkerton-style affair with a Japanese prostitute, and he pointedly parodies 'One fine day'. In *The Professor*, a jealous Australian wife calls the maid Fusehime 'Madam Butterfly'. Porter seemed unable to get the G & S pastiche and the Butterfly Phenomenon off his mind. When he reversed the roles, in 'Mr Butterfry', Porter's contempt for the Japanese wife in the story, a former Mess housegirl to the Occupation forces, and her 'half-breed' daughters was greater, if anything, than his distaste for the loutish Australian.

Reruns of the Butterfly theme would not come to an end with Porter, either in Australia or in the West. General MacArthur, in real life, left his mistress in the Philippines with a Pinkerton-like promise—'I shall return.' The Quiet American, Pyle, in Greene's novel, lures Phuong away from his British rival by offering her marriage and migration: in this case he dies before he can break the promise. Such American movies as *The World of Suzie Wong*, *The Lady from Shanghai* and *Sayonara*, together with their counterpart novels, perpetuated images of Asian women as desirable, vulnerable commodities, used and abandoned by Western men, and images of Asian men, as they had to be, as vicious, lustful, or emasculated.

Nicholas Jose's short story, 'One Fine Day' (1987) and his novel, *Avenue of Eternal Peace* (1989) would apply the Butterfly Phenomenon to modern China. Robert Allen's stories, *Tokyo no hana* (1990) would recall it in Japan of the 1960s, and James McQueen's stories, *Lower Latitudes* (1990), would carry it, in all but name, around the South Pacific and Southeast Asia. The Victorian company Handspan in 1984 devised *Chō Chō San*, a theatre piece using lifesize puppets by Peter James Wilson. In the

1987 Playbox production, which toured in China, Pinkerton slowly removes the clothes and limbs of the Butterfly puppet and metaphorically rapes the face, all that is left of her.

In 1988 John Upton's play, *Hordes from the South*, would reverse the direction of the insect-plague of invasion fiction. The invaders are now Australians in Asia, the Philippines in this case, where Australian men on the 'marriage express' can whisk a dancer from Del Pilar to the altar and off to Mount Isa within a month, to be followed by her family as migrants.

> CLAUDE: When he gets her home he'll beat the crap out of her. And in six months time, in his mind, she'll be running round with every Tom, Dick and Harry in Mt Isa. Probably kill the poor bitch.

The much-travelled Australian photographer Max Pam, who found cheap accommodation in Bangkok brothels in the 1970s and 1980s, would explicitly describe himself as a 'low-life William Holden living with many oppressed Suzi Wongs'. The filmmaker Dennis O'Rourke would follow his example in 1989. Both recorded the experience, and both left the women behind. O'Rourke called his film, *The Good Woman of Bangkok* (1991), an 'ironic parable,' recognising that its voyeurism involved prostitution as a metaphor for economic dominance in both racial and sexual relations.

Broadway would adapt the Butterfly scenario and reinforce it for Australians, in *Miss Saigon* (1989), and *M. Butterfly* (1988). In the former, orphaned Kim, a bar hostess in love with an American marine guard, loses both him and their child at the fall of Saigon, and shoots herself; in the latter, genders are switched in a French-Chinese espionage power-play. The theme remains the same: in Illicit Space, the Asian woman is a commodity, a victim, and dispensable.

ACCORDING TO THE perennial myth in Australia, Harold Stewart left Australia in the wake of the Ern Malley affair of 1943–44 and became a reclusive exile in Japan. He had published two books of verse before his 1949 travels, when he hoped to go to China, but did not get beyond Hong Kong and Japan. He returned to live in Kyoto from 1965 and brought out two volumes of haiku translations, *A Net of Fireflies* (1960) and *A Chime of Windbells* (1969). Having established himself, consciously imitating Bashō, in a hanare, a detached room in the garden of a Kyoto lodging-house, Stewart received visitors warmly and in considerable numbers, in spite of being a master hypochondriac, 'on his death bed for thirty years'. His monumental *By the Old Walls of Kyoto* (1981), a spiritual biography in verse, accounted for how he spent his time, studying Japanese and Chinese art, literature and Buddhism, as well as the minutiae of the old imperial capital. Fittingly in a case of false identities, what Max Harris wrote in 1943 about Ern Malley turned out to be true of Harold Stewart: 'It is unbelievable that a person going away to die could write poetry of this objectivity and

power'. Had Australians read Stewart's epic in greater numbers, part of the myth about him might have been dispelled.

Stewart, unlike most of his modernist enemies in Australia, had always been drawn to the traditional culture of Asia, and from 1939 had immersed himself in Jung, René Guénon, Ananda Coomaraswamy, Frithiof Schuon, Marco Pallis and Kathleen Raine; this led him to Buddhism, Taoism, and Chinese poetry. His job in Norman Robb's bookshop, where he joined Les Oates' classes on Buddhism from 1957, enabled him to pursue his esoteric interests. In Kyoto he studied for many years under Bandō Shojun, a professor of Buddhism at Otani Daigaku, a university of the Shinshū sect.

Because modern Japan disappointed him, Stewart obliterated it from his mind and lived in the past. He made the Expatriate Shift in time as well as place, coming to regard Australia as distant and barbarous, a place which would be the death of him if ever he went back 'to exile in the land of [his] birth'. For similar reasons he would not go to Tokyo or venture even to the newer parts of Kyoto; the old city was his middle kingdom. He regarded the future with intense pessimism.

Stewart, like other exiles, held to ideas formed in his youth, including his image of Australia. He remained, by his own admission, a 'wicked old reactionary, dedicated to abominations like rime and metre and direct statement as against obscurantist pseudo-symbolism'. What saved him from stuffiness and his work from unreadability was his awareness of being a part of this world, while yearning for the next. As early as his 'A Flight of Wild Geese' (published in *Phoenix Wings*, 1948) he adopted the Chinese device of entering a painted landscape and there meeting a wise hermit, whose conversation reveals to him a flash of insight, satori in Zen terms, epiphany in Joyce's:

> I fled not from the world, but into it.
> What other, pray, could I escape to? I'm
> Still in this world. I've been here all the time.

Stewart's prose commentaries are those of a civilised, erudite companion on walks packed with interest. He invites the reader to stop at a tea-house in a building 300 years old, next to the Entoku-in Zen temple and drink amazake, sweet hot sake. But still the practical joker, he delights in suddenly dropping from the high ground of culture to a lower plane. His Kyoto guide, unlike many trompe l'oeil accounts put out by Japanese and foreigners alike, is not a victim to the Hearn prettification syndrome. Even in Kyoto not everything is good, true, or beautiful. He sees and notes the 'grey malignant growth of concrete', hears and smells the 'noisome farts of trucks and cars' and, in spite of his claim that he has become so Japanese that he sees only what he wants to see, he does not avert his gaze or the reader's from ugliness. He describes a monstrous concrete Kannon statue, erected in 1955 in memory of the dead of the Second World War. And he does not pretend to be a sage, mocking himself when a fly settles on his nose while meditating and when his legs crumple after zazen like those of any other gaijin.

Self-mockery did not make Stewart a common man, nor an average Australian, nor did he seek that it should. He believed he was ahead of his time as a writer, while behind it as a stylist:

> It is just fifty years [he wrote in 1985] since I first began to realize that Australia is not geographically part of Europe and North America (though it seems that many Australians still believe that it is).

In another letter, two years later, he added:

> Only very recently have a few Australians begun to realize that their homeland is not attached to England but is geographically part of South-East Asia and the Pacific and surrounded by Oriental people, languages and cultures.

Other writers—Hal Porter was one—clung to their Western self-image, and to the idea of Australia as imperfect but still an outpost of European civilisation. But Stewart the conservative, while equally critical of Australia, had a radical's view of Australia's proximity to Asia. He saw the European tradition as having been worked threadbare by writers, to the point where it was no longer capable of saying anything new. Asia was for him a source of stimulation, not of strangeness or threat.

UNLIKE STEWART, Hal Porter, Tom Hungerford, and most other Australian writers born before the Second World War, Randolph Stow had a university degree. His early novels (like those of Patrick White which began to appear at the same time, the mid-1950s) focused on isolated, difficult men, partly understood by women, living in remote parts of Australia.

White's early work was informed by his knowledge of Hindu philosophy: Stow's was founded on Taoism. In 1965, two years after his novel *Tourmaline*, Stow wrote a set of short poems, 'From the Testament of Tourmaline, Variations on Themes of the Tao Teh Ching' (Dao dejing), which posed a sequence of Taoist riddles and was an invitation to read the novel—as his critics had failed to do—with the philosophy of Lao-tse (Laozi) in mind. The messianic, imperialist conquest of the land is anathema to Taoism. So Tom Spring, a sage-like, ivory-coloured figure in the novel,

> unveiled his God to me [says the narrator], and his God had names like the nameless, the sum of all, the ground of being. He spoke of the unity of opposites, and of the overwhelming power of inaction. He talked of becoming a stream, to carve out canyons without ceasing always to yield; of being a tree to grow without thinking; of being a rock to be shaped by winds and tides. He said I must become empty in order to be filled, must unlearn everything, must accept the role of fool . . .

This was pure Taoism, as well as Aboriginal knowledge. Stow's aloof way of offering the key to his work without explanation, argument or preaching was Taoist too; 'in the silence between my

words, hear the praise of Tao.' He quotes from Lao-tse in 'Ruins of the city of Hay'. He is not concerned to find Tao in India, China or Japan: it is in Australia. 'Tao wells up like warm artesian waters'. In all Stow's novels, the characters who try to impose their will on the world cause disasters which repeat the tragedies of the past, although Heriot, in *To the Islands*, realises finally that his life's effort has been futile and sees his salvation in the Way of Tao. Earth is earth anywhere and is the guide for anyone, just as heaven is the guide of earth and Tao the guide of heaven. So Tao is the guide for Australians too.

> For a century and a half [A. D. Hope wrote in 1974] Australian civilisation has hardly been touched by the great civilisations of Asia, to which geographically we belong. Randolph Stow and Harold Stewart may well be the harbingers of an important change of heart and, ultimately, of culture.

Hope's prediction would prove true, but only slowly. Stewart's work, anachronistic in form, would not attract enough readers or publishers; Stow's, while widely admired, was not seen as a signpost to Asia for Australians. Both writers, without being solemn or messianic about it, showed the Way. But both were exiles, for whom Australia became an alien place.

A SMALL GROUP of friends in Brisbane, Judith Wright among them, was reading whatever books they could get in the 1950s on Asian literature and philosophy. Indian concepts which began to interest later Australian artists and writers appeared early in Wright's poems 'Canefields' and 'Seven Songs for a Journey (V)'. Wright visited India with other writers in 1970 and later stayed with a friend in Pakistan, but this was long after her first visit to Ceylon (on the way to Britain in 1937) where she stayed for three months, and long after she had inhabited the subcontinent in her imagination. Direct contact with Japan came later, in visits to her daughter in Kyoto, enabling her to sample the best of historical Japan and an abundance of Japanese literature in translation.

AUSTRALIANS, GIVEN THE League of Nations' mandate for New Guinea after the First World War, in addition to being the administrators of Papua since 1906, were latter-day colonists, inheriting both the guilt for a corrupted paradise and the obligation to guide its inhabitants out of barbarity to independence. Thus to the themes of earlier Australian fiction and film about Oceania—the naked or the noble savage, the fatal impact, the lost Eden—was now added a sense, equally familiar to other colonial writers, of time running out and of the approaching apocalypse. In the post-war years it fell to such writers as Lewis Lett, Olaf Ruhen, R. D. Fitzgerald, Thea Astley, and Osmar White—though neither Lett nor Ruhen was Australian-born—to re-shape fellow Australians' images, particularly those of Australian expatriates in New Guinea who hoped nothing had changed.

Lett was among the earliest writers to reverse the presuppositions of the colonialists and argue the natives' case. In 'Treachery' (*Savage Tales*, 1946) he turned the 'never trust a native' dictum back on its originators, showing that what was seen as treachery was the only response possible for people faced with modern weapons. While he did not doubt the superior qualities of British civilisation, Lett deplored the 'necessity' of thrusting 'barbaric tribes' into its complexities. Ruhen believed Australians knew too little about themselves or their region to claim that their civilisation was superior. 'Primitive' societies had much to teach them, and Australians would benefit from this only when they acknowledged the common destiny and common ties to the land that bound them to Papuans and New Guineans as equals. He found 'logic, beauty and effectiveness' in New Guinea's oral literature and was one of the first writers to adopt the indigenous story-tellers' incantatory style.

James McAuley, on the other hand, who helped to establish university education in New Guinea, saw there an opportunity for Australia to build its own 'moral monument' by reordering the country through Christianity—one of the forces which, others thought, had contributed to its disorder. McAuley's support for European tradition was, if anything, made more ardent by his New Guinean experiences: he saw the disintegration of traditional culture as a 'great drama' and one that raised fundamental moral questions. History and geography were not opposed for McAuley, but complementary.

Contrary views persisted in Australia about the fatal impact of the past and its results in the future. Geoffrey Dutton in *Queen Emma of the South Seas* (1976) found a retrospective example of the possibility of a happy integration of cultures in the person of Emma, a nineteenth-century Samoan who had an American father, an Australian education, and business and love affairs everywhere. But in Barry Oakley's 1977 story about pre-independence Papua New Guinea, the whites' hold on civilisation is seen to be slipping, while 'they'—the blacks—are poised to destroy all that Australia's money and effort has established. There will be blood, and worse, on the floor. John Bailey's *The Wire Classroom* (1972) reveals the chaotic farce that was primary education in Papua New Guinea and Australia's attempt at a mission civilatrice. The contrast with Satendra Nandan's British schoolteacher in *The Wounded Sea* (1991), imparting his love of Tennyson to Fijians, is poignant. The ex-colonial mind, uncertain of self, has no assured civilisation to impart to the colonised.

Generations of kiaps (patrol officers) planted the seeds of youthful adventure, language study, and cultural awareness, and the harvest was their autobiographical novels and short stories about Papua New Guinea. These kiap and resident magistrate novels were in the tradition of George Orwell's *Burmese Days*, but without either the self-confidence or the burden of Britishness. The genre was still in existence as late as 1989, in Robert Carter's *Prints in the Valley*.

By the time Randolph Stow published *Visitants* (1979), the

apocalypse had come. A kiap novel, *Time Expired* (G. C. O'Donnell, 1967) had anticipated both the country's independence and Stow's 'novel about disintegration', as he called it. By 1975 Papua and New Guinea were joined in one country, and separated from Australia. But Stow's story was based on the year he spent in 1959, first in Port Moresby and then in the Trobriand Islands, working as an assistant to the government anthropologist, and later as a cadet patrol officer. His poems in *Outrider* (1962) also drew on that experience. Stow learned Biga-Kiriwina, and recognised the ancient wisdom of the islanders and their land, believing that both would outlast his own 'ludicrous legends'.

In Stow's novel, *Visitants*, a young Australian, Dalwood, stands at the intersection of indigenous and expatriate pressures, caught in the nexus of tradition and modernity, where the planters and prospectors represent the old world and Papuans and New Guineans the new. His coming of age requires him to choose the wisdom of his tribe or theirs. This stood out from the earlier kiap stories as an 'unwinking examination of the death-throes of the Australian colonial myths', an examination which takes place from half a dozen different angles, as Stow assumed in turn the voices of the old planter, Macdonnell (who speaks English only to his wireless), Benoni, Osana, Saliba, Dalwood, the newly arrived patrol officer, and Alistair Cawdor, the senior kiap. Cawdor has made the Expatriate Shift, knowing and identifying with the people in a way that makes him prefer to die as an exile in the Trobriands rather than to face an alien Australia. Cawdor, however, is 'troppo' — he represents what happens in colonial fiction, and in Conrad, to whites who lose their grip. On an island of magic where supernatural beings arrive, he began as Prospero and has become Kurtz.

By means of the *Rashōmon* technique, recounting the same events as seen by each person, Stow enabled Australians and Papua New Guineans to comment on each other, revealing not one perception but many, and allowing both humour and subtlety, then new in this sort of fiction: when the Dimdims think they are at their most impressive and white-Masterful, the New Guineans see them as most absurd. Osana, the government interpreter, speaks:

> Mister Dalwood, who seemed to be drunk, but he often seemed to be drunk without drinking anything, sang his song with the men, and Benoni, who was sitting at his feet, looked ashamed. I knew what Benoni was thinking. Because it happens to everybody, that one day, they meet a Dimdim and think: At last, here is a Dimdim that is kind and clever and cheerful and will be like my brother to me. And always the Dimdim turns out to be the same as the rest, only an ignorant person after all.

Saliba chooses Benoni in preference to Dalwood, who has made love to her and, modest as a flower, tells him: 'Taubada, you fuck off.'

Stow succeeded in turning the perceptions of readers around, so that they too shared the eyes and ears of the beholders. Just as non-English speech had often been called 'gabble' or 'yammer' in

Australian fiction, now English, to Benoni, becomes white men's 'chatter' and seems foolish and unintelligble to the reader as well:

> While the Dimdims were talking to each other, the rain began . . . soon there were only we few men on the verandah, and the chattering Dimdims.

Early in the book, just after Tim Dalwood's arrival, Cawdor reflects on the island's historical capacity to absorb outsiders:

> *The island took him [Dalwood] in & digested him at first sight.*
> *Think about that. The receptiveness. So many visitants coming, none that anyone knows of driven away . . . And the same, next century, with the sailors, traders, missionaries, Government officers. They dropped in for a day or two, never came back, but they fitted. And the same, fifty years ago, with young Macdonnell and his partner. They arrived and announced that they owned the islet. Nobody sweated. It was all in the scheme of things.*
> *It's a comforting institution, the scheme of things . . .*

The contrast between this and the attitude of European invaders is poignant; yet here, perhaps, is an Australian who understands and does not exploit it.

'All in all, Mother, the situation has made me feel pretty depressed about the image we Asians have in Australia.'

Yasmine Gooneratne, 1991

IV
On the Road:
1968 to 1991

SINCE THE END of the Second World War, Australians had been coming to terms, slowly it is true, with the fact that several neighbouring countries were no longer colonies of the West, but independent Asian states, and that exclusion of their people, their products, and their culture from Australia was no longer feasible, and intervention in their affairs no longer productive. The Vietnam War represented a reversal of this trend. By splitting the consensus, it forced Australians to extreme positions for or against involvement, and deflected attention from building up contacts with new governments and growing economies in other Asian countries. For Australians, it was the wrong war, in the wrong place, at the wrong time. Few, however, considered how the Vietnamese felt about it.

An intellectual and artistic climate less likely than that of Australia in the late 1960s and early 1970s to support a war in Vietnam would be difficult to imagine. Visual art of the period provided ikons for the counter-culture, mocked established values, and drove artists who defended them out of the galleries. The Australian War Memorial prided itself on its collection of art from the two world wars and from minor campaigns, but in assuming that the Vietnam War could be approached the same way, the trustees showed they were as out of touch with the times as the government.

Ray Crooke, who had missed out on being a war artist in the Pacific war, but who had been fascinated ever since by tropical landscape and island life, turned down the War Memorial's invitation to go to Vietnam. Bruce Fletcher and Ken McFadyen were sent, for periods of six months each, in 1967, but their output was limited. The War Memorial's art committee came to the conclusion that

> The list of available artists was not very inspiring. Vietnam was not 'in' with the artistic world, particularly with the younger artists, who seemed unable to appreciate the importance their role might be in capturing the scene and its social effects, whether or not they agreed with the military operations taking place there.

The War Memorial, said its Director, W. R. Lancaster, was no place for non-figurative painting or sculpture. Minimalist, pop, or colour field paintings of the killing fields, certainly, would have been hard to conceive. Style apart, for the first time in Australian history—although Korea had begun the process—almost no artist in Australia wanted to have anything to do with war art unless it was the art of protest.

Brett Whiteley was at work in America in 1968 on a vast, anguished painting, *The American Dream*, which said much about the war, but not what the War Memorial was used to hearing or displaying. Nor would the trustees have been tempted by such works as Bob Boynes' *US Ruling Oz*; or Richard Larter's juxtaposition of Western men with Western and Vietnamese women in *Apropos Placement: Bi-polarity Caper* (1972); or Geoff Lowe's series *I See*, for which, in 1989, Lowe used an Australian-born Chinese dental student in Melbourne as a model Vietnamese in a fantasy landscape.

10
Followers and Leaders

Vietnam in visual art, poetry, cartoons, fiction, drama, film —new enemies

PLATE 7 *Raoul Dufy,* Le Plage de Sainte-Adresse *(1902) oil on canvas, 52×64 cm. Australian impressionist painters followed Europeans in adapting Japanese art. Dufy painted his beach scene, however, fourteen years after Conder's* A Holiday at Mentone. *(Collection Armand Drouant, Villefranche.)*

PLATE 8 *Charles Conder,* A Holiday at Mentone *(1888) oil on canvas, 46.2×60.8 cm. Australian impressionists combined observation of Sydney and Melbourne beaches and Japanese prints with a fashionably aesthetic result. (Art Gallery of South Australia, Adelaide.)*

PLATE 9 *Kitagawa Utamaro,* Gathering Shells along the Shore of Shinagawa Bay *(c. 1790), from* Gifts of the Ebb-tide. *Shells chosen with great care were later used for the popular game kai-awase.*

PLATE 10 *Ando Hiroshige,* The Lake at Hakone *(1832–34), from* The 53 Stations of the Eastern Sea Road, Tokaido gojusan tsugi *colour woodcut, 22×35 cm. European artists began using ideas from Japanese prints in their work in the 1860s. Hokusai and Hiroshige had already adopted techniques from Western art some forty years earlier.*

PLATE 11 *Paul Haefliger,* Sublime Point at Bulli *(1936) relief colour woodcut on paper, 26.5×36.6 cm (composition). Haefliger visited Japan, China, and India in 1932, and studied Japanese mokuhanga techniques as adjuncts to stylistic modernity. (Australian National Gallery, Canberra.)*

PLATE 12 *Martin Sharp,* Ginger in Japan *(1981) colour screenprint 33.6×22 cm. Sharp inserts Joseph Bancks' Australian comic strip character, Ginger Meggs, in on Hokusai's* Thirty-six Views of Mt. Fuji, Fugaku sanju rokkei *(1823–29).*

Disaffection with any ground war in Asia spread through Australian society, as it did through America and other Western countries. The United States in a quarter of a century had won one war, had drawn one, and was about to lose one. As the art historian Daniel Thomas recalled:

> Quite suddenly around 1970 the Vietnam experience seems to have caused a major shift in Australian society. Scepticism and questioning replaced acceptance. Art ceased to show its audience a status quo, and began more to question and change the system. Sometimes it was the high-art systems themselves that were questioned ... However, there was also direct questioning of politicial and social structures.

Printmaking, with its association with political posters, was more suitable as an expression of artists' views about the war than was painting. So while painters explored the outer limits of psychedelia and altered mindstates, the Earthworks poster collective at the University of Sydney, Redback Posters at the Griffith University's Queensland Film and Drama Centre, and the progressive art movement in Adelaide were among several enterprises whose massive output of posters from the 1970s and into the 1980s served to universalise left-wing images, including images sympathetic to Vietnamese. Noel Counihan who, in the midst of abstraction, had doggedly gone on using realist art as a vehicle for political and social comment, continued to do so on the subject of Vietnam. Udo Sellbach produced a series of ten etchings in 1965–66, *The Target is Man*, with such titles as 'To Execute', 'To Sacrifice', and 'To Persecute', suggesting that enmity between Australians and their regional neighbours was immoral and irrelevant. So too, by means of a series of understated empty war uniforms, did the ceramicist Olive Bishop and the painter Ray Beattie.

POETS WRITING ABOUT the Vietnam War, like visual artists, generally opposed the war itself, Australian participation, and the role of the United States. When seventy-seven contributors published their poems and stories—'a mixed bag of manifestos and poems, elegies and rant'—in *We Took Their Orders and Are Dead* in 1971, Australian troops were already being withdrawn from Vietnam. But because few of the poets went to Vietnam, they focused less on Indochina than on the political ironies of Australia's involvement and on such domestic issues as conscription, the ballot, television images, news reporting, protest, police brutality, the generation gap, and the veteran as victim. Apart from Len Fox, who had lived in Hanoi and Bruce Dawe, who had been in the RAAF squadron in Malaysia from 1966, poets had limited knowledge of what the war meant to Vietnamese people on either side.

Cynicism, mistrust, and mateship, the perennial themes of Australian war writing, were maintained in poems of the Vietnam War. A new element was added: writers now felt Australia had been trapped into fighting the wrong enemy by their subservient government, which believed that 'the faceless monster,

Communism, had Chinese eyes'. The result was self-disgust. For fiction writer Frank Moorhouse, Australians were 'miserable shits', a composite mimic Anglo-American culture; broadcaster Gerald Stone saw Australia as one of 'the world's leading followers'.

The Vietnam War was already over for Australia in 1973, when *Overland* brought out a special issue which represented the views of many Australian literati on the war, including some like Bruce Beaver, Geoffrey Dutton, David Campbell, Judith Wright, and R. D. FitzGerald, who had fought in or lived through the Second World War. Its editor, R. H. Morrison, asserted that Australia had withdrawn its troops in order to avoid defeat and that the Australian people had not been told the truth 'about why we had entered, nor why we had left, nor what we had lost'.

In the *Overland* collection, in four poems dealing with the My Lai massacre, all the perpetrators are Americans: war's brutalising effect on Australians is still an uncomfortable topic. But the possibility of Australian soldiers massacring defenceless Vietnamese villagers was confronted in the novel *Token Soldiers* (1983) by a non-combatant writer, John Carroll, and its cover-up by another, Michael Frazer, in *Nasho* (1984). In 1988 an eyewitness account of such an incident appeared in the press, recalling nineteenth-century invasion literature and the dire consequences for Asians of their speech being heard by Australians as gibberish or 'yammering'.

> This woman, about 40, was walking with her basket and just stepped into the middle of the road. She started yammering away. The lieutenant got the interpreter to ask her to move. We told her again. She didn't . . . This old woman kept yammering. After some time, this bloke just walked up to her and blew her head off. Just like that. We were just horrified . . . Somebody dragged her away and we drove off at a fairly rapid pace . . .

It was habitual, and less disturbing, to see allies—Americans now—as responsible, and Australians as their helpless followers, almost their victims. Bruce Dawe, who had been writing anti-Vietnam War poems since 1965, in 'Homecoming' (1968) traced the blue curve of the Pacific from Saigon to suburban Australia, the route taken by tagged green-plastic American body bags containing Australian bodies. The poem, he said, could have been written about Viet Cong or North Vietnamese war dead—'equally victims, equally vanquished'.

AUSTRALIAN POETS REFLECTED a growing belief that the United States was their real enemy and that this made the war an unprecedented obscenity. Bruce Beaver remembered several wars, but of this one he

> writes Vietnam like a huge four-letter
> word in blood & faeces on the walls
> of government . . .

A collection of writing by Vietnam 'veterans'—Americanised

now, no longer the 'returned men' of earlier wars—ended with a sardonic acknowledgement to the sponsors of the war: the Governments of USA, Australia, North Vietnam and South Vietnam, without whose help the war and the book would not have been possible. The collection included 'I Was Only Nineteen', John Schumann's poem which became Redgum's song. It epitomised the ignorance, confusion, and despair of Vietnam—the third war Australia had fought in Asia under American leadership and, many hoped, its last.

Judith Wright always used poetry to express her three main concerns: preservation of the environment, justice for Aborigines, and peace. Her anguish about human destructiveness, whether of the land, of its Aboriginal people, or of Koreans and Vietnamese, continued and was expressed in 'Christmas Ballad', 'Back for Christmas', and 'Massacre of the Innocents'. In 'Fire Sermon' the bombs have turned into napalm, 'chemical rain'. In this poem and in 'Newsreel' Wright reflected on her inability to accept with resignation the Buddhist explanation that 'all is fire', that everything has its place in creation. Although she was one of the earliest of prominent Australian writers to oppose the Vietnam War, Wright stuck to what she knew best, and left consideration of how the war affected Australians' views of Asia to others.

ANTI-AMERICAN VIEWS had replaced the anti-British tradition in novels about earlier wars—for example, John Hooker's *Standing Orders* (Korea), and George Johnston's *The Far Road* (China). Anti-Americanism was the latest version of post-colonial defiance which was itself the reverse side of Antipodean dependency. In spite of Robert Drewe's claim in 1986 that Australians' 'sudden interest in Asia' was principally a product of the Vietnam War, it was, as in much else, led there by the United States. Opposition to the war, equally, drew its inspiration from conscription and the American model. In the view of the experienced Asian scholar J. A. C. Mackie, the war turned more students away from Asian studies between 1965 and 1975 than it attracted.

Dymphna Cusack in *The Half-burnt Tree* (1969) anticipated the brutalising and maiming effect of the war which Australians would bring back. Protesters take over the Shrine of Remembrance in Melbourne in Barry Oakley's *Let's Hear it for Prendergast* (1970), the tabernacle of Australia's warrior ethic. Thomas Keneally paid passing attention to anti-communist wars in Asia in *Passenger* (1979), but he, like other leading Australian fiction writers of the day, pushed the 'dirty little war'—as the American rock musical *Hair* called it—to the margins. In Dal Stivens' *Horse of Air* (1977), Koch's *The Year of Living Dangerously* (1978), Bruce Grant's *Cherry Bloom* (1980), Blanche d'Alpuget's *Turtle Beach* (1981), it was an obligatory background presence, like the television left on. In several of Frank Moorhouse's stories, anti-war radicalism was shown up as another face of the same Americanisation that had got Australia into the war.

A war that had not been declared and one in which it was

difficult, not only physically but acronymically, to distinguish the enemy—USSR, PRC, SRV, DPRK, ARVN, or VC—offered great potential for satire, if not for tragi-comedy. But it was left to *Hair* to mock the FBI, LSD, LBJ, and CIA, and to Australians to sing along. Australian cartoonists such as Sharp, Petty, Cook, Tandberg, and Oliphant responded to the war's comic potential, and their work had no small effect on changing public opinion and editorial policies in the major dailies. Bruce Petty in particular presented Australians with new, benign images of Asians, not as threatening enemies but as interesting neighbours and as fellow victims of oppressive, muddling governments. In April 1976, when the first refugee boat arrived in Darwin, cartoonists led a community response which was, on the whole, sympathetic and self-critical. The irony of the situation was not lost on the cartoonists: just as Japan, which had no explicit plans to invade Australia in wartime, penetrated much of its economy in peacetime, so the Vietnamese whose southward advance was to be stopped by the war, arrived anyway with the peace. The formerly-dreaded Chinese would follow.

In 1989 Nicholas Jose would recall, in his novel, *Avenue of Eternal Peace*, about an Australian in China, other absurdities of the period:

> Now Wally's people were creating a blockade of incineration and carnage in Vietnam to stop the Yellow Peril running down into Australian homes and gardens as inevitably as falling dominoes. His mother said she didn't want to break her back in a rice paddy and eat stones for bread. His father said that if the Chinese stood in a line holding hands they would ring the globe.

Images of Asians were overdue for revision. But they were unlikely

Les Tanner, Hands off Asia *(1962). Australia's general SEATO obligations were cited to support intervention in the Vietnam War. An Australian Prime Minister was reported to have asked who General Seato was. (*The Bulletin, *1962.)*

"Why should we defend countries we've never heard of like Laos, SEATO and ANZUS?"

to get it while Australians thought of themselves as having nothing in common with their region, and while Vietnam was equated with all of Asia.

On the whole, fiction writers left the Vietnam field to the fighters. Lex McAulay, who wrote *When the Buffalo Fight* (1980) as David Alexander, and factual accounts of the war under his own name, was a career army man who completed three tours of duty in Vietnam; William Nagle was a commando from 1966 to 1967 before writing *The Odd Angry Shot* (1975); Kenneth Cook (*The Wine of God's Anger*, (1968), Michael Frazer (*Nasho*, 1984), Rhys Pollard (*The Cream Machine*, 1972) and John Rowe (*Count Your Dead*, 1968) all wrote from personal experience of the war. Hugh Atkinson, who was not a participant, researched the work of the Red Cross in Vietnam and concentrated on the effects of the war on the peasant population in *The Most Savage Animal* (1972); John Carroll, a 'nasho' (national serviceman) who never saw action, wrote in *Token Soldiers* (1983) of others who did.

In most of these novels, the Vietnamese presence is exiguous, or generalised into an intangible, mass Asia. In Cook's novel, Vietnam is never mentioned. Attention is concentrated on Australians. In Alexander's books, the Antipodean myth of the Australian fighting man as superior to all others is desperately maintained; in Nagle's it is narrowed down to a beleaguered belief in the superiority of regular soldiers over 'nashos' and over Australian civilians; in Frazer's, the claims of superior Australian performance are revealed often to have been fallacious propaganda; and in Pollard's the Australian conscripts vent their disgust at the protesters back home. *The Odd Angry Shot* carries on the digger tradition with characters who are socially iconoclastic, opportunistic, but no doctrinaire radicals, loyal to their mates, hostile to Americans, Vietnamese and women, and as cynical as the government that sent them to Phuoc Tuy province. But in both *The Unforgiven* (J. C. Caincross, 1978) and *The Odd Angry Shot* these Antipodeans now anticipate vengeful mayhem on their return to Australia. In none of them was there any suggestion that Vietnam and its people might be interesting in their own right.

Pervading the Vietnam writing was a sense that for Australians to debate policy in the hope of changing it was futile. So when Australian writers like Morris West in *The Ambassador* (1965), Hugh Lunn in *Vietnam: A Reporter's War* (1985), Robert Allen in *Saigon, South of Beyond* (1990), and John Rowe sought seriously to analyse the war, they focused not on Australians or Vietnamese but on the Americans, and in Allen's case, the pre-war French as well. Lunn delved into the morass of US propaganda. West's starting point was Graham Greene's prescient *The Quiet American* (1955), which contrasts the world-weary British journalist and the ingenuous, Harvard-trained CIA man whose type is going to lead America to repeat the French failure in Indochina. Robert Allen's CIA agent tries ineffectually to prevent that. Allen, like several other Australian novelists, saw Vietnam through Greene-tinted glasses.

John Rowe, a professional soldier who served in Malaya,

Kashmir, and Borneo before Vietnam, and whose moderately presented views in *Count Your Dead* nevertheless led to his resignation from the army, also made Americans central to his story. Australia, one of his American officers declares, need not be in Vietnam at all: 'You're not a country, you're a tennis court.' The reasons given for Australian participation could have come from an invasion novel sixty years before: that Australia looks 'flat, rich, and empty' to the Chinese who it's assumed are the enemy; that Australia has to pay the premium on its insurance policy with the United States; and that Vietnam is Australia's buffer against China. The exclusionist instinct of 1901 was still present among the Australians, who would not allow Vietnamese into their camps; everyone outside the perimeter was the enemy.

While Australians at home sang of peace and love and flower power, hatred found its targets, in the Australian war novels, among the Americans, or other Australians, or the Vietnamese in general, with particular vilification reserved for Vietnamese women. In *Nasho*, Frazer's hero, before leaving for Australia, sodomises his fourteen-year-old mistress and cuts her throat, a Pinkerton act which he rationalises as killing the enemy. The episode closely resembles a suppressed flashback in a draft of David Williamson's 1973 play, *Jugglers Three*. The phenomenon of Australian hatred was noticed even by the *San Francisco Examiner*, which wrote in 1968:

> The Vietnamese hate the Americans. The Americans hate the Vietnamese. Americans hate other Americans. The local Chinese are hated by both the Vietnamese and the Americans. The Australians hate everybody.

Yet there was a human side to the war. If any emotion could be said to characterise the Australian photo-journalist Neil Davis' experience in Vietnam, Cambodia, and Thailand, it was not hate but love: for war victims, orphans, prostitutes, rivals, and colleagues irrespective of nationality and politics.

WHEN AUSTRALIAN INVOLVEMENT in Vietnam was beginning, Australian theatre was still dealing with the aftermath of an earlier war in Alan Seymour's *The One Day of the Year* (1960 play, 1967 novel). In 1965, with *The Gaiety of Nations*, the first anti-Vietnam War play produced in London, Seymour was well ahead of others. But it was never staged in Australia. Alan Hopgood's *Private Yuk Objects* (1966) was another early attempt to air some doubts about the war. Thomas Keneally's *Childermas* (1968), a war parable for children, made no explicit mention of Vietnam; Bob Ellis and Michael Boddy's *The Legend of King O'Malley* (1974) dealt with it obliquely by referring to the 1916 conscription debate; and Leonard Radic's *Sideshow* (1971) and Ron Blair's *Kabul* (1973) used historical settings as metaphors for Vietnam. In *Lamb of God* (1979), John Summons identified in two Catholic schoolboys the prototypes of the gung-ho Vietnam volunteer and the anti-war activist. Later, Radic deplored the

failure of protesters against the war to maintain their rage, in *Now and Then* (1982).

The first draft of David Williamson's *Jugglers Three* (1973) was called *Return from Vietnam*, and the second, *Third World Blues*. In the drafts, Williamson, a committed opponent of the war, used flashback scenes to present the unheroic squalor of an Australian soldier's life, his pact to 'kill a Yank', his assassination of an American colonel, and his capture of a wounded teenage female Viet Cong. Graham cuts her throat and he and his mates sodomise the body. The flashbacks were removed by the Melbourne Theatre Company, and the resulting production, which toured Australia to some acclaim, concentrated on Graham's response to his wife's infidelity with an anti-war protester.

A year later, wealthy professional Australians in Louis Nowra's *Sunrise* (1983) react with embarrassment when their Vietnamese gardener Ly reads a passionate poem about his country's lost liberty. Their discomfiture, much like that of the Bent family in Helen Heney's *The Chinese Camellia*, arises from the sexual and social irritant of this Asian presence in their midst, as well as from having supported Hanoi. 'We are incapable,' Nowra commented, 'of fully understanding the historical significance of moments that have been important to us as a nation.' Australians had lost confidence in the United States' capacity to identify friends and enemies in Asia, Nowra suggested, but they did not yet rely on their own judgment either.

Theatres where rage against the war was maintained included the New Theatres in Sydney and Melbourne, which as early as 1967 put on Mona Brand and Pat Barrett's *Onstage Vietnam*, a mixed media, 'living newspaper' presentation. This was followed by an American anti-American play: *Macbird* (Barbara Jarson, 1967), satirising Lyndon Johnson who visited Australia in that year, and an Australian one, *Going, Going, Gone!* (1968), a revue by Brand and Margaret Barr about the selling-off of Australia to Americans and Japanese. *Baggy Green Skin* (F. J. Willett, 1979) could make fun of conscript life once it was all over; the musical play *Sandy Lee Live at Nui Dat* (Robert George, 1981) was yet another comparison between the views of those who fought and those who protested, culminating in a veteran's assault on civilians; and the revue *Pearls Before Swine* (Dennis Watkins, 1986) about a troupe entertaining the troops, was tilted toward amusement, put-downs, and profit, and away from analysis, boredom, and financial loss. The after-effects of stress, chemicals, and herbicides on Australian veterans and their families kept Vietnam plays going: they included *The Living Room War* (Ron Hoenig and Jon Firman, 1985), *The Luck of the Draw* (Rosemary John, and veterans, 1985), and *Contact* (Domenic Mico, 1986), in which a Vietnamese woman appears in a Greek chorus role, commenting in Vietnamese on the angst of a schizophrenic veteran and his friends.

In *Dustoff Vietnam* (1988) a four-part play put together in Darwin by veterans and local Vietnamese residents, much has changed. For the first time in Australian theatre, a veteran reflects on how the war must have been for the Vietnamese; a

Vietnamese-Australian tells Australians, who have never asked, about her experiences as a boat person; an Ethnic Affairs Minister in Darwin divides his time between the Vietnamese and Portuguese communities. But the Minister's adviser, Peter, cannot shed old images, even though his sister says they are American, racist, and dehumanising:

> PETER: If I could stop myself feeling like this, I would. I know I'm supposed to think of the Vietnamese as human beings who happen to come from South East Asia, but I looked at this guy and I kept thinking: don't expect anything from me slope, zipper-head.

TELEVISION NARRATIVE FILMS which followed the war concentrated so much on Australian domestic issues—the moratoria, the splits in families, the personal conflicts, the war romances—that by the late 1980s there seemed little more to be said on the subject, unless the Vietnamese side was to be explored, or the broader issues about Australia and Asia. Two television series of 1987, Kennedy-Miller's *Vietnam* (John Duigan, Chris Noonan), and Simon le Mesurier's *Sword of Honour* were typical in concentrating on what was close to home.

Allies (Marion Wilkinson, 1983) was one of the first documentaries to consider the 'CIA war' and seriously to question the alliance and the identity on which Australia's participation was based. Menzies states Australia is British; the American spy Christopher Boyce asserts that the Pentagon sees Australia as 'an autonomous Alaska'; Australian military people work covertly under United States command. Nothing was as it seemed. Commercial television was an inadequate medium to deal with such complexities.

By the time these films were made, the presence of Vietnamese as refugees and migrants was visible in Australia. So, while the Butterfly Phenomenon reappears in both *Sword of Honour* and *Vietnam*, with the deaths of the Vietnamese lovers of both young Australian soldiers conveniently enabling their reconciliation with their Australian girlfriends, a Vietnamese cousin in one film and an Australian-Vietnamese son in the other can now be brought home and absorbed into a changed Australian society.

Throughout the decade of Australia's involvement in Vietnam, from 1962 to 1972, films made by the armed services, the Commonwealth Film Unit, and the ABC far outnumbered those made by individuals, but while they might inform Australians about Asia, they did not seek to awaken identity with any part of it. A few groups—the kind of people who were described by the police as 'a rabble whose interests are foreign to our own'— recorded moratorium and anti-conscription demonstrations on film and used the cinema as a theatre of protest. One of the earliest documentaries, *Hearts and Minds* (Bruce Petty and Phillip Adams, 1967), was rejected by the television networks. It used Petty's Southeast Asian drawings in combination with filmed scenes to explain the historical origins and effects of the war, and was the

first statement on film of Australians' opposition to it, as well as a rare attempt to identify with Asian rather than American perspectives.

Patricia Penn's *Once Upon a War* (1970) documented the civilian casualties in a South Vietnamese hospital. Martha Ansara led a three-woman team to Vietnam to make *Changing the Needle* (1981) which, with its unsentimental coverage of Vietnamese self-help methods of dealing with drug addiction among prostitutes and ex-soldiers, served to put the more self-pitying of Australian veterans' films into perspective. As well, it offered a contrast between Western medicine's concentration on symptoms and scientific detail and Eastern medicine's approach to the whole person in or out of balance with her or his society. In 1990 psychologist and peace activist Di Bretherton, with an all-female team of four, made a one-hour documentary, *As the Mirror Burns* (Cristina Pozzan, AFC) examining another almost entirely neglected subject—the effects of the war on six Vietnamese women.

Another Australian, John Pilger, revealed the disillusionment of American forces in Vietnam in *The Quiet Mutiny* (1971), a film for BBC television which the ABC banned; he wrote of the Vietnamese side of the story in *Heroes* (1986). The Vietnam War turned censorship and the Customs into weapons of thought-control in Australia: the police confiscated *American Atrocities in Vietnam* from the International Bookshop in Melbourne, and a Liberal minister warned against the dirty thoughts which, like the Asian pestilence of old, or cheap Asian labour or manufactures, were 'ready to invade Australia, if we drop our barriers'.

Feature films, like television, tended to stay on safe ground by dealing with familiar and predictable personal relations against an anti-war background. John Duigan's *The Trespassers* (1976) was one. Another, in black and white, *Every Day, Every Night* (Kathy Mueller, 1983) was part documentary, part psychodrama about a disturbed veteran. But Australian movies about the Vietnam War were by no means the only ones Australians saw. By 1990 more than eighty American films had been made about Vietnam, and if Australians had few counterbalancing images of their own of Vietnamese people, American impressions were a powerfully-presented substitute. American cinema assumed rights of arbitration and dominance over other countries, and over images of them, which Australians did not pretend to exercise.

After the Vietnam War the defeated side, not the victors, wrote the history, and much of it was written on video film. The most potent current means of propagating an image and controlling what people think, as advertising agents and coup leaders everywhere know, is television. John Pilger called it 'the global medium of reassurance'. In films of the Vietnam War, he wrote,

> the angst of the invader is celebrated ad nauseam while the Vietnamese flit across the screen as stick figures of no consequence, or as monsters, or as child-like objects of patronising sentiment.

Although Australians abstained from making movies in the

Rambo genre, only the documentary-makers challenged the view that Vietnamese people were 'all just gooks'. Friendship with a selected one or two, singled out for loyalty or attractiveness, could be sentimentalised in the manner of *The Killing Fields*, but none of the feature films, plays, or novels of the war, American or Australian, gave the personal experiences of the Vietnamese full or even equal time. Vietnam was television's Illicit Space, a nowhere place where the apocalypse was let rip.

BY 1986, WITH Alan Wearne's verse novel *The Nightmarkets*, radical student experiences of the 1960s and 1970s were coming in for reassessment. But the actuality of Vietnam comes close only to Robert, who goes to a prison farm for six months as a conscientious objector. Although he and his radical mates have their minds made up, the lessons of the war were poorly articulated to most Australian readers and viewers. Many producers trod cautiously, editors were gagged, policy makers who took decisions on the war in secret gave the public a different version. Public discussion was polemical, so that the complex issues were clear only in the more persistent of Australian minds. After the war, a chance to redefine Australia's place in the Asia-Pacific hemisphere, in a way that was not determined in Washington, was lost. No sooner had Vietnam faded from television screens than talk about avoiding more wars faded too. Even before the 1980s, and well before the next war in 1990–91, some Australians were writing Asian invasion fiction again.

The new themes were much like the old. John Rowe's invasion novel, *The Warlords* (1979), dealt with 'the big themes of Asia' as Donald Horne called them in a cover note, and how they would impinge on Australia caught between two ataxic giants, India and China, in 1999. Yet his Australians' fears are the same as those of the invasion writers of the nineteenth century:

> 'India and those billion half-starved beggars terrify me. Here it is, 1999, the edge of the twenty-first century, and half the world an over-populated rat colony going mad.'

Both John Hooker (*The Bush Soldiers*, 1984) and John Vader (*Battle of Sydney*, 1971) speculated about what might have happened if Japanese had landed in Australia. Retreat from Sydney to the centre is Australians' response, as it is also to the threat of nuclear bombardment by the Soviet Union in *Hostage* (Colin Mason, 1973), a novel based on research of the Hiroshima and Nagasaki bombings. Britain intervenes at the last moment, too late.

By the 1980s the world's centre of economic gravity had shifted eastwards. Among Australian writers who reflected sourly on how Japan had won the peace and reversed the 'natural' order of things was Bruce Dawe:

> —I mean it stands to reason, lower forms
> of life give way to higher, and the rising sun

that shone on digger hats can't hold a candle to
the incandescent omnipotence of the *yen* . . .

Confrontation with Malaysia, then the takeover of Irian Jaya and East Timor and border problems with Papua New Guinea, made Indonesia no longer the protégé of the left, as it had been in 1949, and qualified it to replace China as the sleeping dragon of the Australian imagination. 'Indonesia in the post-war years has seemed a land of instability and uncertainty,' wrote Alan Watt in 1967; and by the 1980s, Australians in several surveys thought of Indonesia as the most likely threat. Ken Bullock's *Pelandok* (1986) and Gerald Sweeney's *Invasion* (1986) appeared on cue and were in much the same vein as invasion novels a century earlier.

Neither Bullock nor Sweeney presented the Indonesians as ogres, and most of their characters are likeable people, yet each appealed to the 'threat from the north' paranoia in Australians, and harped on the perennial 'wake up Australia' theme, with an implied 'I told you so'. Yet neither had anything more positive to recommend than more alertness, more weapons, and the Western alliance.

Australians who still idealistically generalised about China were disabused by former Ambassador Stephen FitzGerald and by the events of 4 June 1989. Poets anthologised their revulsion, and Geoffrey Dutton and Garth Clarke mourned 'for all students, everywhere' and vilified the old men who had marched with Mao. Nicholas Jose wrote a fictional account of such a massacre in 1987 and then watched it happen in Beijing in 1989. Dedicating his novel selectively to 'some Chinese friends', Jose showed he knew better than to predict or generalise about a billion people.

IN 1968, FORCES that had been gathering strength in many countries rose seismically to the surface, and establishment edifices everywhere were shaken. In the Washington Mall, the Champs Elysées, the King's Road, Aoyama dōri, and Martin Place, the young demanded change, a revision of the hierarchies.

Ninety per cent of Australians had approved by referendum in 1967 the enfranchisement of Aboriginal Australians; body blows had been dealt to the White Australia policy by the Holt and Gorton governments; and between March 1966 and September 1970, 15 000 'non-European' migrants settled in Australia. Recognising the political power of writers, artists, and filmmakers, governments increased funding for the arts and the artistic diaspora was reversed.

If, as Gough Whitlam said, the First World War had changed an independent Australia into a British province, the Second World War and the Vietnam decade made it an American one. As the 'Anglo-grip' loosened, Australian poets suddenly acquired middle initials. In a sonnet, one of them, Les A. Murray recalled the period as 'Vietnam and the American conquest'. Some Australians who had chafed under the dominance of British interpretations of culture and United States militarism now willingly accepted American trends in poetry. In the still unfamiliar area of Asia, particularly, they still needed someone to guide them, someone to trust, and that mentor was, often, American.

Where the piping Beats led, several Australian poets, fascinated with newly available American collections, danced Asia-wards in their wake. But none of them would so attract disciples, or make such claims to be visionaires, or elevate their own thing so publicly to an art-form as the Americans did; no Australian poet matched Gary Snyder's synthesis of American Indian nature mysticism, shamanism, Sanskrit, Chinese, Zen, and haiku. Shane McCauley might take Pound's *Cathay*, Li Po (Li Bai), T'ao Yuan Ming (Tao Yuanming), Mencius and Confucius, Waley and Rexroth as his guides to a China of the mind; Michael Dransfield could dream of satori, the sound of sitar, sarod, and tablas, and the taste of hashish while taking the mickey out of the American Dharma bums in 'Bums' Rush'; Laurie Duggan might hark back to haiku, Kerouac, Pound, and Dharma too; Ken Taylor, who had spent time at Yale, in a series of haiku, *Five, Seven, Fives* (1984) could match the instantaneousness of John Olsen's brush stroke but keep American 'Zen cleverness' in perspective; and John Tranter could devour the new American poetry and its Chinese, Japanese, Buddhist, and Zen precursors and then move on to wider concerns; even so, poets cut Australian gurus down to size at a time when other differences between them and Americans were falling like flies.

Australian ways of combining Taoism and Aboriginal knowledge were emerging in the novels of Randolph Stow and the paintings and prints of John Olsen. Les Murray was among the poets who from the 1970s sought a similar synthesis.

Miles across, cattle-coloured
are the plains of Ryoanji . . .

The real vastness of Australia and the illusion of vastness induced by the Zen stone garden in Kyoto are seen as a duality. In 'Aqualung Shintō' (1973), Murray reflects on the dichotomy, perceived by so many before him, between cultivated and militaristic Japanese, who seem to be Europeans just 'askew by a fraction'. Australia he calls a land of 'shamefaced shrines', lacking the authentic religious consciousness of Japan, which is deeper than any faddish Zen. This leads Murray to speculate about doing away with enmity altogether, becoming 'clear, again, of armies'. But his last lines slide back into uneasiness about Japan, the peacetime invader, warning of the danger of 'minds aloof' from other cultures.

Long before his first visit to Japan in 1985, Robert Gray had immersed himself in Chinese and Japanese poetry in translation and had collaborated with Japanese translators to produce his own poetic versions. Like Harold Stewart, whom he met in Kyoto, Gray built his erudition on self-education in East Asian literature. He came to Zen through reading Allan Watts. His long poem 'To the Master Dogen Zenji', admired by Patrick White for its distillation of Buddhism, has clear affinities with Gary Snyder. But in several series of poems, he combines a haiku-like form, a Japanese mode of compression, irony, and observation of nature with an authentically Australian image. In longer poems, he drops into the text with lapidary precision single percussive words on separate lines—clang, sling, cling—which resonate like bells or gongs. Satori, the sudden revelation resulting from Zen meditation, is both his personal experience and a poetic technique. After complex journeys, the mind returns to its starting point and knows, as if for the first time, that

> all that's important
> is the ordinary things.

For both Gray and Stewart, Japan was at first, and China remained, countries of the mind. Japan in 1985 proved to be both less and more than Gray anticipated. On his return, he warned Australians against the industrialisation and contrivance that he saw devastating nature in modern Japan, reducing people to materialism and servility; yet he was still entranced with the Japan of his imagination, inhabited by the thirteenth-century monk Dogen and the eighteenth-century Zen master Ryōkan. Gray's major poetic comment on his three months in Japan came in 'Under the Summer Leaves' (*Piano*, 1988). Like a renewed warning of Japanese invasion, he saw the blighted landscape and 'shattered ants' nest' of the continuous east-coast cities as a tunnel Australia was entering. Australia would go the way of Japan not by being physically overrun, Gray feared, but by being sucked into the same meretricious materialism:

> We're all sentimentalists of a Millenium
> who cannot conceive there is wealth in not having.

A poet who survived the psychedelic era without abandoning its visions was Vicki Viidikas. After 1974 she lived almost continuously in India, which seemed to her fecund by comparison with the West: 'We *feringees* have never produced enough soul food.' She made the Expatriate Shift easily, without adopting the hippy delusion that wearing toe-rings and a sari would make her part of India or Malaysia. Australianness was not that easily shed: 'Our reputation goes before us: tall, generous, comedians, sometimes vulgar (not meaning to be), and often skint.'

Rodney Hall, whose interest in India dated from the time he had spent in Cochin in 1957 on the way to England, founded his detachment from materialism and industrialisation in teachings about the karmic transmigration of souls through eleven life cycles. He began a series of poems, *The Law of Karma* (1968) with the reflections of an Indian holy man of the fourteenth century which were the fruit not of American-led fashion, but of his long pre-occupation with Hindu philosophy.

Colin Johnson (Mudrooroo Narogin) had written three novels before his volume of poems, *The Song Circle of Jacky*, appeared in 1986. After a Damascene conversion in gaol, Johnson was convinced he was a Buddhist in a previous life and that 'the central flow of [his] life follows the Dharma.' The second series of poems in *The Song Circle* draws upon extended periods Johnson spent in Thailand and India training to be a Buddhist monk. He feels Calcutta flowing through himself: 'my being is so intwined with your dreaming.' Yet this was not a result of '*ganga* dreams' or of the putative common heritage of Aborigines and southern Indians; it was Johnson's sense of sharing the suffering of oppressed people. In 'Four Aboriginal Poems from India' he urged Indians and Aborigines alike to get ahead by their own efforts. In 1988, under his Aboriginal name, Mudrooroo Narogin used the black bittern's migration to trace his own travels from Western Australia to Singapore, the Himalayas, Calcutta, Britain, Thailand and back to Australia. In *Dalwurra: The Black Bittern* (1988) he passes through metamorphoses, as in the stages of Buddhist enlightenment, learning from Asians and West Indians and from their bird-equivalents.

Travel in Asian countries, and education about them, were now resources for poets. They included Julian Croft, whose *Breakfasts in Shanghai* (1984) includes meditations on China's exploited past and on Australia recollected at a distance; Nicholas Hasluck, who visited China with Christopher Koch as an official guest in 1981, and who published their impressions in *Chinese Journey* (1985); Mark O'Connor, whose poetic experience spanned New Guinea, Thailand, and north Queensland, as though they were a continuous peninsula; and the British-born Kris Hemensley, whose reflections from a distance on the idea of Japan extrapolated from Hiroshige, Tanizaki Jun'ichiro, Bashō and others became an amused juxta-position of old and new. Hemensley took his investigation of Japanese culture further than J. S. Harry and Kenneth Gardiner in their poetic retellings of Japanese and Korean tales. Leith Morton's *Tales from East of the River* (1982) included several poems on Japanese themes, and he followed those with translations of con-

temporary Japanese poetry and fiction. Both Morton, teaching Japanese at the University of Sydney, and Clive Faust, who lived in Japan for several years and collaborated with the American expatriate poet Cid Cormon, absorbed the atmosphere of old Japan and sought correlations with it in Australian experience; 'no one's different'.

The title story of *The Book of Sei* (David Brooks, 1985) transubstantiates the past more by the means of poetry than those of fiction. In China of the tenth century, a woman in green robes receives a traveller in the name of the Emperor; their couplings and his dreams are coolly expounded in the manner of a Chinese or Japanese sex manual (性 , sei in Japanese means 'sex' in both languages); the names of animals, insects, birds, and fish label each coital position. We are in the Adventure Zone of the Odysseus/Circe encounter or in Cathay, where Western men had erotic experiences with women who could be manipulated, abandoned or bought off, or who might, like Butterfly, 'somehow disappear', as Brooks' Chinese woman does in one of his two endings. In the other, the man wrecks her house.

As a literary academic and a feminist, Brooks said, his irony against himself and against male critics was intentional. He had written of the cities Marco Polo overlooked; he was also aware of accounts written by the foreign devils in China such as the German von le Coq in 1909, which matched his own fantasy:

> There suddenly appeared a tall young woman in a little Chinese jacket and splendidly embroidered undergarments . . . I found that the beautiful lady was a well-known *demi-mondaine* who was anxious to offer her services to the foreign gentleman.

For Brooks, as for Rod Jones, China itself was unimportant; in his novel *Julia Paradise* (1986) Jones used it as a country coming out of colonialism, and one that suggested 'notions of the exotic, the East, Kubla Khan and all that'. These were images, clearly, that had become fixed in Australian minds and, because they had such appeal, might be a long time fading.

FOR SOME FORTY years after it went down under the onslaught of American and British movies in the 1920s and 1930s, Australian film was, as one of its greatest supporters, Phillip Adams, put it, 'as stuffed as Phar Lap'. It is often acknowledged that one of the reasons for this was the inability of the Australian film industry to recognise the capacity of Australians themselves; another is the failure of most people to see the potential of their vantage point in Asia and the Pacific. But government funding brought out the filmmakers, and between 1970 and 1985 nearly 400 films were produced in Australia, at an average rate of one every two weeks.

In spite of the Australian film renaissance, feature films of minor quality and minimal Australian content were still being made. Some of them contained British or American formula versions of Asian countries. They included *That Lady from Peking* (Eddie

Davis, 1970), the kung-fu movie *The Man from Hong Kong* (Brian Trenchard Smith, 1975), and *Felicity* (John Lamond, 1979), in which the Australian-educated daughter of a Hong Kong business-man learns to 'accept poverty . . . as part of the admirable diversity of the mysterious east'. Tom Cowan, who made several films in India between 1968 and 1975, was in that respect an exception among Australian narrative filmmakers. So was Terry Bourke, who worked in Hong Kong in the 1960s as a show business journalist and stuntman before directing *Sampan* (1967–68) in Hong Kong with an all-Chinese cast, and *Noon Sunday* (1970) in Guam.

Australian talent was still concentrated in the Asian docu-mentary field, rather than in narrative. Films made for government, such as *White Australia* (United Films, 1964) which, coming full circle from *The Birth of White Australia* thirty-six years earlier, showed student demonstrations against the deportation of Asians, and gave an account of the difficulties Asian Australians had faced. Film Australia, ABC, and SBS (the Special Broadcasting Service) made generally well-researched documentaries on Asian affairs. In reconstructing controversial events as narrative film, television was sometimes less impressive. But television and video were now the media of influence, overshadowing cinema, books, newspapers, and cartoons, which had been the image-shapers of the past, although not displacing them. *Barlow and Chambers* (Nine network, 1988) tended to ennoble two convicted Australian drug-runners and to sneer at and cast suspicion on Malaysia's legal processes. The series *Embassy* (Alan Hardy 1990–91) was shot in Melbourne and Fiji. It sought scrupulously to avoid identifying a national location by inventing its own 'Asian' synthesis, Ragaan—a Third World, tropical, Islamic, formerly British colony, a country that has a honey-coloured ruling class, Indians and Chinese in menial jobs, corruption, inefficiency, oil, discrimination against women, a refugee problem, and an unstable government succeeded by a military dictatorship. Lacking a national identity, Ragaan perpetuated assumptions about a generalised 'Asia' which seemed out of date in the 1990s.

Although the Vietnam war was reduced to little more than background noise in David Williamson's plays, in 1984 he and Kristin Williamson re-examined the early years of the Pacific war on television, concentrating on power struggles and personalities in Washington, London, and Canberra. But *The Last Bastion* (Chris Thomson), by offering no reconsideration of the matching personalities and motives in Tokyo, missed a chance to analyse what led to the Pacific war and to reassess Australians' perennial mistrust of Japan from the vantage point of the 1980s.

Later David Williamson took as his subject for another tele-movie (aimed at the United States market) the death of Aquino, the fall of Marcos, and the rise of 'people power' in the Philippines, a subject about which Australians may have felt more confident. The protagonist in *A Dangerous Life* (Chris Thomson, Bob Markowitz, 1989) is an American journalist, with an Australian photographer as his wife and a Filipina who becomes a rebel as his girlfriend. Williamson accepted this formula under pressure from

the United States distributors, who wanted fewer Filipinos in the cast, and who did not think it credible for an Australian woman journalist to have an affair with a Filipino military officer (a coup plotter) with an American man in a minor role, even though this was based on fact. Thus the image presented to Australians of events in the Philippines was synthesised to match the image American television viewers could accept.

While *A Dangerous Life* was in production, Sydney playwright John Upton was at work on his play *The Hordes from the South* (1988), which turned out to mirror so closely the fictional subtheme of the Williamson series that the two, together with the John Duigan film, *Far East* (1981), suggest a common perception of the Philippines. In Upton's play, President Aquino is already in power in the Philippines, but in his script, Williamson's and Duigan's, Australian journalists are on assignment in Manila, having affairs which give them insights into the society, breaking up and eventually being reconciled with their spouses—a staple theme of Williamson plays. The period, the professions, and the nature of the local love affairs are only slightly different in *Far East*. As well, the Filipina girlfriend in all cases is tortured or killed by goons, leaving the male protagonists, one American and two Australians, distressed, and their liberated wives sympathetic, and all with increased respect for the courage and resilience of ordinary Filipinos. The guns, the goons, and the slums, the grand hotels, and the Mabini nightclubs with their gyrating pelvises are covered by all three; images based on observable facts, certainly, but always the same ones.

John Duigan addressed anti-Marcos activism at a time when no such film could be made in the Philippines. It was shot in Hong Kong and Macau, and as a result there are Chinese street signs, Chinese music, and officials who speak British-accented English instead of the Tagalog and Americanese that characterises Manila; the cars drive on the left instead of on the right, in streets without jeepneys. With a couple of exceptions, the local cast is Chinese, not Filipino; the architecture, temperature, clothes, and uniforms are not those of the Philippines. It is possible to go along with *Far East* only if it is accepted that any Asian can pass for a Filipino and that the Philippines is any Asian country: the Far East Fallacy. In one of the film's more authentic moments, the Antipodean Keefe (Bryan Brown), a bastard who has knocked around Asia being more loyal to his mates than to women, is asked by one of his bargirl employees: 'When are you going to have some *Australian* girls dancing? I think you are a racist.'

In John Upton's play, the reverse invasion of Asia by the Antipodeans is in full swing. An Australian bar-owner tells the newly arrived George that Australians 'have to get into Asia before they get into us'. 'Asia' is used interchangeably with 'the Philippines' throughout, because, although he was aware of the differences between Asian countries, Upton said, he wanted 'to contrast certain values or circumstances which are found in the Philippines and throughout the Asian region with Australian values and circumstances'. The differences between Australia and Asia, in

other words, were such as to eclipse distinctions between individual Asian countries.

> CLAUDE: Asia's where it's at, George. Mix of cultures, emerging nations, exotic people.

Similar preconceptions led filmmaker Dennis O'Rourke to Bangkok, which he called 'the Mecca for Western men with fantasies of exotic sex and love without pain'. There, living in a seedy hotel for several months in 1989, he was the regular customer of a young prostitute, and she was the subject of his film, *The Good Woman of Bangkok*. Intended as a consideration of prostitution as a metaphor both for capitalism and for male/female relations, the film inevitably involves its maker, its participants and its audience in voyeurism and collusion. It poses complex questions about the enduring Pinkerton male. With sex roles reversed, the perennial Butterfly Phenomenon reappeared as the theme of *Shadows of the Peacock* (Phil Noyce, 1987) in which a Sydney woman has a passionate affair with a Balinese dancer and later returns without him to Australia.

Recurring difficulties with films set in Asian countries—and a factor in keeping their number and quality low—were the sensitivities of host governments, concerned about bias and about their national image abroad, and the compromises required of filmmaking organisations. Both accuracy and inaccuracy could bring down hostility upon filmmakers. Few foreign films could be shot on location in 'Asian trouble spots'. The problem enters the story-line: in *Far East*, Reeves' film and tapes are confiscated by the security forces; and in *The Year of Living Dangerously* (Peter Weir, 1982), an Australian broadcaster (played by Mel Gibson) is attacked while covering the anti-Sukarno coup in Jakarta. Tom Cowan's *Wild Wind* (1975), made in India, was suppressed by Indian authorities until 1977. Curtis Levy was able to return to the Philippines with the Australian priest Brian Gore to make *White Monkey* (1987) only after the Marcos government, which had imprisoned Gore, fell in 1986. David Bradbury's two Asian documentaries, *Frontline* (1979) and *Public Enemy Number One* (1980), were both accounts of Australians' attempts to report what governments did not wish reported. The deaths of reporters and photographers in Asian countries, particularly in Thailand and East Timor, reinforced in the minds of filmmakers and public alike the time-honoured image of Asia as difficult, despotic, dangerous, and above all, as Upton found it, *different* from Australia.

A documentary film conceived on a much grander scale than most independent filmmakers could afford, and with an explicitly international purpose, was *Messengers of the Gods* (Hugh Lavery, Ken Taylor, 1985), which set out with ecological and conservationist motives, as well as aesthetic ones, to record the place of the crane family in the traditions of many countries, including China, the United States, Scandinavia, Nepal, India, Korea, and Japan, and in the ceremonies of Aborigines, Eskimos, and Ainu, and in doing so to diminish images of difference. It included Olsen's drawings of brolgas and music by Peter Sculthorpe.

Directors of recent Australian ethnographic films about Asian

Half Life *(1986). Dennis O'Rourke's documentary film examined the effects of nuclear testing in the South Pacific. (Dennis O'Rourke and Ronin Films.)*

and Pacific countries, in reaction against the stereotypes imposed by feature film, sought to take each society, and its substrata, on their own terms, and not to advance any commercial or national purpose, but to adopt 'a more level approach', as Gary Kildea (*Celso and Cora*, 1983; *Valencia Diary*, filmed 1986) did in the Philippines. Kildea observed how everyday city or rural life of poor Filipinos intersected with national events, but made no judgment about which had greater significance as history. Solrun Hoaas, who grew up in Japan, the child of Norwegian missionary parents, found it as natural to make films there as most Australian directors did in Australia. Her perceptive work added unconventional studies of Japanese women's lives in Japan and of war brides in Australia to the corpus of Australian ethnographic and documentary film already

noted: Curtis Levy's in Japan, the Philippines, and Indonesia; Dennis O'Rourke's in the South Pacific, Papua New Guinea, and Thailand; John Darling's in Bali. Others active in the documentary field in the 1970s and 1980s included Roger Sandell (India), John Pilger and Jim Gerrand (both Cambodia), Graham Shirley (Australian prisoners of the Japanese), Bob Burns and Gil Scrine (Indonesia/PNG), Chris Nash and Graham Chase (Philippines), Oliver Howes (Japan, Korea), and Bob Connally and Robin Anderson (PNG). But feature films that uncritically reinforced received images still commanded the mass audiences.

Peter Weir took his trade to be drama and story-telling, not ethnographic filmmaking, and the films he directed were more important to him than the countries in which they were set. It is hardly surprising that, evocative as many of his images are, and skilfully though his sets represent Jakarta, Weir saw his greatest achievement in *The Year of Living Dangerously* not as the insight it gave into questions about Indonesia (for which Hamilton, the Australian protagonist lacks answers), but the daring casting of Linda Hunt, an American woman, as the Australian-Chinese dwarf, Billy Kwan. He created an ambiguous love story, not a document on Indonesian history.

Narrative film made perhaps the slowest progress into Asia of any of the art-forms, and until it could deal with the countries in Australia's region with more assurance, the industry's assumption that Asia was too hard would remain unchallenged. It would continue to ignore a source that had yielded riches in the other art-forms, and in which Australia could lead and surprise the world. But as well as needing an informed industry, directors, and audiences, film in Australia deserved better critics than the man who on ABC television in 1983 said *The Year of Living Dangerously* and *Far East* were part of a fad for 'chop suey drama'.

In 1991, hope of better things was growing with films in production based on Blanche d'Alpuget's *Turtle Beach* and Nicholas Jose's *Avenue of Eternal Peace*. For *Children of the Dragon* (Peter Smith, ABC/BBC, 1991), actors and extras were recruited in Sydney from the Australian-born Chinese population and from newly arrived mainland Chinese students, refugees, and Hong Kong Chinese—which in itself was evidence of progress. But the part of Wally, the Australian doctor in Jose's story, was given to a British star, as a concession to the BBC, and Jin Juan was played by Lily Chen, who had left China for the United States in 1988.

IT IS HARDLY surprising that a substantial character that was not a European pastiche had long eluded Australians in dance—since it still eluded Australians as a nation.

Robert Helpmann came late to the task as well as early. In 1965, only three years after the establishment of the Australian Ballet, he had taken a score by Tōyama Yuzo and the Nō play *Hagoromo*, long a favourite in France, as the basis for his ballet *Yūgen*, about the mythical encounter between a fisherman and the moon goddess. The costumes were modern, and loosely japoniste;

the sets were not cluttered with the decorative japonaiserie of G & S productions and of countless stage spectacles. Now an Australian was attempting a tribute to Japanese theatre, not a mockery of it.

In 1968 Helpmann again tried to lead the public in a non-Western direction—as Pavlova, Michael Fokine and Georges Balanchine had done before him in Europe and the United States—with the ballet *Sun Music*. He used an amalgam of Peter Sculthorpe's *Sun Musics I, II, III*, and *IV*, and a vocal work, *Sun Music for Voices and Percussion* (1966), adding more rhythmically active passages to their slow-moving textures. The style of the ballet and its design were universalist, rather than imitative of traditional Japan. Helpmann shared Sculthorpe's conviction that Australians, in ballet as in music, 'should begin to draw on the cultural heritage of her Asian neighbours in the way that England has drawn on European culture and tradition'. Here was a new rationale for Australians seeking stimulus from Asia: it replicated the British relationship with the continent of Europe.

In spite of their success at the time, the originality and significance of Helpmann's choreography, both in the 'Japanese' ballets and in his lyrebird piece, *The Display* (1964), were largely ignored. 'Ballet' was the operative word, not 'Australian', and European tradition ruled. In spite of several visits to countries in the region, and in spite of having had dancers from Asian countries to train and dance with the company, the Australian Ballet's collective mind remained in the West, and was only 'tentatively venturesome'.

Openness of mind was a quality that in the mid-1980s distinguished the Sydney Dance Company from the Australian Ballet. The chief choreographer, Graeme Murphy, who had gained experience with the Australian Ballet, committed the SDC to 'do something different' from fifty other companies dancing the same repertoire. In China he found that in the absence of a European mentor, genuine closeness developed between Australian and Chinese dancers.

Ballet patrons increasingly expected to see performances ranging from the classics and the international contemporary repertoire to ballet with an Australian vision. That vision gradually began to be drawn from non-Western sources, and to use Australian music with Asian instruments. The versatile Rodney Hall, musician, poet, and novelist, having spent considerable time in India, acted the Indian guru in a performance by Ramli Ibrahim, *Adorations* (1968), of the classical dance of Odissi. Ibrahim, a former member of the SDC, moved on to interpreting Indian dance in small venues to appreciative Australian audiences.

The Canberra-based Human Veins Dance Theatre began in the mid-1970s with an even smaller constituency and by the late 1980s was performing in Southeast Asia and in China. The company's director, Don Asker, like many others, was stimulated by Japanese Butō, as well as by the avant-garde street performances he saw in 1987 while studying dance, mime, and movement in Japan. As Butō groups visited Australia more often from the late 1980s, more young Australian actors and dancers were studying the technique and using it in their own way.

Margaret Barr had an American father and an English mother and was born in Bombay. She headed an experimental movement group in Devon in the 1930s and was a student of Martha Graham in the United States. For her production *A Day in the Life of Mahatma Gandhi: 1869–1948* (1982) she traced Gandhi's journeys in India, with the help of Barry Underwood, a Gujarati-speaking NIDA graduate who had lived there for eight years. Another performer, Paul Maloney, who had studied Kabuki in Japan, advised her on movement for *Climbers* (1976), about the Japanese women's conquest of Everest. Of the dance-dramas she devised on the Vietnam War, two used Vietnamese folk music; another, *A Small People* (1969) was set to music by Villa-Lobos.

Margaret Barr's Dance Drama group was the catalyst for other new dance ventures, among them the Aboriginal and Islander Dance Theatre, and the One Extra Company, founded in 1976 by Kai Tai Chan. Chan arrived in Australia from Penang in 1966 and graduated in architecture, which he practised for several years, taking dance classes with Margaret Barr at night. It was her Vietnam work which attracted him to dance. After spending 1974–75 in London, working as a choreographer, he drew together a small group of people, 'a motley collection of dance students, actors and choreographers who mostly shared ideas and themes held by Kai Tai'.

Australia offered Kai Tai Chan things to say and permission to say them. 'For a Chinese person, being a dancer is not a respectable occupation,' he remarked in 1984. Certainly, acceptance and funding for an explicitly homosexual work like his *Jacaranda Blue* (1983), with Aboriginal dancer Richard Talonga, was new enough in Australia and might not have come his way at all in Malaysia. Asia was an escape route for some Australian artists, but the reverse was true for Kai Tai Chan. It was in Australia that he was able—with a struggle—to prise the bars apart.

In *Ah Q Goes West* (1984), in which he danced the lead role, all but two of the dancers were Asian. The work symbolised his own personal experience as a migrant to the 'West'—in which he included Australia. He pointed to arrogance and hypocrisy towards Asian migrants and, more broadly, suggested that Western commercialism has a corrupting effect on Asia, particularly on Japan. In much of his work the audience is challenged, though not forced, to weigh tradition against internationalism, old against new. By casting Chinese and Aboriginal Australian dancers, trained in Australia, Kai Tai Chan was presenting audiences at a pointing finger's length with an interpretation of themselves as *Asians*. He deplored the second-hand copies of Western work that often passed for contemporary dance in Australia, and believed that instead of importing traditional dance from India and Japan for festivals 'we should be doing it ourselves'. In 1991, still developing the East–West theme, he traced his own progress, in *People Like Us*, from China to Penang, to Sydney, and back to China in contemplation of the Tienanmen Square massacre and took *Dancing Demons* to Bali.

In spite of Kai Tai Chan's views about it, Japan continued to

attract young actors and dancers such as Tess de Quincey to study with Tanaka Min; Julie Drysdale with Tenkei Gekijō, and with Nō, Kabuki and Butō troupes; and Nigel Kellaway, Richard and Yaffa Moore, Carrillo Gantner, and others with Suzuki Tadashi, Japan's latest bridging person in avant-garde theatre. Kellaway, the first Australian to take his physically demanding course, found in Japan what Western theatre had lost: 'We don't have to say what is Asia—it all comes from the same roots. Shakespeare understood ritual, and Asian theatre has kept in touch with it.'

As Australia's population gradually became more Asian, dance and drama groups were formed to keep traditions alive as well as to pass them on to other Australians. The Bharatam Dance Company claimed to be the first completely non-indigenous dance group in Australia. Its choreographer and artistic director, whose stage name Chandrabanu means 'sun and moon', in 1971 left Malaysia to study anthropology in Australia, but like other former students among his one hundred dancers, he turned to the creative life. The Melbourne-based group's style reflected its origins—an amalgam of Chinese, South American, middle European, as well as Anglo-Celtic performers, which tended to echo Peter Brook's 'family of man' cast in the *Mahabharata*, as well as its message.

IF, AS THE Chinese proverb says, one may judge a king by the state of dancing in his realm, the same may be true, and even more so, of drama.

In 1983 the Director of the National Institute of Dramatic Art in Sydney, John Clark, declared that 'our national temperament differs from the Asian'. He went on:

> Nothing could be further from the traditional and highly sophisticated forms of Chinese or Japanese theatre, or the many forms of India. We go for the new, sensational and the vulgar, and prefer not to be too sophisticated, austere or refined. I can think of no Australian playwright who is attempting to deal with contemporary Asian relationships.

Even if he had in mind only the traditional techniques of Asian drama, which were becoming more familiar to Australians, from a series of visiting companies, and from local performance, Clark was ignoring the presence of such techniques in some Australian drama: the Nō play within a play in Hal Porter's *The Professor* (1966), for example; Bob Herbert's *By the Billabong*, also based on Nō; John Lee's experiment with Chinese opera style in *The Propitious Kidnapping of a Pampered Daughter* (1978); the melange of Australia and Asia in the dance-drama of Kai Tai Chan and others; Roger Pulvers' use of Japanese themes, techniques, and masks in several plays; and director Aubrey Mellor's adaptations of Shakespeare using elements of Nō, Kabuki, and Ching Hsi (Jingxi) traditions. Each of them had first-hand experience of Asian countries, and they were, as well, the beneficiaries of Brecht's interpretation of Chinese and Balinese theatre, of Yeats, Meyerhold, and Artaud.

Yet Clark was right about the lack of 'contemporary Asian

relationships'. There had for long been an undercurrent of timidity and xenophobia in Australian theatre, against which a few plays had taken a stand in the 1960s, but without getting more than their feet wet. Not until Alex Buzo's *Norm and Ahmed* (1967) did an Australian play confront its audience with anti-Asian bigotry, and the postwar Asian challenge did not surface as a theme until 1974, in John Romeril's *The Floating World*.

By sending his ex-serviceman Les Harding to Japan on a 'cherry blossom cruise', Romeril juxtaposed several ambiguities: the invasion threat of the past, the reverse invasion of Japan by Australian tourists, Japan's new economic penetration of Australia, and the impact of one floating world on another. National identities become ambiguous too: Australians are seen as Judases, selling the country to 'two Nips' for a handful of yen, and making themselves the new 'Asian coolies'. To Les, Asians are indistinguishable one from another, and in describing them as slant-eyed and as foreign devils he confuses images held by Chinese and Europeans of each other. His experience of Japanese in the Second World War has entrenched his image of Asians. His world is governed by war, and the play is a meditation on xenophobia.

In *Lost Weekend* (1988) Romeril created another racist bigot: Charles, the Korean War veteran who vents his inadequacies on Asians and Wilfred Burchett and who, like Les, lapses into irrational violence at the climax of the play. But Charles is offset by a wife who, reflecting contemporary Australian society, is an expert in Asian cooking. Other Australian characters display more knowledge and less prejudice. Romeril's purpose in theatre for more than twenty years was not a crusade for or against Asia, but a struggle to 'rid Australian cultural life of the crippling hangovers, distortions and abortions foisted on us by British and American cultural imperialism'.

Romeril and Geoff Hooke adapted the Chinese play *The Impostor* for the Playbox Theatre in Melbourne in 1987. Concerned that Australians might feel daunted by a Chinese play, the directors provided a narrator, a bridging concession which had not been felt necessary in the New York production. Hooke explained:

> What we are trying to say is, 'Surprise, surprise, China is just as accessible, just as sophisticated as we are. It's not as strange as we think.

As the extent of Japan's peacetime victory became ever clearer, the same year saw two more plays exploring the ironies of the theme: Jill Shearer's *Shimada* and Nigel Triffitt's *The Fall of Singapore*. In Shearer's play, the widow of an Australian prisoner who defied Japanese brutality agrees to a Japanese takeover of the bicycle company he and his ex-POW mate set up in Queensland. To the surviving ex-soldier, the ingratiating Japanese businessman who has come to discuss the merger seems the same person as the prison camp boss, Shimada, once again taking advantage of helpless Australians in Japan's 'hundred years' war'. In spite of the play's inaccurate Japanese, the revival of the invasion fiction image of the

octopus, and Uchiyama's stilted Japlish, his voice is heard as that of the future. Young Mark uses the time-honoured Australian phrase: 'We're a multicultural society, *whether you like it or not*'.

Extracts from Australian war memoirs, in oral history form, were used as voice-overs in *The Fall of Singapore*. Britain's perfidious abandonment (long predicted in invasion fiction) of its helpless offspring to face the Asian nightmare was powerfully suggested by staging which included incense and percussion, Oriental dragons, steaming jungle, and diabolical bicycles displacing plantation-and-tonic. Antipodean puppets in bamboo cages with stick legs, shorts and boots summoned up audience responses whose origins went back to Anzac and beyond. What Triffitt did not explicitly ask his audience was why they should still identify with a man in a shabby greatcoat who cannot find his way around Southeast Asia, and why Australians should still shudder at gongs and dragons in the late 1980s as in the 1880s. The play did brilliantly what it set out to do by operating on the biological, not on the political level. Theatre, John Romeril said, is 'about having your biochemistry worked over'. The equivalents of these wartime images were absorbed by the Japanese too, but they weren't still dwelling on them in the late 1980s.

Alex Buzo's *Norm and Ahmed* was greeted in 1968 with a court case. The censors' offence at the medium—the play's language—was confined to obscenity; they were not offended by 'boong'. The staging of the play symbolically defined the issue: Ahmed, a civilised Pakistani, has been let into Australia as a student; yet Norm, who claims to be a former Rat of Tobruk, patrols a white fence protecting a building site as if to ensure that he gets no further in. At the end Norm, like Les and Charles in Romeril's plays, compulsively resorts to irrational violence; racism is not rational. From the Anzac literature, the audience at once realises where Norm comes from, with his aggressive egalitarianism, his sycophantic authoritarianism and his ignorant dogmatism. Les, Norm and all the other Antipodeans who sought to keep Asians out of Australia shared Romeril's problem: 'What are we, where are we, who?'

For his own answer to the conundrum, after several plays about outsiders in Australia, Alex Buzo turned to the South Pacific and Southeast Asia to find them in new settings, on islands, or close to the sea. The Celebes port of Ujung Pandang, in *Makassar Reef* (1978) has none of the parasols and rickshaws of the raj; the wheels of imperial enterprise have almost ground to a halt; there is little but boredom to show for it. Both in this play and *The Marginal Farm* (1983), set in Fiji, sold-out Australians are faced, as Conrad's people were, with moral choices while living self-destructive lives on the margins of a society where class, race, and generational props have deliquesced into a mess of materialism.

Buzo delights in ridiculing their use of such expressions as 'a typical Indian'. Weeks Brown, the Australian tourist in *Makassar Reef*, thinks the newspaperman Abidin is a Muslim from the Celebes, whereas he is a lapsed Catholic from the Moluccas. In *The Marginal Farm* Illy, a southern Indian Muslim, is an outsider in Fiji,

where Indians are predominantly northern Hindus. These too are people outside the mainstream.

The questions posed by post-colonial drama were much like those posed by fiction about Papua New Guinea: what have we done here? have we improved the place or destroyed another Eden? how will we look if they follow our example? how has this place changed us? The imperial colonisers at the height of their power would not have asked such questions, and would have dismissed as impertinent the views of their colonial subjects on such matters. They knew who they were. But in *The Eyes of the Whites* (1981), dealing with newly-independent Papua New Guinea, Tony Strachan, who grew up there, explores identity crises on either side of independence and of the generation gap. A Nigerian WHO doctor comes to assess and dismiss the Australian doctor for incompetence. Strachan lays bare as well the impact of the Western cash economy, questions of appropriate technology and the hypocrisy surrounding the rape issue.

Louis Nowra, in several plays in exotic or historical locations, and in his novel *Palu* (1987), sought to reveal the barbarian behind the sophisticated mask. Nowra demanded of the theatre an effect like Romeril's biochemical buzz; he liked 'to be shattered and spun around' by a play, and in turn he aimed to 'shatter people, unnerve them'. Even in *The Precious Woman* (1980), a play about a Chinese warlord and the suffering and eventual triumph of a virtuous, 'precious' woman, this could be achieved if the playwright and director could show the universality of her emotional dilemma as overriding remoteness and exoticism—using China in the way eighteenth-century moralists had used chinoiserie. Yet the play had to be in China, and of the 1920s, to make possible the monstrous tyranny of Bao and the entrapment of his mother.

Unlike Romeril and Buzo, Nowra preferred to create major roles for women. Because women have rarely been involved in aggressive conflict against or within Asian countries, this gave him a different avenue of approach to Asia. Hostile, racist epithets do not occur; conflict takes the form of the morality play—vice against virtue, beauty against ugliness; the civilised interior is surrounded by barbarous extremities. In *Sunrise* Nowra considered the world's future in an Australian microcosm. His Vietnamese refugee, Ly, is the inept, baffled outsider in the Australians' adult playground. 'These people,' he is told by the maid Peggy, who is the other outsider, 'they are nice but not real.' They learn odd languages, feed their appetites, dance and sing, and are never serious, least of all about their Asian neighbourhood.

A *Sydney Morning Herald* correspondent in Beijing, Margaret Jones, first drew the attention of playwright Thérèse Radic to Jiang Qing (Chiang Ch'ing), and the question of whether she was or was not a demon, equally responsible with Mao Zedong (Mao Tse-tung) for the atrocities of the Cultural Revolution, or a 'disobedient woman' using the theatre as a propaganda tool for reform. Radic dramatised the issues in *Madame Mao* (1986), seeking to set changing, contemporary China against its historical background, and using techniques of Chinese theatre and acrobatics. A stage direction reads:

A group watches through a window the rich dining . . . opiumed bodies are robbed, women are burdened, children drowned, feet bound, rags stolen, puritan soldiers restore order, women unbind feet, fleeing refugees pass in fear, and in the later era Red Guards terrorise, loot, make wall posters, quarrel . . .

Timor had entered the consciousness of mainstream Australia with the battle of the Timor Sea in 1942. It dramatically re-emerged in 1975 when, in the wake of a mismanaged departure by the Portuguese colonists, Indonesian troops invaded the island of East Timor. The issue was one about which Australia's foreign policy mentors in the West had no strong views. Seen by Indonesia as its own business, Timor was much closer to Australia than Vietnam or, indeed, than Indonesia, and it evoked strong responses from Australians. American plays about Timor didn't exist; by the late 1980s, Australian plays did.

Death at Balibo (Maria Alice Casimiro, Jose Manteiro, Graham Pitts) took Australian drama about Asia in a new direction. First staged in Darwin in 1988, it reconstructed the invasion by Indonesian troops of East Timor in October 1975 and the deaths there of five young men working for two Australian television companies. Two were British, and one was a New Zealander; as the play joked, 'nobody's perfect'. A third Australian, the journalist Roger East, was killed a few weeks later in Dili. East Timorese had shortly before this declared their independence both of Portugal and of Indonesia. While it stuck to known events, the play left its Darwin audience no room for doubt that the men were shot by Indonesians, and not by accident. It used Portuguese for scenes of village life, English for the Australians' imported microworld, and the Timorese language Tetum for the spiritual dimension, linked through omens, ceremony and song to the events of the play. The ill-prepared Australians' Timorese interpreter, Mau Kruma, turns out to be the son of a man who fought against the Japanese with Australians when they invaded Timor in 1942. His outdated Australian slang is a satire on the digger tradition.

John Romeril did not unreservedly blame Indonesia for events in Timor in his play *Top End* (1988). His journalist-activist Jill has friends both in Indonesia and in Timor, and knows enough about the situation to be able to list a number of possible reasons for the Indonesian attack on Dili of 7 December 1975, the time when Roger East was killed. Through Jill, Romeril suggests that American capitalism is implicated in responsibility. It was the Ford and Kissinger formula:

to keep Indonesia and this part of the world safe for an Exxon IBM Coca Cola led recovery—send in the troops.

Jill is an idealist by comparison with Romeril's assorted Australians in Darwin. On the eve of the bicentenary of Britain's invasion of Australia in 1788, how, Romeril seemed to be asking, could these people take Indonesia to task for invading East Timor and for practising genocide? Nevertheless, Timorese, as refugees, were the latest to join the curious mix of outcasts, nomads, and characters who had established a different kind of Australian community in the north, a de facto Australasia. The cast includes a former soldier

who first knew of Timor only in Banjo Paterson's poem, but who at the end will help the resistance, and a Chinese-Australian whose father bears the scars of the anti-Chinese violence of 1945. Their experience, Romeril wrote,

> (for all that it's a weirdly subterranean and subliminal one)—does auger well for our ability to develop an Ab-Eur-Asian form of civilisation in our neck of the world.

Patches of Australian society, he pointed out, had always been Asian. The quantity and quality of interactions varied, but

> they do constitute a kind of cultural given when one lives in Australian society. And they do—I put it to you—by force of necessity create a mass disposition to tolerate and entertain 'the other'.

The Australasia that had always existed in the northwest, with Aboriginality as its bottom line, was on display in the musical play, and film, *Bran Nue Dae* (Jimmy Chi, 1990). Josie Lawford, Ningali, was the principal woman dancer. The musicians included descendants of Filipino and Greek fishermen, and Chi himself, whose forefathers were Japanese, Chinese and Scottish. Fore*fathers*, because it was men who visited the Adventure Zone, and Aboriginal women who bore their children, who in turn made up the quilt of Broome.

AUSTRALIAN AND JAPANESE puppet-makers had been exchanging visits and ideas since the 1930s. But they found common ground in adapting the European puppet tradition, not in Bunraku or Ningyō gekijō. When they used shadow and rod puppets, little attention was paid to the Indonesian Wayang kulit or to the Chinese shadow puppet theatre. Until 1972, Australians could not readily visit China, and Indonesia had been in turmoil.

Richard Bradshaw, who followed Norm and Nancy Berg and Norman Hetherington (the pioneers) to Japan, over two decades developed a close association with the Puk Puppet Theatre in Tokyo, which was working in a modified Western or international style.

Peter James Wilson, trained as a dancer, followed Bradshaw to Puk and from there, in 1979, to studies of Bunraku in Japan. He explored the puppet traditions of Bali and Yogyakarta, India and Sri Lanka, as well as working with Philippe Genty in France, and brought his knowledge to Handspan Theatre in Melbourne, which by 1983 was using the Bunraku style, with manipulators visible in black, on a wide stage.

His namesake, Peter L. Wilson, established Terrapin in 1981, which became Tasmanian Puppet Theatre, before moving to Spare Parts in Perth, where he was joined by Japanese puppeteers Nishimoto Noriko from La Clarte in Osaka and Hoshino Takeshi of Puk. Nishimoto's *Eros* (1986) and other works set Australians an example of the creative use of anthropomorphic objects in slow, significant movement.

The Sydney puppeteer Norman Hetherington studied Wayang kulit in Indonesia, and Sydney University's theatre workshop used his research in devising puppet plays. In the 1970s and 1980s, performance by puppet groups from Japan, China, Indonesia, and India became more frequent in Australia, and water puppets from Vietnam appeared at the Adelaide Festival in 1988.

Peter Scriven devised the Tintookies for the Marionette Theatre of Australia, which in the 1960s and 1970s toured every country in South, Southeast and East Asia apart from China and Vietnam, with puppets that Akemitsu Tōru helped to create. Scriven, who after 1970 lived for long periods in Japan, Singapore, Malaysia, and the Philippines, attributed his success as a puppeteer to escaping from Australian school at an early age, and avoiding the grand tour of Europe (and, he might have added, to inheriting a fortune). Unlike an earlier generation which had fled Australian philistinism, Scriven escaped to Asia in order to go on playing at being an outcast. He fled a society in which, by then, everyone seemed to have 'at least one child in "the Arts". And everybody has a wine cellar.' He sought, perhaps too late, to discover in Asia what Australia was not.

A LIVING RITUAL with populist roots in the dramatic traditions of many countries, circus, like film, dance, drama, and puppetry, had fallen under the chariot wheels of foreign competition in Australia, but rose again with the help of government funding in the 1970s. Circus Oz was born in 1978 of the union of two existing groups, and as it gained strength both it and its junior understudy, the Flying Fruitfly Circus, toured Asian and other countries and trained with visiting Chinese instructors. The Nanjing Acrobatic Troupe's visit in 1980 was a strong stimulus and a source of further contact. Scrupulously democratic and shunning sex roles, hierarchical management and animal exploitation, both groups contrived to meet European and Asian expectations of what circus is and still to produce something identifiably Australian. Circus Oz members played acrobatic Red Guards in *Madame Mao* at the Playbox. The growth of some seventy other circus groups by 1989 was testament to the dynamism of a renewed industry and its sources of stimulation.

TELL ME TO write my music. Tell me to come up with something . . . composed with honesty and integrity and to the best of my ability, something that reflects all the influences on my life. If I do then there's at least a chance that other people will find something there of value.

Martin Wesley-Smith typified a generation of Australian composers born after the Second World War, who had got beyond 'influences' and tokenistic 'world music' courses, for whom technology and tradition were free of national boundaries, and who were freeing themselves, in turn, from rules.

Computer music workshops in Beijing, an electronic music

studio in the Philippines, and a computerised musical exchange between Australia, Canada, and Japan by satellite were only a few of his interests. Brought up in an Adelaide home which was often shared with Asian Colombo Plan students, invited by his father, a university administrator, Wesley-Smith had since the Vietnam years used music of Asian countries to amplify political points, in his *Vietnam Image* (1970), *Kdadalak (For the Children of Timor)* (1977), *Silencio* and *VENCEREMOS!* (1983–4), audio-visual pieces which included the work of Timorese poet Francisco Borga da Costa. *Quito* was a later music theatre piece about a young Timorese composer and his suicide in 1987 in a Darwin hospital. Wesley-Smith's music, based on Timorese national songs, was used in the Darwin production of *Top End* in 1988.

For the latest composers, freedom of expression was not an issue. Asian ideas were only some of the periscopes they used, standing on the shoulders of their predecessors, Grainger, Sculthorpe and Meale, to take risks and see further. All born during or after the war, they included Alison Bauld, Ian Cugley, Peter Shaefer, Ross Edwards, Ian Shanahan, Ros Bandt, Michael Whiticker, Greg Schiemer, George Michell, and Sculthorpe's biographer Michael Hannan. British-born Richard Mills, Richard David Hames, Edward Cowie, Andrew Ford, Roger Smalley, and the Canadian Ian Currie joined what had become an international snark-hunt in Australian-based composition, ranging from ancient Asian instrumentation to the electronic avant garde, from classics, jazz, rock, folk, and Aboriginal music.

For all its internationality, music was now intensely individual, and Helen Gifford was an individualist who, apart from a year in England in 1962, a visit of one month to India in 1967, and another of two weeks to Bali in 1971, had lived what she called a 'secret life' in Melbourne, composing, collecting records and scores, reading *Arts of Asia*, watching Asian film on video, and 'making [her] own discoveries', which included ideas derived from the design, colour and texture of Afghan rugs, and devising unconventional instruments for music theatre pieces and for such explicitly Asian-based compositions as *Of Old Angkor* and *Myriad* (1968). She recalled seeing *Chu Chin Chow*, hearing gamelan on ABC radio in her early teens, discovering Hindustani music and Chinese opera in Thomas' music shop, and collecting all thirty records in the Unesco series, 'A Musical Anthology of the Orient'.

Music theatre was even more rewarding for Barry Conyngham, another Melbourne-based composer, who like his mentors Sculthorpe, Meale, Peart and Raymond Hanson, in the 1960s 'tried to get away from the dullness of Australia and the intimidation of Europe'. His statement, on acceptance of a Churchill Fellowship in 1970, that he wanted to go to Japan, not to Europe, caused something of a scandal among people who, even then, felt some insult was being given to England's wartime leader. Under the wing of Takemitsu Tōru in Tokyo and Osaka he found 'magic music—like falling in love,' Conyngham said. He compared the frenetic pace of the city and the quiet, studious life—two more aspects of the duality of Japan—in his first orchestral work, *Crisis—Thoughts*

in a City (1968), and koto-like harp sounds, settings of haiku and the music of Nō appeared in other pieces. *Ice Carving* (1970) drew on the impression of snow sculptures seen in Hokkaido, with a violin part written for Wilfred Lehman.

Another of Sculthorpe's Sydney students of the 1960s, as dedicated and successful a scholar as Helen Gifford, but one who was able to study and compose for long periods abroad, was Anne Boyd. Before leaving Australia she had already begun to use Vietnamese and Gagaku music, and her first string quartet, *Tu Dai Oan—The Fourth Generation*, based on a Vietnamese folk song, was played at an anti-war rally in 1968. She later collaborated with Korean-Australian writer Don'o Kim in three choral works. By 1990 she had composed a piece on the Tiananmen Square massacre of June 1989.

After studying under Mellers at York University and teaching at Sussex, two well-developed strands wound helix-like through Boyd's composition: Japanese and Indonesian. From the Japanese strand, her *Etenraku* provided the thematic climax for her orchestral work *The Voice of the Phoenix* (1971) and also appeared as a recording in *The Rose Garden* (1972), a music theatre piece in the Nō tradition. Takemitsu was impressed with her *As I Crossed a Bridge of Dreams* (1975), in which its sound of the shō had something in common with his early piece *The Dorian Horizon*. When it was performed in China, audiences detected the sheng, the shō's Chinese equivalent. From the Indonesian strand came *Anklung* (1974), based on the four-note scale used by the gamelan bamboo ensemble. Boyd referred to *As It Leaves the Bell* (1973, composed for the pianist Roger Woodward) as her 'on the way to Java' piece. She was hardly the first to have been struck by the totality of the experience:

> What impressed me about Bali was the inter-connectedness of all things and the way in which the spiritual and material worlds flowed into each other without the divides which are so characteristic of the West.

She made the first of two visits to Bali and Java at the same time as Sculthorpe, when he 'was becoming disillusioned with Balinese music for not corresponding with his dreaming,' she said. But for Boyd, the Balinese gamelan was as loud and direct, and the Javanese as meditational, antique and mystical, as she had hoped. She found the same spiritual concentration in the music of Gagaku, linking it to the 'magical landscape' of her childhood in central Queensland. But Boyd deliberately avoided visiting Japan, even when she held the chair at Hong Kong University from 1987 to 1990. She said she had her own image of Japan and did not wish it dispelled: 'I'm frightened to go there in case it's not what I think it is.'

At 17, Colin Offord left the home of his English migrant parents on the western edge of Sydney and went to Bali and Malaysia, where he was carried away by the music he heard, and took up the Chinese flute. He later explored other traditional instruments, dance, and visual art in Thailand, China, and Papua

New Guinea, deliberately rejecting demarcations between art-forms, and creating his own 'sound sculpture' in combination with poetry, visual media, and found objects. His music has been used by Kai Tai Chan and the American choreographer Yen Lu Wong, whom he met in Massachusetts. Offord collected contacts throughout the global village: among them were the leading composer Harry Partch, Gyo Yue, a Chinese flautist met in London, Acaah Pree Cha, a Thai khene (reed organ) player, and a Nigerian drummer. He was a collector, creator and performer in a new world he defined for himself and for equally unconstrained audiences, often of schoolchildren.

Through the work of these and other Australian composers it became possible for audiences to hear Indonesian gongan, Chinese pipa or Japanese shō and think them part of the modern panoply of sound. The Australian guitar virtuoso John Williams—whose grandfather was Chinese—had music written for him by Takemitsu. It had become commonplace for the best students, like Gary Watson, Hugh de Ferranti, Chin Yoke, and Kimi Coaldrake, to begin their careers with a long period of composition and performance study in Japan. Music was now diverse. Nō dance was part of the music course directed by Allan Marrett at the University of Sydney; the experimental Melbourne group Gonghouse performed on home-made gamelan instruments; in Sydney, the percussion group Synergy used Japanese taikō. In Bali, Murdoch University drama students performed their Balinese version of *The Tempest*, and in 1991, Graham Sheil combined Balinese music and dance in a play about the impact of Dutch colonialism, *Bali: Adat*.

Conyngham taught ethnomusicology at the University of Melbourne in the 1980s to 'staggered' students whose expectations were still within the Western tradition. At Monash University, on the other hand, in an interdisciplinary department under Professor Margaret Kartomi, which owned a historic set of gamelan instruments, music of every Asian country was studied and performed. Young people in the 1980s listened with enjoyment to Sirocco and Southern Crossings using Tibetan, Korean, Vietnamese, and Chinese instruments in combination with strings and a didgeridoo. Astra, 'the most remarkable contemporary performing group in Australia', under John McCaughie, had Asian traditional and Australian Asian-influenced works in its repertoire. The sitar player Alan Posselt, performing on ABC FM, described himself as a 'raga junkie'. Sarod player Ashok Roy established the Australian Institute of Eastern Music in Sydney in 1984 to teach the music and dance particularly of India and Pakistan.

Perhaps music in Australia had reached the 'cross-over place' which Anne Boyd predicted. Perhaps Percy Grainger's aim had at last been realised: to show

the threads of unity running through all kinds of music (Primitive music, folk-music, jazz, Oriental & Western art-music) and to point out the apparent goal of all musical progress . . . until finally 'Free Music' is reached, when music will be technically advanced enough to tally the irregularity, subtlety and complexity of life and nature . . .

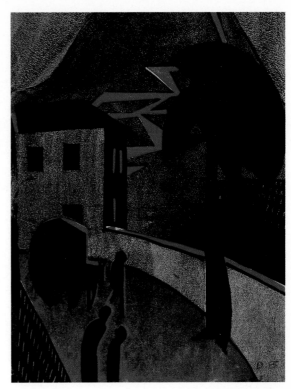

PLATE 13 *Katsushika Hokusai,* Rainstorm underneath Mt. Fuji, *from* Thirty-six Views of Mt. Fuji, Fugaku sanju rokkei, *(1823–29) colour woodcut, 24.3×36.4 cm. Landscape became a theme for the first time in Japanese print-making with Hokusai's famous series on the sacred mountain.*

PLATE 14 *Dorrit Black,* The Eruption, *(c. 1928) colour linocut, 26×19 cm. Australian printmakers adopted japonisme as a decorative technique and applied it to images with other origins. (Private collection.)*

PLATE 15 *Fred Williams,* Bushfire in the Northern Territory, *(1976: detail, number 6 of 12) gouache on paper, 57.6×76.6 cm. Williams visited China in 1976. His lines of fire, waterfalls, and geological formations, like those of Robert Juniper, have resonances in Chinese and Japanese art. (Australian National Gallery, Canberra.)*

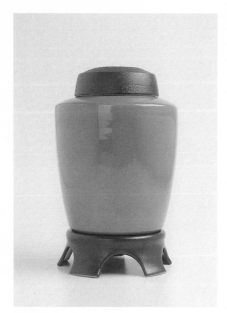

PLATE 16 *Allan Lowe,
Ginger Jar (1952) glazed
earthenware 24.0×13.5 cm.
One of Australia's earliest
studio potters, Lowe was led to
simple shapes and pure colours
in the 1950s by the Kent
collection at the National
Gallery of Victoria.
(Shepparton Art Gallery.)*

PLATE 17 *Peter Rushforth,
Stoneware Jar Jun Glaze
(Chun) (1991) stoneware,
26×23 cm. A long association
with Japan began for Rushforth
when he was a prisoner of war
on the Thailand-Burma
railway. (Distelfink Gallery,
Melbourne.)*

PLATE 18 *Lorraine Jenyns,
The East is Red (1978)
earthenware in two pieces,
54.4×28.5×31.3 cm overall. In
the 1970s, younger ceramic
artists reacted against
restrained, utilitarian ware and
turned to highly decorated,
sculptural objects. In rejecting
japonisme, some revived
chinoiserie. (Australian
National Gallery, Canberra.)*

Brett Whiteley, Self Portrait
Drawing Calligraphically
*(1976). Japanese references
appear in much of the work of
Whiteley, who believed he was a
'ginger Nip'. This one closely
resembles Emil Orlik's woodcut*
Le Peintre japonais *(1901).*

FROM THE 1970s to the 1990s, Australian visual artists in whose
work Asian elements appeared could be roughly divided into three
groups: those who took as their starting point the expectations of
New York, those who avoided expectations altogether, and those
who were attracted to international post-modernism.

The first group were led to Asia by America. From the late
1950s, American artists and their European counterparts, breaking
away from post-impressionism to explore Zen and Taoism, had
begun to experiment with the potential of the ink line, the
spontaneous brushed gesture, and calligraphy — the act itself — as
means for the artist to 'enter the arena'. Ian Fairweather, with his
knowledge of Chinese, understood that calligraphy is more than
brushwork, that meaning and being are inseparable, and that 'a few
strokes of the brush, dramatic, delicate and with a tremendous
power of suggestion and imagination' can contain ontological
significance. But when Peter Upward moved in the 1960s from
abstract expressionism to large, black-on-white calligraphic paint-
ings he was following not Fairweather but Franz Kline and Mark
Tobey, 'releasing energy in an aesthetic way'. He was a close
associate of the painter John Olsen and the Australian sculptor
Clement Meadmore, later American-based. The spontaneity of the
one and the fluent black steel masses of the other, together with
Pierre Soulages' work which he saw in Sydney in 1953, attracted
him to the Japanese-inspired calligraphic art that was developing in
New York. Tony Tuckson, who had been moving through Abor-
iginal and Melanesian periods in the 1960s, arrived at white-on-
black calligraphy in the early 1970s.

Royston Harpur, on the other hand, followed American artists
in going to the Japanese source to study sumi-e, ink painting, in
Kyoto with Ibata Shōtei in 1972. He absorbed the Chinese aesthetic
practices of the Ch'an (Chan) sect, the austerity of Ni Tsan (Ni
Can) and the spontaneity of the Ming eccentrics, had a seal with his
given name transliterated in katakana, and on his return to Aus-
tralia, showed his calligraphic images with the work of con-
temporary Japanese calligraphers.

Brett Whiteley was already a celebrity in the Australian art
world when he went to the United States on a Harkness Fellow-
ship in 1967–69. Whiteley followed Warhol in producing his quota
of multiple Mao images, and distancing himself from collective
responsibility for the contentious issues of those years: 'I con-
sidered myself an outsider,' he told his biographer, 'a foreigner, a
white Asian staying in America for a short time.' Always adept at
parading the latest on the catwalks of public taste, Whiteley
candidly admitted the self-display which was central to his work:

> Some drawings are made in order for me to see something, some are
> made in order for me to show something, some are made to show
> off . . .

Having come to see himself as a 'white Asian', a 'ginger Nip', and
knowing that this put him in the same camp as Van Gogh, who
believed he was himself an artist in Japan, Whiteley produced

Tony Tuckson, White on Black, with Paper *(1970–73). Peter Upward and Royston Harpur, like American abstract expressionists before them, used black and white Zen-like calligraphy. Tuckson sought similar spontaneity. (Ballarat Fine Art Gallery.)*

self-portraits whose antecedents were Buddha, Van Gogh, and a fourteenth-century Japanese monk. He created two sea series (1973–75, 1985) in the manner of Hokusai, worked in India ink on white or cream rice paper, signed his work with red seals, and adopted the elongated kakemono format for his *Single Wave* (1975) and *Portrait of Mick Glasheen* (1972). In *The Dive*, a bare bottom disappearing under a Bondi wave has a replica among Hokusai's pearl divers in *Manga*. On his return from the United States (after eight months of paradisal painting in Fiji) he was a leading collaborator in Martin Sharp's Yellow House in Sydney, where he created the Bonsai Room (to which Royston Harpur also contributed). He linked himself to the succession from the Aesthetes who had dressed up to feel Japanese. So in his *Self-Portrait Drawing Calligraphically* (1976), Whiteley is fully attired, like Toulouse-Lautrec in 1892, for the japoniste experience, kneeling over the unrolled rice paper with the brush held correctly, inkstone at the side. But the 'character' he has drawn, not written, is a design, not a word with sound or meaning. In one of his Van Gogh series of 1982, Vincent's razor is suggested as having 'written' a calligraphic splash in red on a white ground. Burnt and unburnt wooden matchstick sculptures, planted beside his Sydney front door were at once a monument to his Buddhist period—light/dark, being/nonbeing, hot/cold, life/death, yin/yang—and a statement about the use he continued to make of the West's image of Asia as a source of the modern, and as a means of staying ahead of the crowd. Zen, for him, was no less than the theory of painting, and in the 1970s shortcuts to satori were produced by drugs. Australian poets, too sardonic to aspire to Beat shaman status, left the role of Australia's Allen Ginsberg to Whiteley.

Peter Sculthorpe, Robert Gray, and Anne Boyd all had reservations about going to Japan after years of constructing their own images of it. Whiteley shared their hesitation, while savouring the prospect. In 1989, after having been to other Asian countries several times, and after years of talking of wanting to 'make a big statement about what Japan means to me,' he spent five weeks in Tokyo and Kyoto. The cleanliness, courtesy and artistic restraint he found were what he expected from his reading, and he puzzled about 'how in the hell they got these people to go to war'. Although he made none of Robert Gray's adverse judgments, he decided he would not want to live in Japan. He attended a calligraphy demonstration by Harpur's old friends, and at the time when Hirohito was dying in the palace nearby, he was shown the Emperor's bonsai collection by an 'interface' Japanese, a 'clown of a curator', who had worked at Kew Gardens. Whiteley's painting with a single falling leaf, *The Emperor's Bonsai* (1990), was the only work, by July 1991, to result directly from the visit, although Whiteley had a 'big Japanese garden picture' in an unfinished state, and in some of his Paris paintings after the visit to Japan, 'bridges leapt graciously across the Seine as if Japanese calligraphers had drawn up the plans'.

For Australians working in all the art-forms, Asian cultures had always represented an escape from conventional expectations. From

the 1960s, some visual artists—the second group—used Asia as a resource for deliberate eccentricity, creating their own visions and enjoying the public's bemusement. Asia, defined in the West as non-Europe, anti-mainstream, counter-cultural, became a happy hunting ground for eccentrics, and then for their admirers and emulators.

Eccentricity generates humour, hyperbole, exuberant optimism, and flashes of what the dedicated eccentric knows are great insights. Martin Sharp, plucking a Hiroshige print out of the reverential hush which by then surrounded them, in Japan as much as in the West, inserted the Australian larrikin comic-strip kid, Ginger Meggs, in a boat on the Seto nai kai, the inland sea of Japan. In a kakemono he called *The Lost Hokusai*, Sharp found 'an Oriental *Birth of Venus*'. He gave the comedian Roy Rene a Kabuki actor's make-up in his poster 1978 for Nimrod Theatre. By means of such eccentricities, Sharp was discharging his personal responsibility to 'look after' Japanese and other images, to revitalise and re-interpret them—as he also did with Sydney's Luna Park—and to return them to contemporary culture.

Sharp's Sydney colleagues in the Yellow House in Potts' Point in 1970–72 saw themselves as the artists' community Van Gogh dreamed of but never realised. Sharp's murals restated Van Gogh, Magritte, and through them, Hiroshige; Richard Weight produced a byōbu, *Tribute to Hokusai*; Antoinette Starkiewicz made *Vietnam Statements* in silkscreen print; and Whiteley created his exhibition of bonsai paintings.

Other forms of eccentricity were always possible, in a continent so vast that people could literally disappear into its interior and could come back changed by the genius loci. If it took the south of England to produce Vaughan Williams' music, the Appalachian Mountains to produce Aaron Copland's, and Manhattan to produce Leonard Bernstein's, it remained to be seen what the 'avoided vision' of Australia as not-West might throw up.

With this in his sights, John Wolseley from 1976 spent months at a time in the centre and northwest of Australia, as well as in Japan. He would map his own journeys, observing both natural phenomena and manmade ephemera, always believing that what he found flowed from the land through him onto the paper. His paintings sought to preserve scientific evidence of fragile things, to register outrage at their destruction, and at a deeper level to reveal immanent forces which might emerge from the land at what he called hot spots: sacred sites, chakras, or emanations of chi (qi). A found insect might be the 'visible tip of a compositional iceberg'; jagged ridges in the Napier Range emerging from the desert, curving away and sinking under the sea to emerge from it as islands, could be evidence of leung (long), the Chinese dragon that is the ikon of the energy of the cosmos; the Taoist contrast between the ruggedness of one side of a rock formation and the smoothness of the other seemed to reveal yin and yang; in the structure of a boab tree or a termite swarm, a Buddhist diagram of earth, water, fire, and air awaited interpretation.

> On this ancient wall [in Kyoto] an under-layer of red 'boule' showed under the gold, and I realised I was using the same paint combinations that I had used the week before . . . on that ancient Australian hillside . . .

Five journeys between Australia and Japan up to 1989 enabled him to produce visual cognates of his experiences in such paintings as *From Bendigo to Kyoto in Search of Bashō* (1986), in which the crossed struts of goldmining derricks at Bendigo, wings of butterflies, a kimono spread flat and the torī arches of Japanese shrines lend the journey the emblematic synthesis of 'manipulated chance'. In another e-maki, elongated scroll-painting, *The Pearl Fisher's Journey from Ise Shima to Roebuck Bay* (1989), the trail of found and natural objects is reversed, from Japan to Australia.

Jorg Schmeisser, who had studied and taught in Japan for four years before arriving in Australia in 1976, also became a meticulous observer of the desert. In his *Fushimi Inari Torii* (1968) he glimpsed some of the same congruencies as Wolseley. The work of both artists exploits the tension between traditional scientific observation and the post-modern notion of knowledge as play, the product of chance and anarchic escape. Their sense of chance emanations through the artist of the genius loci would also serve to explain the Chinese elements which artists in Beijing and Nanjing observed in Hilder's landscape stylisation, or, for that matter, in works of Blamire Young, Lloyd Rees, or Fred Williams.

In 1981 the Continuum group of artists in Australia and Japan, led by Hamada Goji, Namikawa Emiko, John Davis, Stelarc, Maryrose Sinn, Peter Callas, Makigawa Akio, and Ken Scarlett, began an exchange of exhibitions which broke the rules and rejected national prescriptions for art. Davis collaborated with Hamada Goji, a sculptor and avant-garde performance artist from

John Davis, Evolution of a Fish (Eight Parts) *(1990). 'Together, Davis, the "sculptor of ephemeral means", and Hamada, from the world's richest country, create an art of poverty' (Elwyn Lynn, 1988). (Artist's collection.)*

1981, Davis collecting bleached sticks and firewood on a beach at Tokoname, joining them to tarred forms with eucalyptus twig structures which had been brought from Melbourne, and exhibiting them across the floor of the Ina Gallery in central Tokyo as a single work, *Journey Extended*. In 1983 Hamada visited Australia, where dragging his canoe-like wooden construction along Australian beaches and through the bush was his reciprocal artistic act.

Davis had moved between woodcarving, industrial processes, video, and constructional art as he had between Australia and Iran, Hong Kong, India, Bali, and Japan. His interest in anthropology and myth, and in the ritual objects of tribal societies, particularly those of the Pacific islands close to Australia, led him and others to withdraw their collaboration from an alienated, exploitative society which had commercialised art, and to seek to diffuse art back into the ordinary lives of the people. So Davis' structures of calico and tar, stretched over frail twig frames, harked back to the tapa cloth of Fiji and the dried globefish of Japan. His *Earlier Incident 1985* resembled a reliquary with skulls from an Indonesian house of the dead. He continued to make humble poetry out of roping and stringing wood together, sometimes with a stretched skin of fabric like a New Guinean boat, or with taut paper like a Japanese kite.

A fellow member of the Continuum group, Makigawa Akio had lived in Australia since 1974, having grown up close to the sea in Kyushu, worked as a sailmaker, and used what he learned to make sculpture of suspended stones, wooden forms, and ropes. His first years in Australia brought about a complete change, from concentration on individual objects to installations reflecting landscape as a more spacious whole, though still using canvas and wood, but adding light and water.

Stelarc was born Stelios Arcadiou in Cyprus and arrived in Australia as a two-year-old. Lured by what he had seen and read of the Gutai avant-garde performance group, and of Japanese traditions and philosophy, he moved to Yokohama after Expo 70. He rapidly shed his direct interest in Japanese art, instead frequenting cancer hospitals and robot factories where he found people who not only spoke English but who were interested in his *Third Arm*—as art recalling the multiple arms of Shiva, and as prosthetic technology. As well, for help with body-suspension events using steel hooks inserted through the skin in the manner of Hindu Fakirs, he was able to gather Japanese friends who gave him 'unemotional astute assistance'. He doubted that he could find anywhere outside Japan the combination of elements needed to sustain his work, including a teaching job, excellent photography, and a technological wonderland. In other events, Stelarc filmed the interior of the body and amplified its sounds, dramatising the impact by reflecting laser beams from mirrors in the eye sockets.

Throughout his long career, Sidney Nolan was always ahead of his time, redefining modernity, stimulating and shocking the public. When younger artists were once again turning to literal representation, he moved on, first to the River Kuei paintings of 1979, lurid, intense, and flamboyant, and then to two series of China paintings done in his least representational style, not so much to

Katsushika Hokusai, Instructions on Colour Painting: Ehon Saishiki Tsū *(1848). A student mixes ink while the master executes all five characters of the title at once.*

Stelarc, Handswriting *(1982). The* Third Arm, *powered by the user's gut muscles, operates at the interface between art and technology. (Artist's collection.)*

outrage the West perhaps, as to cut loose from Chinese landscape convention. His rapid, lax lines verged on slickness; his large, flat monochrome canvases got their gradations of tone out of a spray-can; camels done with stencils all went East-West, and Buddhas wore iridescent, lopsided haloes; luminous vulgar colours had more to do with Western graffiti and lapses of modern taste in ancient Buddhist temples than with time-honoured tradition. This was Nolan's 'Silk Route' series (1987), which included groups of paintings with matching names: *Himalayas*, *Buddhas*, *Journey*, and *Foreign Devils*.

Nolan spoke of trying to capture 'the grandeur of mountains with human flow underneath'. But he had added an intellectual appreciation to the visceral by familiarising himself with Hopkirk's *Foreign Devils on the Silk Road* (1980), for there they were in the *Foreign Devils* group, just as in Hopkirk's illustrations: Hedin, Stein, von le Coq, Bartus, Warner, and Otani, all 'discoverers' of ancient Chinese treasures and some little better than thieves. Was this Nolan's reflexive comment on foreign appropriators of Asian images, including himself?

Past approaches to Asia, the scornful and the reverential, were ripe for knocking. Heresy had become dogma. Mike Brown's collages of the 1960s including Asian-ish kitsch deliberately set out to shock, and by the 1980s he was interpreting Chinese landscape through Pop and minimalist detail. Lynn Quintal, after studying in China at an academy of traditional Chinese medicine, produced paintings that, like Brown's, combined in fine, all-over meshlike detail, cultural patterns from East and West. Jenny Watson's *Alice in Tokyo* (1984) implied the juxtaposition of blonde innocence and *louche* experience, a Lewis Carroll image and one from the ukiyo, floating world, channelled through Baldessin and Utamaro. Her rump-fed horses seemed to have Chinese forebears, or to have been mediated through Castiglione. For Martin Sharp's followers Garry

Shead, Peter Kingston, and Cressida Campbell, and in a wider array of work by Sarah de Teliga, Noela Hjorth, Geoff Hooper, Greg Irvine, Max Miller, and Graeme Townsend, and the sculptors Emily Hope, Robert Owen, and Joan Dickson Grounds, incorporation of heterodox devices from Asian sources became the norm.

National origins, too, had gone out the window, and travel was omni-directional. Jan van Wieringen, a Dutch-born Australian, followed his childhood colonial roots back to Indonesia to paint giraffes and monkeys in his version of a Balinese manner; James Willebrant, born in Shanghai in 1950, also of Dutch parents, travelled in Asia and the Middle East throughout his childhood and painted mock-exotically; Herbert Flugelman (born in Vienna, in Australia since 1938) covered large ceramic torsos with erotic ukiyo-e in the manner of yakuza tattoos, spread liberally over the limbs of unabashed twentieth-century women. Made Wijaya (Michael White) left Australia to live in Bali, where he made large, limited-edition books of his painting, writing, collage, and Balinese art. Paul Greenaway in the 1980s spent a year living in the small Middle Sepik village of Korogo, and in 1987 produced sculptures and wall pieces which were not a verbal or oral narrative but accounted for village life by means of curious objects.

Tim Johnson, like several artists interested in Asia as 'Other', was equally drawn to Aboriginal art as 'Another'. He could see China, Tibet, and Japan without leaving the Fisher Library in Sydney, but from 1980 he made several visits to the Papunya people in the Central Desert, which seemed to him the Pure Land, a 'laconic paradise'. In the earliest surviving forms of both Buddhist and Aboriginal cultures he found a similar visual language based on circles and wavy lines, illusionary visual devices, which he combined on large flat grounds, using dot techniques, Tibetan and Chinese elements, to express a personal synthesis.

In this sort of art, a third group was identifiable: artists who, in restating the already-said, in irony or in innocence, once again chose India, China or, most often, Japan as a means of making the binary oppositions of post-modernism—image/sign, self/other, interior/exterior, male/female, original/derived, traditional/avant garde, centre/periphery, and so on. For Gareth Sansom, a self-described 'random artist', to delve into seamy contemporary India and juxtapose what he found with 'visual debris' from surrealism, S&M, Dada, or Pop represented 'another layer in all the layering you have been using for 30 years'. And, he might have added, the layering and juxtaposing of East and West that had been going on for centuries. Now, however, meaning was mutable, fluctuating and fragmented, both for the observer and for the observed. Exceptions were the rules, and knowing subversions became the new conventions.

Japan by the late 1980s had surpassed the West in the West's own terms, not only economically but also as a locus of ultra-modern creativity. Imants Tillers acknowledged as much in 1988, by his adoption in one work of elements both from the contemporary Japanese-American artist Arakawa and from George Stubbs' eighteenth-century *Kangaroo*. Yet Japan for some art

Herbert Flugelman, Tattooed Lady *(1974). Ukiyo-e erotica, commonly adapted by contemporary Japanese artists, are lightheartedly used here in the manner of yakuza tattoos. (Art Gallery of South Australia, Adelaide.)*

theorists, particularly for Europeans like Barthes, was still a distant, unvisited place, a fictitious 'paradigm of free-floating signs, artifice, cultural clichés, and coded representations', Mikado-land restated as 'le Japon'. Post-modernism, with its appropriational and recitative strategies, reapproached Orientalism, and could be as reflexive and commercial as anything in the past. The Orient, for Barthes, was 'a matter of indifference'. For those Australian artists who still allowed the West's ideas to shape their thinking about the East, this was absurdity revisited.

Pat Hoffie, who had arrived in Australia from England in 1956 and travelled in many Asian countries, explored what she called the 'shared disenfranchisement' of women everywhere, by juxtaposing 1950s Tretiakov images of green- and blue-skinned 'Asian' women with gagged women from Japanese movie hoardings, and Aboriginal

Pat Hoffie, Hotel Paradise (detail, 1989–90). Recalling Tretiakov images of green- or blue-skinned 'Asian' women from her childhood, Hoffie first associated Asia with decorative ideas, and later with feminist ones about the exploitation of Aboriginal, Asian, and settler Australian women. (Heide Park and Art Gallery.)

and settler Australian women. Micky Allan selected minimal japonaiserie motifs and eclectically dropped them with Persian or other randomly associated images into vast seas of colour. Susan Norrie, with the eclecticism of dream and intellectual association, could include a Hokusai wave, a scene in Venice, and the Melbourne skyline in one painting. William Yaxley built collages called *Tokyo Bay* (1987) from unconventional materials. Marc Sauvage's bowl and chopsticks in wood and porcelain, satirical because unusable, *For Special Occasions* (1984) took the mickey out of the utility/beauty, art/craft, poverty/luxury, Australia/Asia dichotomies.

Post-modernism, in its neo-Orientalist mode of restated iconography, could also restate chinoiserie. Lorraine Jenyns' visit to China was the gestation for her vividly coloured earthernware jar *The East is Red* (1978), with kitsch porcelain pagodas. For Tony Clark, the intrusion of chinoiserie into post-modern paintings had the appeal of 'wrongness', of parody, of liberation from classical strictures.

For Korean-born painter Hyunmee Lee and Japanese-born ceramicist Shoji Mitsuo, their moves to Australia in 1985 and 1973 respectively meant (as for Makigawa Akio, Heja Chong, and Hiroe Swen) escape from the confines of an art establishment and freedom to travel into themselves. Much of Shoji's work was in unfired clay: large transient installations which, instead of remaining collectors' objects, would dry and crumble away during an exhibition; or ironic ceramic calligraphies in white clay slip on black masonite, framed behind glass, fired with a blow torch. Australia and the west coast of the United States attracted Shoji not for their familiarity but as the Other. For all their japoniste ceramics, he found them both 'so different culturally and socially from Japan'. Reversing the Western search for enlightenment in Asia, however, he declared that after Japan had educated him, Australia 'grew me up'. The two-way street was becoming an artistic freeway.

By the mid-1980s Australian visual art was showing the effects of a more intense and diverse relationship with Asia than either European or American art enjoyed. Australia had always been carried along by international movements but, the curator Alison Carroll believed,

> for the last fifty years particularly, our physical closeness has increasingly inspired travel of both works of art and of people to such a degree that our own culture has been more significantly affected by Asia than any other based on Western ideals.

While contact with Asia had certainly widened the vision of Australian artists, the young of the 1980s and 1990s were bombarded with images from the small, rectangular screen, which could still be as Orientalist as any in the past. When Geoff Lowe asked adult students to paint 'Asians' as part of his work *Wall of Vietnam*, he found, even in the late 1980s, that their images alternated between Asians as 'sage, wise, more civilised', and Asians as 'dirty, coloured, with no respect for human life'.

IN THE 1980s, among Australians who had never objected to the presence of British, American, or New Zealand investment in Australia, some took truculent exception to what — predisposed by their inherited images — they saw as the Japanese peacetime invasion of Australia. This response was evoked by the proposal for a Multifunction Polis, by condominium construction on the Gold Coast of Queensland, and by a major building in central Melbourne, designed by Kurokawa Kishō in collaboration with Australian firms, and built by the construction firm Kumagai gumi, which also built the Adelaide casino. An architect used metaphors of entrapment and deception to describe the metal space frame that was was erected over the old, 'simple and honest' Walter Coop shot tower on the site, and she suggested it would survive its prison. Indian or Malaysian ownership and renovation of hotels or casinos, in contrast, had not attracted notably hostile comment.

Architectural exchange with Japan was well established by the 1980s. Tange Kenzō, Seike Kiyoshi, Ashihara Yoshinobu, Nagashima Koichi, Maki Fumihiko, and Kikutake Kiyonari were among those who worked on joint projects in Australia. Australian architect Daryl Jackson collaborated with Isezaki Arata in designing the country's first private university for Alan Bond in Queensland. A building designed by Tange's firm rose in Sydney where Hordern's store once stood. Robert Clayton, Peter Armstrong, Donald Gazzard, Jennifer Taylor, Roger Barrett, and others, studied and worked with Japanese architects and made further visits. Non-traditional Japanese architecture was added to courses taught in Australian universities by Taylor, Neville Quarry, George Molnar, R. N. Johnson, and Adrian Snodgrass.

Moving beyond Japan, the Melbourne architect James Birrell worked on World Bank projects in the 1980s in Papua New Guinea and Indonesia. He wrote a novel, *Water From the Moon* (1989, with Rory Barnes), deploring the suffering of re-located Javanese in the face of official corruption and Japanese wood-chipping. His houses, like buildings by Donald Gazzard and Edwin Codd, adapted tropical architecture to the coast of Queensland.

In the 1980s a Melbourne firm of hospital architects, Stephenson and Turner, developed expertise in fengshui (feng shui) principles of Chinese geomancy and took into account special requirements of the Taiwanese defence forces for a veterans' hospital and a military teaching hospital in Taipeh. In a way that would have pleased Hardy Wilson, they adjusted Australian design concepts to Chinese needs. Harry Charalambous, who had studied Chinese and Japanese architecture at the University of Melbourne in the late 1970s, went to Hong Kong, Fujian, and Guangdong (Canton) for further experience before he collaborated on the hospital projects and on the design of the Dai Gum San (great gold mountain) project at Bendigo, which Stephenson and Turner undertook for the Victorian tourist authorities. Again, fengshui principles were applied to ensure the proper use of colour, orientation and disposition of functions, and hence the prosperity of the venture, its proprietors and its users.

Official Chinese cooperation enabled local authorities to develop a northern-style Chinese garden in Young, NSW, formerly the notorious Lambing Flat; a Tang dynasty village in Brisbane; and another in the southern style at Darling Harbour in Sydney.

Japanese gardens also proliferated. The New South Wales town of Cowra established one in 1979 after six years of planning and construction, providing a tourist site for Japanese visiting the nearby war cemetery and graves of those who died in the 1944 outbreak. Another, in parkland south of the city of Adelaide, was established in 1984 and altered, with advice from Adelaide's sister city, Himeji, in 1987. Sydney had a Japanese garden, including a bonsai section, in the Auburn Botanic Gardens on the banks of Duck Creek. Planning for yet another, a samurai theme park to be called 'My Country', was under way in 1990 for Tamworth—it was designed a historical fantasy-land to which Australian children and Japanese tourists would equally be attracted. In 1991 a mountain, rock, and waterfall garden was created at the Melbourne zoo, in liaison with Aichi prefecture.

Like their Chinese counterparts, these were Japan-illusion gardens, whose design was intended to transport the mind away from Australia, and to recreate the image of willow-pattern-plate lands of exotic plants, tea-houses, curved bridges, and tile-capped walls, where water, colour, and foliage were more concentrated than in the surrounding Australian environment. Like the palace garden at Versailles, such gardens did not represent the environments in which most Chinese and Japanese people live, but those in which a few of them used once to live. Moreover the 'typical' Japanese garden, according to Jennifer Taylor, a leading Australian authority on the subject, is 'uncomfortable in an alien setting'.

Peter Armstrong, Courtyard *(1977). Instead of creating an illusionary Japan, Armstrong designed this University courtyard in accordance with Japanese design principles, using local stone and plants.* (Architecture Australia, 1977.)

The School of Architecture at the University of Melbourne constructed a Japanese conference room, from pre-cut materials brought from Tokyo, to a design by Yura Shigeru; Balvant Singh Saini matched it with an Indian room in the same School. At the Asia Research Centre of Murdoch University a small courtyard garden with moon gate, lake, and teahouse was constructed. And for the Department of Japanese Studies at the University of Western Australia, Peter Armstrong designed a courtyard, which was completed in 1976, seeking to avoid any pretence that Australia was Japan or that he was a Japanese designer. Within the 20 square metres of the courtyard, he reduced in scale the real landscape of the nearby Swan River to represent the sansui, mountain and water, elements of the Japanese garden. People in the surrounding building were invited to make 'journeys of the eye' into the courtyard, contemplating oppositions of scale, texture, light, and colour, and hence of Japan and Australia. The yin-yang symbol was suggested by curving paths built from limestone blocks around a pool, but there were no stone lanterns, humped bridges, willows, cherry trees, or wistaria: only Swan River reeds and native shrubs. Nothing was *copied* from Japan; instead, a common source was tapped.

CHINESE WERE AMONG the first settler Australians. In 1988, by way of belated recognition, their achievements and those of their successors were collected by Mo Yimei at the Australian National University and recorded on a scroll 50 metres long and 80 centimetres wide, by two painters from China, Mo Xiangyi and Wang Jiangwen; it was exhibited in both Australia and China. The scroll format was also chosen by Chan Leong for his *Leung Yeung* (long yang), male dragon. It represented a lover's progress, with symbolic clues from Chinese literary tradition, and was kept in a lacquer box as a treasured object to be brought out and shown with restraint and ceremony. The artist, born in Malaysia and educated in Armidale, studied architecture and printing before moving on to create comic-strip-style handscrolls, concertina- and fan-fold books. Primary pop art colours, hard lines from poster art, Chinese silk bindings, and Japanese paper reflected the synthesis Chan was able to produce in his adopted environment.

Photographer William Yang, whose grandparents reached Australia from China in the 1890s, went to China a century later, just after the 1989 Tienanmen Square massacre. He photographed student demonstrations outside the Australian Embassy with a sense of ambivalence: he was in his motherland, but it was a country his parents had discouraged him from knowing anything about. Helene Chung, a fourth- generation Tasmanian, had similar experiences when she went to Beijing in 1983 as an ABC (Australian-born Chinese) correspondent for the ABC.

A curiously rare view through a reversed lens was provided by Nanette Carter, who in 1982-84 assembled images of Japanese landscape, Buddhist festivals, and enigmatic closeups of women, which posed questions about concepts of beauty and tradition as

both confiner and liberator. The difference between her vision of Asia and Max Pam's was as great as the difference between the views of the male and female writers we have considered. Pam, who from 1970 spent more time in the counter culture in India, Japan, Nepal, Thailand, Borneo, and the Philippines than in Australia or Britain, particularly captured the 'luminosity and secret presence' of Indian buildings, with multiple human presences as well.

INDONESIA EXERTED ON the minds of perception-shapers in Australia 'a fascination similar to that exercised on the British imagination by the Arab world in the first half of this century', Bruce Grant wrote in 1973. As familiarity with Indonesian art and music grew, so did appreciation of Indonesian batik. The Australian National Gallery followed the example of several American museums by acquiring a major collection of Indonesian textiles, representing all the islands, as well as pieces from India, Laos, and Cambodia. Batik designers Tony Dyer and Jenni Dudley were among a growing number of Australians bringing the fruit of their experience in Indonesia back to Australia and following in the steps of Byram Mansell, who had experimented with batik in Sydney in the 1920s.

Australian textile designers adapted ancient techniques of painting and dyeing silk to enrich their own work: among them, Lyn Elziga-Henry studied ryōketsu some, wax dyeing, in Kyoto with Takagi Kyoko, and Carolina de Waart learned the yūzen some, paste-resist technique, from Wada Mitsumasa. Mary Teguchi, in Mittagong, NSW, combined ikat-woven and indigo-dyed fabrics from Japan to make clothes and textiles of her own design for household use.

The Perth-born artist Carlier Makigawa used sculptural materials and techniques to make jewellery and small jewel-like sculptures, suspending found objects—pebbles, twigs, skin—in metal frames which suggest shōji, and with intricate bindings of copper wire which recall in miniature the Japanese techniques with rope and cord used by her husband Makigawa Akio in his early sculpture.

The transmigration of culture spread into kite-making (Peter Travis and Leon Pericles), Nō mask-making (Solrun Hoaas), knotted rugs and paper and fabric collage (Gloria Goddard, who travelled in the Middle East and India), collaged paperworks juxtaposing Japanese and Western emblems (John Hinds), folded-paper products (David Murray, Philip Mitchell, and Jennie Tate), and set design through the study of local Japanese festivals (Tate).

By the 1990s Jenny Kee (born in Australia, with Chinese, Italian, Scottish, and Irish ancestry) had established a successful range of clothes designed for Australians, using Tiwi fabric, silks from China, batik from the Aborigines of Bathurst Island and Utopia, and motifs from the Australian bush or the Malaysian rainforest, printed in Italy. The result was what she called Oz-ethnic. She had reacted with aggression to being called 'chinky chonky' at primary school, and in response went out of her way to be different. The difference included several years as a fashion

leader in swinging London in the 1960s, where among her many other achievements, she was cast as Shanghai Lil in an underground film.

FOR HIS SUSPENDED-BODY installations, Stelarc was dependent on the help of several English-speaking Japanese. He claimed in 1985 to be 'one of the only gaijin who after fifteen years is still walking around saying how beautiful the kanji [Chinese characters] is without knowing what the hell it means'. Australians in occupied Japan, as we have seen, had found themselves short of interpreters. Of those they had, several were not Australians or had learned Japanese outside Australia. And thirty years later, Australian artists fluent in any Asian language remained exceptional.

Ignorance of the languages of the countries closest to Australia perpetuated the imperial attitude that the natives had better learn English, as well as the Antipodean tendency to seek an interlocutor, a bridging-person. In spite of numerous reports to government on the subject, European languages were dominant in the curriculum of Australian secondary schools, and in 1990 only 0.5 per cent of tertiary students were taking an Asian language, although first year enrolments were growing. Claims of the success of Australia's multi-cultural experiment were made by those who remembered past hostility to Asians, but they could not yet point to significant adjustment to the Asian presence in the majority population. From 1986 onwards, migration to Australia of people from Asia increased faster than from any other source, and tourism and investment, particularly from Japan, expanded rapidly in the mid-1980s. These developments were greeted with satisfaction by some Australians and with outright racist distaste by others, particularly after history professor Geoffrey Blainey from 1984 onwards lent respectability to talk of an 'Asian invasion' and of discrimination against 'traditional' migrants.

The lack of an Asian language hampered writers, dramatists,

Jan Murray, Untitled *(1986). All Australians are boat people. The most recent immigrants from across the sea are Indo-Chinese refugees. Others arrived over 40 000 years ago. Infinity (symbol 8) stretches forward and backward in time. (Artist's collection.)*

and filmmakers directly. Potters, composers, visual artists, choreographers, and architects could get by, however, and (as Jennie Tate found in her theatre design work) could even benefit from being forced to concentrate on the significance of non-verbal signs. But on another level, immersion in an Asian culture through the effort to learn its language narrows the 'we/they' gap and broadens the mind; without it, preconceptions of Australian artists could remain unchallenged. And artists were the image-makers for other Australians, including those who would later teach literature, history, and art. Australia had courses in 'world music', which included Asia, in the 1960s, but world art, world literature, world history, world philosophy, and world religions were still not comprehensively taught in the 1990s. These were only the more obvious signs of the Euro-centrism of the Australian canon.

In spite of this, Australian translators in recent years have added to the range of Asian writing that Australians can read—drama, poetry, children's fiction, and film, as well as novels. A. H. Johns, Benedict Anderson, Max Lane, David Reeve, Harry Aveling, and David Irvine gave Australians an insight into Indonesian poetry, fiction, and drama through their translations; Joyce Ackroyd, Graeme Wilson, Roger Pulvers, Yasuko Claremont, Leith Morton, Hugh Clarke, and Robert Gray added to the amount of Japanese poetry and fiction internationally available in English; Graeme Wilson and Kenneth Gardiner adapted translations of Korean fiction, and Choe-Wall Yang-hee translated Korean diaries; Ian Fairweather, Daniel Kane, Linda Jaivin, and Geremie Barmé made translations from Chinese; Jeremy Nelson did the same with Bengali.

There might well have been more, had the Australian publishing industry—like the Australian film industry—not been so slow to see a role for Australia as a centre of regional expertise on Asia, and to reject the imperial partition of the English-speaking world into British and American fiefdoms. Reluctance to market Australian books and films directly in Asia and Asian ones in Australia, and to promote translation, bespoke continuing indifference, or subservience.

ALTHOUGH SETTLER AUSTRALIANS had been trading with Asian countries for nearly two centuries, and although there had always been Asia-literate Australians, the knowledge they gained was insufficiently ingested into the culture to benefit succeeding generations, and the artifacts and books they brought back were often not appreciated. When the great collections of Oriental art and literature were being established in Europe and America, Australia missed out. The burghers and art historians who defined gallery policies in Australia believed—as some continue to do—that old art was Greek, Byzantine, or European, and new art was American. Australian art had to be measured against 'the works of eminent artists in Europe'. In 1991, not one professor of art history in an Australian university was a specialist in Asian art.

It was left to individual artists and a few connoisseurs and

eccentrics to collect Asian art. John Peter Russell's collections of French impressionists and Japanese art, and Eleanor Hilder's of Chinese objects were turned down by galleries in the 1930s. Relatively few as they were, the Asian works given by private patrons had a great impact on the Australians who saw them. H. W. Kent, a trustee of the National Gallery of Victoria, had business interests in China and Japan, and lived in Tokyo for some years from the early 1900s. His collection, and his lectures at the gallery on Chinese bronzes, porcelain, stoneware, and furniture, had a lasting influence on many artists. On the gallery's behalf he bought more objects, dating from 1766 BC to 1795 AD, while on a visit to Europe in 1938. A bequest from the estate of G. E. Morrison, who was more interested in collecting books than art, enabled a start on a Chinese collection at the Victorian gallery in the 1920s. The author Alan Marshall and visited China in 1956 with Leonard Cox and acquired Chinese ceramics for the gallery.

A decade later, Tate Adams was among the first collectors to put contemporary Asian art before the Australian buying public, with his Japanese print collection at Melbourne's Crossley Gallery. Other significant private collectors included Dr R. S. Godsall, Rodney Weathersby, William Bowmore, Dr Albert Cymonds, Joseph Brown, James Fairfax, and the Myer family.

Belatedly in 1978 the Art Gallery of New South Wales appointed the first full-time curator of Asian art and under the guidance of Edmund Capon, an English-born expert in Chinese art, set about acquiring and exhibiting an extensive Oriental collection, and devoting a new section of the gallery to it. The Waterhouse collection, of painted scrolls and Wei, Tang, and Ming sculptures, had been in the gallery since the 1920s. Sydney Cooper had left Chinese tomb figures and later ceramics to the gallery in 1962, and a trustee, Hepburn Myrtle, selected some fine Ming and Qing (Ch'ing) porcelain for acquisition. Japanese contemporary ceramics were donated after 1981 through a Shintō priest, Koizumi, and important screens and lacquer objects by Kenneth Myer. Capon's books and television series on Chinese art brought an appreciation of the subject within the reach of many Australians for the first time.

From the 1970s onwards, the Art Gallery of South Australia, the Queensland Art Gallery, the Australian National Gallery in Canberra, and the Australian Museum in Sydney acquired and displayed Asian art objects in selected categories. Some thirty-five of Paul Haefliger's coloured woodcuts, wood engravings, and lino-cuts in the Japanese manner, many done in Japan in the 1930s, were added to the Australian National Gallery's collection, together with Hardy Wilson's drawings, many of which had also been given to the National Library of Australia. The textiles collected in Indonesia since the 1960s by Michael and Mary Abbott of Adelaide, dating from the seventeenth century, added particular significance to the ANG holdings. The galleries queued to get the splendid touring exhibitions that were often sent abroad from Japan and China, but often they could not afford them, which meant that public taste remained less educated than that of Europeans and

North Americans, and indeed of Japanese. Although the series of Japanese exhibitions in the 1960s and the four major Chinese exhibitions that began in 1977 attracted great interest, detailed study of the arts of Asia seemed destined to remain a minority pursuit for some years.

AND YET, AS more young Australians studied and visited Asian countries, and as more Asians arrived to live in Australia, an efflorescence in what might be called the 'living arts' took place, enlivening Australian tastes in food, clothes, sport, and entertainment, just as post-war migration from Europe had done. At last, food in restaurants and markets and cookbooks reflected the tastes of the Asia-Pacific hemisphere. In 1987 Robert Brissenden could include in a novel a description of the perfect breakfast,

> . . . papaya with green limes, fresh sweet pineapple, fragrant bananas, and half a pomelo, the salmon-pink grapefruit that seemed all juice

with reasonable assurance that his Australian readers would agree. Rosemary Brissenden, the author's wife, and many others, Charmaine Solomon in particular, wrote cookbooks which from the 1970s made Asian cuisine accessible to Australians, as did thousands of chefs all over the country.

The struggle to shed Anglo-Saxon tastes in food and in horticulture was constant, as poet Mark O'Connor found when he was planting tropical fruit and flowers on Dunk Island. His task was to rehabilitate the plantation of E. J. Banfield, an Australian Buddhist who had in the 1910s and 1920s brought in and established the Asian species O'Connor lists in his poem.

Yet many Australians (the number can only only be guessed at) had for years been cultivating the gentle, private arts of flower arrangement, orchid cultivation, and bonsai growing, and attending courses in Australia for the purpose.

ANOTHER RESULT OF more direct contact with Asia—or perhaps with Bruce Lee films—was the growth of Australians' enthusiasm for new sports, especially those derived from the martial arts of China, Korea and Japan. Australians had for long been learning the benefits of yoga, and some studied at the feet of Ayenga in India. Jūdō was joined in popularity in the 1970s and 1980s by kendō, tae kwon do, karate, t'ai chi (taiji) and aiki dō, giving Australians who might not otherwise have had any contact with the culture of an Asian country a familiarity with the terms and philosophy of these disciplines, as well as opportunities to meet Asian experts. If there is any significance in the fact that Australians have never gone to war against a cricket-playing people, the growth of interest in these Asian forms of self-disciplined release of aggression may be a hopeful sign.

By 1985 the novelist David Foster had a black belt in tae kwon do and had come half seriously to believe that martial arts were one

Mates of Mars *(1989). Author Dr David Foster and medical scientist Dr Francis Seow, both second dan, with Hee Jung Sung, sixth dan taekwondo Master. (Photograph: Samantha Foster.)*

of the two contributions of importance—the other being marijuana—which Asia had made to Australian culture. His novel *Mates of Mars* (1991) concerns seven Australian martial artists. One is a Jewish man of distinction in Australia, who finds himself a nobody in Master Lim's domain in Penang and who finds no answer to the riddle of why he came and why he tortures himself doing martial arts. For Foster, martial arts served as a metaphor for his own work, which followed a fitness circuit, a ritual pattern of aggressive and defensive moves. He aimed for the literary equivalent of the martial arts, for performance executed with 'skill, speed, strength and assurance'. These, he believed, were also a remedy for the slackness and hypersensitivity of Australian society:

> Battle is the *only* means by which both science and art advance! In my recent fiction, I have tried to inject a little *yang* into the *yin* of Australian writing, which I find, for the most part, pathetically soft and feeble.

Settler Australians had been hostile to Asia for much of their history. Now Foster's martial artists variously exchange that hostility for the East's methods of ritualising aggression and channelling both fear and anger, with varying degrees of success.

ASIA HAD ALWAYS been an alternative source of tradition for Australia in the arts. Now, as a new generation took to exploring the limits of understanding the mind and body, questioning the Platonic view that they were separable and unequal, Western medicine was being challenged, and Asian sources of medical knowledge were being explored for alternatives. Australians, almost as much as Americans, were impressed with the possibilities of

Chinese medicine; and holistic approaches and ancient healing practices such as acupuncture, shiatsu, and moxa burning, along with exercise and meditation disciplines, became part of the ways of life chosen by Australians, more eclectic than their parents, from the 1970s. How a man copes with injury, according to a paraplegic former martial artist in David Foster's novel, is 'the whole secret of life'.

Religious leaders bearing the gifts of alternative faiths from Korea, India, Tibet, and Japan found followers in Australia. If Australians had been more inclined to enthusiasm and evangelism, and less to cynicism, the saffron-robed among them might have been more numerous. But Zen, as we have seen, reached a new generation of Australian artists, poets, and composers in the 1960s; and Buddhism in Australia remained as perennial as the Bible. Mandalas were painted and written about in the 1960s, and hexagrams appeared in the 1970s, particularly in Brett Whiteley's paintings. The *I Ching* (Yijing) became a guide in confusing times for many Australians, including novelist Jan McKemmish's heroine, and Blanche d'Alpuget's Minou, in her novel *Turtle Beach*. The sculptor Robert Owen studied Kriya Yoga in India, and drew on its centring discipline in his stupa-like works; ceramic artist Stephen Brown travelled in India, Nepal, and Thailand in 1981, where in a forest monastery he studied the philosophical and meditative disciplines he used in his later work. Melbourne artists Ross Moore and Peter Guiliano studied Buddhism in Tibet before joining others in establishing the Tara institute. French artist André Sollier arrived in Australia in 1970, after studying Zen for three years in Japan, and established the Satsuma Dōjō in Melbourne where he taught sumi-e, Zen archery, and meditation.

EVEN IN ROCK music, where the innovative meets the merely loud, consciousness of a sort about Australia's presence in the Asia-Pacific hemisphere revealed itself in odd ways. A rock group might for no apparent reason call itself 'Samurai Trash'; a singer might 'think he's turnin' Japanese'; another sings 'dōmo arigatō, Mister Robot-to'. All of them might have learnt guitar at a Yamaha school, or had early violin lessons by the Suzuki method. Jimmy Barnes of the group 'Cold Chisel' might wear a hachimaki headband and sing of the Rising Sun having stolen his girl away. Ted Egan's song for poor Nakamura, who died of the bends in Broome, dredged up history. Global technology made it possible for Peanut, a 'crazy Asian kid' in an Australian novel, to be mates with Eli, a 'crazy American kid', whose music captures the 'Zen spirit of paradox and general bullshit'. All of it could be dismissed as ephemeral fun, if it did not perpetuate certain anachronistic images.

Japan, for popular songwriters and artists of all kinds, had become part of the panoply of international trendiness, as the 'Teenage Mutant Ninja Turtles', who practice martial arts, proved in 1989–91. Young Australians now played video games such as those produced by the California-based Koei corporation which

simulated and perhaps stimulated a Japanese view of history: 'Nobunaga's Ambition', 'Genghis Khan', or 'Bandit Kings of Ancient China'.

Japan, more than any Asian country, continued to be the epitome of ultra-style, as cultural theorists had realised in the 1970s. Japan, wrote one of the theorists,

> just *is* the post-modern . . . the simultaneous site of capitalism and Godzilla, of the microchip as an achievement of capitalism and of that same chip as the promise of something 'beyond capitalism'. 'Japan': land not only of the cassette player, the VCR, and the DAT, but the land where these things multiply internally into high-speed dubbing decks, and start opening the imagination of *Bladerunner* or William Gibson's technopunk science fiction . . . a kind of heaven of theory where there are no choices to be made among Jameson, Lyotard, Baudrillard, Debord . . .

After a century and a half of being the Other, Japan was becoming ultra-mainstream.

IMAGES OF ASIA formed in childhood were potent influences, as we have seen, on the later careers of many Australian visual artists, writers, filmmakers, and composers. If young Australians in the 1970s and 1980s drew their images more from film and television than ever before, they would grow up with views of Asia as the Adventure Zone that reinforced some of the old stereotypes. The excellent animation of *Marco Polo Junior Versus the Red Dragon* (Eric Porter, 1972) did not make up for the Orientalist images that it perpetuated. Cecil Holmes' film about Asian students in Australia, *Gentle Strangers* (1972), was cut by its producers, Film Australia, losing twenty minutes about a Chinese boy gambling in Australia and an Indonesian boy encountering racial hostility in an RSL club. In *Avengers of the Reef* (Christopher McCulloch, 1973) an Australian boy is cast away on a tropical island (Fiji) with a good introduction to local customs, but with no suggestion that his young Fijian friend could expect a similar experience in Australia.

Children's fiction and verse set in Asian countries included Len Fox's *Chung of Vietnam* (1957) and Don'o Kim's *My Name is Tian* (1969), based on their experience of two divided countries, Korea and Vietnam. Kenneth Gardiner translated Korean tales for children and Leith Morton produced a bilingual volume of verse for children, *Kitsune/The Fox* (1989), with haiku translations by Tubouchi Toshinori and paintings by Murakami Yukuo. The beautifully illustrated Japanese tales in English by Sydney-based writer Junko Morimoto became well known to Australian children in the 1970s and 1980s. From 1979, after studying Japanese language and literature and spending a year in Japan, Ruth Manley produced three elegantly illustrated children's books with plots involving geisha, ghosts, ninja, tengu, and tenshi—complete with glossaries. Barbara Ker Wilson's *The Turtle and the Island: Folk Tales from Papua New Guinea* (1978, 1990) adopted the same mythical accounts of animal behaviour as Mervyn Skipper had done in his Kiplingesque *The*

Meeting Pool (1929) and *The White Man's Garden* (1930). David Martin based his *The Man in the Red Turban* (1978) on his experience in India in 1948–49, taking two young Australians along the Murray River in the company of Ganda Singh who tells them about his childhood. Martin, a Hungarian migrant and a passionate explorer, in *The Chinese Boy* (1973) recreated the experiences of a group of Cantonese goldseekers on the Victorian and Kiandra fields, poking gentle fun at the barbarous behaviour of the Europeans. In *Hughie* (1971) he created an Aboriginal boy, an alien in his own land.

David Lake was born in Bangalore, brought up in Calcutta and educated in England before teaching literature in Vietnam, Thailand, India, and finally, Queensland, where he wrote his children's novel, *The Changelings of Chaan* (1985), a Cambodianish futuristic fantasy in which a white boy is still the hero. Allan Baillie, whose fiction often involves children in challenging circumstances, some of them in Asian countries he has visited, wrote of a Cambodian boy on the run from the Khmer Rouge in Cambodia in *Little Brother* (1985), and his daughter and his Penang-born Chinese wife were the models for the characters in *The China Coin* (1991). His own visit to China coincided with the Tienanmen Square massacre, and his novel was a response to the challenge he felt to turn 'a pleasant story' into an account of real events for young Australians.

Nigel Krauth and Caron Krauth wrote *Sin Can Can* (1987) for teenagers, making a Bali holiday—an increasingly common experience for young Australians—the vehicle for satire of adult stereotypes. Because she has absorbed these images, Ashlie isn't rapt about going:

> All I'd learnt about Asia from the tele made it sound like an overcrowded open drain full of beggars.

Predictably, she and her parents emerge irrevocably changed by the experience, but not before Ashlie has been able to observe a Bali sunset that looks to her like a scene on an Australian surfer's panel van, and tourists who want to dress like Balinese while the Balinese want to dress like tourists.

Bali, on a popular level, had by the mid-1980s become the cultural crossing-place where Australia and Asia met. R. F. Brissenden in 1980 brought out what was probably the first Australian poem on the subject, pairing Vegemite Jaffles and Buddha Sticks, Balinese boys on Hondas with blonde girls from Curl Curl.

EVEN IN 1990, according to a critic, Australians' image of Papua New Guinea, formed by film, fiction, and the Pacific war, had not changed.

> All the average Australian knows about PNG is the Kokoda Track, Errol Flynn . . . and that Papua New Guineans to a man are blood-thirsty savages, maddened with lust for the fragile flowers of Australian womanhood.

Australians who wrote fiction about the South Pacific in the decade before Papua New Guinea's independence in 1975 were partly responsible for perpetuating perceptions that were long on memories and short on expectations. No writer since McAuley had found much to be idealistic about. The heirs of Errol Flynn included Maslyn Williams, Keith Pickard, and Desmond O'Grady as Australian observers of the temporary *mastas*, whose time was about to expire. Their stories reflected the theme.

John Emery, John Stafford, and Robert Carter all wrote kiap (patrol officer) novels reliving the decades before independence and contrasting the 'beastliness and horror' of cannibal society with the new system which would inadequately replace it. Carter in *Prints in the Valley* (1989) envisages his kiap and Koam, a woman with second sight, even after their death at the hands of clay-men, heralding a future free of cross-cultural divisions. But in Emery's account of a punitive mission into the highlands, the Australian 'sky people' are reduced to adopting the practices of tribespeople by the sex and violence that attracts them to the country. The novel is awash with both. Emery, who was brought up in Papua New Guinea himself, found it 'frighteningly magical, darkly blood-thirsty and primally sexual'. Life there represented everything that conventional Australia was not.

Pickard found the same pre-independence years less bloody but equally sexual. His two new arrivals, Corinne and Darius, are said to constitute a 'Nigger Lovers' Society' as a result of their local affairs, and are scorned by both sides. In the same years, Helen, in *A Lease of Summer* (Jean Bedford, 1990), joins a group of academic expatriates and locals in uninhibited swapping of partners. Nigel Krauth, who had taught in Papua New Guinea, in *JF was Here* (1990) combined a retrospective fictional account of the life of the chain novelist Beatrice Grimshaw with a *fin de siècle* story of her grandson, walking the Kokoda Trail with his lover, a New Guinean man. Krauth, like McAuley, Williams, Emery, and Shearston in their various ways, responded with deep empathy to the question Papua New Guinea posed to all Australians, of why they were there: 'I felt it was where I should have been born,' he said. For Bedford's Helen, however, to arrive or leave is merely to exchange Illicit Spaces, Moresby for Balmain.

After independence, Trevor Shearston, who had lived in Papua New Guinea from 1968 to 1976, began a series of novels about the country. Although he deplored the falsification of Australians' experience in Papua New Guinea at the hands of early romance and adventure writers, and their stock characters—strong, upright patrol officers, benevolent missionaries and beautiful women anthro-

13
Australians and Asians

Oceanians: *Post-independence fiction about PNG and the South Pacific*

pologists—he was not interested in portraying all colonialists as violent, sexist, and racist. So in *Sticks that Kill* (1983), he went back to 1900, when the issue was Australia wresting control from Britain, but when the personalities and pressures were hardly different from those on the eve of Papua New Guinea's independence from Australia.

Time about to expire was also the theme of *A Boat Load of Home Folk* (1968) and *Beachmasters* (1985) by Thea Astley, as well as *The Children Must Dance* (1984) by Tony Maniaty. Astley caught an Anglo-French condominium in the South Pacific at the turn of the tide, the moment when the colonial powers have stayed too long and the new claimants of authority are not quite ready to run the place; she compared colonial behaviour, learned from the British by Australians, and by islanders from them, and found more tolerance, grace, and euphony in the colonised than among the colonisers. On Maniaty's island, the Democratic Republic of Inhumas is already in place, and only bits of Portuguese litter remain; the struggle becomes a post-colonial one between the Livres and the Fragas. One of the colonists recalls the words of a Portuguese queen fleeing from Napoleon in 1807: 'Don't go so fast. People will think we're running away.'

In the end, all the colonists have left are the ridiculous symbols of their former grandeur, the tattered, damp remains of flags, proprieties about tea, ashtrays, cleanliness, and what R. L. Stevenson called 'mercantile Christianity's blundering trespass'. People risk their lives for such things. Some die for the most trivial reasons: a mere dispute over medical treatment in Shearston's *White Lies* (1986) and a card game which leads to a man being kicked to death in *Something in the Blood* (1979). Cordingley, the British Foreign Office chap in *Beachmasters*, sees through the symbols but can say nothing:

> How could he speak honestly of the criminality of colonialism, the banditry of planters and trading empires, of the fools of men who strutted on the red carpets of tradition sustained by a bit of coloured rag, centuries of acute class distinction and belief in their own godhead?

The revolutionaries make the symbols their targets. As a result, a mission hospital and an arrogant missionary's ego are both flattened in *White Lies*, and his church is torched. Schools get burnt in *Beachmasters*, in *The Children Must Dance*, and again in 'Virgin', a story in Shearston's *Something in the Blood*. A university library goes up in flames in Barry Oakley's Papua New Guinea independence story. Similarly, in Rod Jones' novel of colonised China, *Julia Paradise*, fire consumes a mission school, an ikon of the white man's power, another of which was similarly destroyed in Carlton Dawe's *The Mandarin*, written almost a century earlier. Even the elements turn against the colonists, whose shibboleths are gone with the wind of cyclones and typhoons in Astley's, Shearston's, and Maniaty's stories.

On the narrow colonial verandahs of these novels, where men are the colonists and women the baggage, soured white female

characters proliferate. Violet Fletcher in *Sticks That Kill* speaks for them all, for Belle in *Beachmasters*, Barbara in *White Lies*, and Ethele in *Bilong Boi*, when she attacks young Rhys:

> '. . . But you, Perce—Gilbert—all of you—you've little idea what it's like for *a woman* living here. All of you sitting on your precious little heaps. Looking around to see who's on a bigger heap than you are—who you can knock off his heap. You're all afraid to be honest with yourselves, let alone with each other.'

Lies, as Shearston suggested, are the gang-nails in the colonial scaffolding. Australian expatriate society is no less patriarchal than British, and in both, lies and double standards about sexual liaisons are integral to the scheme of things: a Catholic priest with a mission boy; Corinne with Tokram; Rhys with Boio; everyone is living out 'white' lies. Macho protectiveness of white women, a mainstay of novels about colonies, conceals the fundamental lie: that white men could have sex with Papua New Guinean women, disown their offspring, and get away with it, while black men could not do the same in reverse. Grilles on windows in the country are even now called 'boi bars'.

Hypocrisy about sex is reflected in hypocrisy about language. Shearston's stories often revolve around what can be said or not said, by both Australians and Papua New Guineans, and in front of whom. Both Rhys and Ruth, a missionary of the new generation in *White Lies*, are aware that their knowledge of local languages enables them to betray or manipulate those who taught them. Several of the Oceania writers have used pidgin in their novels, with or without glossaries: Astley created an italicised variant she called 'seaspeak' in *Beachmasters*, explaining that pidgin is not condescending or colonialist unless the speaker or listener thinks so.

For Woodful, Astley's headmaster, the advent of independence brings the loss of everything he has believed in, but paradoxically it also brings his greatest linguistic moment, when he capitulates and uses seaspeak to good effect, which until then he had considered was 'talking down'.

Some of Shearston's stories were translated from the original pidgin, and he tried deliberately to preserve its flavour. The pidgin word 'boi', for example, subtly conveys a suggestion of homosexuality which is left unstated in the narrative. Other pidgin words enrich, rather than erode, the effectiveness of language: manples, wanpis, tanimtok.

Australian Oceania fiction is a barometer of changing assumptions. In his historical novel Shearston reported the whites' attitudes of 1900, their views of the natives as cheeky, impertinent, stupid, or vicious. Closer to independence, in *Something in the Blood*, he found a change. It is exemplified in the reaction of the Australian planter, Stuart, to the death of the wife and son of his houseboy, Kelare. Having regarded him as 'some sort of complicated animal' to be disciplined and trained and, if possible, liked, Stuart is surprised to find in Kelare depths to which he is not admitted, and is uneasy about this subtle limitation of his power.

Questions about which side you are on, common in fiction about India in the 1940s, arise again in pre-independence Oceania fiction. In *Beachmasters*, the boy Gavi Solway who is part Australian, part British, and part French, represents the trilemma facing his island. A 'rough-as-guts-bugger', an Australian, asks him:

'You're hapkas aren't you?
The boy's white half flinched.

One token of identity after another fails Gavi: the church, the school, and Lorimer, an Australian who lives (and dies) like a guru on a remote mountain.

For several of the characters in these stories, travel is the usual quest for identity. Each time it is to the interior of the country; each time it involves an old man and his writings; and each quest in one way or another ends in failure. These inland pilgrimages, like a series of trials in European mythology, with initiations and temptations along the way, end with a climax which brings the protagonist to a new self-awareness. What Shearston said of himself applies to them all: 'You come back a completely different person to the one that went away.'

John Kolia (formerly John Collier) took the identity debate further and, having lived in Papua since 1956, became naturalised on independence and chose to stay. Having made the Expatriate Shift, he identified with Papua New Guinea and deplored the destruction of its traditions. In one story, he too has an old PNG hand as his exemplar, who reverses colonial tradition by finding the colonists, administrators, and missionaries amusing. Burning down a church would represent no disaster for him; he preferred native structures to survive. Kolia cynically understood the lure of modernity for the people and, for all his hostility to it, could see the funny side of grafting one culture over another. But in a later story, *Without Mannerisms* (1980), Kolia examined the two violent cultures, the black and the white, to which PNG is heir.

In Louis Nowra's *Palu* (1987) and Robert Carter's *Prints in the Valley*, the laid-back, casual view of the funny side of PNG, which was one side of the colonial legacy, is not present. Palu tells her story from jail in a hypothetical republic presided over by her husband, who is about to execute her; and Carter's character, Koam, who has second sight, denounces the falsity of ritual savagery. Both novels are diachronic, and in both, the past presages a future of chaos. Both women become victims. Palu, who is present at independence, witnesses a 1788-like orgy and an 1888-like attack on Chinatown. Working as a cleaner in Australia while her husband becomes a Third World hero in political exile, Palu is the vehicle for ironic comment on the colonial process in reverse, including the new nation's backslide into corruption. As its president, her husband constructs a weird new ideology out of tribal symbols, Western technology and Phantom comics, witchcraft and sorcery.

Vitatavu is another fictional British/French island group in the South Pacific in Peter Corris' thriller *The Cargo Club* (1990). It is a

convenient location for an Australian secret agent to destabilise a potentially radical minister in the government, with the Soviets under the beds, and a steamy social mix. The rationale is simplicity itself: Australian Intelligence doesn't like the idea of Russian bases with a straight run west to Townsville. This Australian does not emerge much changed by his experience:

> My old dad told me the Pacific was a good spot except for all the bastards shooting at you. I guess I found it pretty much the same.

The whole Pacific remains the Adventure Zone, a generalisable, violent setting for thrillers.

This sort of fiction had been read and written so consistently for so long that it seemed a response to something deeper, something Conrad and Shakespeare knew when they brought Willard and Kurtz, Prospero and Caliban, together in Illicit Space: the codifiers of enlightenment and the releasers of dark mysteries. Australian male novelists, torn between the two, showed themselves to be both attracted and repelled.

Journalists: fiction by and about Australian news media people in Asia—a new world— Kipling and Koch—journalists as newcomers—common themes and outcomes

THE TWO DECADES between 1965 and 1985 saw the publication of more than fifty Australian novels set in Asian and Pacific countries, which reassessed and mostly rejected the images of the past. Six interlinked reasons for this outpouring emerge: the withdrawal of Britain from east of Suez; prosperity; better education; more contact with Asia, through Asian students, migration, trade, travel, and the media; the end of the Vietnam War; and the restoration of relations with China.

Australian novelists hardly became instant sinomaniacs in 1972 as some politicians did. By the time new Australian novels about China began to appear, the China euphoria had already degenerated into disillusionment with the Cultural Revolution. The few writers who were instantly expert enough to make fictional comment on China were not dewy-eyed idealists but experienced journalists. Ian Moffitt had been there in the 1950s and then had worked in Hong Kong; Margaret Jones reported from Beijing in 1973–74, a period which, as Mao said of revolution in general, was not a dinner party.

A more deeply felt cause of the re-discovery of Asia in Australian fiction was the British demise—as Australians saw it—from the region in 1966, leaving east of Suez wide open. From the 1970s on, tales from the hills and the south China seas would still be plain, but they would be by, and about, Australians. As one of them, Blanche d'Alpuget, wrote in 1981, the British raj, in retrospect, was 'so different that it seemed unreal now, and ridiculous'. Along with this, as the Americans turned their backs on Vietnam, Asia seemed an untrodden beach for Australian Crusoes, theirs until the next wave broke. Writers shared a sense that Asia was their new world, a place where Australians could stop cringing or snarling at the West, could dispense with the 'resentful need of faraway authority', as Bruce Grant called it, and could write as they pleased.

By no means the first Australian writers to travel in Asian countries or to write about them, they felt as if they were, which was almost the same thing. Glenda Adams went to Indonesia zealous to bring East and West together and to save the world. Robert Macklin made his protagonist in *The Paper Castle* (1977) an idealistic Australian politician who seeks to liberalise migration from Asia. It was the hope of new relationships, as well as the disillusionment that followed, which d'Alpuget sought to reflect in her first novel, *Monkeys in the Dark* (1980) about Indonesia:

> I was writing . . . as much about Australians in the sixties as about Indonesians. I chose the metaphor of a liaison between a rich, good-natured woman and an impoverished, desperate man to convey what I believed was the relationship between our two countries.

Macklin too was concerned about Australian identity, defined by the dilemma of Asia. His conservative politicians, even in the late 1970s, conceived of Asia as 'an alien place, a threatening place', with 'hundreds of millions . . . living in starvation conditions, corruption everywhere, no education', and still talked about skin colour. Like most of his real-life counterparts, Prime Minister Jamieson's acceptance of Asian immigration as a fact of life is grudging, and even the reforming Senator Carlyle uses the time-honoured Australian phrase about Asian proximity, 'whether we like it or not'.

When Christopher Koch got off a ship bound for Europe in 1955 to spend several months in India, and wrote a novel about it a decade later, he saw the experience less as the crossing of a mere gangway and more as a venture into the void. He, and Australians generally, Koch believed, had drifted

> across a suspension bridge made from three decades—a bridge that swings above the enormous gap between the end of an empire as ubiquitous as Rome's and our unknown future.

In *Across the Sea Wall* (1965; revised 1982), Koch's young Australian, travelling across India on second-class trains with his friends, (one an Indian), echoes the delight Koch experienced. Yet Koch's closest companion was Kipling, who had also loved the Great Trunk Road. *Kim* had been read to Koch by his father, and he had grown up steeped in Kipling. Koch's account of being mistaken for a sahib was like a re-enactment of Kipling's stepping ashore in Bombay in 1882, when he felt like a 'prince entering his kingdom'.

Clearly responding to dualities in Kipling—who called the Filipinos 'half devil and half child'—Koch recorded Hamilton's first impressions of Jakarta, in *The Year of Living Dangerously* (1979), as a netherworld of colour, smells and heat, sensuality and danger, the childish and ancient, the toylike and the fearful, the gimcrack and the laughable, the queer and the miserable, 'carnal nakedness and threadbare nakedness'. Kipling wrote:

> I find heat and smells and oils and spices, and puffs of temple incense,

and sweat and darkness, and dirt and lust and cruelty, and above all, things wonderful and fascinating innumerable.

Koch's Robert O'Brien, in *Across the Sea Wall*, finds similar dualities, the 'double smell of excrement and incense', in India.

British boys' fiction until the Second World War had been dominated on one level by Kipling, Rider Haggard, P. C. Wren, G. A. Henty, and the like, and on another by *Chums* and *Boys' Own* papers. Young Chris Koch read them in Tasmania, his Antipodean, upside-down England, and Europeans' adventures in the empire became his imaginary otherworld. He responded readily to Kipling's ambiguities: English values and Indian instincts, imperial morality and colonial creativity, the allure of beauty and its dangerous dark side. Koch's duality was epitomised by the fact that in those days Australian citizens had British passports. He lived in an independent, yet still dependent country. Koch realised that Kim and his creator Kipling were the same person, pulled both ways by their two identities, and that in this (as in much else) they were like himself.

His own fiction was filled with doublemen. In *Across the Sea Wall* O'Brien's enigmatic lover Ilsa, a migrant Australian, is composed of contradictions like the goddess Kali. Koch was struck by the similarity between Anglo-Indians and Anglo-Australians (and hence between himself and Kipling/Kim). Each, he thought,

> had a foot in both camps: in the one overseas that they were supposed to love (truly their soul's country) and in the other that had taken possession of them in childhood.

Koch endorsed the *fin de siècle* belief expressed by Kipling and Rider Haggard that Western civilisation was overripe; it would decline as drugs and perverse practices, which he observed in America in the 1960s, took hold. England for him still had the allure of the 'cultural Blessed Isles', but as he continued his exploration of Hindu mythology, the *Ramayana* and the *Mahabharata*, and their manifestation in the Indonesian Wayang kulit, he became more convinced that transmigration of the cattle-centred Hindu culture gave Australians an affinity with India and Indonesia which the West did not share:

> What I did not consider then but am convinced of now [Koch wrote in 1980] was that it was those Indians who were our brothers under the skin—not the British. We have turned out to share a similar destiny.

KOCH'S BROTHER PHILLIP, on whom Hamilton is based, was a journalist representing the ABC in Jakarta during Sukarno's coup. Many of the new novels about Asia were by or about journalists. These were often semi-autobiographical, first novels about relatively inexpert, pragmatic, apostatic Australians, conscientiously free of the racial prejudice and imperialism of earlier generations, but mostly disinclined to get too caught up in con-

tentious local issues. Most of the authors had been at universities, though Glenda Adams—whose protagonist Neila, in *Games of the Strong* (1982), is exceptional in being politically active—was the only one who had received any formal education about Asia or learnt an Asian language. She was the only one who sought to blend into the local culture.

Awareness of the political quicksand they were treading made journalist writers edgy about taking stances and naming names. Just as in the Oceania novels—in which Timor masquerades as Inhumas, Vanuatu as Trinitas, and Santo as Kristi—euphemisms proliferate for newspapers and radio stations, and for countries: Cambodia is Khamla in Margaret Jones' *The Smiling Buddha* (1985), Punan in Maslyn Williams' *The Temple* (1982), and Chaan in David Lake's *The Changelings of Chaan* (1985); Angkor Wat is given a different name in each book. Robert Drewe has Dick Cullen, in *A Cry in the Jungle Bar* (1979), working for the United Nations, and visiting five named Asian countries, but he is based in an unnamed Manila where an anonymous Marcos has imposed martial law on a nameless Philippines.

The Far East Fallacy is alive and well in Cullen's view of the Philippines, to which he refers as 'Asia', as if one is interchangeable for the other. Cullen's wife Margaret, driving to Baguio, perceives the Philippine nipa huts, sarisari stalls, and San Miguel signs, road chickens, pariah dogs, and bare-bottomed children as an 'Asian scenario'. Cullen has a drink with Jenny Loh, who has 'canny Asian eyes'. That Cullen is an expert in Asian agriculture makes his culture-bound attitude to Asians all the more absurd. Blinkered as the Cullens are by their ignorance and assumed superiority, they fail to come to terms with the individuality of Asian countries and people. She shops and is a hypochondriac; he lurches from bar to bar in five countries.

Jon Cleary in *Pulse of Danger* (1966), and Morris West, John Rowe, and Robert Allen in their Vietnam novels, dispensed with Australians almost entirely, as figures lacking authority. The journalist novels dealt with Australians' ignorance of Asia by inserting interlocutors who might be British, Americans, or locals. Chris Koch gave his Australian innocent abroad in *Across the Sea Wall* an Indian guide, and the part-British Hamilton in *The Year of Living Dangerously* had the international 'old Indonesia hands' of the Wayang Bar as well as Billy Kwan to introduce him to Jakarta. Robert Drewe's all-Australian couple have their neighbours, an Australian and her Filipino husband, as guides to Asia, as well as an American and a smooth Bangladeshi who are Dick's colleagues and fellow-drinkers.

Bruce Grant's Cherry (*Cherry Bloom*, 1980) and Margaret Jones' Gilli (*The Smiling Buddha*) are Australian women whose British husbands are their intermediaries to Singapore and Cambodia; both women also have Americans as lovers and alternative interpreters of events. These nationalities are reversed for Joanna Robinson in Jones' other Asian novel *The Confucius Enigma* (1979). Blanche d'Alpuget's women have Australian men as authority-figures: the diplomat, Sinclaire, plays this part for his

cousin Alex in *Monkeys in the Dark* (1980); and the High Commissioner, Hobday, fills the mentor role for Judith in *Turtle Beach*. But both turn to non-Australians, including their Asian lovers, for other views. The implication of Australia's dependence on the judgment of former Western masters to lead it in these strange lands, is hard to ignore. Only Glenda Adams, the Indonesian speaker, locates her protagonist within the society, but it is one where everyone, including her mentors and lovers, plays double games and no-one's interpretation can be trusted.

British expertise is in retreat. In Maslyn Williams' novel *The Temple* the foreign experts are American and Polish-American; in Margaret Jones' *The Smiling Buddha* they are American, French-speaking Cambodian, and Irish-American, even though the latter is modelled on Australian Neil Davis; in Ian Moffitt's *The Retreat of Radiance* (1982) the Australian old-timer Quinn has a trail of interlocutors leading back to the past, including Americans, Japanese, a series of Chinese characters and crooks, and British has-beens. Moffitt's earlier stories included vignettes of the British in Hong Kong and India, centring on beached, blubbery relics of the old system, moral cowards, and conmen. But in 'Overnight in Agra' a gauche Australian newcomer is pitted against a calculating Englishman who, by the end of the story, has escaped bizarre entrapment in a hotel, symbolically leaving the gullible Australian to bear the white man's burden as his successor.

In some of this fiction, the end of empire takes the emblematic form of a British doctor, washed up against the bar of some pub or club, but still with a degree of *savoir-faire* and hereditary assurance which the Antipodean newcomer in Asia lacks. This doctor appears as Agett in Maniaty's Oceania novel, as Ayres in Rod Jones' *Julia Paradise*, and as Trumble in Astley's *Beachmasters*. His presence suggests that these Australian new writers on Asia, as well as their readers and publishers, did not yet feel it was quite credible to cast Australians in roles of confidence, mastery, and authority, knowing what went on and calling the shots. Those parts were still reserved for Americans, and for British remnants. The new generation of Australian writers, indeed, with their newfound distaste for racism and colonial domination, could scarcely identify any Asian whom an Australian had the right to dominate.

The male protagonists of almost all the journalist novels reflect their creators in being on short-term investigative missions of some kind, often self-motivated, in Asian countries. The women's missions are significantly different. There is work, assigned to them by some man: Judith's Sydney editor sends her to cover the refugee story in Malaysia, Joanna and Alex are found jobs in Beijing and Jakarta by their diplomatic cousins, Gilli's boss gives her journalistic assignments in Cambodia, and Neila has propaganda to write. But then there are the objectives of conscience they are drawn to as well: Cherry works for her friend's release from a Singapore prison; Gilli, Judith, and Neila become committed to helping groups of refugees; Joanna tries to get medicine for a man she thinks is Lin Piao (Lin Biao). The women are all seen as young and relatively inexperienced, headstrong but with a social con-

PLATE 19 *Kiku Eizan,* Hour of the Dog in the Evening, *from* The Twelve Hours of the Green Houses (Yoshiwara) *(c. 1804–29) colour woodcut. Accounts of the entertainment quarter by both Japanese and foreigners made it the subject of vicarious fantasy, an Edo theme park. (Australian National Gallery, Canberra.)*

PLATE 20 *Rupert Bunny,* On the Balcony (Champ de Mars) *(c. 1913) oil on canvas, 222.5×180.7 cm. Bunny's japonisme was sometimes overtly expressed in balconies, screens, and fans, and sometimes suggested in the poses of leisured women in loose teagowns. (Australian National Gallery, Canberra.)*

PLATE 21 *Jenny Watson,* Alice in Tokyo *(1984) oil, acrylic ink, and horsehair on hessian, 208×170 cm. Utamaro's courtesans, holding tiny teacups, have their successors in George Baldessins' performers and Watson's Alice, a knowing innocent abroad. (Rosslyn Oxley Gallery, Sydney.)*

PLATE 22 *Katsushika Hokusai*, A Magician Turning Paper into Cranes, *from Manga vol. 10, (1819) woodcut. In 1812, Hokusai made a large number of amusing sketches for a drawing manual*, Denshin Kaishu: Hokusai Manga, *published 1814–19, which from the 1850s gained great popularity in the West. (State Library of Victoria.)*

PLATE 23 *Ethel Spowers*, The Gust of Wind *(c. 1930) colour linocut on paper, 22.0×16.6 cm. Japonisme stimulated artists' sense of modern design and offered a fresh vision of ordinary life. (Australian National Gallery, Canberra.)*

PLATE 24 *John Wolseley*, The Day the Termites Flew, no. 2 *(1987) oil on canvas, 205.5×138.0 cm. Quoting from 'Lau Tsu' (Laozi), Wolseley noted transmutations familiar to Hokusai in his journal: 'I will have rock, Boab tree, termite mound described by outlines, projections, patterns of termite flight across them . . .' (22 Oct. 1985). (Australian Art Foundation.)*

science, nurturers of life, higher-principled than the men and less inclined to be antagonistic towards Asians. But all of these Australian protagonists, men and women alike, find their tasks more complicated than they expected because of the complexity of the Asian societies where they must perform them.

A THEME COMMON to most of the journalist novels is the Australian's first encounter with an Asian country and the experience of arrival. The airport scenes are virtually interchangeable with accounts of Asian harbours half a century earlier. This is typical:

> We walk out into a blast of heavy hot air and huge sheets of rain pelting on the black bitumen. There are dozens of small brown men staring up at us from under yellow plastic capes . . . the men of the East.

Because knowledge of Asia acquired by Australians over 150 years had not effectively been passed on, or only in stereotypical terms, this generation of novelists wrote as if they were discoverers of a new world, yet they inherited the predispositions of the past to its hygiene, morals, poverty, danger. The journalist writers were merely the latest to reflect them. In all the novels, the foreigners whose senses are affronted are the ones whose inadequacy makes them feel threatened, who are in Asia but not of it. Moffitt's Australian reporter, going to interview Mr Harry Yee about Confucius, momentarily has the same sensation in Sydney's Chinatown. Not until late in the 1980s would Australian novelists write of arrival in Asian cities as a less overpowering experience, or omit writing of it at all.

Having arrived, the first place for the culture-shocked Australian journalist to repair to was the foreigners' bar. As d'Alpuget observed,

> in an alien culture the instinct to become part of a group intensifies. In Asia we look for the succour of friendship—either that of Asians or that of other foreigners—with an urgency unknown to us at home or in countries whose mores are close enough to our own to be familiar and reassuring.

While each of the journalist novels has its bar, the Jungle Bar and several others in Drewe's novel are important retreats for Cullen, and the Wayang Bar in Koch's even more so. Here the Westerners take cover from the regime, the rules of survival are explained to newcomers (and the political situation to the reader) and in Koch's novel the Wayang puppets are introduced in their roles as commentators on and imitators of the action. The Wayang Bar, like Kipling's, Forster's, and Orwell's British clubs, is the foreigners' 'spiritual citadel'.

But the Australians in the journalist novels, like their authors, wear the ties of no school, club, or regiment, if they wear ties at all. Koch's narrator, Cook, recognises that the mateship of the Wayang

Bar is spurious, a camaraderie made feverish by tension. Over all the drinking holes and oases where Australians retreat from Asia hangs the sense of fools' paradise and its coming end, a presentiment familiar to them from Australian invasion fiction. A second expulsion from Eden looms. Those on the inside are aware of the pressure of numbers outside. The hotel in Drewe's novel is the Eden, and around the Hotel Indonesia pool where Koch's Hamilton meets Jill, foreigners are watched through the fence by brown faces whose owners know that these 'pastures of bliss' will some day be theirs.

Yet some of the foreigners never leave, or keep coming back. Bill Geraghty in *The Smiling Buddha* is an addicted curry-eater whose Australian family will break up before he is prepared to leave Asia. International rejects in the happy hunting ground for 'white misfits, petty tyrants and dreamers' are tolerated in Asia as they are nowhere else. Others stay in Asia because they find travel itself stimulating, even erotic. In Drewe's novel, the American Galash finds arrival in the Illicit Space of a new country an aphrodisiac: 'the traveller had masculine power'. Wally, the mainstay of Koch's Wayang Bar, tells how even in post-Orientalist Indonesia, boys are delivered to his room like hamburgers:

> 'Somehow, with another race it doesn't seem so wrong. I felt like Andre Gide, discovering the beautiful Arab boys—you've read the journals? South-East Asia—the Australian queer's Middle East.'

When they emerge from the bar and the bedroom and set about their missions, the journalists' purpose, time and again, in these Asian stories as in the Oceania novels, involves a journey inland, up a high mountain, into the heart of darkness. If they had met and decided on themes of universal mythology and how each should apply them to Asia, the results could not have been more congruent. At the end of the quest is a friend or an 'old hand' foreigner to be freed or avenged, an ancient monument or, for the journalists, the answer to a mystery, the 'big story'. Moffitt's *The Retreat of Radiance*, Margaret Jones' *The Confucius Enigma*, and Nicholas Jose's *Avenue of Eternal Peace* (1989) all involve long quests into China in search of wise old men. In Richard Beilby's *The Bitter Lotus* and John Upton's and John Romeril's plays *The Hordes from the South* and *The Floating World*, men are in search of the truth about a son, a father, or themselves. In *Turtle Beach* a woman seeks her children. In Glenda Adams' *Games of the Strong* Neila hunts for the truth about both her parents. No-one seeks a wise old woman.

Climaxes occur on mountains, as they do in the Oceania novels. At the climax, the illuminating wisdom of the East and its dark dangers collide. Those who do their best to deny the foreigners the enlightenment they seek, or trick them into false perceptions, include corrupt, barely scrutable males, and bitch-goddesses. In Don'o Kim's *Password* the Chinese hero Noh, who has a deceptive Russian lover, Iveska, undertakes a dangerous mission into the mountains, while Margaret Jones' journalist Brock in *The Confucius Engima* is targeted by Sophie, who is probably with the KGB.

Echoes of Adela Quested's experience in the cave in *A Passage to India*, and of the Melbourne schoolgirls in *Picnic at Hanging Rock* (Joan Lindsay, 1967) are heard with Jungian clarity, assisted by light/dark, rational/passionate cues. Judith, in *Turtle Beach*, is swept away by the Thaipusam mountain festival to which she goes with Kanan, her Tamil lover. He is so dark that his skin seems purple. Alex Wheatfield, in *Monkeys in the Dark*, her hair the colour of straw, goes up to Bogor where her dark-skinned lover Maruli ritually marries her. Koch's Hamilton has a bizarre encounter with Vera, also at Bogor, who is cast as the black goddess of Hindu and Wayang mythology, the opposite of his fair Jill, his 'Arthur Rackham nymph, his English Alice'. Koch did not need to have read Kim's adventures in the mountains with Russian spies, nor did d'Alpuget did not need to know Han Suyin's *The Mountain is Young* (1973), to be aware of the universal theme of Eastern passion, the dark side, overcoming a Western woman's rational inhibitions.

With modern young women joining men as protagonists in the Asian Adventure Zone, the old conflict between head and heart, foreign and local, race and class loyalty gained a feminist dimension as well. The women in the journalist novels are aware of their subordinate status and share fellow-feeling with local women. They see through the double standards that govern foreigners' behaviour, the covering-up of sexual perversion, and the economic manipulation of women. Alex, hurt by her lover's callousness, is comforted as a sister by Ibu Hadi, who says they are both 'just the poor slaves, picking stones out of rice'. Both Alex, and Judith in *Turtle Beach*, lose their Asian lovers by rejecting the double standard. Judith, recognising that Kanan exploits her as cynically as her Australian husband does, and as the diplomat Ralph Hamilton does his Malay whore, senses the universal sisterhood of the underclass:

> This was the real Asia: infant girls abandoned on rubbish dumps; women murdered for losing their virginity; wives divorced by the repetition of three words; villagers stoning to death helpless people because they were Chinese. No mercy here for the weak. You'd be kissed in public whether you were embarrassed or not. Kissed, killed—it was a matter of degree only, the source was identical, disregard for the unimportant.

Robert Drewe's masculine impression of Asia was the mirror-reverse of this. Describing the environment in 1986 as simultaneously menacing and erotic, moral and immoral, he echoed the familiar attraction/revulsion, Prospero/Kurtz dichotomy of male writers in the Illicit Space of Asia. 'I could go further', he added,

> and say that many western men would fantasize that Asia was one big nameless nightclub, one lush Garden of Eden where the women are petite, subservient and available.

It is interesting that although Koch's Guy Hamilton, Drewe's Cullen, and Maslyn Williams' Spotwich, and men in James McQueen's stories are attracted at one time or another to the idea of

making love to an Asian woman, only one of the protagonists in the journalist novels and a couple of McQueen's and Brissenden's characters actually do so. Affairs, for the male Australian central characters (apart from Moffitt's Quinn) are had not with Asians but with foreign women. Ambassador Hobday in *Turtle Beach* has abandoned his Australian wife and has married the Saigon bar-girl Minou, but he continues to see her as the classic Asian mistress of Orientalist fantasy:

> What power he had felt owning Minou! The tricks she'd do for him, eager as a circus poodle, while he held the whip.

Few of the affairs prosper. Had they been with Asian women, by the Butterfly definition none could have done so. It follows that Minou, the Asian wife, dies. Hamilton is exceptional in leaving the country to join Jill, and even as he flies out there is a hint of disillusionment to follow. But these are not the cynical exits of Westerners from Asian affairs à la Puccini: the only one of the stories in which an Western man abandons an Asian woman is Moffitt's 'Willow Pattern', and there his Curtis is scorned for playing Pinkerton. Instead the Australian protagonists, men and women alike, are the ones who emerge scarred by their affairs or rejected by their lovers, including those who are Asians. A few will stay in the country, but most leave, and mostly for Australia. The solution to the complications of 'the East', as Ayres says in *Julia Paradise*, is as simple as an airticket home. But issues of dominance are not so simply resolved.

Not until Robert Brissenden's *Poor Boy* (1987) does an Australian bring his Asian woman back to Australia for the happy ever after. Judith, in *Turtle Beach*, is the first to admit her love for another woman, Minou, but by the end of the novel Minou is dead. Not until Ross Davy's *Kenzo* (1985) do male homosexual lovers appear, and Peter Corris' *The Cargo Club* was the first, apart from *Julia Paradise*, to give a lesbian affair a central place in the plot. Julia and her German lover Gertie leave China together but the question of their future does not arise; Gertie is terminally ill. In Robert Allen's *Saigon, South of Beyond*, the lesbian lovers are parted. But the sun had certainly set on stereotypical sexual relationships in Australian fiction about the Adventure Zone east of Suez.

IN EACH OF the journalist novels of the 1960s and 1970s, as well as in some later Australian fiction about Asia, the outcome is enlightenment of a sort, with the sadness of innocence and immaturity lost, and experience gained. This is frequently a metaphor for Australian ignorance and prejudice, tested, found wanting, and abandoned. The hard-bitten Quinn learns almost to love his Chinese enemies and, in freeing himself from hatred, finds purpose in his life. Even Spotwich has at last understood what goes on in Punan, and for that reason must die, drinking a kamikaze cocktail.

For some, the realisation dawns that if Australia is to change, its attitude to Asia must do so. Cherry Bloom is forced by her

British husband and her American lover to face up to the reality of Asia, a subject that does not impress her flighty friends in Melbourne. Australia is second-rate, Tom the American says,

> not serious about being true to anything. It's on the make. Nor is it serious about being part of Asia. It's trying to con the Asians into thinking it doesn't mind them, in the hope they'll leave it alone.

As if to prove the point, each of the journalist novels has an Australian as its central figure, and while the Asians are not stereotypes, few are complex, fully developed characters. Some are surrogate westerners. Several remain enigmas, like Wu in Margaret Jones' China novel, Kumar in Koch's, everyone in Glenda Adams' *Games of the Strong* and, as well, in Jean Bedford's *A Lease of Summer*, one of the Oceania novels. Cullen and Quinn both encounter a wide selection from the Asian family of humankind, but they are seen in profile because of Cullen's ineptitude and Quinn's cynicism.

Blanche d'Alpuget broke new ground with her two Asia novels by taking the reader into the houses of her Malaysians and Indonesians when no Australian is present and exploring what they think. Barbara Hanrahan would do the same, with no foreign characters at all, in her Chinese girl's self-told story, *Flawless Jade* (1989). Jade, like d'Alpuget's Kanan, and their families and friends, appear in close-ups which expose racial and sexual prejudice within Asian societies, instead of among Australians.

D'Alpuget could reverse the image and look at foreigners as though through Malaysian eyes:

> The boat man waited patiently for the foreigners to begin swearing at him and the women to give him sour looks with their nasty, pale eyes. They had the unpleasant, milky smell of all white people. The men were already shouting at the island servant boys to hurry with the luggage.
> 'Absolutely typical,' Julie Ashby was saying. 'Lie and cheat . . .'

Yet Alex's betrayal by Maruli depends upon his retaining a degree of inscrutability, a part of him from which d'Alpuget as narrator and Alex as lover are barred. They can enter his mind, but only so far. The same is true in *Turtle Beach*, in which the final veil is never lifted to reveal Kanan's private feelings about Judith.

Poor Boys: *non-journalist novels—drugs—new familiarity, new ignorance— purpose and lack of purpose— satire and clichés—new endings*

THE LATE 1980s produced novels whose Australian characters in Asian countries, like their creators, were usually not dependent on journalism for a living. Although David Foster was given to claiming cynically that writing fiction was the last card in every man's pack, having a decade earlier given up a promising scientific career for it, he and Ross Davy, James McQueen, and Jan McKemmish at least had the support of literary grants; others, Bob Brissenden, Roger Pulvers, David Brooks, and Nick Jose were academics and then authors; Rod Jones was a teacher and Barbara

Hanrahan a printmaker. Nancy Corbett, a Canadian who arrived in Australia in 1973, worked as an editor and as a professional punter, among other things, before writing *Floating* (1986). Gerard Lee, who wrote *Troppo Man* in 1990, and Michele Nayman (*Somewhere Else*, 1989) were sometime journalists, but Lee was as well a teacher and film scriptwriter, and Nayman had worked in advertising.

The way young Australians lived had profoundly changed between the 1960s and the 1980s, and certain manufactured substances were essential facilitators of the change as well as symptomatic of it: birth-control pills and hallucinogenic and addictive drugs. These, together with the universal, genderless, classless use of jeans and sneakers profoundly altered the way people travelled in Asia and, it is not unreasonable to suggest, the content and style of fiction about it.

Koch and many writers before and after him had remarked on the keenness of perception that accompanies arrival in an Asian city for the first time. David Foster in 1987 saw it less as a result of the impact of Asia than of the fact that now Australian travellers habitually covered long distances and arrived jet-lagged or high: 'That means we are seeing things as though we were stoned or something. It impinges on us in a more heightened way.' Pauline, in Robert Allen's *Saigon*, and an Australian woman in 'Funeral at Tautira', one of James McQueen's stories, are heroin addicts. The morphine addiction of Julia and Dr Ayres was one element— another being feminism—which gave Rod Jones' *Julia Paradise*, set in the 1920s, its modern relevance. For Mary Stevens, in Jan McKemmish's *A Gap in the Records*, a handful of painkillers and speed is the normal way to deal with a hangover in Paris after arriving from China and Hong Kong. Contrary Pete Blackman in David Foster's *Plumbum* (1983) travels with his heavy metal band from Bangkok to Calcutta to Amsterdam—drug capitals all— without indulging in drugs 'only because he lives in a world where everyone uses them'.

Some 150 years after the opium wars, the Chinese in Nicholas Jose's *Avenue of Eternal Peace* have turned the tables on the foreign devils and are corrupting Australians with bronzes, porcelain, girls, boys, currency, and heroin in a Beijing bar. Drugs, apparently, had a greater capacity to bring East and West together than much else that had been tried. Roger Vickery wrote short stories about the drug trade in Thailand; and Kings Cross, in Robert Brissenden's *Poor Boy* and in Nancy Corbett's *Floating*, is Sydney's Greenwich Village, Montmartre, and Patpong all at once. For Marele Day's detective in *The Case of the Chinese Boxes* (1990) Asia is as close to home as Sydney's Chinatown: Cabramatta is the nearest she's been to Asia without leaving the country.

In these novels the women are eclectic about lifestyles and lovers, and most now go to Asian countries on their own initiative, skimming the air routes with aplomb. Gone are the yearnings for life-long commitments, the dependent roles, and the agonising over pregnancy and contraception that preoccupied the women in the journalist novels. Julia Paradise, like Louis Nowra's Palu,

seems to be a victim but turns out to be the manipulator of the men around her: both are women of the future, as is Julia's lover Gertrude. Dr Ayres, the ageing pederast who has preyed on little Chinese girls, looks at Gertie and

> it always seemed to him afterwards that he had been looking into the face of the future, the face of the twentieth century.

Ross Davy's Linda in *Kenzo* (1985), is a 'very late twentieth-century girl', as is Jin Juan in *Avenue of Eternal Peace*, and the American Dulcia who turns the old fear of Oriental seducers back on itself by handing out to her unsophisticated Chinese lovers copies of *The Joy of Sex*.

Names in these non-journalist novels are fearlessly and topically named; and cities and countries need no disguise. 'Asia' as a whole is virtually unmentioned; individual countries are what count now. In *Avenue of Eternal Peace*, Jose gave his chapter titles in Chinese characters, and translated the names of Wally's Chinese friends, producing such absurdities as Eagle, Pearl, Lotus, Jumbo, Sunshine, Build the Country, and Philosopher Horse, and giving nicknames to others—Foreign Trader and Party Greenhorn. But this was not the old, ignorant amusement at what Chinese names sounded like in English. Jose and Hanrahan on China and Pulvers on Japan— one of whose characters is Noborigama, Climbing Kiln—conveyed their amusement from inside the culture with accuracy and humour, not from outside it with contempt and carelessness. Jose was the first Australian writer of fiction to take the trouble to explain his use of pinyin romanisation.

In other Asia novels of the 1980s and early 1990s, however, old-fashioned respect for grammar, spelling, style, and proof-reading seemed to be dispensed with, like shibboleths of the past. Some illustrations showed that Australian literacy in Asian written languages had not greatly risen in a century. Joan, in Jan McKem-mish's *A Gap in the Records*, finds a Second World War bunker on the south coast of New South Wales with 'some apparently Arabic or Japanese glyphs' written on the wall. In Brian Castro's novel, *Birds of Passage* (1983), an Australian Chinese finds his ancestor's diary behind a mirror but cannot tell, because of the deficiency of his education in Australia, whether the characters are Chinese or Japanese. In many Australian minds, something of the Far East Fallacy lived on; the image of Asia as an undifferentiated, remote place, full of inscrutable Asiatics gabbling indecipherable languages which it was not worth Australians' trouble to get the hang of.

But since the essence of the post-modern is the ironic, renewed scrutiny of the familiar, some of the novelists of the post-modernist years, led by David Foster, saw Australian ignorance of Asia in the 1960s as ripe for satirical review in the 1980s and 1990s. The first Australian writer of fiction to reveal knowledge of Menière's syndrome, Foster took two members of his heavy metal band, Plumbum, to the Kangaroo Club in Bangkok, but instead of finding the reassuring ambience of the journalist novels, and unable to distinguish 'one Oriental race from another', they wander

instead into a high-class brothel for Japanese. Nicholas Jose, on the other hand, reversed familiar fiction by giving the place at the bar formerly occupied by British old hands and sharp, purposeful Americans to Ralph the Rhino, a 'raving Aussie ocker', who, in spite of his accent and adjectives, knows more about China than most.

In novels of the post-modern years, the all-male, all-foreign journos' bar is gone. In Tokyo's gay discos, drinking takes place with no stools and no rules in Ross Davy's *Kenzo*. Nancy Corbett's eighteenth-century courtesan Hanatsuma and her twentieth-century counterpart Hannah dance to entertain men in a floating world that extends across the centuries and the hemisphere from Yoshiwara to Kings Cross. A cruder version of their floating ethic motivates Davy's young Australians and Japanese: if it feels good, do it. When this place palls, 'cuss, and move on'. They might have been embarrassed, however, by the intrusion on their scene by Andrew Paton (in *Tokyo no hana*, 1990) whose 65-year-old creator, Robert Allen, was still writing of Japan, without irony, as the Illicit Space of the 1960s, a place where serial sex with unequal partners was what you, a Western man, could expect.

But the encounter with Asia was no longer a climactic entry to a new world. These novelists' Australians are already in place in Asian countries, moving from one capital to another. In Robert Drewe's stories in *The Bay of Contented Men* (1989), in Michele Nayman's in *Somewhere Else* (1989), in James McQueen's Australian-in-Asia stories, and in Brian Castro's second novel, *Pomeroy* (1990), they are playing out their personal dramas on a set that is as likely to be Tokyo, Chieng Mai, or Hong Kong as the Gold Coast. Before leaving for Hong Kong, Nayman's journalist Laurie Michaels 'already felt like Suzie Wong'. Marele Day easily transposed China, food, drugs, and Tongs, to Sydney. It was newly credible for Melissa Chan, an Australian lawyer, to write crime fiction about Australia as an Asia-Pacific country. It was now plausible for Castro's Pomeroy, a private detective, to speak two Asian languages. Maniaty's Ranse, on his Timor-like island, is an Australian who has come from Bangkok, not from Australia. These Australians live in, or alongside, an Asian society; they don't peer out at it from a hotel pool or down on it from a bar stool. Close contact makes them less judgmental, less morally judgmental, less different.

But progress was not uniform on the home front, if Robert Drewe's poignant 'The Needle "Story"', in *The Bay of Contented Men*, about a Malaysian-Chinese doctor hounded to suicide in Perth was typical of the experience of Asian Australians. Another Malaysian-Chinese suicide ends David Martin's Melbourne story 'Staying on', in *Foreigners* (1981).

Few Australians in this newer fiction are driven to Asia by a sense of purpose, and such goals as they have are different in kind from those of the journalist novels. In *White Light* (1990), James McQueen's Italian-Australian, Caramia, goes to Bangkok to buy rubies and to track down a German-Australian, a former Nazi, who in turn is there buying orchids. Wally Frith in *Avenue of Eternal Peace* has what he calls an 'oblique causation' for going to China: to

find a Chinese cure for cancer as well as to resolve a dilemma that symbolises the dilemma of Australia, the imbalance between his grandfather's love for and his father's hatred of the Chinese. Mary Stevens, however, in *A Gap in the Records*, is without ideals, a political neutral, a trained assassin, ironic, motiveless, post-modern. Hannah, in *Floating*, who lives on the dole and dances in clubs, appropriately meets Jack on the Manly ferry, a floating world on which they can—or could then—drift all day in the sun for a dollar. Their art is their only purpose.

Self-absorbed Harriet, in Ross Davy's novel, writes a lot of grant applications but not much of her master's thesis on Buddhism. Her friend Linda at first has no motive at all except to have a good time. 'One of the reasons she came to Tokyo was to get away from modern narcissism,' Linda solemnly tells herself, surrounded by the world's greatest concentration of narcissists, both Japanese and foreign. She dabbles in Zen meditation and loses interest; on impulse she takes smooth trains to distant parts of Japan. A typical excursion, a 'journey without a climax', ends high on a mountain not with enlightenment but viewing a new stupa, 'a giant white fondant elephant joke of neo-Buddhism'. Kenzo's lover, Tatsuo, who frequents a coffee shop near Shinjuku with Louis XIV chairs, chandeliers, and a Fragonard ceiling, has to go to California where Zen is taken seriously, to get interested in it. Kitsch is transnational; the archetypal has been commodified. A Beijing palace courtyard, in Jose's novel, is now a rivet factory.

Hannah in *Floating* is convinced that the course of her life in Sydney is predetermined by that of a courtesan in Edo Japan. After the evening crowds have left Kings Cross and Yoshiwara, the geisha, the transvestites, the players and stayers remain, the 'people who didn't belong and couldn't fit in anywhere else'. Yoshiwara had been a theme park for Edo Japanese: Kings Cross in the 1980s was equally escapist. The East as a retreat for eccentrics and outcasts from the West had not closed for business, but the traffic now was two-way.

Australians had been in Asia long enough to be sent up. Foster mocked the stereotypical Australian response to the sights, sounds and smells, the crowds, corruption, and cruelty of Asia: but experiences that gave Australians in Koch's, Grant's, and d'Alpuget's novels ethical indigestion are relished by Foster's characters.

> What *texture* life has here [in Calcutta]! Jason is enraptured. He abandons himself gladly to what Ghalib has called 'the ferment'. Into the vat go refugees, the dispossessed, the landless, the Raj, the silk trade, the millionaires, the Marxists: add water, water that pours in torrents from the black monsoon sky . . . in this huge reflux condenser, under whose slimy coils dregs settle as husks and butts, turds and ashes . . .

The Plumbum musos complain about the noise level in Bangkok, which offends even their metal-stunned ears; Pete admires the *Bangkok Post* as having quality he is unused to; Rollo eats and eats from street stalls with no ill effects. Foster satirised, as well, the

perennial foreigners' claims about untrodden paths, having Jason go off in search of

> the Real Bangkok, a mystical city reached through a dark alley off Chinatown ... [where] bare-breasted women flick rambutan pips into the dark waters of canals, as smiling Teravada monks accept sweet-smelling garlands of jasmine.

Gerard Lee's Matt, in *Troppo Man*, is a send-up of every Australian who ever claimed not to be a tourist and to have found the 'real' Bali and 'undiscovered' artists in Ubud. Kevin Brophy's chair salesman Erno, in *The Hole through the Centre of the World* (1991), is a tragi-satiric version of the Australian businessman out of his depth in China. For Mary Stevens in *A Gap in the Records*, it is a relief to fly across the pole from Hong Kong and 'down to the earth of anciently civilised Europe. It felt like coming home'. Anciently civilised China has made little impression on her, although in this case no satire appears to be intended.

Oriental inscrutability is not dead, in spite of greater Australian familiarity with Asia. Obfuscation is practised not on Wally alone, who likes China, but by the Chinese on each other in Jose's novel, on Erno in Brophy's, and on everyone in Glenda Adams' *Games of the Strong*. All are victims, all are aggressors. The lenses are reversed and reversed again. Nicholas Jose's gay Englishman, Clarence, sees Autumn as a dirty cherub, while the Chinese boy sees Clarence's 'pale, funny-shaped face, like a kind of horse'; the novel involves a double disguise, in which Jin Juan impersonates Azalea, a male actor of female roles in Chinese opera, to seduce Wally. Her grandmother, moreover, turns out to have been the wife of the old professor Wally is seeking, and the adopted daughter of Wally's missionary grandfather from Adelaide. A similar impersonation of Mao's designated successor, Lin Piao (Lin Biao), by an actor, is central to the plot of Margaret Jones' *The Confucius Enigma*.

The soft-hearted or high-principled hero who befriends a token Asian or African and goes to great lengths to save her or him had appeared often enough in Western fiction and film for this to become a self-suggesting theme in the journalist novels. Koch's Billy Kwan and Jones' Peter Casement, d'Alpuget's Ralph Hamilton and Brissenden's Tom Caxton all foster Asian children and their mothers, and Grant's Cherry Bloom takes responsibility for a part-Chinese child. A human-interest theme, it was also one that revealed high principles in dominant imperialists and hearts of gold in hard-bitten Australians. But in the fiction of the post-modern years, no such easy solutions to the myriad problems of Asian societies were possible, least of all coming from Australians.

Although in Jose's novel, Wally befriends and helps Eagle and Clarence fosters Autumn, neither is allowed to walk tall off the last page; in post-modern times, aid does not buy friends. The small Chinese girl for whose sake Julia Paradise extracts long and complicated vengeance from Ayres the pederast is long dead before the end of Rod Jones' novel, and Julia's objective is a feminist point of principle, not gratitude. Aid does not even buy token

Max Pam, What the Papers Say *(detail of four panels, 1985). While Australian artists like Pam concentrated for most of their working life on Asia, and several sought to redefine Australia's connections to the region by redrawing the map, some representations of Asia and the Pacific left Australia out altogether. (Art Gallery of Western Australia.)*

survival: Maria, the dancer in Upton's play *The Hordes from the South*, refuses the Australian couple's paltry 200 Australian dollars before she gets shot. Instead of love-matches, real-life deals get done: O'Rourke's Aoi, the Good Woman of Bangkok, accepts his money for a farm but not his condition that she give up prostitution. Noree, a Thai woman in James McQueen's *White Light*, helps Caramia with his ruby deal and sleeps with him once, but only to ensure that he leaves Thailand without the former Nazi he has tracked down there.

David Foster supplied satirical proof of clichés about aid in *Plumbum*. Like the heart-of-gold foreigners of the past with their one token Asian, Pete adopts Satya, a street-wise Indian kid who by begging for food can sustain both himself and Pete, living on their outdoor staircase in Calcutta, so well that the protein-rich diet makes him ill. Pete is tutoring him to go to Geelong Grammar and insists on the best of medical attention even though he, an Australian, is as destitute as his Indian neighbours. Rollo, on the other hand, who keeps himself alive on what he earns at the post office, selling and reselling stamps, sees India's problems in Lang Hancock's terms: 'the best way to help the poor is to make sure you don't join them'. Aid is trenchantly defined as taking money from poor people in rich countries and giving it to rich people in poor countries.

One by one, the stock themes of Australian-in-Asia novels are sent up by David Foster, Gerard Lee, and Kevin Brophy. Lee's satire of Australians in Bali, in *Troppo Man*, deals with several clichés: the Expatriate Shift, Australian attempts at Asian languages, transliterated speech, sensory epiphanies, foreigners' paranoia, and American mentors (one of whom says: 'We're all crazy, deep down'). Brophy deals with others in *The Hole through the Centre of the World*: the Far East Fallacy, the shock of arrival, the issue of dominance, and the Butterfly Phenomenon, this time in the form of a disposable Chinese prostitute. Foster's targets are not only the cultural cringe, self-discovery, altruism, and the quest for identity, but Antipodeanism, the Adventure Zone, Asian hordes, and peacetime invasion; not just Porter's Schizophrenia about the contradictory Japanese character, but dichotomies in general (yin/yang, Calcutta/Canberra). Yet in Foster's *Mates of Mars* (1991) the dualities of Taoism suggest paradoxical answers to Australians' perplexities.

Foster's purpose was more than satirical. In sending his band, Plumbum, and his martial artists to the third world, he was exposing middle-class Australians to the real poverty, hardship, and anguish that inspired the blues and the Buddha, an experience that changes their lives as it did his own. Twenty-seven years after Koch and Robert Brain had been the only Australians getting off the ship at Bombay and, like Kipling, had been treated like sahibs, Foster had the same experience getting off a plane at Calcutta, and found it ironically enjoyable. For Australians in post-modern Asia were no longer sahibs even in their own imagination, and settler Australians were being outclassed by their Asian competitors. 'We're all poor boys,' says Caxton in Brissenden's novel.

David Foster, aloof from Australian literati, sought consciously to join the third world that included Aboriginal Australians, Korean and Malaysian martial artists, and the multicultural crews of prawn trawlers in the Gulf of Carpentaria—a world which was both attractive and threatening. In Calcutta, he had shared the experience of Moffitt's Australian in the hotel in Agra, of panic at being surrounded by uncontrollable forces, a 'huge wall and torrent of terror' about to fall on him in a blacked-out dining room. Unlike his Plumbum musos who weave easily through the Calcutta crowds, Foster shut himself in a hotel room, writing, speaking to no-one, agoraphobic and on the verge of madness, and then, like Pete, was thoroughly fleeced by a beggar. Five years later, from 'sleepy hollow Australia', however, Foster could so miss the feeling of being fully alive which he had in India that, reversing the exits-for-good of the journalist novels, he declared he wanted to go back, to live and die there.

In fiction in the post-modern period, new endings became possible. Australian lovers are sent sorrowing away. This is true of almost all of James McQueen's protagonists in *Lower Latitudes*, and in *White Light*. Wally, in *Avenue of Eternal Peace*, will leave China but without Jin Juan, and Clarence leaves for England without his lover Autumn, who abandons him to join the army. Dulcia manages to take her Chinese lover to America, but he has his own agenda in readiness, and it doesn't include staying with Dulcia. Getting out of China, as Clarence remarks, is no longer a solution, either to personal or Chinese problems.

David Brooks, in post-modern style, in *The Book of Sei*, offers two endings. Jan McKemmish has several alternative endings for Mary Stevens' exploits in *A Gap in the Records*, adding: 'it is not complete. There is no end'. The last ending offered has Mary arriving at Alice Springs and simply disappearing—the same fate of minimalist shrinkage, like a dot from a screen, as Roger Pulvers devised for Ron in *The Death of Urashima Taro*. In a final, dream-like sequence in a setting like a Nō stage, Ron, like Mishima Yukio in *Yūkoku* or Neil Davis in Bangkok, is the dramaturg of his own death. *Floating* ends in an equally spaced-out manner. A second Kanto earthquake shatters the floating world in *Kenzo*, leaving all Linda's fun-loving friends dead or likely to die, while she, because 'there is nothing else left to do', simply walks away. To Australia? Japan? The answer doesn't matter.

Asian Australians:
Autobiographical novels—
Ching-Chong-Chinaman—
reverse images—reverse culture
shock

BARBARA HANRAHAN, GLENDA ADAMS, and Nancy Corbett each created a protagonist who was her 'Other', an Asian woman in an Asian country. Uyen Loewald's girl in *Child of Vietnam* (1987) was herself. Parallel with them, another group of characters appeared in the 1980s who reflected their creators. The writers, who produced novels, plays, and poetry, included Brian Castro, Don'o Kim, Dewi Anggraeni, Achdiat K. Mihardja, Idrus, Sang Ye, John Lee Joo For, Ernest MacIntyre, and Yasmine Gooneratne and all were 'Asian' Australians.

Castro, born in Hong Kong of Portuguese and Chinese-English

parents, was the first Australian to take up in fiction the experiences of the Chinese in colonial Australia with a sense of kinship. In his *Birds of Passage* (1983) Seamus O'Young, an Australian-born Chinese living in Sydney, has as his alter ego and ancestor Lo Yun Shan, who travelled from China to Victoria in 1856. Seamus becomes the amanuensis of Shan, bringing into play variants of their names: sham, shaman, shin (new), san (mountain), and so on, even though at school in Australia he has learnt no Chinese. Seamus/Shan, like Castro, is a 'perpetual exile' struggling against national typecasting:

> If I write something horrible or nice about Australia I am still uneasy about being called Asian, Chinese or Australian . . . They are surprised when they find I am not Chinese-looking or a ratbag or a priest.

Seamus, a century after Shan, is still taunted in Australian schools where in spite of his exoticism, or mystical barbarism, he is seen as inherently inferior, a 'Ching Chong Chinaman'. The same words rang in the ears of characters in Mena Abdullah's, Don'o Kim's and Yasmine Gooneratne's fiction, none of whom was Chinese, as they did in real life in Jenny Kee's at school in the 1950s. While their responses ranged from amusement to aggression, the effect of the teasing on Seamus is to make him isolated and obsessive. It is women, as in d'Alpuget's, David Martin's and Don'o Kim's novels, themselves outcasts and fringe-dwellers, who identify with and help Seamus.

Kim Dong-ho, born in North Korea, arrived in Australia in 1961 as a post-graduate student and became Don'o Kim. By 1990 he had lived about half his life in Korea and half in Australia. Through all his work, including his Australian novel *The Chinaman* (1984), ran a semi-autobiographical absorption with men cut adrift from their ancestral moorings, clutching in life's cross-currents at what is of value: love, honour, loyalty, political idealism, understanding. Each of Kim's protagonists is a 'spiritual orphan', whether it is Tian, alienated from family and friends by war; or Noh in *Password* who leads a double life between China and Japan and whose aspirations for a central Asian kingdom, Tartaria, are unfulfilled; or Joe, whose intellectual pursuits are utterly at odds with his day-to-day job off the Queensland coast on a luxury yacht appropriately named *Quo Vadis*. Kim relishes the irony of Joe, known to the Australian oafs and drifters on the yacht as the 'Chinaman', being partly Jōbu, a Japanese, and partly himself, a Korean Australian.

Dewi Anggraeni's women characters inhabit both Indonesia and Australia equally. In *The Root of All Evil* (1987), her semi-autobiographical Komala, married to a flawless Melbourne doctor, reverses the usual pattern of Australian-in-Asia fiction when she visits Jakarta to see her dying father. Komala, Indonesian-born, experiences the Australian shock of arrival in Asia: crowds, heat, smells, traffic. She is Christian now, a writer and a feminist, and uses expressions like 'fair enough' and 'bludger'. She shocks her family by going to a nightclub, but is herself shocked by

Indonesians' exploitation of women and servants. Women, acording to Komala's mother, are the root of all evil of the title: but although the sisterhood of the underclass exists, Komala sees women driving down their own value by competing with each other to get a man and keep him. Komala, like foreigners in the journalist novels, makes an altruistic effort to save a token Asian, a bar hostess blinded in an acid attack by the jealous wife of a wealthy man. 'Was I a foreigner in my own country?' Komala asks, somewhat super-fluously.

If Anggraeni intended a satire on Australian-in-Asia novels, she could not have replayed more of their themes in this and her subsequent novel, *Parallel Forces* (1988), in which twin sisters of sophisticated Indonesian and French parents are occasionally mis-taken for Filipinas or South Americans by Australians, who also seek to correct their French. But both grow up to be successful professionals, friendly with and married to Australians. Anggraeni displayed none of the cross-cultural angst of the male Asian Australian writers.

Although settler Australians from the 1960s onwards had become less sure that British identity made them superior to Asians, or had come utterly to reject that assumption, many in Asian countries continued to doubt that Australian thinking had progressed so far or that they were entitled to such a view in the first place. Writers from Asian backgrounds replayed this familiar theme about Australia back to readers in their former home countries, making their Asian protagonists, like Kim's Joe, lonely men of culture in an inimical environment.

Achdiat K. Mihardja created such a character in Rivai, an Indonesian journalist and writer, in *The Dust of Love Scattered* (1973), and Australian hicks and bigots abound in Idrus' *The Story of Princess Penelope* (1973). Both books were published in Indo-nesian. A Malaysian poet living in Western Australia, Ee Tiang Hong, made the same point with more restraint in English, seeing Australians as a complacent, materialistic people with no place at which to converge and no issues worth converging about.

Achdiat and Idrus looked for and found discrimination against migrants, Aborigines, and overseas students in Australia in the 1950s and 1960s. Australian women in Achdiat's novel are portrayed as sexually promiscuous, just as Asian women so often were in Australian and Western fiction about Asia. Rivai and his Indonesian friends are fascinated with white flesh and bikinis. They see Australian males either as violent or threatening, or as unattractive wimps, much like the stereotypical Asians in Western fiction by male writers. Distaste for miscegenation appears to be mutual: these Indonesians' affairs with Australian women do not develop into cross-cultural marriages. In Idrus' fairy tale, an Australian royal princess is in love with an aristocratic Javanese student. The government in Canberra is desperate to marry her off even to a royal bastard as long as he is European: the young Indonesian marries a German instead. In both novels, the attitude to Australia is of contempt.

Sang Ye, whose exploits in Australia included transcontinental

journeys by motorbike, collected oral histories of Chinese in Australia in *The Year the Dragon Came* (1991). It included a cynical account of life as a prostitute in Brisbane by a woman who had entered Australia as a student in 1988, and whose scorn for the system that had allowed her to stay was equalled by her disdain for Australians.

Roger Pulvers, having tried for years to gain acceptance for Asia in Australian theatre, left for Japan five years after John Lee Joo For arrived from Malaysia, where he had been the *enfant terrible* of Kuala Lumpur theatre. Kai Tai Chan had arrived ten years earlier and for similar reasons. Responses in Australia to Lee's *The Propitious Kidnapping of a Cultured Daughter* (1978) were among the things that drove Pulvers away; critics' reports included such headings as 'A Chinese Puzzle' and 'Never the Twain Shall Meet'. But like Kai Tai Chan, Lee persisted, working as an art teacher and writing plays which he believed Australia needed to 'break out of its sham-refuge Ockerism'.

In Lee's *Sarong Aussies* (1979), the petty hopes and indulgences of Alan are used to suggest that the presence of Australians in the RAAF squadron, boozing and basking at Butterworth, was a satire of defending Malaysia. Alan's mounting fears of it all coming to an end are punctuated by the insistent and rising percussion of the maid chopping food for a party. The Butterfly Phenomenon re-appears: Alan pays the pregnant O-Lan off while maintaining the double standard with his wife Wendy, whom he accuses of having a 'native romeo'. In terms that hark back to invasion fiction and Rosa Praed, Wendy retorts that she and her lover Cheng share an interest in Asian culture: the thinking Australian woman's customary answer to Antipodean man.

In 1978, Lee had burst upon the Melbourne scene at the Playbox with his *Propitious Kidnapping*, an interpretation of the Patty Hearst story in Chinese opera style, with a yin/yang symbol on the floor, incense, cymbals and drums: 'Western story and Eastern style . . . embracing all the winds of the world'. In his later plays *The Satay Shop in Perth* and *Declare It Three Times*, Lee used more naturalistic techniques without abandoning his East–West theme. The first dealt with relationships between migrant Asian parents and their children growing up as Australians; the second with the clash of cultures between a Malay sultan's son in Australia and his two wives, one a Malaysian and the other Australian. His prejudice against 'black men'—Aboriginal Australians—is at least the equal of that of settler Australians.

The original title of Ernest MacIntyre's *Let's Give Them Curry: An Austral-Asian Comedy* (1981) was 'Dark Dinkum Aussies.' His Sri Lankan doctor, Hector Perera, has a 'natural empathy' with England and scorns Australians as third rate, not a part of the 'imperial process', and ignorant of Chaucer and Shakespeare. He believes Sydney men are out to get his wife and daughter, and fears America abandoning Australia to Indonesian invasion.

HECTOR: I read between the lines in the newspapers, that Canberra

had decided to hush up the coldblooded murder of five Australian journalists by the Indonesian Army in Timor . . . Fifteen million white squatters isolated precariously under the massive, swaying, creaking, historic chandelier of Asia.

Hector's Sri Lankan wife does not share his fears or his cultural elitism and wants simply to make Australia a home for her children. One of them now has an Australian boyfriend, Thommo, whose father is Hector's match as a racist, opposing the friendship because Asians generally are unreliable. This he knows because he was once charged the price of a jewel for a piece of glass in Colombo. But the young pair face a different Australia with hope. 'Maybe,' Thommo suggests, 'someone should write a play with Asians in it.' He is wrong: several people already had done so. But he is right as well: Asians were not yet unquestioningly accepted in the cultural landscape. There were not enough roles for Asian actors to earn a living in Australia then or in the 1990s; few were enrolled in drama or film school; and for the Tienanmen film *Sign of the Snake*, the leading lady, Lily Chen, was brought in from the United States.

Yasmine Gooneratne had lived in Sydney since 1972, researching Sri Lankan history, and teaching English Literature at Macquarie University, long enough to collect a copious supply of matching anecdotes from her homeland and her adopted country, and to give them fictional form in *A Change of Skies* (1991). An ancestor of the Sri Lankan couple in her novel witnessed the violent incidents at Burnett and Mackay in 1882; they encounter 'Asians Out' slogans on their arrival a century later. But they find greater acceptance in Australia, and more sophistication, than they had expected from their preconceived image of Australians. They also observe the desperate problems of Asian migrants less well-off than themselves. Gooneratne obliquely satirises the Australian-in-Asia novelists by putting her Sri Lankans through the Expatriate Shift, and then subjecting them to reverse culture shock on a return visit to Colombo, where their friends and relatives consider themselves, not 'Far Easterners', to be the real Asians, and where tensions between Singhalese and Tamils make Australia seem harmonious by comparison. Like other novels by women about Asians, *A Change of Skies* is not hostile, but amused; optimistic, not fearful.

As long as the pendulum does not swing too far in the opposite direction, with all things Asian being endowed with virtues equally imaginary, any future image of the Asian in Australia must be an improvement.

J. V. D'Cruz, 1973

V
Conclusion: The Best of Both Worlds

THE QUESTION OF Australia's place, on one side of the East–West schism or in the middle, depended on what Australian images of Asia were. It confronted all the artists in this study and produced a variety of responses.

Kipling's much-quoted cliché seemed to many Australians, as all simple images do, to have validity:

> Oh, East is East and West is West
> and never the twain shall meet,
> Till Earth and Sky stand presently
> at God's great Judgment Seat.

But they did meet in the old country Kipling knew best, India, and there was a chance of them meeting more successfully in an ancient but 'new' country, Australia, which had a historical foot in one camp and a geographic one in the other.

From the first, only those among settler Australians who were specially imaginative, disaffected, or eccentric thought the chance of East–West fusion worth investigating. Imperialist aspirations, material ambition, or religious zeal inspired some to hope that the new and old worlds, East and West, would meet and join hands to benefit their causes. But West was 'us' and East was 'them', and few saw the encounter from the Other side. Politics in Australia sided with history and against geography, even to the detriment of economics. Australians' images of themselves and their neighbours were simplistically typecast, and the process of East–West fusion was set back by decades.

But the closer the contact Australians had with the countries closest to them, the less the division of humanity along East–West lines seemed to them to make sense. G. E. Morrison, Henry James Black, and Ian Fairweather ignored such distinctions, though their breadth of vision was not taught them in Australia. Gradually, however, more Australian artists followed them, finding in Asia, and most of all in Japan, a liberating alternative to Europe, a stimulating store of tradition, a continuing source of modernity, or of perplexity, a locus for personal discovery, and their own new world.

The change was grudgingly slow, and in the 1990s was still incomplete. From the nineteenth century into the twentieth, most Australians, accustomed to having intellectual and artistic standards set for them in the West, took few initiatives of their own to develop a deeper understanding and subtler use of Asian culture. Most stayed numbly unaware or drily unimpressed by movements in the Western avant garde to do so. Australia in 1973 still seemed to the poet Andrew Taylor to be as Antipodean as ever, hanging crookedly on the globe, 'dependent in a south-westerly direction/ from the United States.' In 1988, a literary academic still believed Australians were interested in undertaking only three explorations — the voyage in search of Australia; the quest back 'Home' to Europe; and the journey into the centre of the country. But these were quests for old worlds, not new. Few people noticed the new world waiting for Australians in their own hemisphere. Few even thought of Australia as *having* a hemisphere.

14
Images of East and West

Creative iconoclasts, nevertheless, sought to redefine Australian national identity in terms of Asia, and often did so by redrawing the map. Percy Grainger selected Nordic and Pacific countries to be Australia's cultural associates. Hardy Wilson dreamed of Australia as a new civilisation on an arc between East (China) and West (America). Margaret Preston's imaginary new world was triangular, with Australia at one point, America at another, and China, India, and Japan at the third; she herself would be the bridge between East and West. Australian ceramicists, inspired by Leach's advocacy of pottery as a two-way exchange between East and West, belatedly followed his lead. Peggy Glanville-Hicks conceived an Australia-America-India triangle in music. John Olsen, led by Laozi (Laotse), produced an enigma: 'East is East but East is also West'. By 1987 composer Anne Boyd saw East–West distinctions as having outlived their usefulness for Australians, whom she thought of as having already arrived at a 'cultural cross-over place', an agora of communication. Peter Sculthorpe foresaw an eastward movement of Western musical consciousness, with Australia and Asia taking the lead by 2000. Fred Williams, for whom Chinese influences had displaced American ones, pondered about maps as the most 'universal' of pictures. For fellow-painter Geoff Lowe, the map itself had changed since his childhood. Now Australians lived in 'the Region', he said, and 'obviously Asia is part of us; we *are* more responsive to the region and Asian people *are* part of Australia.' In his 1991 novel David Foster went further, describing an Anglo-Celtic Australian as an 'outsider' among successful Asian Australians.

A characteristic of artists who were concerned to relate Australia's identity more closely to its location, and hence to make connections with Asia in their work, was that they tended also to be interested in Aboriginal culture. Grainger, Preston, Fairweather, Haefliger, Wright, Sculthorpe, Stow, Narogin, Foster, Tony Tuckson, Richard Beilby, Len Fox, Jeff Mincham, Ross Edwards, and Tim Johnson were among those who perceived the link to the Other as a double, Aboriginal/Asian strand. Louis Nowra had one of his characters speculate on what would happen if Australians amalgamated European, Aboriginal, and Asian cultures into a 'unique alchemy of history . . . a model for everyone'. Blanche d'Alpuget believed a 'new human race' was being formed, and that Australia would be the world's first Eurasian country.

Such visions emerged only rarely in a century of writing about Papua New Guinea and the South Pacific. Although Alan Moorehead in 1966 had perceived the impact of Europeans on the South Pacific as 'fatal', and their presence as an invasion, the old ideas about prerogatives of exploitation and enforcement by violence were hardly dissipated after independence; and in spite of genuine empathy between individuals, the prevailing Australian view, represented more by writers than by artists, was that the gap between the two cultures was permanent. The literature, moreover, revealed another gap, between the rationally enlightened and the darkly passionate sides of personality.

Writers, a 'language species', were generally less eager than

Australians working in the non-verbal arts to redraw the map or to dispense with history in favour of geography. Narrative film makers were still less so. Wartime propaganda and images of invading hordes in cartoons, film and fiction were mutually reinforcing. Impressions of inscrutable, devious, treacherous, or salacious 'Asiatics' began to be widely challenged only after the Pacific war, and differentiable nationalities and individual personalities took even longer to replace them. Images of starving millions, political instability, and natural disasters as the Asian norm were reinforced by television, and reports of the successes of Asian societies made less impact. But among women writers who themselves knew what it meant to be the 'Other', and who saw themselves as members of 'one oppressed minority addressing another', as David Foster put it, images of Asia were generally less hostile than those held by men. And in the western suburbs of various Australian cities, the vocabulary of Eastern medicine, cuisine, philosophy, and martial arts were entering the vernacular of 'thugs with tattoos. Bikies with beards and ponytails and beanies.'

Chris Koch and Bruce Grant did not go along with the 'geographically inaccurate cliché' about Australia being part of Asia. Koch was convinced, for all his fascination with India and Indonesia, that the European inheritance was Australians' greatest cultural treasure. He urged Australians, whom he saw suspended between two worlds, merely to develop points of contact, accepting that they and the people of Southeast Asia had different cultural identities. Grant argued that a dilemma of civilisation faced all Australians: whether to remain an insignificant appendage of Western culture or to share the variety and richness of Asia as an equal. The challenge of Asia, he believed, would 'save us from ourselves'. He argued in strategic terms that while isolation of Australia *from* Asia or domination by Australia *of* Asia were equally impossible, the American alliance remained indispensable to protect Australia from domination *by* Asia. So in his schema Australia remained yoked to the West and to history by its insurance policy against the East and against geography.

This was the yoke under which Australians had been driven into Vietnam, and which, Frank Moorhouse thought, had made 'miserable shits' of them. Certainly, the war retarded by another ten years the process of acculturation to Asia. A British academic, living in Perth, agreed with Moorhouse in opposing Antipodeanism:

> So long as Australians continue to look to Europe and America for confirmation of their own identity, they will never exist as anything but a peripheral culture, forever condemned to be an exotic and alien people.

Modern variants of the invasion theme that had occupied Australian writers for more than a century would not go away. As long as Australia was West and Asia was East, conflict remained a possibility, and one threatening image replaced another. This habit of generalisation about an entire Asian country produced absurd mood swings, from enmity to adulation and back again. Only after

two centuries did prominent Australians begin to drop the word 'inevitable' when they spoke of their proximity to Asia, and only when Australia's economic interests had changed direction did government ministers refer to that proximity as an advantage to be welcomed. Even so, when the near north was said to have replaced the Far East, it was still more often with avarice, distaste, resentment, uncertainty, or foreboding than with familiarity or pleasure. In spite of the years he had happily spent in Asian countries, puppeteer Peter Scriven was in no doubt about where Australia belonged:

> No, Australia is not part of Asia, nor will it ever be: Australia is an outpost of the First World, part of the American Empire. In the 21st century the Japanese might buy it—then?

The more powerful modern Japan became, the longer the predatory image of all Japanese as predators endured. In 1990 the poet Bruce Dawe wrote bitterly of how 'lower forms/of life give way to higher', in the 'Greater Australia Co-Prosperity Sphere'. As Japan prospered, Porter's Schizophrenia persisted among Australians. Drewe's inept, non-Japanese-speaking Australian in Tokyo, brought up on stories of the Pacific war, had a case of it, facing the dilemma, which became sexual, of whether to sneer at or to grovel to the economically dominant Japanese. Countries in 'lower latitudes' became the Illicit Space Japan once was, although in fiction in the 1990s Australian males were becoming more troubled and less dominant, even there.

'Everything's sex', declares Stow's young kiap in Papua New Guinea. This, when you consider the longevity of the Orientalist perception of Asia as female, submissive, emotional, immoral, alluring, repulsive, exploitable, and treacherous, is only a slight exaggeration. You hear its echoes in fiction by Drewe, Koch, Emery, Beilby, James McQueen, Robert Allen, and others, see it in films like *Far East* and *The Good Woman of Bangkok*, and plays like *Hordes from the South*, and encounter its sardonic restatement in paintings by Pat Hoffie, Gareth Sansom, and Jenny Watson.

Les Murray's point of reference, for all his interest in Shintō,

Aragon, The Age of Asia *(1989). The fear of indolent Australians turning into the white trash of Asia, and being overrun by cheap Asian labour or Asian ingenuity was over a century old when this cartoon appeared. (*The Weekend Australian, *1989.)*

THE AGE OF ASIA
... and how to survive it

was different. He remained '*country, and Western*'. Although he understood that a nation's rituals grow out of the land and the seasons, he asserted in 1985 that settler Australians (like himself) were still guided mainly by the imported traditions of distant lands and climates. He could acknowledge no impact of Asia's seasons on Australia, or of Australia's on Asia. But the mythological congruities of the natural environment were documented on film by Ken Taylor and Hugh Lavery, the botanical ones were recorded by Mark O'Connor, and architectural adaptations to the regional climate were suggested by Richard le Plastrier, Peter Armstrong, and others.

John Romeril wrote into *Top End* a weather song about Asia:

> . . . headed north, every June hot winds travel slowly across the deserts of Australia getting hotter, reaching Timor they bring the Dry. Months later that pattern reverses itself, monsoons build up in Asia and journey south, bringing with them the Wet. Such are the connections. Australia-Asia. Weather-wise.

He felt the way the wind was blowing, as he wrote, with Japan and China promising to be the command economies of the next century and Australia positioned close to the centre of the new, Asia-Pacific world. The future, he asserted, would depend on how Australians 'look West and look East before crossing the road', and on getting rid of what he roundly called British and American cultural imperialism.

Visual artists who found a life-force, chi (qi), in the land — John Olsen, John Wolseley, John Davis, Noela Hjorth, Tim Johnson — sensed its reemergence in Japan, India, Brunei, or Tibet: in Aboriginal and Asian places, not in Graeco-Roman or Judaeo-Christian places. For them it was natural that an Asian-Pacific spirit should inform Australian art, since both were subject to the same environmental facts of life.

By 1989 Nick Jose could declare that China, not the European canon, was 'the element in which [his] work is plunged', and dedicate his novel to his Chinese friends. But even with the arts canvassing Asian issues and with Asians living in Australia in growing numbers, deep-seated images changed slowly, not least in the minds of Asians themselves. Kai Tai Chan built an idiosyncratic, successful dance theatre, yet for him, Don'o Kim, and John Lee Joo For, Australia was still West, and they were East. Achdiat Mihardja, who had written antagonistically about Australia in the 1950s, by 1991 conceded that he loved and hated Indonesia and his adopted Australia equally.

On a visit to Australia in 1968, Indira Gandhi urged Australians to see themselves as bridging the East–West gap between South Asia and the 'new world' of the Pacific. The Indonesian poet W. S. Rendra, much admired in Australia, saw the day coming when, from an Asian viewpoint, there would be three kinds of 'West': Europe, America, and Australia. His advice to Australians was to go on being their kind of Western, but to be the West for Asia:

You will come through as a Western society and yet be uniquely different from America and Europe and help the lot of the Asian people. Through you the Asian will be left alone to be Chinese, Indian, Japanese or Indonesian. Let the Indonesian be Indonesian, and the Australian be Australian. Then we shall expand the human image.

In spite of these hopeful words, Australians' ability to write convincingly about Asia and to make good films in Asian countries depended upon their ceasing to see themselves as foreigners there and to accept Asia in all its variety as part of mainstream Australian life, as the young were indeed beginning to do. But even that was no guarantee (as Roger Pulvers pointed out) that Asians would accept them, or would quickly change their own inherited images of Australians.

IN 1991, THE Australia Council announced that it would devote half of its international budget for arts funding to the Asia-Pacific region. Although initiatives like this, together with government aspirations for Asia-literacy, and government ministers' abandonment of 'inevitable' as the adjective of choice for describing relations with Asian countries, seemed to suggest that change was accelerating, official image-making and public perceptions had been unsynchronised before.

The events of the bicentennial year, 1988, like those of 1888, must have reassured those who didn't want Australia to develop a Euro-Asian identity. Indonesians sailed a specially constructed prau to visit their forefathers' old Aboriginal friends and relations, but their north coast visit was eclipsed by the arrival on the west and east of European tall ships. Boat-people and Asian migration, some seemed to think, represented the replacement of the old tyranny of distance from Europe by a tyranny of proximity to Asia. A revival of anti-Asian feeling greeted 1988, as it had 1888. Whether statements of RSL leaders, conservative politicians, European migrants, and slogan-writers reflected majority opinion, or whether tolerance of the Asian presence was prevalent among settler Australians is impossible to say.

Now, however, Yasmine Gooneratne was living in Australia and could publish a satire of it:

> Ronald Blackstone is a sociology professor from the University of Woop-Woop who'd nicknamed a Sydney suburb 'Vietnamatta' because it was full, so he said, of Asians [who] . . . pollute the air with the fumes of roasting meat. 'And we Australians,' he'd said on TV, 'must be alert to the dangers involved for our society if we allow Asians in who cannot assimilate.'

Asians were still blamed, as in 1888, for causing hostility to their presence.

The bicentennial year passed without a concerted reshaping of Australia's national identity. Artists who might have celebrated their country's 200th year as a European outpost by devising less anachronistic musical and visual Australian symbols refrained from doing so. *Antipodes* and *Australia Felix* were among the compositions produced; a group of Australians called Terra Australis Incognita performed in New York; a pastiche flag won *The Bulletin* competition and was forgotten. Burnam Burnam took the black, yellow, and red ensign of Aboriginal Australia to the cliffs of Dover and there unfurled it in a token invasion. David Foster, fearing that Australia would end up with a British flag and an Argentine economy, was among the few, together with historian Manning Clark and composer Vincent Plush, who pleaded for Australians to assert their cultural independence with more appropriate, less Antipodean symbols, but without tangible effect.

By 1988 'multicultural' was a term some held in disrepute. Brian Castro, as an Asian Australian writer, anticipated an 'hysteria of national consciousness' during the bicentenary, but Australia, he believed, should allow its contradictions full play, and not suppress them. Choreographer Graeme Murphy was equally unafraid of

15
Another
Century

Australia's complex new world. 'Diversity', he said, 'is what makes dance strong.' But contradictions and diversities were more contained than cultivated in 1988. Not until 2001, a hundred years after Federation, would Australians have another, perhaps their last, chance to redefine their identity and to expose anachronistic images of their shared hemisphere.

Asian-born people, it was officially predicted in 1990, would not make up 7.7 per cent of Australia's population until 2021, a figure that no doubt comforted the Professor Blackstones. Those who feared that Australians' facility in European languages might suffer could take heart: Australia in 1990 was critically short of Asian-language teachers, even though there were now so many native speakers in the population, and even though the number of students taking Asian languages remained so far below those studying European ones. There was, as well, no sign of appointments to top jobs of Asians or Asia-literate Australians commensurate with the economic importance Asia was repeatedly said to have. Eagerness to hire people with their capacities remained rare in the private and the public sectors, and was largely confined to the tourism and education fields.

Reassuringly for the Blackstones, knowledge of Australians in the arts who did regard Asian countries as important and interesting was hampered by the almost total absence, until the mid-1980s, of reference to Asia as a formative influence by Australian cultural historians. No university even had a chair of Australian history until 1949, and Asian Civilisation courses were sparse until the 1970s. The 'Anglo-gripped', Euro-centric, West-skewed view of the world, which even well-educated Australians inherited, locked many into thinking anachronistically of Australia as discovered not located, colonised not invaded, and of Asian countries and (especially) Oceanian countries, as the 'white man's burden', to be dominated, democratised, developed, defeated, or defended. Euro-centrism might produce mild intellectual anorexia in some Europeans: in Australians the condition could be life-threatening.

Artists in any society have an obligation to explore beyond its limits. The Australian artists who sought to explore Asia and the Pacific did so for a wide variety of reasons, and the images they created vary as widely. But they were generally in agreement: Australia is not Asia, but Asia and the Pacific are part of Australia's hemisphere and culture, an interesting and growing part. It is clear from their work that images of Asia reflect and affect Australians' images of themselves. Further, it is clear that until Asia occupies a place equal to that of the West in Australian minds, the nation's pursuit of its interests will remain distorted. If Australia's identity and self-image are to change, they must therefore do so in a way that locates Australia in the Asia-Pacific hemisphere.

Illustrations

Unless otherwise stated, all measurements are in centimetres, in order height, width, depth. h: height d: diameter

[COLOUR PLATES]
Nicholas Chevalier, *Japanese Musicians*, 1873, oil on canvas, 61.0 × 91.5 cm, bequest of Caroline Chevalier, Art Gallery of Western Australia.
Sam Byrne, *Mt. Robe Silver Mine 1896*, 1964, oil on board, 23.5 × 30 ins, Archer M. Huntington Art Gallery, the University of Texas at Austin, gift of Harold E. Mertz Fund, 1972; photo credit—George Harris.
J. C. F. Johnson, *Euchre in the Bush*, c. 1967, oil on canvas, 42.0 × 60.2 cm, Ballarat Fine Art Gallery, bequest of Clarice May Megaw, 1980.
John Peter Russell, *Portrait of Dr Maloney*, 1887, oil on canvas, 48.3 × 37.2 cm, purchased 1943, National Gallery of Victoria.
Tom Roberts, *Mrs L. A. Abrahams*, 1888, oil on canvas, 40.8 × 35.9 cm, purchased 1946, National Gallery of Victoria.
Girolamo Nerli, *The Sitting*, 1888, oil on canvas, 119 × 77 cm, Robert Holmes à Court collection.
Raoul Dufy, *Le Plage de Sainte-Adresse*, 1902, oil on canvas, 52 × 64 cm, Armand Drouant collection, Villefranche.
Charles Conder, *A Holiday at Mentone*, 1888, oil on canvas, 46.2 × 60.8 cm, Art Galley of South Australia, Adelaide. State Government funds with assistance of Bond Corporation Holdings Ltd through the Art Gallery of South Australia Foundation, to mark the Gallery Centenary 1981.
Kitagawa Utamaro, *Gathering Shells along the Shore of Shinagawa Bay*, c. 1790, from *Gifts of the Ebb-tide*.
Andō Hiroshige, *The Lake at Hakone*, 1832–34, from *The 53 Stations of the Eastern Sea Road, Tokaido gojusan tsugi*, colour woodcut, 22 × 35 cm.
Paul Haefliger, *Sublime Point at Bulli*, 1936, relief

colour woodcut on paper, 26.5 × 36.6 cm (composition), gift of the artist, Australian National Gallery, Canberra.
Martin Sharp, *Ginger in Japan*, 1981, colour screenprint, 33.6 × 22 cm, private collection, W. Payne photograph.
Katsushika Hokusai, *Rainstorm underneath Mt. Fuji* from *Thirty-six Views of Mt. Fuji, Fugaku sanju rokkei*, 1823–29, colour woodcut, 24.3 × 36.4 cm.
Dorrit Black, *The Eruption*, c. 1928, colour linocut, 26 × 19 cm, private collection, Adelaide.
Fred Williams, *Bushfire in the Northern Territory*, 1976 (detail—number 6 of 12), gouache on paper, 57.6 × 76.6 cm, Australian National Gallery, Canberra.
Allan Lowe, *Ginger Jar*, 1952, glazed earthenware, 24.0 × 13.5 cm d., Shepparton Art Gallery.
Peter Rushforth, *Stoneware Jar Jun Glaze (Chun)*, 1991, stoneware, 26 × 23 cm, Distelfink Gallery, Melbourne.
Lorraine Jenyns, *The East is Red: in the Shape of a Mountain*, 1978, earthenware in two pieces, 54.4 × 28.5 × 31.3 cm overall (irregular), Australian National Gallery, Canberra.
Kiku Eizan, *Hour of the Dog in the Evening*, from *The Twelve Hours of the Green Houses*, c. 1804–1829, colour woodcut, Australian National Gallery, Canberra, gift of National Panasonic (Australia) P/L.
Rupert Bunny, *On the Balcony (Champ de Mars)*, c. 1913, oil on canvas, 222.5 × 180.7 cm, Australian National Gallery, Canberra.
Jenny Watson, *Alice in Tokyo*, 1984, oil, acrylic, ink, and horsehair on hessian, 208 × 107 cm, Rosslyn Oxley Gallery, Sydney.
Katsushika Hokusai, *A Magician Turning Paper into Cranes*, from *Manga*, 1814–1878 (vol. 10, 1819), woodcut, State Library of Victoria.
Ethel Spowers, *The Gust of Wind*, c. 1930, colour linocut on paper, 22.0 × 16.6 cm, Australian National Gallery, Canberra.
John Wolseley, *The Day the Termites Flew*, no. 2, 1987, oil on canvas, 205.5 × 138.0 cm, Australian Art Foundation, W. Payne photograph.

[BLACK AND WHITE PRINTS]
unknown, *Wake, Australia! Wake*, 1888, *The Boomerang*, 11 February 1888.
Tommy McCrae, *Aborigines chasing Chinese*, sketch, late 19th century, Museum of Victoria.
Phil May, *The Mongolian Octopus—His Grip on Australia*, 1888, *The Bulletin*, 14 July 1888.
unknown, *Beware the Octopus Takeover*, 1989, *The Australian*, 8 February 1989.
Alf Vincent, *The Relative Sizes of Chairs: Somebody's Move!*, 1913.
Livingstone Hopkins, *Piebald Possibilities—a Little Australian Christmas Family Party of the Future*,

206

Scorfield, *The Almost-unknown Soldier*, 1953, *The Bulletin*, 1953.

Gerald Carr, *The Exile of Fire Fang*, Vampire Comics, no. 3, 1976, National Library of Australia, courtesy G. C. Carr.

Ian Fairweather, *Perjinnan (Persimmon)*, 1951, gouache, 76.2 × 48.3 cm, dated lower rt. in Chinese 'if' [], 'Persimmon' bottom right, purchased 1952, National Gallery of Victoria.

Donald Friend, *Two Boys, Ceylon*, 1958, watercolour, pen, ink, gouache on paper, 51 × 35 cm, purchased 1959, Art Gallery of New South Wales.

John Olsen, *Improvisations on Bashō's Frog*, 1976, watercolour, gouache on paper, 79.6 × 61.0 cm, Parliament House Art Collection, Canberra.

George Baldessin, *Performer*, 1968, etching, aquatint, stencil on paper, 37.5 × 50.3 cm (image), Art Gallery of South Australia, Adelaide, d'Auvergne Boxall Bequest Fund 1968.

Heja Chong, *Tsubo*, 1988, stoneware, artist's collection.

Madam Butterfly in Australia, photographs, Mitchell Library, Sydney; State Library of Victoria; Gyger, 1990.

Les Tanner, *Hands off Asia*, 1962, *The Bulletin*, 1962.

Dennis O'Rourke, *Half Life*, 1986, poster, Ronin Films and Dennis O'Rourke, J. McKinnon photograph.

Brett Whiteley, *Self Portrait Drawing Calligraphically*, 1976, ink on cardboard, 182 × 81 cm, private collection, Melbourne.

Tony Tuckson, *White on Black, with Paper*, 1970–73, acrylic and paper collage on hardboard, 244 × 122 cm, Ballarat Fine Art Gallery.

John Davis, *Evolution of a Fish (Eight Parts)*, 1990, eucalyptus twigs, paper, calico, Bondcrete, bituminous paint, 160 × 105 × 15 cm, Jill Crossley photograph.

Katsushika Hokusai, *Instructions on Colour Painting: Ehon Saishiki tsū*, 1848.

Stelarc, *Handswriting*, 1982, photograph, artist's collection.

Herbert Flugelman, *Tattooed Lady*, 1974, ceramic, 116 cm h.; Art Gallery of South Australia, Adelaide.

Pat Hoffie, *Hotel Paradise*, 1989–90 (detail), colour laser copies on board, 145 × 336 cm, artist's collection, courtesy Heide Park and Art Gallery.

Peter Armstrong, *Courtyard*, 1977, University of Western Australia.

Jan Murray, *Untitled*, 1986, oil on linen, 3 pieces, 190 × 240 cm, artist's collection.

Mates of Mars, 1989, Samantha Foster photograph.

Max Pam, *What the Papers Say* (detail of four panels), 1985, gelatin silver photograph, Art Gallery of Western Australia.

Aragon, *The Age of Asia*, 1989, *The Weekend Australian*, 1–2 March 1989, National Library of Australia.

Glossary

(C): Chinese (F): French (H): Hindi
(I): Indonesian (J): Japanese (K): Korean
(L): Latin (M): Malay (P): Pidgin (S): Spanish
(T): Tagalog (U): Urdu

aikido (J) weaponless self-defence
Ainu (J) indigenous natives of Japan archipelago
anagama (J) single chambered sloping kiln opened from the bottom
annus mirabilis (L) a year of marvels
batik (I) wax resist dyed fabric
bijin-e (J) picture of a beautiful woman
bijutsu kōgei (J) art and craft
boi (P) native man, servant
bonsai (J) miniature potted tree or plant
bunraku (J) puppet theatre with visible manipulators
butō, butoh (J) void or blackness: modern dance genre founded by Hijikata Tatsumi in 1920s, revived in 1960s
byōbu (J) folding screen
carabao (S) water buffalo (Philippines)
chinoiserie (F) 'Chinese' style: western use of Chinese motifs for decorative, exotic or fantastic effect
chan (C) chanzong, Chinese precursor of zen
cloisonné (F) decoration with enamel set in metal
dan (J) holder of degree of proficiency in martial arts or J. chess
dharma (H) law
dimdim (P) 'white' person
dōjō (J) hall for martial arts practice
Edo (J) period when capital was at present day Tokyo, 1603–1867, under Tokugawa shogunate
e-maki (J) narrative handscroll
enso (J) work, performance
feng shui (C) geomancy
gagaku (J) traditional court music and dance
gamelan (I) set of percussive instruments
gaijin (J) foreigner

gaikokujin (J) foreigner (polite)
gasshi zukuri (J) thatched
geisha (J) specially schooled entertainer
go (J) board game with black and white stones
haiku (J) poem with seasonal subject, including change of mood or perspective, 3 lines of 5, 7, and 5 syllables
hapkas (P) half caste
Han (C) dynasty, 206 BC–220 AD
hanko (J) personal seal
hashira-e, hashirakake (J) pillar-shaped print
Hideyoshi (J) H. Toyotomi, 1536–1598
hiragana (J) syllabic script for Japanese words
hoso-e (J) narrow vertical print
I Ching (Yijing) (C) the Book of Changes, Taoist writings 1000–700 BC
japonaiserie (F) objects in 'Japanese' style
japonisme (F) incorporation into western aesthetics of devices of structure and presentation which match those forms in Japanese art
jūdō (J) unarmed self-defence, refined from jujutsu
kabuki (J) classic popular theatre, originally performed by commoners' troupes in early C16
kakemono (J) hanging scroll painting
kagami (J) mirror
kagok (K) court music
kampong (M) village
karate (J) unarmed self-defence, from China
karma (H) fate, destiny, result of past actions on next existence
katakana (J) syllabic script for foreign words
kempeitai (J) secret police
kendō (J) martial art using bamboo sticks and protective clothing (gi)
kiap (P) patrol officer
kimono (J) silk garment
koto (J) zither-like 13-stringed, plucked instrument with a bridge for each string
kris (I) long-bladed knife
kyōka (J) comic verse, 31 syllables
kyōgen (J) 'crazy words,' popular theatre, partly masked, originally performed by commoners' troupes as comic interludes in Nō drama
mandala (H) contemplative or religious circular or square diagram symbolic of unity
manga (J) sketch, comic art
manples (P) one's own locality
Meiji (J) period, 1868–1912
minkan (J) village house
Ming (C) dynasty, 1368–1644
mingei (J) folk art/craft
Mingeikai (J) Japan Folkcraft society
mokuhanga (J) woodblock print
mon (J) badge of family
netsuke (J) carved miniature figures used like a pendant or toggle
nagauta (J) 'long song', epic ballad with samisen accompaniment in kabuki
neriage (J) decorative inlaid clay technique in ceramics

ningen kokuhō (J) living national treasures: from 'holders of important intangible cultural properties' (jūyō mukei bunkazai)

nipa (T) palm leaf (Philippines)

nishiki-e (J) 'brocade pictures', colour prints

noborigama (J) multichambered climbing kiln, opening at the side

nō, noh (J) traditional, classical, aristocratic theatre combining song, dance and drama, dating from C14, partly masked

nōgaku (J) song from Nō drama

origami (J) paper folding

prau, prahu (I) dugout sailing canoe

raga (H) pattern of notes as basis for improvisation

rakugo (J) comic recitation

rebab (H) two-stringed instrument

ryokan (J) inn

sake (J) rice wine

samisen (J) 3-stringed banjo-like instrument

sari-sari (T) small general store

sarod (H) stringed instrument

sashimi (J) sliced raw fish

senryu (J) poem on wide range of subjects, 3 lines of 5, 7, and 5 syllables

sensu (J) folding fan

shakuhachi (J) vertical bamboo 5-hole flute

sheng (C) traditional vertical mouth organ

shiatsu (J) finger-pressure massage

shibui (J) aesthetic value of restraint

Shigaraki (J) durable sandy clay with coarse granules of silicon

Shintō (J) one of the two major religions, with basis in animism, naturalism and ancestor-worship

shō (J) traditional vertical mouth organ, 17 pipes

shodō (J) calligraphy

shōji (J) sliding screen with panes of white paper

shōriken (J) star shaped weapon thrown by ninja

shōmyō (J) chanting of Buddhist invocation

Silla (K) kingdom: Old, 57 BC–668 AD, Unified, 669–936

suiboku-ga (J) monochrome ink painting

Sung (C) dynasty, 960–1278

shunju matsuri (J) spring (or autumn) festival

sumi-e (J) India-ink painting, from suiboku-ga

sushi (J) raw fish slivers on rice

tabla (U) pair of small hand-played drums

tae kwon do (K) martial art

Tang (C) dynasty, 618–905

tanimtok (P) interpreter

tanka (J) poem on modern literary subject, 5 lines of 5, 7, 5, 7, and 7 syllables

tanzaku (J) narrow vertical print

Tao (C) Tao te ching,'The Way and its power,' by Lao Tsu, c.600 BC, philosophy of universal harmony and order corresponding to everyday human life

tatami (J) straw padded mats fitted in internal floors

tat-e (J) vertical paintings, prints

taubada (P) 'white' master

tayu (J) narrator for bungaku; high-ranking courtesan

tengu (J) mountain goblin

tenshi (J) ogre

torii (J) gateway to Shinto shrine

uki-e (J) perspective pictures

ukiyo (J) floating (i.e. fleeting, transitory) world of the gay quarters and the Kabuki stage

ukiyo-e (J) C17–19 paintings and prints of the 'floating world', natural scenery, and early Europeans in Japan

waigouren (C) foreigner

waka (J) poem on ancient literary subject, 5 lines of 5, 7, 5, 7, and 7 syllables

wanpis (P) all together

wantok (P) person speaking the same language, relative

wayang (I) drama: w.golek, 3-dimensional wooden puppet theatre; w. kulit, 2-dimensional leather shadow puppet theatre

yin yang (C) theory of the unity of opposites, a principle of Tao te ching; yin-female, yang-male

yoga (H) ascetic meditation and physical discipline

yoko-e (J) horizontal paintings, prints

yuzen some (J) paste applique design on fabric

yatoi (J) foreign experts (oyatoi gaikokujin)

Yi (K) dynasty, 1392–late 16C

yūgen (J) essential aesthetic value in noh

zen (J) meditational, intuitive and austere form of Buddhism

zazen (J) seated zen meditational posture

Notes

ABBREVIATIONS

A *The Australian*
AA *Art in Australia*, 1916–42
A+A *Art and Australia*, 1963–91
AB Alison Broinowski
ABC Australian Broadcasting Corporation
 (formerly Commission)
ABR *Australian Book Review*
AGNSW Art Gallery of New South Wales
AGSA Art Gallery of South Australia
AI 'The Asian Interfaces: Australian Artists and
 the Far East', ASAA conference and AGNSW
 exhibition, 1983
AIIA Australian Institute of International Affairs
AL *Australian Letters*
ALS *Australian Literary Studies*
ANG Australian National Gallery
ANU Australian National University
ASAA Asian Studies Association of Australia
AWM Australian War Memorial
AWTA 'Australian Writing Turns to Asia', AIIA
 conference, November 1980
B *The Bulletin*
CT *The Canberra Times*
EO 'Europe and the Orient', HRC conference
 July-August 1987
DOI Department of Information
G&S Gilbert and Sullivan
GW *Good Weekend*
H *Hemisphere: an Asian-Australian magazine*
HRC Humanities Research Centre, ANU
ISCM International Society of Contemporary
 Music
LS Library Society of New South Wales
MN *Monumenta Nipponica*
ms manuscript
MUP Melbourne University Press
NGV National Gallery of Victoria
NIDA National Institute of Dramatic Art

NLA National Library of Australia
NLHA *New Literary History of Australia*
NT *The National Times*
NWF National Word Festival
OAAL *Oxford Anthology of Australian Literature*
OCAL *Oxford Companion to Australian Literature*
OHAL *Oxford History of Australian Literature*
PNG Papua New Guinea
RMIT Royal Melbourne Institute of Technology
SMH *Sydney Morning Herald*
TLS *The Times Literary Supplement*
TOS *Times on Sunday*
TWA *The Weekend Australian*
UCLA University of California at Los Angeles
UNSW University of New South Wales
UWA University of Western Australia

PREFACE

Page
x J. D. B. Miller, 'Godzone: Other Places',
 Meanjin, 109, 26, 2 (June 1967), 125.

1 AUSTRALASIANS

Page
2 Said, 1985, defines the Orient as beginning in
 the Middle or Near East and extending to the
 Far East, all as observed from Europe.
 Roberts, 1935, p. 17.
 Wilton Hack, the author of one of the South
 Australian schemes, was associated with the
 Theosophical Society. (Roe, 1986; Frei, 1991).
 Japanese: 'Why should Australia not play an
 imporant role in Pacific affairs . . . considering
 her natural wealth and general progress? Japan
 should import raw materials from Australia
 . . . and industrialize herself to augment our
 nation's economic potential.'(Inagaki Manjiro,
 1891, cit. Frei, 1984).
 Matra, cit. Ged Martin, 1973.
 Young, cit. Roberts, 1935, p. 4.
 Wakefield, *A Letter from Sydney*, pub. 1929,
 cit. Levi, 1958, p. 3.
 Jefferis, 1889, cit. Ingleson, Walker, 1988.
3 A. E. Cahill, 'Cardinal Moran and the Chinese',
 Manna, 6, 1963.
 O'Dowd, cit. Manning Clark, *A History of
 Australia* V, p. 161; O'Dowd, cit. Croucher,
 1989, p. 14.
 Theosophists: Roe, 1986.
 Clarke, 1877.
 Japanese were also planning a Mediterranean in
 the Pacific: Frei, 1991, p. 41.
 Deakin, cit. Horne, 1972, p. 157.
 OCAL, pp. 44-6. In 1766 'Australasia' was
 used in the sense of 'Australia and other islands'
 (OED Oxford). *Austral-Asiatic Bulletin*:
 Andrews, 1985, pp. 86–7.

Theosophy: Roe, 1986, p. 281.

Deakin, cit. Alomes, 1988, p. 40. Deakin in 1890–1 spent three months in Ceylon and India, wrote a book, *Temple and Tomb in India*, and became active in the Theosophical Society in Melbourne. (Croucher, 1989, pp. 10–11).

4 H. McQueen, 1978, p. 2.
Convicts: Hughes, 1986, pp. 206–16.
Whalers: Sissons, 1978, pp. 1–2; Ian McArthur to AB, 16 October 1985; Bourn Russell, 'Journey of the Ship *Lady Rowena* 1830–32, with later annotations, etc.' Mitchell Library, MS3532.
Travel: Walker, Ingleson, 'The Impact of Asia', in Meaney, 1989, pp. 310–13.
Streeton to Roberts, cit. Galbally, 1969, pp. 32–3.
Wilson, cit. J. M. Freeland, 'Hardy Wilson', H, 24, 2 Sept./Oct. 1981, 108-13.
Streeton: to Frederick Delmer 1900, to Roberts 1907, cit. Galbally, Gray, 1989, pp. 84, 107. Streeton admired Edward Arnold's epic poem on the life of Buddha, *The Light of Asia* (1879), as well as calling Kipling's story 'The Light that Failed' (1890) 'wonderfully fine and true'. Arnold, Kipling, and A. P. Sinnett's *Esoteric Buddhism* (1883) and *The Occult World* (1881) were widely read in Australia. A drover in one of Furphy's stories has read Arnold (Roe, 1986). 'Esoteric Buddhism' and Theosopy were considered synonymous in the 1880s. (Croucher, 1989, p. 4).

5 Boyd, 1968, p. 7.

2 WHITES ONLY

Page
6 America: Bell, in Meaney, 1989, pp. 325–78.
Near north: Latham cit. Frei, 1991, p.184; Gilmore, Warner, 1948.
Democratic Labor Party television election advertisement, 1963: Albinski, 1965, p.458.
Wallace: Vickers, 1989, p.116.
E. G. Whitlam, address to Australian Institute of Political Science Summer School, *Australian Foreign Affairs Record*, 44, 1, (Jan. 1973), 31.
Wright to AB, July 1987. 'For we are the Antipodes, the Opposites, the Under-dogs. We still live in a hut that's upside-down . . . Some day we'll be able to think of Europe as *our* Antipodes.' (Wright, 'The Upside-down hut,' AL, III, 4, 1961, 30–34) Boyd, 1972.
Threat: Horne, 1970, pp. 213, 230.
Harries, 1979, xvii; dissenting note by J. T. Smith, p. 21.
Tyranny: Blainey, 1985.
Isolation: Harris, 1986.

7 'Are we a nation of bastards?' Manning Clark, 1980, p. 209.
Australians took part in the following conflicts: Zulu Wars, 1845; Crimean War, 1854–56; Indian Mutiny, 1857–58; Maori Wars, 1863–66; American Civil War, 1860–65; Sudan Campaign, 1885; Boer War, 1899–1902; Boxer Uprising, 1900–01; First World War, 1914–18; Second World War, 1939–45; Malaya Emergency and Peninsula, 1948–60, 1964–65; Korean War, 1950–53; Indonesian Confrontation, 1962–66; Vietnam War, 1962–72; Persian Gulf War, 1991.
Boxer Uprising: Andrews, 1985, p. 29.
1906 film: Reade, 1970, p. 28.

8 Fleet: 'The American Influence', Bell in Meaney, 1989, pp. 349–51.
Deakin, cit. Hornadge, 1976.
Esson to Vance Palmer, 1917, cit. Palmer, 1948, p. 8.
Pike, Cooper, 1980, pp. 50–1; Reade, 1970, pp. 72–3.

9 Horne, 1989, p. 186.
Cartoons: See Lindesay, 1970.
Casey, cit. Andrews, 1985, p. 161.
Gregory Clark, 'Beware the octopus takeover', A, 8 Feb. 1989, p. 11.
Tipping, 1982, p. 28. The background of von Guérard's sketch of 'Chinese in Melbourne' was a scene in Dusseldorf.
Stewart, 'The Sword of Genghis Khan', cit. Pierce, 1985.
The Age, cit. Andrews, 1985, p. 8.

10 'For Australia', 'The Old, Old Story', in Colin Roderick, ed., *Lawson, Collected Poems*, Sydney 1967.

11 Mackay, 1895; Dawe, 1895, 1900; Lane, 1888.
Furphy (Tom Collins, pseud.): Serle, 1987, p. 66.
Continuing 'colour' consciousness: Hank Nelson, *Black, White and Gold: Goldmining in Papua New Guinea 1878–1930*, 1976; Michael Moynagh, *Brown or White? A History of the Fiji Sugar Industry 1873–1973*, 1981; Nourma Abbot-Smith, *White Girl, Brown Skin*, 1969; Peter Ryan, *Black Bonanza: the Discovery of Gold in PNG*, 1991.
Evelyn, 1909, cit. H. McQueen, 1978, pp. 59–60; Mackay, 1885; Roydhouse, 1903.
'The Japanese invasion', B, 31 Aug. 1895.
Phil May, 'Both on the wallaby', 1888, showed Chinese and rabbits as equal pests. (Mahood, 1973, p. 193).
Williams, 1983, pp. 235–45.
Lindsay, cit. Dutton, 1984, p. 154.
Calwell, cit. Alomes, 1988, p. 134. Calwell cracked the notorious 'two Wongs don't make a white' joke.

12 Horne, 1970, p. 186.
Jewel: MacIntyre, 1985.

Orientalist fiction: Winks, Rush, eds. 1990, passim.

Hingston, *The Australian Abroad*, 1880, Australian edition 1885: David Walker, 'Travellers to the Orient', ASAA *Review*, 12, 1 (July 1988), 12–17.

Kent Hughes, 1946.

Braddon, 1952, cit. H. McQueen, 1991, p. 297.

13 Kipling, cit. Spry-Leverton, Kornicki, 1987, p. 17; Kipling, cit. Hal Bolitho, 'From the feudal to the future—Japan after Perry', H, 23, 6 (Nov./Dec. 1979), 369.

Eggleston, *Round Table*, 12 March 1921: cit. L. F. Fitzhardinge, 'Immigration Policy: a Survey' *Australian Quarterly*, 2 Dec. 1949.

The Times, cit. Spry-Leverton, Kornicki, 1987, pp. 21–2.

Enemy: W. Macmahon Ball, *Japan: Enemy or Ally*, 1948.

Menpes, 1901, p. 95.

Sadler, 'The influence of Japanese culture and tradition on her foreign relations', in Clunies Ross, ed. 1935, p. 107. Sadler's engaging lectures on Japan, and his collection of prints and architectural drawings fascinated younger Australians: poets Judith Wright and Harold Stewart, novelist Hal Porter, academic and diplomat W. Macmahon Ball, and Japanese scholar Joyce Ackroyd. (L. McKay, 'Pioneers in Asian Studies: Professor A. L. Sadler', ASAA *Review* 10, 1 (July 1986), 49–53).

Murdoch, 1919.

Piesse, cit. Frei, 1991, p. 99.

3 NEO-ORIENTALISTS

Page

14 Cathay: Honour, 1961, pp. 1, 5, 30.

Zipangu: see Hugh McCrae, 'The Mimshi Maiden'.

Columbia University, *Impossible Picturesqueness: Edward Lear's Indian Water Colours 1873–75*, 1989.

Kendall, 'Prefatory Sonnets II', 'Fire in the Heavens'; Gordon, 'A Dedication', OAAL, 1985, pp. 66, 67, 62.

Chinese population: Andrews, 1985, p. 33; Roberts in Clunies Ross, 1935, p. 12.

Hughes, 1986, pp. 203–4, 212–17.

Brophy, 1991, pp. 16–17 (Brophy's punctuation). 'As far as national traits go, my poetry might as well have been written in China,' Brennan, cit. D. J. Quinn, 'Current Poetry in NSW', *Sydney Mail*, 9 June 1909. I owe this source to Brennan's biographer, Dr Axel Clark.

Painting should be understood by a 'cultivated person whether he comes from Norway or China,' Bell, cit. Helmer, 1985, p. 10.

De Groen, *The Rivers of China*, 1986.

Vietnam: Cook, 1968, pp. 13–14.

Changing images of China: see Mackerras, 1989.

15 Iriye, 1975, ch. 2; catalogues and guides to the Melbourne International Exhibition, NGV library.

Chintz: Honour, 1961, p. 50. Paisley: Carroll, 1985, p. 32.

Katherine Sorley Walker 'Dance—East and West,' H, 18, 11 (Nov. 1974), 2–8.

Loan-words: Beverley Kingston, 'The Taste of India', in Walker, ed. 1990, pp. 36–48; Les Murray, 'Aspects of Language and War on the Gloucester Road', *The Daylight Moon*, 1987.

Impey, 1977, p. 10.

16 Minton: Carroll, 1985, pp. 4–7. The Museum of Technology, Sydney, exhibited Doulton chinoiserie ware. Arts and crafts society exhibitions in Tasmania in 1903 and 1904: Timms, 1986, p. 77.

Critics: 18 April 1877, 2.

Smith, *Argus*, 5 March 1881, 4.

Japonisme: a 'fusion of themes that were in the air,' (Wichmann, 1980, p. 9); 'A new style partly based on Japanese aesthetic principles' (Whitford, 1977, p. 104); 'The Japanese influence on French nineteenth-century art' (Weisberg, 1980, p. 327); 'The taste for things Japanese', Philippe Burty, 1872 (Meech, Weisberg, 1990, p. 7). 'The movements called *chinoiserie* and *japonisme*, [are] so named for the use the West has made of style, motif and technique developed, or thought to have developed, in China and Japan.' (Carroll, 1985, p. 4).

Patricia McDonald, 'The Asian influence in the popular and decorative arts c.1870–1920', AI, 1983.

Japonaiserie: 'paintings of exotic objects in familiar styles.' (Whitford, 1977, p. 104).

Content and extent: Whitford, 1977, p. 23.

Ann Galbally, 'Aestheticism in Australia', in Bradley, Smith, 1980, pp. 124–33.

Smedley: Prof. Joan Kerr, typescript, Power Research Library, University of Sydney.

17 Lee: Mahood, 1973.

Riots against Asian migrants: the Anti-coolie league in the 'Battle of Burnett' stoned 215 Sinhalese migrants and prevented them entering Bundaberg in 1882 (Croucher, 1989, pp. 4–5; Gooneratne, 1991, p. 72).

Cartoons: Mahood, 1973.

Senator Edward Pulsford, 28 Sept. 1905, and Defence Minister George Pearce, cit. Frei, 1991, p. 86.

B, 'The Japanese invasion', 31 Aug. 1895, 68.

Ron Casey, cit. Errol Simper, 'No discipline for "offensive" Casey', SMH, 2 May 1991. See Gooneratne, 1991, p. 307.

4 IMAGE-MAKERS

Page

20 Westall: Flinders, *A Voyage to Terra Australis*, 1814; Bonyhady, 1985, p. 5.
Aboriginal nature mysticism and tolerance are linked to early exposure to early Hindu-Buddhist cultures of Indonesia by Elkin, 1977.
Chinese: Ward, 1982, pp. 20–2; Blainey, 1982, pp. 230–54.
In 1991 large numbers of Indonesians were arrested and jailed for trochus fishing in what had been their ancestors traditional waters off northern Australia.
Macknight, 1969; Macknight, 'Macassans and Aborigines, *Oceania* 42, 283–321; Macknight, 'Outback to Outback: The Indonesian archipelago and Northern Australia', in Fox, 1980; Macknight, 'Macassans and the Aboriginal Past', photocopy, 1987.
Howard Nelson, 'Far beyond the Eight Points of the Compass', H, 21, 5 (May 1977), 2–10; George Chaloupka,' Rock Art of the Arnhem Land Plateau', H, 27, 1 (July–Aug. 1982), 2–3; Chaloupka, 1984; Mulvaney, 1975, pp. 153–4; McCarthy, 1962, p. 35; McCulloch, vol. I, 1968, p. 20.
Athol Chase, 'All Kind of Nation: Aborigines and Asians in Cape York Peninsula', and Carol Cooper, James Urry, 'Art, Aborigines and Chinese: a Nineteenth Century Drawing by the Kwatkwat Artist Tommy McRae', *Aboriginal History* 5 (June 1981), I, 7–21, 81–8.
Hurley: Specht, Fields, 1984, p. 4; Shirley, Adams, 1983, p. 87.
Harcourt, *The Pearlers*, 1923.

21 Film: Pike, Cooper, 1980, p. 117; Reade, 1970, p. 105.
Connally and Anderson followed *First Contact* with *Joe Leahy's Neighbours* (1989), about the unacknowledged son of an Australian pioneer, Mike Leahy.

22 Film: Pike, Cooper, 1980, pp. 125, 171–3.
The Devil's Playground, *The Birth of White Australia*: Pike, Cooper, 1980, pp. 194, 191.
Bindley's film was called *Trobriana*, and *Pearl of the Pacific*, in early versions (Reade, 1979, p. 73).
Lovers and Luggers (*Vengeance of the Deep* in the US): Pike, Cooper, 1980, pp. 235–6; Stewart, 1984, p. 276; Adamson, 1978; Hall, 1977.
Charlie Chan: Dower, 1986, p. 159.

23 Murder of Cook: Moorehead, 1987, pp. 95–6.
'Aztec splendour . . .': Krauth, 1982, p. 12.
Krauth includes stories by Clarke, Cole and Watson.
Monckton, cit. Shearston, 1983.
McLaren, OCAL, p. 448.

24 Beatrice Grimshaw, *In the Strange South Seas*, 1907.

Brown, Turnbull: Krauth, 1982.
Walsh: *Overdue: A Romance of Unknown New Guinea*, 1925, p. 57.
The Outpost, p. 286. Republished as *Hurricane* (1934), both it and *The Enchanted Island* (1923) were by Ram Daly (Vance Palmer, pseud.).

25 Johnston, 1984; Hungerford, 1952.
Aborigines: Ross, 1985, p. 166.
Angels of War (Andrew Pike, Hank Nelson, Gavan Daws, 1982); *Tidikawa and Friends* (Michael Edols, Jack Bellamy, 1973).
Boyd: Diamond, 1989.
T. J. Metcalf, 'The British Response to Hindu Architecture,' EO, July 1987; Freeland, 1968, p. 176.
Verandahs: Freeland, 1968, pp. 22,32; Cox, cit. Paroissien, Griggs, 1983, p. 12; Frizell, 1983; King, 1984.
Antipodean house: Paroissien, Griggs, 1983, p. 15.

26 Churchill, cit. Irving, 1985.
Australian: Boyd, 1968, p. 34.
Brian Lewis, 'The Asian Touch in Building', H, 15, 4 (April 1971), 26–30.
Joss: Corruption of Portuguese Deos: God. (Croucher, 1989, p. 3)
Chinese club: Larkins, 1979, p. 97.
Attacks on temples: Hornadge, 1976, pp. 78–9; Croucher, 1989, pp. 3–4; Mark Singer, 'Hidden Temples of Australia,' *The Australian Way*, Dec. 1987–Jan. 1988, 97–100. In Perth in Feb. 1942 two Chinese seamen were attacked and killed and others wounded, allegedly by military guards (Andrews, 1985, p. 119).
Destruction of Chinatown in Darwin 'more . . . by local than by enemy action': Lockwood, 1974, pp. 261–2.

27 Australian WW2 troops in Alexandria: 'Because their fathers burned the brothels down in nineteen fifteen they think they've got to do the same.' (Beilby, 1977, cit. Gerster, 1987, p. 183).
Romeril, *Top End*, p. 38.
ANZACs: Gerster, in Pierce, Grey, Doyle, 1991, p. 196.
Saunders, 1966: Joss houses, pp. 54, 98, 131; 'St Ninians', p. 125.
Photographs: Douglas Sladen, an Englishman who lived in Australia 1880–84, published *Japan in Pictures*, 1904, and other books.
Addison, cit. Freeland, 1968, p. 286; 'Building á la Jap', *The Boomerang*, 24 December 1887, 18–19; D. C. S. Sissons, 'Early Australian contact,' H, 16, 4 (April 1972), 18; 'A Japanese house,' *Brisbane Courier*, 21 Dec. 1887.
In 1984, Japan was the featured country at the Melbourne Show and a contemporary Japanese house, built there, attracted large crowds. It was later given to the city by the Japanese government for a cultural centre.
'Mr Mortimer Menpes' House', *The Studio*, 17 (June–Sept. 1899), 170–8.

28 Menpes, 1901.
 Griffin: Taylor, 1986, p. 12. Mahony's best drawings were influenced by Frank Lloyd Wright's collection of Japanese art (Meech, Weisberg, 1990, p. 194).

29 Modernism: Judith Brine to AB, 18 April 1991. Japanese: Dower, 1986, p. 151; Collingridge, 1886, 3–4. Cumulative Japanese resentment at slighting western images and discriminatory treatment were among the underlying causes of the Pacific war (see Frei, 1991; H. McQueen, 1991).
 Indians: B, 27 Jan. 1910, 23, cit. Kingston, 'The Taste of India', in Walker, ed. 1990, pp. 38–9; 'To all the Children in Australia', SMH, 1857, cit. D'Cruz, 1973, p. 28.
 Chinese: H. H. Richardson, *Australia Felix*, 1917. Hungerford, 1977, 'Wong Chu and the Queen's Letterbox', 'Green Grow the Rushes'; Hungerford, 'In the Hills, in Kowloon', TA, 25 Nov. 1967, 13.

30 Custody: Fabian, 1982, p. 77.
 Clift, 1970, p. 123.
 Saw, cit. Ingleson, 1987.
 Koch, 1987, p. 30: 'My friends and I took it for granted that Chinese were sinister, and called "Chinamen"; that the only good savages in "the heart of Africa" were those who devotedly served clean-living young English Bwanas . . .'
 'Out of this World', Zwicky, 1990.
 'Who Flung Dung' was another name in common jocular use. Imported stage shows: *Ching Chow Hi: or, a Cracked Piece of China* (London 1865, Sydney 1880); *A Chinese Honeymoon* (Henley 1899, Melbourne 1902); *Formosa: or, The Railroad to Ruin* (London 1869, Sydney 1870); *The Sultan of Mocha* (London 1876, Melbourne 1889) etc. (Irvin, 1985).
 Dawe, 1899, p. 24.
 Cartoons: Mahood, 1973, pp. 193, 195.
 Sorensen, Dyson, in Porter, 1972.
 Asche had enjoyed a youthful visit to China: see Rees, 1978.
 Marionettes: Vella, Rickards, 1989, pp. 13–15. *The Emperor's Nightingale* was still being staged with glove puppets by Jeral Puppets in 1982.
 D. C. S. Sissons, 'Karayuki-san: Japanese Prostitutes in Australia 1887–1916', I and II, *Historical Studies* 17: 68, 69, 1977, 321–41 and 478–88; Sissons, *Episodes*, n.d., p. 5.

31 *The Geisha*, a two-act musical comedy, text O. Hall, music S. Jones, London 1896 (Irvin, 1985, p. 110). *The Mikado: or, The Town of Titipu*: first performed in London, March 1885, in Melbourne, Nov. 1885, and in Sydney, April 1886. Roth, Collingridge, *Illustrated Sydney News*, 16 May 1887, 20; 15 June 1886, 3–4.
 Preston: Butler, 1987, p. 40. Patricia Macdonald, 'The Asian Influence in the Popular and Decorative Arts c.1870–1920', AI, 1983.
 'Building à la Jap', *The Boomerang*, 1887.

32 Jose, 'One Fine Day', *Adelaide Review*, July 1987, 12.
 Barnett, 1937, pp. 82–3: cover is copied from Felix Régamey and Emile Guimet, *Proménades japonaises*, 1880.
 Rivett, 1991, p. 142.
 Hungerford, 1985.
 See Porter, 1968; Porter, 1966, pp. 262–3; and Porter, 1958, in which Porter describes Japanese servants at a ryokan as 'almost Gilbert-and-Sullivan maids' (p. 161). Collingridge's scornful account of the Japanese Village made allusions to G&S (*Illustrated Sydney News*, 15 June 1886, 3). The novels of Pierre Loti, particularly *Madame Chrysanthème* (1888), contributed to the Mikado-land image.
 Plomer, *Autobiography of William Plomer*, 1975, cit. Alexander, 1989, p. 114.
 Japan-bashing revived in the United States in the 1980s, when used car dealers invited the public to smash Japanese cars to pieces with hammers.
 Aesthetes: Whitford, 1977, p. 22.
 Tea: Rothenstein, 1938, p. 37; Eagle, 1987, 51.
 Menpes, 1901, p. 182
 Porter, 1968, p. 53.
 French chefs: Roger Verge, Paul Bocuse, Jean Troisgros, Michel Guérard, and Alain Senderens.

33 Hungerford, 1985, p. 68.
 Stewart, 1979, Walk II. Brissenden, 1987. Brissenden's wife Rosemary was an exponent of Thai cooking. Stewart believed he owed his survival from a heart ailment to Japanese food. (Stewart to AB, July 1984).
 Morrison, 1895, *1972*, p. 14. Porter, 1970, p. 11.
 Hearn, *Japan: An Attempt at Interpretation*, 1904, p. 393.
 Henry Adams, after three months in Japan in 1886, declared that 'the Japs are monkeys and the women are very badly made monkeys', but he declared he wanted to live in China forever (Adams, cit. Yu, 1983, p. 82).
 Bali: Vickers, 1989.
 Sladen, 1895, p. 35.
 Hales, 1904, p. 9.
 Chevalier, *Waiting for the Ferry, Manila*, 1881; *Japanese Musicians*, 1873.

34 Paterson, 'A Bushman's Song', 1891; Gilmore, 'Fourteen Men', pub. 1954, and see Martin, 1981, 'Plenty got killed here', on the Lambing Flat massacre of Chinese in 1860–61; Yellow Agony, cit. Dugan and Szwarc, 1984, p. 87; Dyson, in Porter, ed., 1972, p. 37.
 Stephens, 1972, vol. I, 'Prejudice and Xenophobia', p. 153.
 Chinese: Rickard, 1988, p. 39.
 Healthy Europeans: Marks, 1923.
 Women's fate: Japanese had the same dread of Americans, who they believed had to be stopped in the Pacific before they reached Japan and

violated their wives, mothers, and sisters (Professor Hirono Ryokichi to AB, 16 Oct. 1988; Dower, 1986; Frei, 1991).
Missionaries: Mahood, 1973.

35 Male subagenda: Alomes, 1988, ch. 7.
Dawe, 1899, p. 114.
Mackay, 1895, p. 274.
Mobs and Englishwomen: Clark, 1980, p. 37.
Murdoch, 1892, pp. 135, 159, 161.
Dawe, 1897, p. 36.
Hopkins, 1882, cit. Hornadge, 1976, p. 34.

36 Praed constrasts the Europeanised Kencho with Yamasaki, the stereotypical Japanese, who has narrow shoulders, an unhealthy, 'yellow' face, slanting beady eyes, 'yellow' tusk-like teeth and bristly upright hair. (*Madam Izan*, pp. 102, 104–5, 159).
Beilby, Hadgraft, 1979, pp. 30–5. Cambridge, 1889, *1990*. 'The habit of the high hand comes out in all sorts of ways—in our treatment of our Chinese fellow-citizens, in the despotic attitude of our Federal Government, which regards foreign nations as pirates and our coloured brothers as vermin unfit to live.' (Cambridge, 1903, *1990*, p. 224).
Lane, cit. Hornadge, 1976, p. 19.
Crossing the Gap: title of the first essay in a collection of the same name by Koch, 1987.
Shanghai: Clune, 1941, p. 24.
Morrison, 1895, *1972*, p. 2.
Morrison and Donald: see Andrews, 1985, and Mackerras, 1989.
Learning Chinese: Fitzgerald, 1985.

37 Clune, 1941.
Fukuzawa Yukichi, founder of Keio University, in *Seiyo Jijo, Conditions in Western Lands*, and *Datsu-a-ron, Departure from Asia* (1885), recommended that Japan face west.
Yatoi: Spry-Leverton, Kornicki, 1987, p. 100. Another reason for Japan overlooking Australians as yatoi was that Australia was regarded even after 1901 as a British colony. (Frei, 1991).
Humour: Rivett, 1991, p. 144.
Morioka Heinz, Sasaki Miyoko, 'The Blue-eyed story-teller: Henry Black and his Raku-go Career', MN xxxviii, 2 (Summer 1983), 133–62; Ian McArthur, 'Henry James Black: an Exceptional Expatriate Story-teller', *The Advertiser*, 19 Aug. 1985; H. S. Williams, 'Two Remarkable Australians of old Yokohama,' *Transactions of the Asiatic Society of Japan*, 3, 12, 1975, 51–69.
The Queenslander: 'Light is the same everywhere and it can be found on the Buddhist altar as well as in the Christian pulpit.' (4 April 1903).
Smedley: Prof. Joan Kerr, Department of Fine Arts, University of Sydney to AB, 8 July 1991; AMS [Mrs A. M.Smedley pseud.], *Nara Hodu [Naru Hodo]: Sketches in Japan*, Paramatta

1884; Eagle, 1983.
Nancy Keesing, 'Not a Pure Merino', with a Coda by Ruskin Bond, H, 24, 2 (March–April 1980), 84–9; Hal Porter ed. 1972, p. 3.

38 Followers of Buddhist, Theosophical, eastern transcendentalist, or spiritualist teachings included Prime Minister Deakin, the writers Brennan, Praed, O'Dowd, Gilmore, Sadler, E. J. Banfield, Max Dunn, David Maurice, Helen Heney, Alice Adair, Dorothy Green, George Johnston, Harold Stewart, and Robert Gray; the artists Desiderius Orban, Godfrey Miller, Margaret Preston, Ian Fairweather, Ethel Carrick Fox, Christian Waller, Frank and Margel Hinder, John Olsen, Peter Upward and Stan Rapotec; the architects Len Bullen, Walter Burley Griffin, Marion Mahony Griffin, and Adrian Snodgrass, and the actor Peter Finch. President Sukarno's father was also a Theosophist. (Jill Roe, 'Out of the Mainstream: Theosophy and Escape from Protestantism: the Cultural Connection', LS, 1988).
The Star amphitheatre was demolished in 1951.
Finch: Croucher, 1989, p. 24.
In 1929 Krishnamurti disavowed any messianic role: Roe, 1986, p. 285; Croucher, 1989, p. 16.
In *Sky High to Shanghai*, Clune was sarcastic about Japan and complimentary to China, reversing union and Catholic opinion in Australia at the time (Andrews, 1985, p. 87).
Prichard, born in Fiji, grew up in Tasmania and Melbourne, and worked as a journalist there and in London. *Moon of Desire* is her only novel set in Asia, though she wrote critically of the Japanese in the 1930s. (Mojeska, 1981).
Cleary: 'I don't think I am one of those you are looking for', Cleary, reply to AB, 31 July 1985.
Clavell, cit. Anne Fussell, 'Clavell's creed', TWA, 5–6 March 1988, magazine 3. Clavell's father, a British naval captain, was stationed in Australia when he was born in 1924, and Clavell lived the first nine months of his life in Australia.
Shanghai: Sergeant, 1991.

39 Bali: Vickers, 1989.
Kabbani, 1986, p. 59.
Japan: H. McQueen, 1991.

5 EMULATORS

Page
40 Menpes, 1902, pp. 40–52.
Smith, *The Argus*, 5 March 1881, 4. Westernisation: Whitford 1977, p. 104.
Brenda Jordan, Department of History, University of Pittsburgh, to AB, 21 Jan. 1990; David Bromfield, EO, July 1987.
Embarrassing: Menpes, 1901, p. 34.
Menpes' articles about Japanese art: *Magazine*

of Art, 1888, pp. 192–9, 255–64. His work and Whistler's were exhibited together in Melbourne in 1885. Other Australian expatriates of the 1890s: artist and architect John Smedley, artist Edward Hornel and friend George Henry. (Eagle, 1987, 63; Kerr, 1991).

Whistler and Goncourt: Whitford, 1977, p. 24.

Authority: 'A Japanese commission sent to Europe to investigate . . . western art some years ago,' Menpes, 1901, pp. 31, 34.

Jap: Menpes, 1901, p. 31.

Russell's reputation: Salter, 1976, p. 26.

Loti, *Madame Chrysanthème*, 1888.

41 Van Gogh: *Japonaiserie: tree in bloom*, 1886–88, copy after Hiroshige Ando, *Flowering Plum Tree in the Kameido Garden*, 1856–58. Van Gogh added to his copy borders transcribed from advertisements for Japanese brothels (Wichmann, 1980, pp. 41–2).

Jap art: Galbally, 1977, p. 38.

Wichmann, 1980, p. 19.

Longstaff, *Lady in Grey*, 1890: Timms, 1975.

Bunny: David King 'Rupert Bunny's paintings of Sada Yakko', A+A, 25, 3 (Autumn 1988), 352–4.

G. W. Lambert: Amy Lambert, 1938, p. 37.

Stewart: AA, 5, 1918.

'Tasma': Jessie Couvreur, novelist.

Cambridge, 1903, p. 171.

Heysen: AA, 3, 74 (Feb. 1939), 56.

Hall: AA, 5, 1918. Hall, who taught Violet Teague, had a collection of Japanese prints (Roger Butler, ANG, 1987).

See also Meldrum, *Portrait of Mme. St. de Tarczynski*, AA, 1, 3 (1917).

Thomson, cit. Eagle, in Thomas, 1988, p. 170.

Bunny, cit. Eagle, ANG exhibition, 'The Art of Rupert Bunny', 1991.

Roberts: Eagle, 1987, 45–63.

42 Bohemian: Virginia Spate, 'Tom Roberts', A+A, 1, 4, 260.

Hokusai: Van Gogh, *Verzamelde brieven*, letter 554, 1888, cit. Whitford, 1977, p. 191.

Roberts, cit. Clark, Whitelaw, 1985, p. 25. The advent of photography contributed to the interest in views of city streets from a high viewpoint. (Splatt, McLellan, 1986, p. 24).

Roberts did prototype 9×5 paintings of the Thames Embankment, modelled on those by Whistler, before his return to Australia (Spate, 1972, p. 24).

Japoniste format: Galbally, 1979, p. 55.

9×5 decor: *Table Talk*, 2 August 1889, 4.

Criticism: Smith, *The Argus*, 7 Sept. 1886; White, 1981, p. 92; Bonyhady, 1985, p. 20; Courthion, 1977, p. 30; 'Messrs Tom Roberts, Conder and Streeton are not at all free from the charge of Whistlerism', (*Table Talk*, 16 Aug. 1889).

Conder, Roberts, Streeton, letter to *The Argus*,

Sept. 1889, cit. Clark, Whitelaw, 1985, p. 115.

Dufy, *Le Bain: Marie-Christine at Sainte Adresse*, 1902, cf. Conder, *Holiday at Mentone*, 1888. Pissarro, *Paris, the Boulevard Montmartre at Night*, 1897, cf. Roberts, *Bourke Street*, c.1886. Bonnard, *The Bridge, Pont des Arts*, 1899, cf. Conder, *The Departure of the Orient*, 1888; Streeton, *The Railway Station, Redfern*, 1893.

Josiah Conder was called the 'father of western architecture in Japan' (Seidensticker, 1983, p. 68); Hearn, 'In a Japanese Garden'; J. M. Richards, 'Missionary of Japan, an exhumation of Josiah Conder', *Architectural Review*, no. 136, 196–8.

Josiah Conder: *Flower Art of Japan and the Art of Floral Arrangement*, 1891 (*The Floral Art of Japan*, 2nd. ed. 1899); *Paintings and Studies by Kawanabe Kyōsai*, 1911.

44 Young: Fink, 1983.

Conder: Hoff, 1972, pp. 15–16; Spate, 1972, p. 52. Lindsay: D. Thomas, 1988, p. 132.

Cassat, Degas: Ives, 1979, pp. 45–5. Teague: Butler, 1981, p. 3.

45 Spowers: Butler, 'Electricity Castle', in D. Thomas, 1988, p. 172.

Palmer: Barbara Goode Matthews, 'An Australian Hokusai', AA, Aug. 1939, 28.

Syme: Burke, 1980, p. 183.

Women: Ambrus, 1984; Deutscher, Butler, 1985.

Lois George, 'Oriental influences in Australian printmakers from the 1900s to the 1930s', Fine Arts honours thesis, University of Sydney, 1982.

Hall, AA, 5, 1918.

Craig, *Japanese Vase and Print*, in Burke, 1980.

Gruner, AA, 3, 58 (Feb. 1935).

Lewis: 'Samoa', AA, 3, 31 (March 1930); *They Call Them Savages*, 1938.

Burke, 1980, pp. 40–1. Convention dictated that Australian men etched, while women did woodcuts, though Traill and Mort were prominent in defying these expectations.

46 Hammond, 1987, pp. 88–93.

Timms, 1978; Timms, 1986, pp. 2–111.

Wanda Garnsey, 'Australian Potters', H, 14, 12 (Dec. 1970), 12–18; Ioannou, 1987; Menzies, AI, 1983.

Godlee: Judith Thompson, 'Australia and the East, Applied Arts', in Carroll, 1985, pp. 60–2.

6 INTERNATIONALISTS

Page

47 Sissons, *Episodes*, p. 5; Bird, 1982, pp. 13, 16.

Bird, 1982, p. 56.

Benjamin Britten, Peter Pears, prefatory note in Bird, 1982.

Iola Matthews, 'The Running Pianist', H, 20,

5 (May 1976), 2–8.
A Guide to the Grainger Museum, 1975.
Griffiths, 1979, p. 8.

48 Bird, 1982, p. 147; Grainger, 1934, pp. 4, 6, 9.
Debussy, Ravel: Sculthorpe to AB, 23 Oct. 1987.
Art-musics: Grainger, 1934, p. 4; Reeves, 1982; Anne Boyd to AB, July 1987.
Pacific music: Reeves, 1982, pp. 39, 43.
Serle, 1987, pp. 79–81.
Grainger, 'The Aims of the Grainger Museum', 1955.
Bird, 1982, pp. 66–7.

49 Grainger to Rose Grainger, 1 November 1903, cit. Reeves, 1982.
Grainger to Nathaniel Dett, 6 March 1925, cit. Balough, 1982, ix.
Frizell, AI, 1983; Anne Boyd to AB, July 1987.
Grainger, cit. Pearl, 1986, p. 220.

50 Lionel Lindsay, foreword, *Norman Lindsay's Pen Drawings*, 1931, *1974*; Smith, 1971, pp. 77–8, 109.
cf. Carlton Dawe, *Kakemonos* (1897), cover illustration: an 'Asian' woman, complete with nose-ring.
Lindsay, cit. Pearl, 1986, pp. 218, 222.
Chefoo, 17 Sept. 1901: Clune, 1941, p. 65.

51 Lindsay: Scarlett, 1980, p. 318.
Heney, 1950.
Wentcher: Scarlett, 1980, p. 680–6.

52 Freeland, 1981, p. 110.
Wilson, 'Oriental Australia', AA, 3,5, (Aug. 1923). Howard Tanner, 'Architecture', in National Trust of NSW, 1980, p. 25.

53 Hardy Wilson, 'Morning Sun elevation of "Celestion", Pymble, Sydney', and 'Plan of "Celestion", Pymble,' NLA.
John Pearman, 'Houses He Built', in National Trust of NSW, 1980, pp. 30–2.
Menzies: H. McQueen, 1979, p. 26.
Wilson, 1929, pp. 93, 112.
Dragon: Wilson, 'Oriental Australia', 1923.
Atomic cloud: National Trust of NSW, 1980, pp. 29, 44.
Boyd, 1968, p. 237.
Streeton to Roberts, 1907, cit. Galbally, Gray, 1989.
Lindsay, cit. Pearl, 1986, pp. 218, 222. Grainger, 1975, 6.

54 Wilson, 1929, p. 178; Wilson, 1945; Rachel Roxburgh, 'Writing' in National Trust of NSW, 1980, p. 54.
MacDonald, 1931, cit. Serle, 1987, p. 96.
Britain: Preston, 'Australian Artists versus Art', AA, 3, 26 (Dec. 1928).
Emile Guimet collected extensively in Japan and published *Proménades japonaises* in 1880.
Preston went to the Musée Guimet on the recommendation either of Rupert Bunny or of his American friend Oberteuffer. From 1915

Gladys Reynell gave Preston books on Japanese art. She used formats from Strange's *Japanese Illustration* and from Fenollosa.
Japanese sources: Preston, 'From Eggs to Electrolux', AA, 3, 22 (Dec. 1927); Butler, 1987, p. 8, n. 67, pp. 40, 53; Carroll, 1985, p. 51; H. McQueen, 1979, p. 141.

55 Dow on qualities of Japanese prints: Meech, Weisberg, 1990, p. 162. Dow's list almost exactly matched the change in Preston's post-war style. Butler, 1987, pp. 106–7, 82–3. Preston cited Lin Yutang, *The Chinese Theory of Art*. (Butler, 1987, pp. 47, 49).
Preston, *The Home*, (Oct. 1928), 32, 76; Butel, 1985, p. 15.

56 Japan: Menzies, AI, 1983; Butel, 1985, p. 29; Butler, 1987, p. 173.
China: Ian North, 'Aboriginal Orientation' in D. Thomas, 1988, p. 142.
Preston, 'Nothing but the East,' *The Home*, 16, (Jan. 1935), 80.
Children's art: Butel, 1985, p. 61.
Wartime: H. McQueen, 1979; North, 1980, p. 11.
McCarthy, cit. Butel, 1985, p. 51.
Preston, 'New Developments in Australian Art', *Australian National Journal*, 1 May 1941.
Preston, 'The Orientation of Art in the Post-war Pacific', *Society of Artists Book 1942*, 1942, p. 7.
Preston, 'Why I Became a Convert to Modern Art', *The Home*, 4, 2, (June 1923), 20.

7 ENEMIES

Page
58 'Yeh'll 'ave to face the old tame life'. ('A Letter to the front', C. J. Dennis, *The Moods of Ginger Mick*, New York, 1916, p. 83).
Other reasons for enlistment: see Ross, 1985, p. 121.
Hungerford, 1985, foreword.
Fullerton, 1983.
C. E. W. Bean, cit. McKinley, 1985.
Rivett, 1945, *1991*, p. 143.
Blamey, 1942, 1943, cit. Dower, 1986, pp. 53, 71.
Viet Cong: McAulay, 1987, p. 10.
Rivett, *1945*, 1991, foreword.
Pugh cit. Allen, 1981, p. 31.

59 Apes: Bartlett, 1955, p. 151.
'The way I see the Jap', McGregor, 1980.
Japanese war propaganda had matching animal images: Dower (1986).
T. Inglis Moore, 1935, 1941, 1945. The play *We're Going Through* was based on Gilbert Mant's *Grim Glory*, 1942, newspaper reports, and oral anecdotes.
Slaves of the Samurai, p. 19.

60 Crooke: Dobson, 1971; Gauguin: Moorehead, 1978, pp. 111–13.
Hele: H. McQueen, 1979, p. 31.
Dargie, *Stretcher bearers in the Owen Stanleys*, 1947.
Dobell was not a war artist, but went to New Guinea in 1949–53. (Gleeson, 1964, pp. 91–104)
Treloar, cit. Fry, Fry, 1982, p. 15.
Friend, cit. Fry, Fry, 1982, p. 7.

61 Fujita Tsuguharu (1886–1968): Selz, *Foujita*, 1981. Tucker also sketched Inokuma Genichiro ('Guen'): Haese, 1981, p. 282; Uhl, 1969. He painted Wakita Kazu and Ogisu Takanori (Clark, 1990).
Tucker, cit. Uhl, 1969, p. 46. Tucker, cit. Hughes, 1970, p. 155.
Pugh, 3 June 1946, cit. Allen, 1981, pp. 40–1.
Coburn: McCulloch, 1968, p. 127.
Vassilief: F. Moore, 1982.

62 Dupain, 1986, p. 12.
Parer: K. Hall, 1977, p. 161.
Ivens: Shirley, Adams, 1983, p. 179.
Other documentary films included: *Jungle Patrol*, (Bill Carty, J. W. Tresise, 1944); *South-West Pacific*, (K. Hall, 1943); *One Hundred Thousand Cobbers*, (K. Hall, 1942).
See also D. G. Haring, *Blood on the Rising Sun* (n.d.).
'Thailand railway', Stow, 1969, was dedicated to and based on the experiences of Russell Braddon, who interviewed Stow in Scotland in 1962–63.
Hungerford, 1952, p. 93.

63 Porter, 'Post-war Japan', in Wilding, Higham, 1967, pp. 170–178.
Lambert: OCAL, 'War Literature,' pp. 717–26.
Malouf, writing about Changi, describes war as a great movement of goods between people (1990, p. 46).
Historian: John Robertson, cit. Gerster, 1987, p. 217.

64 Slim, cit. Dower, 1986, p. 112.
Blood Oath: Evan Williams, 'Kid Gloves Soften Some Very Real Punches', TWA, 28–9 July 1990, review 13. Susan Chenery, 'What happened in the war', B, 26 Dec.–2 Jan. 1990, 174; Marea Williams, 'Reconciliation of the Blood Relatives', SMH, 19 May, 1990, 74.
Braddon, 1983. Braddon, ABC TV interview, 2 Aug. 1987.
Japanese, Koreans: see Nelson, 1985; H. McQueen, 1991.

65 Coolies, egotists: Rivett, 1945, *1991*, pp. 181, 145–6.
Gullett, cit. Gerster, 1987, p. 233. (Gullett: 'a civilised politician', Dutton, 1991, p. 178).
Pearl Buck, *The Patriots* (1939): 'simian physiognomy' of the Japanese. (Dower, 1986, ch. 8).
'The Japanese were maddened before the war by our refusal to take them very seriously, because our obliviousness to the Japanese threat implied a certain degree of contempt.' (Reischauer, 1950, p. 17.)
Houseboy: Norman Carter, cit. Gerster, 1987, p. 234.
Historian: Bean, cit. Gerster, 1987, p. 70.
Race: Wigmore, 1957, pp. 62–3; Long, 1952, p. 71.
Hungerford, 1952, p. 151; Hungerford, 1954, p. 235.

66 Cleary, 1954.
War brides: Carter, 1965.
Affairs: Beilby, *No Medals for Aphrodite* (Greece), and *Gunner* (Crete); John Hetherington, *The Winds are Still* (Greece); Lambert, *Glory Thrown In* (Alamein), Lambert, *The Forty Thousand Thieves*, (Palestine).
Cleary, 1980, cit. Gerster, 1987, p. 183.
Darwin: see Lockwood, 1968.
Kellaway, in Mudie, 1944, p. 76.
Australian atrocities: Warner, Warner, 1982, xi, p. 36. 'The reputation of not taking prisoners became associated with Australian troops in general.'(Dower, 1986, pp. 67–9)
Prostrate Japan: Hungerford, 1985, p. 48.

67 Clifton Pugh shared Hungerford's tastes: 'I am living the life of a millionaire,' he wrote from Japan in 1946, 'being waited on hand and foot, and even having my cigarettes lit.' (cit. Allen, 1981, p. 40)
Haiku: cf. Les Henderson, a student of Sadler: 'I had no knowledge as to what sort of temple I was in, and all I had heard about Zen was that it was a doctrine of "wisdom." I thought, "wisdom," that'll do me.' (cit. Croucher, 1989, p. 31.)
Hungerford, 1985, pp. 67, 76, 64.
Slessor: Dutton, 1991, ch. 9.

68 Warco: Burgess, 1986.
Johnston: Gerster, 1987, p. 223. Title changes: Johnston, *The Moon at Perigee* (Sydney, 1948); *Monsoon* (New York, 1951, London, 1952). The film *A Town Like Alice*: United States, *The Rape of Malaya*.

69 Johnston, 1987, p. 147.
Theatre: Rees, 1953, pp. 169–73.

70 Featherstone, NZ, breakout: Fitzpatrick, 1984.
Ignorance of Japanese: several of Sadler's former pupils joined military intelligence and were sent to Japan. (Croucher, 1989, p. 31) Professor Macmahon Ball represented Australia on the Allied Council and did not try to learn Japanese: Rix, 1986, p. 23; Ball, 1948, foreword. Hungerford learnt enough for blackmarketeering and sex (Hungerford, 1985, p. 67).

71 Inferior: see Dower, 1986, passim, index p. 394; Nelson, 1985, ch. 16.
Japanese guards: 'Having broken up many previous mateships they discouraged attempts to reform them.' (H. Clarke, 1984, p. 30)

Pulvers, 1981, p. 10. Pulvers wrote part of the script for the film *Merry Christmas, Mr Lawrence*, based on the prisoner of war experiences of Laurens van der Post and recorded in *A Bar of Shadow*, 1956.
Clune, 1955.
Between 1890 and 1964, 383 Australians were in China with the Inland Mission, 150 men and 233 women.
Harris, 1958, p. 191.
UNCOK, the United Nations Commission on Korea, also included forces from France, Belgium, Netherlands, Luxembourg, Greece, South Africa, Ethiopia, Turkey, Thailand, Philippines, Colombia and, in secret, Japan (Halliday, Cummings, 1988, p. 77).

72 Kimchi, Korean: pickled cabbage (Harris, 1958, p. 7). Under Japanese colonial domination Koreans were forbidden to use their own language, but that period was over by the time of Harris' story.
Hooker, 1986, pp. 22, 184.
Thwaites, 1968, p. 218.

73 'Sonnets', in Tranter, 1979.
Prichard, 1967, p. 4.
Numbness: Terrill, 1987, p. 79.
Dawe, cit. Shaw, 1974, p. 65.

8 TRAVELLERS

Page
74 Haefliger, colour woodcuts 1932–33: *Kusatsu Hotsprings, Japan; A Junk on the West River off Canton*; untitled (Buddhist temple, Kyoto); *Lyre bird*; untitled (Sublime point above Bulli), 1936. Pearce, 1991, p. 88.
Docking, 1983, p. 29.
Orban cit. Lynn, 1977, p. 118.
Miller: Hughes, 1970, p. 209; D. Thomas, 1973, p. 58. Miller, cit. Roe, 1986, pp. 322–3. L. Thomas, 1980. Miller, cit. Henshaw, 1965, unpaginated.

75 Fairweather: Hughes, 1970, p. 293.
Bail, 1981, p. 20; Bail, 'The Nostalgic nomad', H, 27, 1 (July/Aug. 1983), 54–8; Fairweather, cit. Abbott-Smith, 1978, pp. 64–5.
Bail, 1981, pp. 68, 180.

76 Bail, 'Shared solitude', in D. Thomas, 1988, pp. 220–1.

77 Suzanne Edgar, 'Meet a Special China-Watcher', TOS, 18 Jan. 1987; Richard Thwaites, review of Morrison, *A Photographer in Old Peking*, ASAA *Review*, 11, 1 (July 1987).
Scarlett, 1980, pp. 680–6.
Friend, 1973, p. 48.
Friend, cit. Janet Hawley, 'The Bitter Feud of Donald Friend and Friend', GW (29 Oct. 1988), 47–63.
Salvation: Barry Pearce, 'Donald Friend', A+A, 27, 3 (Autumn 1990), 412.

79 *Tamu*, Jane Oehr, 1972.
'I was disgusted by the white bodies, like maggots': Friend on Thursday Island, 1947, cit. Hughes, 1970, p. 173; Friend, 1972, pp. 44, 97.
Bali: Friend, cit. Hawley, 1988, 55.
Film: *Donald Friend, The Prodigal Australian*, Don Bennetts, 1990.
Nolan, cit. Adams, 1987, p. 185.
 Leigh Astbury, 'New Guinea Journey', ABR, (Aug. 1985), 8–11.

80 Juniper: Lynn, 1986, pp. 22–3.
81 Lynn, 1986, p. 39.
Timothy Morell, 'Expanding the Interior', in D. Thomas, 1988, p. 144; Hughes, 1970, p. 219.
Gleeson, 1971, p. 101.
Lynn, 'Williams' Landscape Foray', TWA, 25–7 Aug. 1984, Magazine, 12. Morell, in D. Thomas, 1988, p. 144. McCaughey, 1980, p. 272.

82 Gary Catalano, 'Zen and the River: An Interview with Barry Gazzard', H, 29, 1 (July-Aug.), 1984, 7, 2.
Gazzard to AB, 23 Sept. 1985.
Grieve: McCulloch, 1984, p. 527; Millar, 1974, pp. 116–18; Grieve, 'Impressions of Japanese Contemporary Painting', A+A, March 1965, 260–7.

83 Olsen, cit. Hughes, 1970, pp. 260–3.
84 Zen: Croucher, 1989, p. 64.
Landscape: Olsen, cit. Hughes, 1970, pp. 264, 262. Olsen, cit. McGrath, Olsen, 1981, p. 120–2. Olsen, 1980, pp. 82, 100.
Lindsay, Holloway, 1983, pp. 12–13. The *Hiroshima Panels* also inspired a cantata by James Penberthy (1958).
Baldessin: Lindsay, Holloway, 1983, p. 10.

85 Lindsay, Holloway, 1983, p. 13. Homma Masayoshi, 'Munakata Shiko: the Man and His Work', *Munakata Shiko 1903–1975: The Woodcut Genius of Japan*, catalogue, AGNSW, 16 Dec. 1987–14 Feb. 1988.
Leach and Hamada: Hammond, 1987, p. 112.

86 Australian potters: Sylvia Halpern was born in Japan, lived in China, and studied with Klytie Pate in Melbourne. Bob Hughan, Ivan Englund, and Patricia Englund went to Japan to study ceramics. (Wanda Garnsey, 'Australian Potters', H, 14, 12 (Dec. 1970), 12–16).
Peter Timms to AB, May 1991.
Hammond, 1987, p. 119.
McMeekin to AB, 28 May 1985. All subsequent relevant quotations are from this source.

87 McConnell, cit. Cooke, 1986, p. 28.
Joyce Ackroyd, 'Phillip McConnell: A Ceramics Virtuoso Down Under' *Look Japan*, 10 Oct. 1986, 20–1.
Harrison-Ford, 1989, p. 244.
Rushforth to AB, 28 Nov. 1987 and 15 April 1985. All relevant subsequent quotations are from these sources.

88 Later visitors included Ishida Chihiro, Iwabuchi Shigeya, Shimada Haruo, Kato Kenji, Ino Kiyoshi, and Kudo Shuji. Chinese potters visiting Rushforth's house saw books there on Japanese ceramics for the first time.
Rushforth, 'The Potter's Art and Outlook', H, 2, 5 (May 1958), 7–9.

89 Noris Ioannou, 'Towards an Australian Esthetic', *The Advertiser*, 29 Sept. 1990. Moon to AB, Feb. 1986.
Levy, Blakebrough: Hood, Garnsey, 1972, pp. 9, 88–9.
Trad-Jap-crap: Mark Thompson, 1980, cit. Ioannou, 1986, pp. 336–7.
Levy, cit. Littlemore, Carlstrom, 1973, p. 11.
'For the people': Merric Boyd, cit. Hammond, 1987, p. 90.
Rushforth, cit. Hood, Garnsey, 1972, pp. 128–9.

90 Others include: Doug Hawkins, Alistair Whyte, Jackie Clayton, Alexis Tacey, David Walker, and Steven Harrison.
Bamford, cit. Mansfield, 1988, p. 33.
Mincham to AB, 12 June 1985. Mincham: Drury, 1990.
Campbell: 'It worries me when people imitate the Japanese or the Chinese. I think we should be aware of all their refinements but we should be confident enough to get to be ourselves' (cit. Hersey, 1975).
Hiroe Swen, brought up in a family of traditional dyers of kimono fabric; struggled against anti-female prejudice in ceramics; and founded the National Association for Women Potters in Kyoto in 1958. Her life in Australia represented a return to the ideal of the folkcraft-farmer (AB, 'Pots by a Good Cook', H, 18, 12 (Dec. 1974), 27–30).

91 Chong to AB, undated, October 1988.
Cox, 'An Architecture in an Australian Landscape', in Paroissien, Griggs, 1983, p. 16.
Saini, 1970.
Taylor, 1986, pp. 11–15, 36.
Freeland, 1968, p. 286.

92 Jennifer Taylor, 'Review: Japanese Courtyard', *Architecture Australia*, June–July 1977, 47–9.
Boyd, 1968, p. 9.
Walter Gropius, *The New Architecture and the Bauhaus*, tr. P. Morton Shand, 1935, p. 19.
Boyd, 1962. Tange, an admirer of Gropius and Le Corbusier, had been well known in the United States since 1949 as the designer of the Hiroshima Peace Museum: Boyd, 1962, pp. 1, 13.
Boyd, 1962, pp. 16–17. Boyd, 1960, p. 57.

93 Le Plastrier: Philip Drew, 'The Hidden Art of a Romantic', NT, 19–25 July 1985. Taylor, 1986, pp. 174–5.
Sitsky, 1969.
Maxwell Davies, foreword, Murdoch, 1972, xii.

Maxwell Davies, 1972, xii.
Sitsky, 1969.
Dreyfus, cit. Sitsky, 1969. The first series of Suzuki Daisetsu's *Essays on Zen Buddhism* was published in the United States in 1961, the second in 1971.
Dreyfus made three visits to China in the 1980s, where he taught conservatorium students using his own international sign language of music. (Dreyfus, 'Cultural Evolution', GW, 27–28 Oct. 1990, 8). Dreyfus' *From Within Looking Out*, 1962, in 5 movements for soprano and quartet, was based on an Annamese street song (Covell, 1967, p. 193).

94 Sue Johnson, 'Peggy Glanville-Hicks, A Composer of Note', GW, 19 July 1986, 46–51.
Murdoch, 1972, p. 104.
Modes: Glanville-Hicks to AB, 17 Oct. 1987.
Unless specified, subsequent quotations are from this interview.
Murdoch, 1972, pp. 104–5.

95 Sculthorpe, ABC TV interview, 1986. Grainger: Hannan, 1982, p. 205, n. 5; Frizell, 1983, 109.
Sculthorpe to AB, 1 Sept. 1987.
Sculthorpe, cit. Murdoch, 1972, p. 165.
Sculthorpe to AB, 1 Sept. 1987.
Sculthorpe, address to UNESCO conference: 'Relations between Japanese and Western Art', Tokyo and Kyoto, 1968.
Sculthorpe, cit. Neil Jillett, 'Most of my work's done at night, in a white heat', SMH, 19 Oct. 1985, 44.

96 Peart: Anne Boyd to AB, 24 Aug. 1987.
Hannan, 1982, p. 17.
Sun Music: Hannan, 1982, p. 18.
'Open their ears': Sculthorpe to AB, 23 Oct. 1987.
'Strong subconscious link' with Japan: see Hannan in Callaway, Tunley, 1978, pp. 136–45.
Javanese and Japanese instruments and melodic correspondences: Hannan, 1982, pp. 147–52, 196.
Sculthorpe's piano music, based on *Mushiroda*, 12th-century Japanese melody, after the nesting place of a pair of sacred cranes, was used in *Messengers of the Gods* (Lavery, Taylor, 1985). *Landscape II* uses the same melody.

97 Japanese composers: Hannan, 1982, p. 20.
Takemitsu lectured in Australia in 1969. Sculthorpe also developed close links with composers Takahashi Yuji, Noda Teryuki, Yuasa Yoji and with the shakuhachi virtuoso Mitsuhashi Kifu.
American reputation: John Rockwell, 'Speculum Musicae in Takemitsu Finale', *The New York Times*, 19 Nov. 1989.
Contradictions: Hannan, 1982, p. 20.
Lack of Oriental collection at ANG: Sculthorpe to AB, 4 Dec. 1987.
Moonwatcher: Murdoch, 1972, p. 139. Meale

to AB, 21 Sept. 1987.

At UCLA each musical tradition was taught by its own method: Indonesians taught the gamelan orally, while Japanese music was taught from written texts. Only slight interest in Chinese music had emerged at UCLA during Meale's time there. (Meale to AB, 21 Sept. 1987) Unless specified, all subsequent relevant quotations are from this interview.

98 Meale, cit. Murdoch, 1972, p. 144. Few composers can write as though from within a non-Western tradition, Meale believed: 'You can only be yourself to be authentic'. (Meale to AB, 21 Sept. 1987)

Sitsky, 1969.

9 EXILES AND ALIENS

Page

99 Communists, pacifists: Max Dunn, David Maurice, Len Bullen, David Martin, K. S. Prichard, Len Fox, Mona Brand (Croucher, 1989).

Pringle, 1973.

Kata to AB, 1980. See Hazel de Berg interview, NLA, 3 Dec. 1979. Kata's first novel, 1961, dealt with racial discrimination but was not about Australians but a blind woman and a black American man. Kata's birthdate is not published.

Transliteration errors in *Someone Will Conquer Them* include: o'denwa for odenwa, num-bum for nam ban. In *Kagami* they include: p. 4, Decima for Deshima; p. 67, jishins for jishin; p. 77, so deska for sō desu ka; p. 78, hari-kiri for harakiri (seppuku); p. 99, kimuchi for kimochi; p.114, kakimonos for kakemono.

100 Mena Abdullah, 'High Maharajah' in Ewers, 1965. Abdullah, who taught literature and drama at Sydney University in the late 1950s, left Australia in 1961, as did her collaborator, the playwright Ray Mathew.

Beilby, 1978, pp. 158-9.

101 O'Grady, 1979, p. 87.

Stead, 1940, pp. 224, 220, 218, 216, 232.

Heney, 1950, pp. 131, 151.

102 Porter's grandfather was something of a painter, who had fought in the Crimean war, had taken part in the looting of the Summer Palace in Peking during the Boxer Uprising and had brought back a collection of Chinese objects (Lord, 1974, p. 3).

Mother: Porter, 1966a, p. 3.

Porter, 1962; Porter, 1971, pp. 60-8.

103 A similar accident in 1983 in Ballarat led to Porter's prolonged hospitalisation and death in 1984. A. B. Jamieson, one of the dedicatees of *The Actors*, says Porter 'had to get away from Australia, it didn't matter where' (Jamieson to AB, 13 June 1987).

Porter, 1968, p. 8; Porter, 1966, p. 181.

Porter, 1958, pp. 46-7. His grandfather's bric-à-brac, Japanese water-soluble sculptures, wind-bells, kimono-clad figures on porcelain plates, and fans decorated with cranes were the sources of Porter's early images of Japan; Hearn, Loti, *The Mikado*, *Madame Butterfly*, Mitford's *Tales of Old Japan*, Hokusai, Hiroshige, Toyokuni, haiku and senryū in translation, and 'God knows what Japanoiserie else'(Porter, 1968, p. 8); also Japan specialists Basil Hall Chamberlain, Rutherford Alcott, G. B. Sansom, and Engelbert Kaempfer. But after his 1968 visit, all the 22 names listed as important influences are Western. (Porter, 1975, p. 12).

Porter, 1986, p. 8. Porter, 1966, p. 181.

Execration and fascination: the English artist, Lucas, in the British writer William Plomer's novel *Sado* (1931) shares these ideas with Medlin in Porter's play (1966). See Alexander, 1989; D. N. Lammers, 'Taking Japan Seriously', in Winks, Rush, 1990, p. 203.

Hearn Syndrome: Edward Seidensticker, 'Japan Scholars Losing Their Love for Subject,' *Asian War Street Journal*, 22-3 Dec. 1988; Harold Bolitho, 'Telescopic Focus', H, 20, 3 (March 1976), 34.

Preferable: Lord, 1974, p. 20. See AB, 'Japan Today From Atop a Cast-iron Balcony', review of *The Actors*, TA, 19 Oct. 1968.

103 Porter, 1966a, p. 262.

104 Japanese are called 'Orientals', Tokyo is 'Eastern Capital', Ginza is 'Silver Street', sake is 'rice wine', tatami is 'straw matting', and tempura is 'prawn in batter'(Porter, 1958, p. 191). Porter's misspelled Japanese words include: irrashaimashi (irrashaimase), Shinjuki (Shinjuku), yugata (yukata), nan-ju (nan ji); and French, Japonoiserie (japonaiserie).

Porter's view of Japan closely resembles Plomer's: see Plomer, 1975, pp. 181-2.

Scheherazade, a choreographic drama by Fokine.

105 Rana Kabbani, 1986, p. 59.

106 *Madama Butterfly*, an opera in three acts by Giacomo Puccini, with libretto by Luigi Illica and Giuseppe Giacosa after John Luther Long (book) and David Belasco (drama), first performed in Milan in 1904, was probably derived from Pierre Loti's *Madame Chrysanthème* (1888). Thomas Glover, a British merchant in Nagasaki, and Townsend Harris were both said to have been the original Pinkerton (Whitford, 1977, p. 14).

Dawe, 1897.

'The Mahommedan Mother,' Lang, 1859.

Kata, 1962, p. 180. Harris, 1958, pp. 86-7.

107 Porter, 1966a, p. 293.

Hungerford, 1985, p. 112. Hungerford, 1954, p. 259. Italics and punctuation are Hungerford's.

Porter, 1958, pp. 90-1, 161; Porter, 1966, pp.

18, 80, 110; 'Mr Butterfry', Porter, 1970.
Ken Russell set his production *Butterfly* (1988 in Australia) in a brothel, with neon signs and a nuclear epilogue. Roger Pulvers' play *Berthold Brecht leaves Los Angeles* (1979) used elements of *Madame Butterfly* in Brecht's House of un-American activities.
Cho Cho San: Daniel Keene, Dal Babare, Boris Conley, 1978, 1988 at Playbox.

108 Upton, 1988, p. 18.
In the 1990s the Asian plague was reversed again in real life, with AIDS being brought into Australia by Thai prostitutes and Australian male tourists.
Pam: Commentary, exhibition, AGNSW, May 1991.
O'Rourke, notes on *The Good Woman of Bangkok*, 1991.
Miss Saigon: Lea Salonga, a Filipina, played the lead role in London and New York.
M. Butterfly: a French diplomat, Bernard Boursicot, was convicted of espionage in 1984, his career ruined by his own folly and by Shi Peipu, a female impersonator of Chinese opera with whom he had an affair in the mid-1960s. (TWA, 13–14 Aug. 1988).
Stewart's habit of 'disengagement', from school, teachers' college, university, the army, and from getting to China: see Ronald Dunlop, 'Pilgrim's Origress in Japan: Discovering Harold Stewart', *Southerly* 43, 2, 1983, 167–81.
Hanare and Bashō's 10-foot-square hut: Stewart to AB, 17 June 1987. (Bashō Matsuo, haiku poet, 1644–1694.)
Hypochondriac: Robert Gray, recorded interview 12 Feb. 1987; Stewart to Hal Porter, 2 Jan. 1964, cit. Croucher, 1989, p. 74.
Biography: Carmen Blacker, 'Landscapes of Inner Space', TLS, Special Japan number, 30 Oct. 1981.
Harris to John Reed, 8 Nov. 1943, cit. Haese, 1981, p. 147.
Ern Malley: Dutton, 1984, pp. 155–63. The Ern Malley hoax may have had a French exemplar (David Brooks, ALS, May 1991).

109 Stewart and Buddhism: Green, 1981, p. 137. Stewart's travel to Japan in 1962 and 1966 was supported by the Sydney architect Adrian Snodgrass, who had travelled in India for nine months, and who, with Stewart, was ordained in the Pure Land sect at Higashi Honganji in Kyoto (Croucher, 1989, p. 73).
Modern Japan: Snodgrass, cit. Croucher, 1989, p. 73.
Tory: Stewart to Les Oates, 17 Dec. 1986, cit. Croucher, 1989, p. 29.
Green, 'Poet's Progress', H, 17, 12, Dec. 1973, 14.
Stewart,1981: compare Clayton Eshleman (*The House of Ibuki*, 1969) and Philip Whalen (*Scenes of Life at the Capital*, 1971).

Foreign poets in Kyoto, Will Petersen and Cid Cormon: Morton, 1988.
Stewart, cit. Green, 1981, 151. Stewart to AB, '14 April Showa 60' (1985): signed 'Oz's newly-created Ribbing Gnashional Trashure, Laughcadio Ern'. Stewart to AB (undated, 1984): 'from the famous poet whom nobody has ever heard of'.
'Become so Japanese . . .' Stewart, cit. Robert Gray to AB, Nov. 1985.
Fly, gaijin: Stewart, 1974, vi, 106–112; 202–7.

110 Stewart to AB, 14 April 1985; 25 Jan. 1987. In the late 1980s Stewart's unpublished works were *Autumn Landscape-roll*, *New Phoenix Wings*, a volume of collected poems, and *Over the Vermilion Bridge*, a third volume of illustrated and annotated translations of haiku. Stewart to AB, 17 June 1987.
White's epigraph to *Happy Valley* (1939) is from Mahatma Gandhi: '. . . Progress is to be measured by the amount of suffering undergone.' Tiffin, 1984, 468–79. See also Tiffin, 1978.
Stow, 1963, p. 148.
Stow, 1966, 1962, 1965.

111 Hope, 'Randolph Stow and the Way of Heaven', H, 18, 6 (June 1974), 33–5. Stow left Australia in 1966 to live in England, publish little poetry or fiction. In the late 1980s he was researching the history of Europeans in the Indian Ocean.
Wright, 1971; Wright to AB, 20 Oct. 1987.

112 Krauth, 1982, p. 199. Lett, 1946, p. 11.
McAuley, 'My New Guinea', *Quadrant*, V, 3, 1961, 25. In the wake of Ern Malley, McAuley went to New Guinea as an administrator and teacher in 1944, was coverted to Catholicism there, and returned many times up to 1960.
'Burning the Library', Oakley, 1977. Colonial mind: Tiffin, 1982, 326–35.
See Sinclair, 1981, 1988. The latter recorded the explorations of Ivan Champion in Papua. See also Souter, 1963; Nelson, 1982.

113 Stow, cit. Hassall, 1990, p. 128. 'Kapisim! O Kiriwina', Stow, 1969.
Stow knew Conrad well, and began a thesis on his novels (Hassall, 1990). Myths: Krauth, 1982, p. 254.
Stow, 1979, p. 107.

114 Stow, 1979, pp. 30–1. Italics and punctuation are Stow's.

10 FOLLOWERS AND LEADERS

Page
116 I am indebted for much of the background to this chapter to Ann-Mari Jordens, and for detailed comments to Jamie Mackie.
William Dargie, a conservative painter and a former war artist, drafted Lancaster's words (Jordens, 1987, 4–5, 16). See also Anne Gray,

in Pierce, Doyle, Grey, 1991, ch. 4.
Lowe, cit. Carroll, 1990.
D. Thomas, 1988, p. 146.

117 Themes: Pierce, 1980.
Poets: Jordens, 1986. See Cass and others, 1971.
Fox, 1957, 1959, 1966.
Geoffrey Dutton, 'Marshal Ky in Australia', postscript in S. Cass and others, 1971.

118 Subservient government: Renouf, 1979, p. 325.
Moorhouse, 1972, p. 58.
Gerald Stone, 1966, cit. Renouf, 1979, p. 280.
Morrison, 1973, intro.
Comments from Vietnam veterans: John Sampson, 'Yesterday's Enemy', GW, 10 Dec. 1988, 99.
Dawe, cit. Shaw, 1974, p. 68.
Beaver, *Letters to Live Poets I* (for Frank O'Hara).

119 Moore, Pleace, n.d. Poems by veterans: see also *Debrief*, the journal of the Vietnam Veterans' Association.
Wright, 1971. 'The bloody lottery'—the conscription ballot—turned most Australians against the war, more than the knowledge of what was happening in Vietnam itself (Wright to AB, 20 Oct. 1987).
Roger Bell, 'The American Influence', in Meaney, 1989, pp. 358, 361.
Drewe, 1986.
J. A. C. Mackie to AB, 29 Aug. 1991.
'If some of our stories did not mention drugs, Vietnam, and liberationist concerns, there would be something unsettling and unreal about our writing'. (Moorhouse, *Westerly* 2, July 1970; Moorhouse, ed. *Coast to Coast*, 1973).

120 Japanese plans: see Frei, 1991; H. McQueen, 1991.
Jose, 1989, p. 39.

121 1930s film precursors of *The Odd Angry Shot* (Tom Jeffrey, 1979): see Murray, 1980, p. 24.
Earlier Antipodeans: Chips Rafferty (*Forty Thousand Horsemen*, Charles Chauvel, 1940), Jack Petersen (*Breaker Morant*, Bruce Beresford, 1980) and, in a civilian version, Paul Hogan (*Crocodile Dundee*, Hogan, 1987).

122 Rowe, 1968, p. 113.
Frazer, 1984, p. 293.
San Francisco Chronicle, cit. Pierce, 1980.
Williamson based the flashback scenes on interviews with Australian veterans: Kiernan, 1990, pp. 117–22.
Davis: Bowden, 1987.
Seymour: Holloway, 1987, p. 190.

123 Williamson: Kiernan, 1990, pp. 117–22.
Nowra, cit. Leonard Radic, 'Louis Nowra Learns to Adapt', *The Age*, 25 Aug. 1984, 14.

124 *Dustoff Vietnam*, 'The Veteran Who Couldn't Forget', 28–9.
Police: Alomes, 1988, p. 191.

Other films include *Demonstrator* (Warwick Freeman, 1971), with Hong Kong actor Kenneth Tsang as the main Asian character (nationality unspecified) attending a Canberra conference on Asian security; and *You Can't See Round Corners* (David Cahill, 1969), adapted from a TV series, adapted in turn from Jon Cleary's 1949 novel.

125 Bretherton: Suzy Freeman-Greene, 'Vietnam—the women's war continues', *The Age*, 17 Nov. 1990, extra Arts 10.
Sir Arthur Rylah, cit. Alomes, 1988, p. 191.
See William Broyles, jr., 'Box office Vietnam: How the War Became the Movie', TWA, magazine, 22–23 Sept. 1990, 20–31; *Hearts of Darkness* (Eleanor Coppola, 1991 in Australia); and Adair, 1981. American anti-war plays seen in Australia included David Rabe's *Sticks and Bones*.
Pilger, 'Vietnam: the Massacre of the Truth', *The Age*, 29 Oct. 1988, 9.

126 Gooks: *Sad Song of Yellow Skin*, Michael Rubbo, Film Board of Canada, 1976. 'Theoretically there are friendly gooks and unfriendly gooks, but fundamentally they're all just gooks.' Rowe, 1979, p. 1.
Dawe, 'All Aboard for Changi', TWA, 28–29 July 1990.

127 Watt, 1967, p. 258.
Indonesia: Reeve, LS, 1988. See Burgess, 1986.
FitzGerald, 1989.
Anthology: Tonetto, 1990.
'Tiananmen Square', June 4, 1989, in Zwicky, 1990; Clarke, 'Tiananmen Square'; Dutton, 'For All Students, Everywhere', SMH, 10 June 1989, 88.
Jose, 1989, 'Afterword: The Peking Massacre'.

11 HERETICS AND DOGMATICS

Page

128 See Hewison, 1986; Michael Wilding, 'Tabloid Story', in Bennett, 1981, p. 234.
See Serle, 1987, ch. 10; Tranter, 1979, intro. Tranter cites the Baby Boom generation, 1950s affluence, printing technology, and drugs as causes of the 1968 phenomenon.
Whitlam, 1979, cit. White, 1981.
Poets: Kirkby, 1982.
Morton, 1888. In the 1990s, Les Murray decided to drop 'the medial A'. (Peter Rose to AB, 4 June 1991).
By 1960, Kerouac's *On the Road* (1954) and *The Dharma Bums* (1958) were available in Australia, and after a customs ban was lifted, Donald Allen's *The New American Poetry* (1960), Donald Hall's *Contemporary American Poetry* (1962), and *The Beat Scene*. America still seemed to Tranter to be Australia's change agent in the late 1980s: 'You can't have a

meaningful art form without an acknowledgement of the way things change so fast in New York.' (Tranter to AB, 13 June 1987).
McCauley, 1984; McCauley, 1991.
Duggan, 1978, p. 17.
Taylor, 1985, with an appreciation by Robert Kenny 'A secret Australia: on the poetry of Ken Taylor'; Taylor, 1984. 'Sonnets', in Tranter, 1979. Tranter 'This is no humourless hippie wimp', review of Gary Snyder *Left Out in the Rain: New Poems 1947–1985*, TOS, 21 June 1987, 35.
'Cycling in the Lake Country', Murray, 1974; 'Aqualung Shinto,' Murray, 1974. See Murray, 'Australian Shinto: Some Thoughts on the White Southern Soul' (1981); 'Some religious stuff I know about Australia', Murray, 1984.
Ryōanji: the 15 rocks in this walled Zen garden in Kyoto are placed so that no more than 14 can be seen at once.

129 Watts: Croucher, 1989, pp. 85–7.
Snyder, *Riprap, & Cold Mountain Poems* (1958), translation of the Chinese poems of the seventh-century monk Han Shan; cf. translations of Ryōkan in Gray, 1988.
Poet Jennifer Maiden objected to the 'dismissive simplicity' of 'the present Japanese-influenced lyrical but skeletal hit-and-run type of poem' (ALS, 8, 2, 1977).
Gray, 'The Death of Ronald Ryan', 'Boarding House Poems 7', 'To the Master Dogen Zenji (1200–1253 AD)'.
Gray, 'Writer-in-Residence in Tokyo', Lohrey, 1988, pp. 60–2.

130 Viidikas, cit. Peter Blazey, 'Life Under a Banyan Tree', NT, 17–23 Aug. 1984, 29.
American-born poet Jeri Kroll lived in Australia from 1978, visited India, where her sister was married to an Indian, and wrote of Kerala, Hyderabad, Mysore, Bangalore, Bombay, and the Jumna River. 'India gets in the pores,' and it heightens and intensifies personal relationships (Kroll, 1984).
'Calcutta Dreaming', Johnson, 1986. Gaol: Croucher, 1989, pp. 88–9.
'Greenhalgh's Pub', 'Breakfast in Shanghai', 'Letter to his son for his eleventh birthday during an absence in China', Croft, 1984.
'Planting the Dunk Botanic Gardens', O'Connor, 1986; 'Tiger Forest', unpublished, O'Connor to AB, 29 June 1987.
'After Hiroshige', 'Kelly Country', Hemensley, 1978; 'A Mile from Poetry' *Island*, 1979. Hemensley owned R. Chiba, *Hiroshige's Tokaidō in Prints and Poetry* (Tuttle, 1958) and drew especially on number 11, 'Mishima' for 'After Hiroshige'. (Hemensley to AB, 8 May 1988).
Harry's first book (1970) included three poems about Japan.

131 Faust, 1980.

'The Blood of Jose Arcadio', Brooks, 1990; Brooks to AB, 20 March 1991.
Brooks, 1990, p. 137.
'Von le Coq assures us hastily that he dismissed the somewhat offended beauty after buying a pair of fine earrings for her': Albert von le Coq, cit. Hopkirk, 1980, p. 138.
Jones cit. Deborah Stone, 'Questions in Paradise', TWA, 21–22 Jan. 1989, 6.
Adams, foreword, Murray, 1980, p. 7. McFarlane, 1987; Best, 1985, p. 55.
Murray, 1980, p. 138. Stratton, 1980, pp. 264–5.

132 In spite of the synthetic country's anonymity, official complaints were made by Malaysia, which took offence at earlier SBS programs as well. Extras in *Embassy* looked 'as South-East Asian as Bruce Ruxton. You can't get away with smearing Melbourne faces with Max Factor and expecting the audience to accept them as Indian, let alone Chinese'. (Phillip Adams, 'Pressing Points and Parallels', TWA, 1–2 Sept. 1990, Review 8).
'The war contributed to the surface chatter of some plays by David Williamson', (Pierce, 1980, 301).
'The Sword and the Flower' (Frank Heimans) in SBS' five-part series *Warriors* (1989), like *The Chrysanthemum and the Sword* and *The Sword and the Blossom*, sought to account for Japanese militarism in terms of Japan's 'uniqueness'.
Williamson, 1989: Kiernan, 1990, pp. 376–8.
Katharine Brisbane pointed this out.

133 Upton, a journalist for 20 years before becoming a writer for film, television, and theatre, visited Manila on a five-day guided tour in 1985, as part of a 28-day trip to southeast Asia. (Upton to AB, 2 June 1989).
Would the journalist's *male* lover in the original script for *A Dangerous Life* have been tortured and killed?
When Reeves (John Bell) is locked up in a 'safe house' by the government's goons, other Australians say 'they don't just wipe out Westerners'.
Upton, 1988, pp. 79–80. Upton to AB, 2 June 1989. Upton, 1988, p. 58.

134 Dennis O'Rourke, notes on *The Good Woman of Bangkok*, 1991.

135 Kildea to AB, 4 Aug. 1986, 4 May 1991.
Anne B. Hutton, 'Nationalism in Australian Cinema', *Cinema Papers*, 26, 1980.
Weir, interview, ABC Radio National, 14 June 1987; Australia–Japan Foundation lecture, Tokyo 1983, pp. 14–16. Comparison of *The Year of Living Dangerously*, the book and the film: Murray, 1984, pp. 40 ff.
Rob Page, ABC, cit. Helen Musa to AB, 25 June 1985.

136 Peggy Van Praagh,'The Australian Ballet in

1969' H, 14, 1 (Jan. 1970), 32.

136 Yūgen: 'felt beauty', a Buddhist concept, the aesthetic ideal to which Nō aspires. Brown, 1967, p. 102.

137 Hannan, 1982, pp. 63, 88.
Katharine Sorley Walker, 'Australian Ballet on the Move', H, 6, 12 (Dec. 1972), 24–31.
'Tentatively venturesome': Lisner, 1984, p. 15.
Serle, 1987, p. 215.

138 Barr to AB, 15 May 1985.
Alex Pollak, 'Kai Tai Chan', SMH Metro, 19 Oct. 1984. Deborah Jowitt, 'Dance' The Village Voice xxv, 28 (9–15 July 1980).
Kai Tai Chan to AB, 7 June 90.

139 Kellaway to AB, Aug. 1985.
Clark, cit. Frizell, 1983.
Visits: Jiangsu Peking Opera Company, 1983; Tenkei Gekijō, 1984; Sankai Juku, 1986; Peking Opera Theatre of China, 1988; Kanze Nō Theatre of Japan 1988; Suzuki Company of Toga, 1989; Dai Rakuda Kan, 1991.
In 1972–73 Mellor studied Kathkali dance in India and Nō in Japan, and applied this to his staging of Barry Conyngham's music theatre piece Edward John Eyre (1973). (Mellor to AB, 26 April 1985).
Examples include Beynon, The Shifting Heart, 1957; Seymour, The One Day of the Year, 1960; David Martin, The Young Wife (1962); Colin Ballantyne, The Ice Cream Cart (1962). 'I tried to incorporate elements of Indonesian theatre into the play [Norm and Ahmed], but scrapped them.' (Alex Buzo to AB, 9 July 1985).

140 Brisbane, introductory comment, The Floating World, 1975, xxvii, xxviii.
Romeril, 'The Impostor: Working Notes', 1987.
Romeril, 1988b.
Hooke, cit. Barbara Cosson, 'Chinese—But The Theme Strikes Home', TOS, 30 Aug. 1987, 29.
Shanghai: Jack Hibberd, A Stretch of the Imagination was performed in Chinese.

141 Mark: my emphasis.
Romeril, interview, Meanjin 3, 1978; Professor Hirono Ryōkichi to AB, Jan. 1989.
Romeril, interview, Meanjin 3, 1978. Fitzpatrick, 1984.
Ujung Pandang: formerly Makassar.
Buzo visited Indonesia in 1976 before writing Makassar Reef, and Fiji in 1981 and 1982 to research The Marginal Farm. (Alex Buzo to AB, 9 July 1985; Adrian Buzo to AB, 18 Oct. 1988).
Fitzpatrick, 1984, p. 11.
Buzo, cit. Willa McDonald, 'The Passage of Alex Buzo: From Satire to Irony', B, 22 Jan. 1985, 44–5.

142 Jo Litson, 'Wicked Ways of Louis Nowra', TWA, Magazine 9, 18–19 April 1987; Hilary Burden 'People Watch: Louis Nowra', Vogue

Australia, May 1987, 67.
Radic, 1991, pp. 188–90.
Nowra, 1983, p. 25.
Nowra's sources: he had not been in Asia; 'I have had little to do with either Vietnamese or Chinese people'; a book on the Chinese warlord era, and The Story of a Stone, seemed to mirror each other and suggested a political fairy tale. 'An Asian being corrupted by Australians appeals to me because it turns the stereotype on its head'. Nowra's mother's first husband was a Dutch Indonesian, a Chinese boy was his close friend at school. (Nowra to AB, 5 Nov. 1985).
Radic, 1991, pp. 235–6, 8.

143 Buried Alive: The Story of East Timor (Gil Scrine, 1989), produced with a grant from the Australian Film Comission, used historical footage to cover events in Timor from before 1974 to 1986.
Ford: the play mentions Presidential discussions held between Indonesia and the United States in Jakarta on 6 Dec. 1975.
Romeril, 1988a, p. 11.
Timor: A. B. Paterson, The Man from Snowy River.
Romeril to AB, undated, (1985).

144 Jimmy Chi, Kuckles: Breen, 1989.
See Richard Bradshaw, 'The Asian Influence on Puppetry in Australia', unpublished, Aug. 1983; Bradshaw to AB, 10 April 1985.
P. J. Wilson to AB, 8 June 1990.

145 In Melbourne, Playbox Theatre staged the Fujian Puppet Theatre (1979), the Hunan Puppet Theatre (1983) and the Yakshanaga Theatre of India (1983). The Awaji Ningyo Gekijō appeared at the Adelaide Festival in 1986.
Katharine Brisbane, 'Pulling Strings', H, 22 (12 Dec. 1975), 16–21.
Scriven to AB, 26 June 1985.
Martin Wesley-Smith, 'The Question is . . .: Australian composers and their influences', Sounds Australian: Journal of Australian Music 26, Winter 1990, 19–21.

146 Da Costa was shot on the day of the Indonesian army's invasion of East Timor. His poems were translated by Australian writer Jill Joliffe and published by Wild & Woolley. As a result of the performance of Kdadalak in Japan in 1977, a Japanese support group was formed to build a school for East Timorese refugees in Darwin.
Gifford to AB, 28 Sept. 1987.
Chow: Murdoch, 1975, p. 96.
Conyngham to AB, 29 Sept. 1987; Conyngham cit. Jo Litson, 'Music and the Making of an Australian Accent', TWA, 5–6 Dec. 1987.
Japanese themes and techniques: Conyngham's double bass concerto (1975), Basho (1979), Three

(1969), and his 'personal reflection on Japan', *Water ... Footsteps ... Time* (1970), in which the guitar and harp resemble Takemitsu's biwa and shakuhachi in *November Steps*. (David Symons in Callaway, 1978, p. 215).

147 Boyd, EO, 7 July 1987.
Boyd to AB, 24 Aug. 1987; Boyd, EO, 7 July 1987.
Jenkins, 1988, pp. 141–8.

148 John Williams' grandfather was a Melbourne Chinese leader, William Ah Ket. (Andrews, 1985, p. 244).
Conyngham to AB, 27 Sept. 1987.
Margaret J. Kartomi, 'The Story of the *Gamelan Digul*', unpublished paper, 1990.
Astra: Margaret Kartomi to AB, June 1991.
A. D. McCredie, 'Musicological Studies in Australia from the Beginnings to the Present', *Australian Aboriginal History*, 1983, pp. 28–9, 42–3; Drummond, 1978.
Posselt, 'Song of India', *24 Hours*, Aug. 1990, pp. 18–19.
Boyd to AB, 10 July 1987.
Grainger, 1982; Reeves, 1982.

149 Elwyn Lynn 'The Japanese Connection', *Quadrant*, Aug. 1977, 78.
Wichmann, 1980, pp. 406, 405.
Fairweather, cit. Abbott-Smith, 1978, p. 63.
Menzies, 1976.
Olsen, cit. Christopher Leonard, 'John Olsen's recent paintings', A+A, 3, 24 (Autumn 1987), 369–75.
Tuckson: D. Thomas and others, 1989.
Menzies catalogue 1976.
McGrath, 1979.
Whiteley, cit. Lenore Nicklin, 'Wicked Whiteley's Surprised—He's Alive and Healthy', B, 15 Oct. 1985, 82–5.
Whiteley selected a bonsai fig tree and showed various artists' drawings or paintings of it in a white room of the Yellow House. (Mendelsohn, 1990).
'. . . my own natural bent . . . is more Asian', Whiteley, 1983, intro.

151 'I *feel* like a White Asian. I feel more like a ginger Nip than a Yorkshireman which is where my Dad came from. I wish now that my Dad had given me an Asian brush when I was eight, instead of a European sable. I think Japanese drawing is the finest form of drawing. It can take only 25 seconds to do.' (Whiteley, cit. Nicklin, 1985).
'For my own part I don't need Japanese pictures here, for I am always telling myself that *here I am in Japan*. Which means that I only have to open my eyes and paint what is right in front of me, if I think it effective.' (Van Gogh, *The Complete Letters*, 1958, W7).
Visit to Japan: Whiteley to AB, 7 July 1991.
Bridges: Elwyn Lynn, 'Luscious Ornaments',

The Independent Monthly, Sept. 1991, 35.

152 Lindsay, 1982, p. 95.
Mendelssohn, 1990.
Carroll, 1984.
'Avoided vision': David Ireland, *A Woman of the Future*, 1979, p. 349.
'Wolseley on Wolseley', Wolseley and others, 1982, p. 126. Wolseley to AB, audiotape April 1986. Wolseley, 1988, p. 3. 'A sort of Klee line going for a walk, but on to the Rock and sand and spinifex and then on to the paper', Wolseley, cit. Catalano, 1985.
Kyoto: 'Postscript', Wolseley, 1984.

153 Manipulated chance: Robin Wallace-Crabbe, A+A, 16, 2, 137.
Wolseley to AB, April 1986.
Chinese: D. Thomas, 1988, p. 132.
Davis makes a practice of bartering, not selling, his sculptural works.

154 Bill Clements, and other sculptors using Japanese sources: Scarlett, 1980, pp. 107–9.
Developed since 1976, the *Third Arm* was a steel and perspex prosthesis powered by electromagnetic impulses from the user's gut-muscles. The body, Stelarc believes, must 'burst from its biological and planetary containment'. (Stelarc, cit. Marguerite Feitlowitz, 'Where Art and Medicine Meet', MN, Feb. 1985, 233. Stelarc to AB, undated, 1985.

155 Professor Derek Freeman, lecture on Nolan's 'Silk Route' exhibition, Nolan Gallery, 13 Sept. 1987.
Mountains: *Sidney Nolan*, video, Nolan Gallery, 1987.
Watson: Chanin, 1990, pp.43–4; Ronald Miller, 'The Celestial Kingdom and the Kingdom of God: A Jesuit Parenthesis in Chinese art', A+A, 8, 3, 252–8.
Quintal: *Kuan-Yui*, 1986; *Reclining Buddha*, 1987.

156 Flugelman: Takeda Hiyoshi, a former cartoonist, from the 1970s produced in Tokyo a series of prints in which yakuza tattoos appear in minute detail on the surfaces of unlikely objects. Johnson, introductory text, Mori Gallery catalogue, 10–28 Nov. 1987.
Sansom, cit. Carroll, 1990, pp. 30–1; Chanin, 1990. Transvestism in Sansom's work: Graeme Sturgeon, A+A, 15, 2, Dec. 1977, 187. 'Visual debris': Christopher Heathcote, 'Exhibition by Sansom raises critical problems', *The Age*, 29 May 1991, 14. Sansom represented Australia at the Indian triennale in 1989, Jenny Watson in 1986.
Tillers, *Kangaroo Blank*, 1988: D. Thomas, 1988, pp. 226–7; Chris McAuliffe, 'A Condition of Suspended Confusion', A+A, 27, 2, Summer 1989, 282–6.

157 Hoffie, *Art FAX: Australia/Japan Art Exchange*, 1989. Allan lived in Japan as a child,

and screens and other Japanese artifacts were familiar from her Melbourne home (Carroll, 1990, pp. 12–13, 18–19).

158 Sauvage: Carroll, 1985, p. 61.
Clark, cit. Carroll, 1990, pp. 14–15. Chinoiserie: Clark, 1989. I am obliged to John Wolseley for this.
Fiona MacDonald, who had not been to China, collected chinoiserie objects and objects from China, Japan, and India, juxtaposing them in collages which comment on changes in taste.

159 Shoji to AB, undated 1987.
Carroll, 1985, p. 50.
Lowe, cit. Carroll, 1990, p. 22.

12 REGIONALISTS

Page

160 Kurokawa building: Dimity Reed, 'Flaws beneath a new "crystal cathedral"', *The Age*, 9 September 1991, 11.
Charalambous to AB, 9 Feb. 1989.

161 David Elias, 'Now that the party is over', *The Age*, 29 Oct. 1988, Saturday Extra, 21
Anne Jamieson. 'Young to bury hatchet in garden', TWA, 4 Oct. 1988, 10.
'Geisha girls in the bush'. TWA, 8–9 Dec. 1990, property 1.
Cowra Municipal Council, *The Centre of Japanese culture in Australia*, n.d.
Corporation of the City of Adelaide, *Adelaide-Himeji Garden, South Terrace*, April 1985.
Shirley Stackhouse, 'Thinking small makes a big Japanese impact', SMH July 1988.
Anne Latreille, 'An Artist at Work on Canvas of Rock', *The Age*, 7 May 1991, 26.
Taylor, 'Review: Japanese Courtyard', *Architecture Australia*, June/July 1977, 47–49.

162 Armstrong to AB, 20 Nov. 1985.
Wichmann, 1980, p. 320.
Giselle Antmann, 'East Meets West', *Craft Australia*, Summer 1987, 4, 40–42.
Yang, video, *China Diary*, 1990.
Chung, *Shouting from China*, 1988, 1989. Other Asian Australian artists who reflect on their former homelands in their work include photographer Christine Ramsay (Malaysia), and Thomas Le (Vietnam).
Joyce Agee, curator, 'Women's Images of Women, a Selection of Contemporary Women's Photography', Westpac gallery II, Melbourne, 4 March–7 April 1991.

163 Pam, commentary, AGNSW exhibition, May 1991.
Grant, 1973, p. 83.
Mansell: AA, 3, 16, June 1926.
Aborigines at Utopia in the central desert, mainly women, began making batik prints on silk in the 1970s, together with artists from Alyawarre and Kaytetye land. Leading artists were Gloria Tamerre Payarre and Ada Bird Petyarre.
Shanghai Lil: the cast included Germaine Greer, Arthur Boyd, and Richard Neville, as well as Jenny Kee. Sample line: LIL to hero: 'Hello Jack, long time you no visit Shanghai.' (Kee to AB, 20 July 1990).

164 Stelarc to AB, 1985.
Asian languages and Australian artists: Barry Gazzard, Carolina de Waart, Roger Pulvers, Solrun Hoaas, Kimi Coaldrake, Gary Watson, Hugh de Ferranti (Japanese); Harry Charalambous, Nick Jose (Chinese); Vicki Viidikas (Hindi); Glenda Adams (Indonesian).
Multicultural success: Donald Horne, ABC radio interview, 6 Sept. 1991.
Arabic courses were begun at the University of Sydney in 1866, and Japanese and Chinese in 1917; Asian history at the University of Western Australia in 1915; Indonesian in 1955 at ANU, Melbourne, and Sydney by Herb Feith, Jamie Mackie, and John Legge.(Greenwood, 1974; Legge, 'Asian Studies: From Reconstruction to Deconstruction', in Walker, 1990, 93–102). FitzGerald, 1990, 13. Of high school students, a significant number were Asian students taking Asian languages as a soft option. Enrolments in first-year Japanese courses at universities increased markedly in the late 1980s. But in 1990, 75 per cent of secondary students were still choosing French, German or Italian. One Australian effort to provide a source of general information on Asian culture was lost when the Federal government cancelled funding for *Hemisphere* magazine in 1984, rather than give it a more commercial basis and a more contemporary approach. Another went with the end of the 'Asia and Pacific Writing' series published by University of Queensland press. (Michael Wilding, 'Tabloid Story' in Bennett, 1981, p. 234) Australia, instead of being a centre for publishing in English on Asia and the Pacific, had no equivalent of the *Far Eastern Economic Review* or the Asian Wall Street Journal, and was not identified by them as an Asian country. Australia still had no official claims to non-military official identification with Asia except in the Asian Development Bank and the Asia-Pacific Economic Cooperation meetings, which included the United States and other Western members. It did not compete in the Asian Games, and at the United Nations, Australia belonged to the group known as 'West European and Others' (while it was a member of the Asian group in Unesco).

165 Collections: Splatt, McLellan, 1986, p. 4.
Galbally, 1987.
H. W. Kent: Basil Burdett, AA, 3, 68, Nov. 1937. Russell: McCulloch, 1968, p. 15.

166 C. F. Laseron, 'The Collection of Dr. S.

Godsall,' AA, 3, 59, May 1935, 73–77. William Bowmore (Milhelm Braheim Ibn Yared) was born in Australia of Lebanese parents. See Daniel Thomas, 'The William Bowmore collection', A+A, 15, 3, Autumn, March 1987, 272–282.

Capon, *Travels in Chinese Art with Edmund Capon*, ABC TV, April 1989.

More detailed information on collections appears in an occasional series, 'Asian Art in Australian Public Collections', ASAA *Review*, July 1981–Sept. 1983.

167 Charmaine Solomon was born in Sri Lanka, where she first worked as a journalist; she arrived in Australia in 1959, and her *Complete Asian Cookbook*, first published in 1976, has never been out of print since.

'Planting the Dunk Botanic Gardens', O'Connor, 1986. Banfield (1852–1923), arrived Ararat 1854, and became an admirer of a wandering British Buddhist Sir Walter Strickland, who financed publication of his books, *The Confessions of a Beachcomber* (1908), *My Tropic Isle* (1911), *Tropic Days* (1918). (Croucher, 1989, pp. 14, 32, 87; *Australian Dictionary of Biography*, vol. 7.)

'I have studied the Korean martial art Tae Kwon Do for many years, and this year began studying Tai Chi Chuan (taijiquan), a form of Kung Fu, under a very gifted exponent who is also a research physiologist, Dr Francis Seow, of Sydney.' Foster to AB, 18 April 1985, 8 April 1991. Foster, 1984, 9–10.

168 Foster, 1991, p. 20.

169 McKemmish, 1986, p. 94.

D'Alpuget, 1981.

Moore: Heather Kennedy, 'No supermarket spiritual', *The Independent Monthly*, June 1991, 14.

Owen, cit. Carroll, 1990, p. 28.

Sollier: Croucher, 1989, p. 118.

Peanut: Richards, 1973, p. 50.

Stephen Melville, 'Picturing Japan: reflections on the workshop', in Masao Miyoshi, H. D. Harootunian, eds, *Postmodernism and Japan*, 1989, p. 280; Cooke, 1990, p. 7.

170 The Marco Polo film was conceived and scripted by an American comic-book artist, Sheldon Modoff, and co-financed by his company, Animation International.

Ker Wilson, born UK, arrived Australia 1964, and wrote a series of folk tales of other countries, including India.

Manley, 1979, 1982, 1987: McVitty, 1989, pp. 131–2.

Martin: born Ludwig Detsinji, arrived Australia 1944.

171 Baillie, cit. Agnes Nieuwenhuizen, 'China's Truths Were Harsher Than Fiction', *The Age*, 11 September 1991, p. 4.)

Krauth, 1987, p. 24.

'On the Beach', Brissenden, 1980, p. 21. Other Australian-in-Indonesia poems in the collection include 'Barong Dance', 'Leaving Jakarta', 'Walking down Jalan Thamrin', 'Under Mount Agung', and 'Surabaya'.

13 AUSTRALIANS AND ASIANS

Page

172 Carson Creagh, 'On and off the Track in PNG', TWA, 17–18 Nov. 1990, review 6.

Pickard, 1969; Williams, 1971; 'Sterner's Double Vision', O'Grady, 1979, pp. 1–20.

Stafford, 1985.

Emery, 1984; Emery, 'Dark and Primal', *Adelaide Review* Oct. 1987, 27; Geoffrey Dutton, review of *The Sky People*, TWA, 10–11 March 1984, 15.

Krauth, cit. Jane Sullivan, 'Still Haunted After All These Years', *The Age*, 29 Sept. 1990, extra 8.

Shearston, cit. Peter Fuller, 'Writer "fills a blank"', CT, 2 Nov. 1983, 20.

173 Astley to AB, 31 May 1985.

Maniaty, 1984, p. 211.

Stevenson, *In the South Seas* (1912), New York, 1891. 'A Game of Cards', in Shearston, 1979.

Astley, 1985, p. 160.

'Defending the Library', in Oakley, 1977.

174 Shearston, 1983, p. 269.

Priest: Astley, 1968. Corinne: Pickard, 1969. Rhys: Shearston, 1983.

Astley, 1985, pp. 110, 144.

175 Astley, 1985, p. 46.

Shearston, cit. Fuller, CT, 1983.

Kolia, 'Putting out the Lamp', in Krauth, 1982.

Corris, 1990, pp. 14, 186. Corris's next novel was *Nasmith's Dominion* (1990), set in the Solomon Islands.

176 Clyde Cameron, *China, Communism and Coca-Cola* (1983), sees China as the country of the world's most generous, honest, clean, gentle, kind people, whose women enjoy equality with men.

Brophy, 1991, satirises Australian eagerness to sell one woollen sock to each Chinese.

'Americans came back from China saying Acupuncture! No flies! No tipping! They give your used razor blades back! They work like dogs! They eat cats! They're so frisky! And Americans even praised Chairman Mao, unaware that many Chinese were privately sick of him' (Theroux, *Riding the Iron Rooster: By Train Through China*, 1988).

D'Alpuget, 1981, p. 3.

'When I saw Australia from Asia the embarrassing comparison with Europe and America became meaningless.' Grant, Australia's High Commissioner in New Delhi under the Whitlam

government: AWTA, 1980.

177 Koch: 'Few Australian writers had then set works of fiction in Asia'. (Koch, 1987, 7) Other novelists who preceded Koch in breaking the voyage to England in Colombo or Bombay included Lang, Praed, Anderson, Stead, Wright, Atkinson, Beilby, and Brissenden, who in Colombo 'began a life-long love affair with hot Asian food' (Brissenden to AB, 27 June 1985).
D'Alpuget, AWTA, 1980.
Adams to AB, 3 Jan. 1991.
Macklin, 1977, pp. 226, 259, 296, 347.
Koch, 1987, p. 6. Koch, 1965, *1982*, p. 161.
Arrival in an Asian country was a common subject in Orientalist travel writing. 'He carried himself with the conceit of a master among servants throughout' (Kinglake, *Eothen*, cit. Kabbani, 1986, p. 9).
Koch, 1979, pp. 19–21.
Kipling, cit. Birkenhead, *Rudyard Kipling*, 1978, p. 63. Kipling, 'The White Man's Burden', 1899.
Koch, 1982, pp. 94, 99.

178 Koch, 1978, p. 117n; Koch, 1987, 19.
The eponymous Ilsa Kalnins and Carleen (Koch, 1965) each represent aspects of Kali: Koch, 'Literature and Cultural Identity', *The Tasmanian Review*, 4, 1980.
Koch, 1987, p. 19.
'California Dreaming, Hermann Hesse and the Great God Pot', 'Mysteries', Koch, 1987. Koch, 1987, p. 6.
Blanche d'Alpuget's father and stepmother were journalists; so was her protagonist in *Turtle Beach*, 1981.
Moffitt, Grant, Drewe, Maniaty, Margaret Jones, Richard Neville and Julie Clark (*The Life and Crimes of Charles Sobraj*, 1979) had all worked as journalists. D'Alpuget's 'initial ignorance of Indonesia was comprehensive' (d'Alpuget, AWTA, 1980).
Drewe, 1986, 133–139.

179 Glenda Adams was the first honours graduate in Indonesian at the University of Sydney in 1961, studied and taught in Indonesia in 1962–63, and studied journalism at Columbia University (Adams, 'Letters from Jogja', in Walker, 1990, 9).
Drewe, 1979, pp. 200, 191.
Koch was aware that pairing hero and guide, Bwana and scout, giant and dwarf had correspondences with Hindu myth and the Wayang, but· Hamilton misses their relevance to himself, seeing the puppet figures in the bar only as 'wierd cartoons'. (Koch, 1979)

180 Moffitt, 1985.
181 Loftus, 1979, p. 5.
New World: see Koch, 1979, 19–21; Brissenden, 1987, 19; Drewe, 1979, 68.
'Confucius,' Moffit, 1985, p. 113.

D'Alpuget, AWTA.
Koch, 1979, pp. 3–14.
Orwell, *Burmese Days*, 1934, *1962*, pp. 17–18.
Koch, 1979, p. 48.

182 Misfits: D'Alpuget, 1981, p. 200.
Drewe, 1979, p. 80.
Koch, 1979, p. 61.

183 Dark/light: d'Alpuget, 1981, p. 143. In Han Suyin, *The Mountain is Young* (1973), a frigid western woman has a passionate affair with a very dark half-Indian, half-Nepalese. (Luree Miller, 'The Himalayas in Fact and Fiction', in Winks, Rush, 1990, p. 93).
Koch, 1979, p. 140.
Arjuna's enlightenment in the mountains, in *The Reincarnation of Rama*, and relevance of the Wayang: see Tiffin, 1982.
D'Alpuget, 1981, p. 86. D'Alpuget, p. 207–8.
Drewe, 1986.
J. McQueen, 1990.

184 D'Alpuget, 1981, p. 277.
Gilli, Quinn, Alex, Ranse (Maniaty, 1984), and possibly Cullen, remain in Cambodia, China, Indonesia, Timor/PNG, or the Philippines. Exit from China was 'as simple as a steamship ticket home' (R. Jones, 1986, p. 98).
Quinn and Cullen are 'obsessively concerned with the nature of being Australian' (Drewe, 1986).

185 Grant, 1980, p. 200.
Wu is based on Margaret Jones' Chinese teacher (M. Jones, LS, 1988).
D'Alpuget, 1980, p. 10.
Foster to AB, 27 March 1987.

186 Jeans: Charles Reich, *The Greening of America* (1971).
Drug culture: Koch, 1987, p. 51; Drewe, 1979, pp. 72, 74.
'High on hashish and hooked on half-baked balderdash', Robert Dessaix, 'Cuss, and Move On', SMH, 1 Aug. 1987.
Stoned: Foster to AB, 27 March 1987.
McKemmish, 1986, p. 85.
Foster, 1983, p. 34.
'The total quality of life . . . was intrinsically tied to the quality of dope available': Vleeskens, 1985.
Day, 1990, p. 34.

187 R. Jones, 1986, p. 90.
Helen Semmler's cover illustration for *Kenzo* includes inaccurate katakana; the Hong Kong section of *A Gap in the Records* has meaningless pseudo-Chinese characters by Sara Pinney.
J. McQueen, 1990: cover illustration with accurate Chinese and Thai signs.
Allen, 1990: cover has correct characters for the title.
Castro, 1983: correct calligraphy on the cover, by Lan Wai Shik.
But Loewald, 1987: Chinese characters, inside

cover illustration, are meaningless, printed in reverse.

McKemmish, 1986, p. 50.

188 'Spring Street', 'Helsinki is further', Nayman, 1989.

Maniaty to AB, 30 May 1985.

Drewe, 1989.

Martin, 1981, pp. 173–82.

189 'Mary Stevens had not been convinced by grand idealism, by the vague resounding arguments for expropriation of western wealth for Third World survival. She was motiveless. An adventuress, and accepting' (McKemmish, 1986, p. 59).

Corbett, 1986, p. 55. 'It sometimes takes more than one lifetime to work things out'. (Corbett, cit. Kristin Williamson, 'Exploring the Psyche', TOS 17 Aug. 1986, 35).

Foster, 1983, pp. 234–5.

Foster, 1983, p. 179.

190 McKemmish, 1986, p. 61.

Jose's forebears included George Herbert Jose, a missionary engineer in China in the 1890s, and A. W. Jose the Australian historian.

191 Sandra McGrath, 'O'Rourke's good woman', B, 25 June 1991, 86–87.

Foster, 1983, p. 240.

Dualities: Pete is bald and his brother Jason has matted hair. 'Siva is the god of both Rastaman and skinhead, though one knows it and the other doesn't.' (Plumbum, 1983, p. 268.)

Calcutta is 'the biggest village in the world . . . The anti-Canberra: totally unplanned'. (Foster, 1983, pp. 268, 203)

Brissenden, 1987, p. 253.

192 Blues: 'the whole of rock is based on the blues, which comes from real hardship, poverty and anguish' (Foster, cit. Janet Hawley, 'Plumbing Rock Culture', The Age 26 Jan. 1985, Extra 12).

Third world: Foster, 1991, p. 463.

Calcutta: Foster, 'The Quandary of an India Addict', TOS, 8 March 1987, p. 24. 'Australia is the Sleepy Hollow of the Western World, and any old shit is good enough out here': Foster, 1984.

'The Eye of the Bull', in Foster, 1989.

Davy, 1985, p. 167.

Adams' fictitious country in Games of the Strong is partly based on Indonesia (Adams to AB, 3 Jan. 1990).

Rodney Hall's novel, 1982, concerns the people of Whitey's Fall and their great gold mountain.

193 Castro to AB, 12 Aug. 1985.

Castro, 1983, p. 83.

Kim's 1969 novel, My Name is Tian, was one of the first novels of the Vietnam war written in Australia. Kim, 1975; Kim, 1967.

C. A. Runcie, 'Don'o Kim', Southerly, 2, June

1985, 202–6.

Anggraeni, 1987, pp. 76, 88.

194 Achdiat K. Mihardja and Idrus were both members of the 'generation of 45', a group of writers formed during the Indonesian independence struggle, 1945 to 1949. Both later took up teaching posts in Australian universities. Their novels about Indonesia and Australia, in Indonesian, were published in 1973 in Singapore and Jakarta, respectively: Debu cinta beretebaran and Hikyat putri Penelope (David Reeve, 'To see ourselves as others see us: Australia and Indonesia in each other's literature—four novels', LS, 7 May 1988).

Ee Tiang Hong, in Dennis Haskell, Hilary Fraser (eds), Wordword. A Critical Selection of Contemporary Western Australian Poetry (Fremantle, 1989).

In 1964 the Indonesian Herald called Australia and New Zealand 'just little white dots on a vast Asian ocean'. (2 Oct. 1964). Indonesian government ministers have since been quoted as likening Australia to an appendix to Asia: small, useless, removable, and only noticed if it hurts.

Sang Ye, 'Are you satisfied?', The Independent Monthly, June 1991, pp. 11–12.

195 Helen Musa to AB, 25 June 1985.

Lee to AB, 25 Nov. 1985.

Lee, 1978, typescript, p. 15.

MacIntyre, 1985, pp. 70–1.

Let's Give Them Curry, published as an educational text in 1985, was staged in Colombo and televised in Sri Lanka in 1982. MacIntyre and his family acted in the first production.

196 Burnett: see Ch. 3, n. 17.

Far Easterners: Gooneratne, 1991, p. 119.

14 IMAGES OF EAST AND WEST

Page

198 Kipling's The Ballad of East and West (1898) continues: 'But there is neither East nor West,/ Border, nor Breed, nor Birth,/When two strong men stand face to face,/Though they come from the ends of the Earth!' For origins of the poem see Zafar Monsoor, 'The Buoyancy of a Cork', H, 19, 5, (May 1975), 26–31.

'The New and the Old World meet on our shores. East and West will join hands.' Rev. James Jefferis, 'Australia's Mission and Opportunity', Centennial Magazine 1, Aug. 1888–July 1889, cit. Walker, Ingleson, 'The Impact of Asia', in Meaney, ed., 1989, p. 298.

Taylor, 'Demonstration Poem', Overland, Spring 1973.

Anthony Hassall, 'Quests', in Hergenhan, ed., New Literary History of Australia, p. 390.

199 Preston, cit. Butler, 1987, p. 46. Williams, cit. Morrell in D. Thomas, 1988, p. 144.

Olsen, 1980, p. 98.

Boyd, EO, 10 July 1987.

Glanville-Hicks: Hayes, 1990.

Lowe, cit. Carroll, 1990, p. 22 (Lowe's emphasis).

Foster, 1991, p. 383.

Nowra, *Sunrise*, 1983.

D'Alpuget, cit. Andrew L. Urban, 'The making of "Turtle Beach"', *The Sunday Age*, 30 Sept. 1990, Agenda 9.

200 Foster, 1991, pp. 125, 153.

Koch, 'The Lost Hemisphere,' Koch, 1987, pp. 104–5.

Grant, 1983, ch. 1; Grant, AWTA, 1980.

Moorhouse, 1972, p. 58.

Peter Fuller, *The Australian Scapegoat*, 1986, p. 68.

201 Scriven to AB, 26 June 1985.

Dawe, 'All Aboard for Changi', TWA, 28–29 July 1990.

'Life of a Barbarian', Drewe, 1989. J. McQueen, 1990.

Stow, 1979, p. 109.

Les Murray's emphasis. Murray, 1977; 'Some religious stuff I know about Australia', Murray, 1984; Murray, 1985, pp. 1–2. 'I wouldn't be surprised if Asian references and influences pop up in lots of my future work, at points of national affinity, tho' I'm a bit underwhelmed with the notion that Aust. is "part of Asia" as some people claim. Sounds like a new colonial cringe to me. I think we're Australia, another continent again, well south of Asia'. (Murray to AB, 28 April 1989).

202 Romeril, 1988a, I, i, p. 3.

Romeril, cit. Kristin Williamson, 'Romeril', NT, 18–24 Oct. 1985, 28. Romeril, '*The Impostor*: working notes by John Romeril' *New Theatre: Australia*, 1, Sept/Oct. 1987, 18. Nicholas Jose, preface, 'The Emperor from Underneath', 1988 (manuscript draft of *Avenue of Eternal Peace*, 1989).

Kim: 'Australia is inescapably part of the Asian region, but culturally and racially it remains a part of the Western democratic world. This is a debate I would like Australians to address, but no-one is interested.' Kim, cit. Chris Ashton, 'Expatriate's Progress', SMH, 10 Feb. 1990, 74.

Achdiat, at National Word Festival, Canberra, 10 March 1991.

Gandhi, cit. Greenwood, 1974, p. 362. Rendra, cit. Katharine Brisbane, 'Sensitive Intruder', H, 18, 10, Oct. 1974, 14–17.

203 Pulvers, AWTA, 1980.

15 ANOTHER CENTURY

Page

204 Gooneratne, 'How Barry Changed his Image', 1989.

Foster, 1984.

Castro to AB, 12 Aug. 1985.

Murphy, cit. Sykes, 'Our dancers sighed, the Chinese gasped', SMH, 4 May 1985, 47.

Alan Wood, 'Australia's population puzzle', TWA, 28–29 April, 1990, 23. Stephen Fitz-Gerald, 'Now is the time to embrace Asia', TWA, 10–11 Nov. 1990, 25. There was 'almost no evidence that the private or public sector sees any need to train its employees to work in or with Asia'. No permanent head of a government department, or head of the Australian foreign service was fluent in an Asian language, nor was any vice-chancellor, editor of a major paper, magazine or television station, chief of a defence force or chief executive of a major corporation. (FitzGerald, 'Australia: The Lazy Country', *Sunday Herald*, 4 Nov. 1990, 13).

In 1990, not one chair of fine art in an Australian university had ever been held by an Asian specialist.

References
and sources

Date of edition referred to is in italics

I FICTION, POETRY

Abdullah, Mena, and Ray Mathews, eds., *The Time of the Peacock* (New York, 1965).
_____'High Maharajah', in Ewers, 1965.
Achdiat K. Mihardja, *Debu Cinta Bertebaran (The Dust of Love Scattered)* (Singapore, 1973).
Adams, Glenda, *Games of the Strong* (Sydney, 1982).
Allen, Robert, *Saigon, South of Beyond* (Sydney, 1990).
_____*Tokyo no hana* (Sydney, 1990).
Anderson, Ethel, *Indian Tales* (Sydney, 1948).
_____*The Little Ghosts* (Sydney, 1959).
Anggraeni, Dewi, *The Root of All Evil* (Melbourne, 1987).
_____*Parallel Forces* (Melbourne, 1988).
Asada Teruhiko, *Cowra*, tr. Ray Cowan (Sydney, 1973).
Asche, Oscar, *The Joss Sticks of Chung* (London, 1930).
Astley, Thea, *A Boat-load of Home Folk* (Melbourne, 1968).
_____*Beachmasters* (Melbourne, 1985).
Atkinson, Hugh, *The Pink and the Brown* (Melbourne, 1957, *1965*).
_____*The Most Savage Animal* (London, 1972).
Bailey, John, *The Wire Classroom* (Sydney, 1972).
Baillie, Allan, *Little Brother* (Melbourne, 1985).
_____*The China Coin* (Melbourne, 1991).
Barnes, Rory, James Birrel, *Water from the Moon* (Melbourne, 1989).
Beaver, Bruce, *Letters to Live Poets* (Sydney, 1969).
Becke, Louis, *By Reef and Palm* (London, 1894).
_____*Edward Barry: South Sea Pearler* (London, 1900).
_____*His Native Wife* (Sydney, 1895).
Bedford, Jean, *A Lease of Summer* (Melbourne, 1990).
Beilby, Richard, *Gunner: a Novel of the Retreat from Crete* (Sydney, 1977).

_____*The Bitter Lotus* (Sydney, 1978).
_____*No Medals for Aphrodite* (Sydney, *1970*, 1990).
Bennett, William R., *Angry Eagles* (Sydney, 1962).
_____*War Wings* (Sydney, 1963).
_____*Mig-meat* (Sydney, 1960).
Boothby, Guy, *The Fascination of the King* (London, 1896).
_____*Dr Nikola* (London, 1896).
_____*A Bid for Fortune, or, Dr Nikola's Vendetta* (London, 1895).
_____*My Indian Queen* (London, 1901).
_____*The Marriage of Esther: a Torres Straits Sketch* (London, 1900).
Brand, Mona, *Daughters of Vietnam* (Hanoi, 1958).
Brissenden, R.F., *Poor Boy* (Sydney, 1987).
_____*The Whale in Darkness* (Canberra, 1980).
_____*Wildcat* (Sydney, 1991).
Brooks, David, *The Book of Sei and Other Stories* (Sydney, 1985).
_____*The Cold Front* (Sydney, 1983).
Brophy, Kevin, *The Hole through the Centre of the World* (Sydney, 1991).
Brown, Alys, *The Pearls of Pilolu* (London, 1933).
Brown, John, *Zaibatsu* (Sydney, 1983).
Bullock, Ken, *Pelandok* (Adelaide, 1986).
Cairncross, J. C., *The Unforgiven* (Melbourne, 1977).
Carroll, John, *Token Soldiers* (Melbourne, 1983).
_____*Tropic of Fear* (Sydney, 1990).
Carter, Robert, *Prints in the Valley* (Sydney, 1989).
Castro, Brian, *Birds of Passage* (Sydney, 1983).
_____*Pomeroy* (Sydney, 1990).
Chan, Melissa, *Too rich* (Melbourne, 1991).
Clavell, James, *King Rat* (London, 1975, *1984*).
_____*Shogun: A Novel of Japan* (London, 1975, *1976*).
_____*Noble House*, (London, 1981, *1982*).
_____*Tai Pan: A Novel of Hong Kong*, (London, 1975, *1984*).
Cleary, Jon, *The Climate of Courage*, (London, 1954).
_____*The Pulse of Danger* (Sydney, 1966).
_____*North from Thursday: A Novel* (London, 1960, *1981*).
_____*High Road to China* (London, 1977).
_____*The Phoenix Tree* (London, 1984).
_____*A Very Private War* (Sydney, 1980).
Clune, Frank, *Korean Diary: A Journey to Japan and Korea in 1950* (Sydney, 1955).
_____*To the Isles of Spice—A Vagabond Voyage by Air from Botany Bay to Darwin, Bathurst Island, Timor, Java, Borneo, Celebes, and French Indo-China* (Sydney, 1940).
_____*Chinese Morrison*, (Melbourne, 1941).
_____*The Ashes of Hiroshima: A Post-war Trip to Japan and China* (Sydney, 1950).
_____*Sky High to Shanghai: An Account of My Oriental Travels in the Spring of 1938, with Side Glances at the History, Geography and Politics of the Asiatic Littoral, Written with Charity to All and Malice to None by Frank Clune* (Sydney, 1939).
_____*Prowling Through Papua* (Sydney, 1943).
_____*Pacific Parade* (Melbourne, 1945).

Collins, Dale, *Ordeal* (London, 1924).
——*The Mutiny of Madame Yes* (London, 1935).
——*Idolators* (London, 1929).
——*Jungle Maid* (London, 1932).
——*Sal of Singapore* (London, 1929).
——*Coral Sea Adventure* (London, 1951).
——*Far Off Strands* (London, 1946).
Connell, R., *Firewinds: Poems* (Sydney, 1968).
Cook, Kenneth, *The Wine of God's Anger* (Melbourne, 1968).
Corbett, Nancy, *Floating* (Sydney, 1986).
Corris, Peter, *The Cargo Club* (Melbourne, 1990).
——*Nasmith's Dominion* (Melbourne, 1990).
Croft, Julian, *Breakfasts in Shanghai* (Sydney, 1984).
Cusack, Dymphna, *The Half-Burnt Tree* (Melbourne, 1969).
D'Alpuget, Blanche, *Monkeys in the Dark* (Melbourne, 1980, 1982).
——*Turtle Beach* (Melbourne, 1981).
Dark, Eleanor, *Prelude to Christopher* (Sydney, 1934).
Davy, Ross, *Kenzo: A Tokyo Story* (Melbourne, 1985).
Dawe, Bruce, 'Homecoming', 1968, in *Condolences of the Season* (Melbourne, 1971).
——*An Eye for a Tooth* (Melbourne, 1968).
Dawe, Carlton, *Yellow and White* (London, 1895).
——*The Yellow Man* (London, 1900).
——*Kakemonos: Tales of the Far East* (London, 1897).
——*The Mandarin* (London, 1899).
——*A Bride of Japan* (London, 1898).
——*Rose and Chrysanthemum* (London, 1899).
——*The Plotters of Peking* (London, 1907).
——*The Girl from Nippon* (London, 1915).
Day, Marele, *The Case of the Chinese Boxes*, (Sydney, 1990).
Dobson, Rosemary, *The Three Fates* (Sydney, 1984).
Downs, Ian, *The Stolen Land* (Brisbane, 1970).
Drewe, Robert, *A Cry in the Jungle Bar* (Sydney, 1979).
——*The Bay of Contented Men* (Sydney, 1989).
Duggan, Laurie, *East: Poems 1970–1974* (Melbourne, 1976).
——*Under the Weather* (Sydney, 1978).
——*The Ash Range* (Sydney, 1978).
Dutton, Geoffrey, *Queen Emma of the South Seas: A Novel* (Melbourne, 1976, 1988).
Eipper, Chris, *Dieback* (Melbourne, 1990).
Emery, John, *The Sky People* (Adelaide, 1984).
Fairweather, Ian, *The Drunken Buddha* (Brisbane, 1965).
Faust, Clive, *Metamorphosed from the Adjacent Cold* (Boston, 1980).
——*Token and Trance* (Devon, 1980).
——*Leavetakings* (Kyoto, 1986).
FitzGerald, R. D., *Forty Years' Poems* (Sydney, 1965).
——*Product: Later Verses* (Sydney, 1977).
Flynn, Errol, *Showdown* (London, 1946).
——*Beam Ends* (London, 1937).
——*My Wicked, Wicked Ways* (New York, 1959).
Forrest, David (David Denholm, pseud.), *The Last Blue Sea* (Melbourne, 1959, *1964*).

Foster, David, *North South West* (Melbourne, 1973).
——*The Pure Land* (Melbourne, 1974).
——*Plumbum* (Melbourne, 1983).
——*Hitting the Wall* (Melbourne, 1989).
——*Mates of Mars* (Melbourne, 1991).
Foulcher, John, *Pictures from the War* (Sydney 1987).
Fox, Frank, (C. H. Kirmness, pseud.), *The Commonwealth Crisis* (London, 1909).
Fox, Len, *Chung of Vietnam* (Hanoi, 1957).
——*Gumleaves and Bamboo: Poems of Australia and Asia* (Sydney, 1959).
——*Vietnam Neighbours: Poems* (Sydney, 1966).
Frazer, Michael, *Nasho* (Melbourne, 1984).
Gardiner, Kenneth, *The Archer and His Son* (Melbourne, 1974).
Gooneratne, Yasmine, 'How Barry Changed His Image', *Meanjin*, 48, 1, Autumn, 1989.
——*A Change of Skies* (Melbourne, 1991).
Gordon, Harry, *Die Like the Carp* (Sydney, 1978).
Grant, Bruce, *Cherry Bloom* (Sydney, 1980).
Grant, Maxwell, *Blood Red Rose* (Melbourne, 1988).
Gray, Robert, *The Skylight* (Sydney, 1983).
——*Selected Poems 1963–83* (Sydney, 1985).
——*Piano* (Sydney, 1988).
Grimshaw, Beatrice, *In the Strange South Seas* (London, 1907).
——*Adventures in Papua with the Catholic Mission* (Melbourne, 1913).
——*From Fiji to the Cannibal Islands* (London, 1907).
——*The Paradise Poachers* (London, 1928).
——*White Savage Simon* (Sydney, 1920).
Hales, A. G. *Little Blue Pidgeon: A Story of Japan* (London, 1904).
Hall, Rodney, *Just Relations* (Melbourne, 1982).
——*Captivity Captive* (Melbourne, 1988).
——*The Law of Karma* (Canberra, 1968).
Halls, Geraldine, *The Voice of the Crab* (London, 1974).
——*The Cobra Kite* (London, 1971).
——*The Silk Project* (London, 1965).
Hanrahan, Barbara, *Flawless Jade* (Brisbane, 1989).
Harcourt, John, *The Pearlers* (London, 1933).
Harris, A. M., *The Tall Man* (London, 1958).
Harry, J. S., *The Deer Under the Skin* (Brisbane, 1971).
Hasluck, Alexandra, *Of Ladies Dead: Six Stories Not in the Modern Manner* (Sydney, 1970).
Hay, John, *The Invasion* (London, 1968).
Hemensley, Kris, *Games: An Exhibition 1970–72* (Melbourne, 1978).
——*The Moths* (Melbourne, 1978).
——*The Poem of the Clear Eye* (Melbourne, 1957).
——*Down Under, A Comic Novel* (Melbourne, 1978).
Hemensley, Kris, Ken Taylor, *Two Poets* (Melbourne, 1968).
Heney, Helen, *The Chinese Camellia* (London, 1950).
Herbert, Xavier, *Poor Fellow My Country* (Sydney, 1975).
Hooker, John, *Standing Orders* (London, 1986).

_____ *The Bush Soldiers: A Novel of Australia* (Sydney, 1984).

Hospital, Janette Turner, *The Ivory Swing* (London, 1983).

Hughes, W. S. Kent, *Slaves of the Samurai* (Melbourne, 1946).

Hungerford, T. A. G., *Wong Chu and the Queen's Letterbox* (Fremantle, 1977).

_____ *A Knockabout with a Slouch Hat: An Autobiographical Collection 1942–1951* (Fremantle, 1985).

_____ *The Ridge and the River* (Sydney, 1952, 1958, 1966).

_____ *Sowers of the Wind: A Novel of the Occupation of Japan* (Sydney, 1954, 1955, 1961).

Idriess, Ion, *Headhunters of the Coral Sea* (Sydney, 1940)

_____ *The Opium Smugglers: A True Story of Our Northern Seas* (Sydney, 1951).

_____ *The Wild man of Badu* (Sydney. n.d.).

Idrus, *Hikayat Putri Penelope (The Story of Princess Penelope)* (Jakarta, 1973).

Jeffrey, Betty, *White Coolies: A Graphic Account of Australian Nurses Held Captive During World War Two* (Sydney, 1954).

_____ *White Coolies: A Graphic Record of Survival in World War Two* (Sydney, 1985).

Johnson, Colin, *The Song Circle of Jacky and Selected Poems* (Melbourne, 1986).

_____ (Mudrooroo Narogin), *Dalwurra the Black Bittern: a Poem Cycle* (Perth, 1988).

Johnston, George, *The Far Road* (Sydney, 1962, *1987*).

_____ *The Moon at Perigee* (Sydney, 1948) (Monsoon, New York, 1950).

Johnston, George, Charmian Clift, *High Valley* (Sydney, 1949).

Jones, Margaret, *The Confucius Enigma* (Sydney, 1979).

_____ *The Smiling Buddha* (Sydney, 1985).

Jones, Rod, *Julia Paradise* (Melbourne, 1986).

Jose, Nicholas, *Avenue of Eternal Peace* (Melbourne, 1989).

Kata, Elizabeth, *A Patch of Blue (Be Ready With Bells and Drums)* (Harmondsworth, 1961,1986).

_____ *Someone Will Conquer Them* (London, 1962, 1978).

_____ *Kagami* (Sydney, 1989).

Keneally, Thomas, *The Cut-rate Kingdom* (Sydney, 1980, 1984).

_____ *Passenger* (London, 1979).

Kent, R. A., *A Chinese Vengeance* (London, 1909).

Kim, Don'o, *My Name is Tian* (Sydney, 1969).

_____ *Password* (Sydney, 1975).

_____ *The Chinaman* (Sydney, 1984).

Koch, C. J., *Across the Sea Wall* (Sydney, 1965, *1982*).

_____ *The Year of Living Dangerously* (Melbourne, 1978, *1979*, 1981, 1986).

_____, Nicholas Hasluck, *Chinese Journey* (Fremantle, 1985).

Kolia, John (formerly Collier), 'Putting out the lamp', in Krauth, 1982.

_____ *Close to the Village* (Port Moresby).

_____ *The Late Mr Papua* (Port Moresby).

_____ *Victims of Independence* (Port Moresby).

_____ *My Reluctant Missionary* (Port Moresby, 1978).

_____ *Without Mannerisms* (Port Moresby, 1980).

Krauth, Nigel, *JF Was Here* (Sydney, 1990).

Krauth, Nigel, and Caron Krauth, *Sin Can Can* (Melbourne, 1987).

Kroll, Jeri, *Indian Movies* (Melbourne, 1984).

Lake, David, *The Changelings of Chaan* (Melbourne, 1985, *1986*).

Lambert, Eric, *The Veterans* (London, 1954).

_____ *The Twenty Thousand Thieves* (London, 1951, 1982).

_____ *Glory Thrown In* (London, 1959).

_____ *MacDougal's Farm* (London, 1965).

_____ *The Dark Backward* (London, 1958).

_____ *Hiroshima Reef* (London, 1967).

Lane, William, 'White or Yellow? A Story of Race War in AD 1908', *The Boomerang*, 1888.

Lang, John George, *Wanderings in India, and Other Sketches of Life in Hindoostan* (London, 1859).

_____ *The Weatherbys* (London, 1853).

_____ *The Ex-wife* (London, 1858).

Langley, Eve, *The White Topee* (London, Sydney, 1954, 1989).

_____ *The Pea Pickers* (Sydney, 1942, 1966).

Lee, Gerard, *Troppo Man* (Brisbane, 1990).

Lett, Lewis, *Savage Tales* (Melbourne, 1946).

Lewis, Aletta, *They Call Them Savages* (London, 1938).

Loewald, Uyen, *Child of Vietnam* (Melbourne, 1987).

Loftus, Peter, *The Earth Drum: An Experience of Singapore and Malaya* (Sydney, 1979).

Mackay, Kenneth, *The Yellow Wave: A Romance of the Asiatic Invasion of Australia* (London, 1895).

Mackenzie, Kenneth Seaforth Simpson, *Dead Men Rising* (London, 1951).

Macklin, Robert, *The Paper Castle* (Sydney, 1977).

Malouf, David, *The Great World* (London, 1990).

Maniaty, Tony, *The Children Must Dance* (Melbourne, 1984).

Manley, Ruth, *The Plum-rain Scroll* (Sydney, 1979).

_____ *The Dragon Stone* (Sydney, 1982).

_____ *The Peony Lantern* (Sydney, 1987).

Martin, David, *Foreigners* (Adelaide, 1981).

_____ *The Chinese Boy* (Sydney, 1973).

_____ *The King Between* (London, 1966; *The Littlest Neutral*, New York).

_____ *Stones of Bombay* (London, 1949).

_____ *The Hero of Too* (Melbourne, 1965).

_____ *The Man in the Red Turban* (Melbourne, 1978, 1981).

Mason, Colin, *Hostage* (Melbourne, 1973).

McAulay, Lex, (David Alexander, pseud.) *When the Buffalo Fight* (Melbourne, 1987).

McCauley, Shane, *The Chinese Feast: Poems* (Fremantle, 1984).

_____ *The Butterfly Man* (Fremantle, 1991).

McCrae, Hugh, *Idyllia* (Sydney, 1923).

_____ *The Mimshi Maiden* (Sydney, 1938).

McGregor, John, *Blood on the Rising Sun*, (Sydney, 1980).

McKemmish, Jan, *A Gap in the Records* (Melbourne, 1986).

McLaren, Jack, *Blood on the Deck* (London, 1933).

_____ *Isle of Escape: A Story of the South Seas* (London, 1926).

_____ *My South Seas Adventures* (London, 1936).

McQueen, James, *Death of a Ladies' Man* (Melbourne, 1989).

_____ *White Light* (Melbourne, 1990).

_____ *Lower Latitudes* (Melbourne, 1990).

_____ *The Heavy Knife* (Melbourne, 1991).

Moffitt, Ian, *The Retreat of Radiance* (Sydney, 1982).

_____ *Deadlines* (Sydney, 1985).

Moore, T. Inglis, *The Halfway Sun: A Tale of the Philippine Islands* (Sydney, 1935).

_____ *Bayonets and Grass: Poems* (Sydney, 1957).

_____ *Emu Parade: Poems from Camp* (Sydney, 1941).

Moorhead, Richard, *The Mists of Makassar* (Melbourne, 1946).

Moorhouse, Frank, *The Americans, Baby* (Sydney, 1972).

_____ *Futility and Other Animals* (Sydney, 1969).

Mordaunt, Elinor, *The Dark Fire* (London, 1927).

_____ *Father and Daughter* (London, 1928).

Morimoto Junko, *The White Crane*, (Sydney, 1983).

_____ *The Inch Boy* (Sydney, 1984).

_____ *A Piece of Straw* (Sydney, 1985).

_____ *Kojima and the Bears* (Sydney, 1986).

Morton, Leith, *Kitsune: the Fox* (1989).

_____ *Tales from East of the River* (Melbourne, 1982).

Murdoch, James, *From Australia and Japan* (London, 1892).

Murray, Les, *Lunch and Counterlunch* (Sydney, 1974).

_____ *The Daylight Moon* (Sydney, 1987).

_____ *Ethnic Radio* (Sydney, 1977).

_____ *The Vernacular Republic: Poems 1961–1981* (Sydney, 1982).

_____ 'Aqualung Shinto', in *Poetry Australia*, 1973, reprinted in Murray, 1974 and 1982.

_____ *Collected Poems* (Sydney, 1991).

_____ *The People's Otherworld* (Sydney, 1983).

Nagle, William, *The Odd Angry Shot* (Sydney, 1975).

Nandan, Satendra, *The Wounded Sea* (Sydney, 1991).

Narogin, Mudrooroo, *Dalwurra: The Black Bittern* (Perth, 1988).

Nayman, Michele, *Somewhere Else* (Melbourne, 1989).

_____ *Faces You Can't Find Again: Short Stories*, (Melbourne, 1980).

Nisbet, Hume, *The Land of the Hibiscus Blossom: A Yarn of the Papuan Gulf* (London, 1888).

_____ *The Rebel Chief* (London, 1896).

_____ *Eight Bells: A Tale of the Sea and of the Cannibals of New Guinea* (London, 1889).

Nowra, Louis, *Palu* (Sydney, 1987).

Nunn, Frank, *Java Sea Mystery* (Sydney, 1941).

Barry Oakley, *Let's Hear It for Prendergast* (Melbourne, 1970).

_____ *Walking Through Tigerland* (Brisbane, 1977).

O'Connor, Mark, *Selected Poems* (Sydney, 1986).

O'Donnell, G. C., *Time Expired* (Sydney, 1967).

O'Dowd, Bernard, *Collected Verse*, Colin Roderick, ed., (Sydney, 1967).

O'Grady, Desmond, *Valid for All Countries* (Brisbane, 1979).

O'Grady, J.P. (Nino Culotta, pseud.), *No Kava for Johnny* (Sydney, 1961).

_____ *Gone Troppo* (Sydney, 1968).

Palmer, Vance (Ram Daly, pseud.), *The Outpost*, London, 1924 (*Hurricane*, 1934).

_____ *The Enchanted*, London, 1923.

Pickard, Keith, *Bilong Boi* (Brisbane, 1969).

Pike, Geoff, *Golightly Adrift* (Sydney, 1977).

_____ *Henry Golightly: A Novel of the Sea* (Sydney, 1974).

Plomer, William, *The Autobiography of William Plomer* (London, 1975).

Pollard, Rhys, *The Cream Machine* (Sydney, 1972).

Porter, Hal, *A Handful of Pennies* (Sydney, 1958).

_____ *Mr Butterfry and Other Tales of New Japan* (Sydney, 1970).

_____ *A Bachelor's Children* (Sydney, 1962).

_____ *Selected Stories*, Leonie Kramer ed., (Sydney, 1971).

Porter, James, *Hapkas Girl* (Melbourne, 1980).

Poussard, Wendy, *Ground Truth* (Melbourne, 1987).

Pratt, Ambrose, *The Big Five*, (London, 1911).

_____ *Wolaroi's Cup* (London, 1913).

Praed, Rosa Campbell, *Madam Izan, a Tourist Story* (London, 1899).

_____ *Fugitive Anne* (London, 1903).

_____ *The Grey River* (London, 1889).

Prichard, Katharine Susannah, *Subtle Flame* (Sydney, 1967).

_____ *The Moon of Desire* (London, 1941).

_____ *The Wild Oats of Han* (Melbourne, 1928, 1968).

_____ *Child of the Hurricane* (Sydney, 1963).

Pulvers, Roger, *The Death of Urashima Taro*, (Sydney, 1981).

_____ *On the Edge of Kyoto: The Unmaking of an American* (Tokyo, 1988).

Richards, David, *Peanuts in Penang*, (Brisbane, 1973).

Rowe, John, *Count Your Dead* (Sydney, 1968).

_____ *The Warlords* (Sydney, 1978).

Roydhouse, R. T. (Rata, pseud.), *The Coloured Conquest* (London, 1903).

Ruhen, Olaf, *Land of Dahori: Tales of New Guinea*, (London, 1957).

_____ *Tangaroa's Godchild: A Memoir of the South Pacific* (Sydney, 1967).

_____ *Naked Under Capricorn* (London, 1958).

_____ *White Man's Shoes: A Novel* (London, 1960).

Ryan, Peter, *Fear Drive My Feet* (Sydney, 1959, 1985).

Sang Ye, *Red Heart of Australia* (Brisbane, 1989).

_____ *The Year the Dragon Came* (Brisbane, 1991).

_____ *Chinese Lives: An Oral History of Contemporary China* (London, 1987).

Shearston, Trevor, *Something in the Blood* (Brisbane, 1979).

_____ *Sticks That Kill* (Brisbane, 1983).

_____ *White Lies* (Brisbane, 1986).

_____ *Concertinas* (Sydney, 1988).

Shute, Nevil (N. S. Norway), *A Town Like Alice*, (Melbourne, 1950).

Skinner, Mollie, *Tucker Sees India* (London, 1937).

_____ *The Fifth Sparrow* (Sydney, 1972).

Skipper, Mervyn, *The Meeting-pool: A Tale of Borneo* (London, 1929).

_____ *The White Man's Garden: A Tale of Borneo* (London, 1930).

Stafford, John, *Time of Rain* (Adelaide, 1985).

Statler, Oliver, *Japanese Inn: A Reconstruction of the Past* (Tokyo, 1982, *1984*).

Stead, Christina, *The Man Who Loved Children* (Sydney, 1940, *1979*).

Stewart, Harold, *By the Old Walls of Kyoto: A Year's Cycle of Landscape Poems with Prose Commentaries* (New York, Tokyo, 1981).

_____ *A Chime of Windbells* (Rutland, Tokyo, 1969).

_____ *A Net of Fireflies: with Japanese Haiku and Haiku Paintings* (Rutland, Tokyo, 1960).

_____ *Orpheus and Other Poems* (Sydney, 1956).

_____ *Phoenix Wings: Poems 1940–46* (Sydney, 1948).

_____ *The Exiled Immortal: A Song-cycle* (Canberra, 1980).

Stewart, W. T., *Yellow Spies* (Sydney, 1942).

Stivens, Dal, *Three Persons Make a Tiger*, based on Chinese translation by Wu Yu (Melbourne, 1968).

_____ *Selected Stories 1936–1968* (Sydney, 1970).

_____ *A Horse of Air* (Sydney, 1970).

Stow, Randolph, *Outrider: Poems 1956–62* (London, 1962).

_____ *A Counterfeit Silence: Selected Poems* (Sydney, 1969).

_____ *Visitants* (London, 1979).

_____ *Tourmaline* (Melbourne, 1963, *1984*).

_____ 'From the testament of Tourmaline, variations on themes of the Tao Teh Ching', *Poetry Australia*, 12, Oct. 1966, 7–10.

_____ *The Merry-go-round in the Sea* (London, 1965, Melbourne, 1968).

Sweeney, Gerald, *Invasion* (Sydney, 1982).

Taylor, Ken, *A Secret Australia: Selected and New Poems* (Melbourne, 1985).

_____ *Five, Seven, Fives* (Melbourne, 1984).

_____ *Travel Notes March 1984* (Melbourne, 1984).

Thwaites, Frederick, *The Dark Abyss* (Sydney, 1951).

_____ *Shadows over Rangoon* (Sydney, 1970).

_____ *Sky Full of Thunder* (Wellington, 1968).

Tonetto, Walter, ed., *Earth Against Heaven: A Tienanmen Square Anthology* (Wollongong, 1990).

Townend, Christine, *Travels With Myself* (Sydney, 1976).

Turnbull, G. Munro, *Mountains of the Moon* (London, 1937).

_____ *Paradise Plumes* (Sydney, 1934).

_____ *Portrait of a Savage* (Sydney, 1943).

Vader, John, *The Battle of Sydney: A Novel* (London, 1971).

Valentine, Douglas, *The Hotel Tacloban* (Westport, Conn. 1984, Sydney 1985).

Viidikas, Vicki, *Condition Red* (Brisbane, 1973).

_____ *India Ink: A Collection of Prose Poems Written in India* (Sydney, 1984).

_____ *Wrappings* (Sydney, 1974).

Vleeskens, Cornelis, *Cashing In: A Mini Novel*, (Melbourne, 1985).

_____ *Full Moon Over Lumpini Park* (Melbourne, 1982).

_____ *Hong Kong Suicide and Other Poems* (Brisbane, 1976).

Wallace-Crabbe, Robin, *Australia Australia*, (Sydney, 1989).

Walsh, J. M., *Overdue: A Romance of Unknown New Guinea* (Sydney, 1925).

_____ *The Lost Valley* (Melbourne, 1921).

_____ *A Girl of the Islands* (Sydney, 1927).

_____ *Tap-tap Island* (Sydney, 1921).

Wearne, Alan, *The Nightmarkets* (Melbourne, 1986).

West, Morris, *The Ambassador* (London, 1965).

Williams, Maslyn, *The Benefactors: A Tale of Intrigue and Passion Set in Bygone New Guinea* (Melbourne, 1971, *1979*); *Dubu: a Novel of New Guinean Conquest* (New York 1971).

_____ *The Temple* (Sydney, 1982).

_____ *The Far Side of the Sky* (Syney, 1967).

Wilson, Barbara Ker, *The Turtle and the Island: a Folk Tale from Papua New Guinea* (Melbourne, 1978, 1990).

_____ *The Willow Pattern Story* (Sydney, 1978).

Wilson, W. Hardy, *The Dawn of a New Civilization* (London, 1929).

_____ *Yin-Yang* (Flowerdale, Tas. 1934).

Wright, Judith, *Collected Poems 1942–1970*, (Sydney, 1971).

_____ *The Two Fires* (Sydney, 1955).

_____ *Judith Wright* (Sydney, 1963).

_____ 'Back for Christmas', *Makar*, 5, 2, 1969.

_____ *Phantom Dwelling* (Sydney, 1985).

_____ 'The Upside-down Hut', AL, III, 4, 1961, 30–4.

Zwicky, Fay, *Ask Me* (Brisbane, 1990).

II HISTORY, BIOGRAPHY, LITERARY CRITICISM, ANTHOLOGY, CULTURE

Albinski, Henry, *Australian Policies and Attitudes towards China* (Princeton, 1965).

Alexander, Peter F., *William Plomer, a Biography* (Oxford, 1989).

Alomes, Stephen, *A Nation At Last? The Changing Character of Australian Nationalism 1880–1988* (Sydney, 1988).

_____, Catherine Jones, eds., *Australian Nationalism: a Documentary History* (Sydney, 1991).

Andrews, E. M., *Australia and China, The Ambiguous Relationship* (Melbourne, 1985).

Arneil, Stan, *One Man's War* (Sydney, 1981).

Ball, W. Macmahon, *Possible Peace* (Melbourne, 1936).

_____ *Japan: Enemy or Ally?* (Melbourne, 1948).

_____ *Australia and Japan* (Melbourne, 1969).

Bartlett, Norman, *Island Victory* (Sydney, 1955).

_____ *With the Australians in Korea* (Canberra, 1954).

_____Land of the Lotus Eaters: A Book Mostly about Siam (London, 1959).

Beilby, Raymond, Cecil Hadgraft, Ada Cambridge, Tasma and Rosa Praed (Melbourne, 1979).

Benedict, Ruth, The Chrysanthemum and the Sword: Patterns of Japanese Culture (London, 1947).

Bennett, Bruce, Cross Currents: Magazines and Newspapers in Australian Literature (Melbourne, 1981).

Bennett, Bruce, and others, eds., The Writer's Sense of the Contemporary (Perth, 1982).

Black, J. R., Young Japan (London, 1880).

Blainey, Geoffrey, The Tyranny of Distance (Melbourne 1966, 1985).

_____The Triumph of the Nomads: A History of Ancient Australia (Melbourne, 1975, 1982, 1983).

_____All for Australia (Sydney, 1984).

Bowden, Tim, One Crowded Hour: Neil Davis, Combat Cameraman (Sydney, 1987).

Bowden, Tim, and Stuart Rintoul, Ashes of Vietnam: Australian Voices (Sydney, 1988).

Braddon, Russell, The Other 100 Years War—Japan's Bid for Supremacy 1941–2041, (Sydney, 1983). (US version: Japan against the world, 1941–2041: The 100-Year War for Supremacy).

_____The End of a Hate (London, 1958).

_____The Naked Island (London, 1952).

Brand, Mona, The Chinese (Melbourne, 1978).

Brooks, David, The Necessary Jungle: Literature and Excess (Melbourne, 1990).

Burchett, Wilfred, Shadows of Hiroshima (London, 1983).

_____Vietnam: Inside Story of the Guerilla War, (New York, 1965).

Burgess, Pat, Warco: Australian Reporters at War (Melbourne, 1986).

Burns, D. R., The Directions of Australian Fiction, 1920–1974 (Melbourne, 1975).

Byles, Marie, The Lotus and the Spinning Wheel (London, 1963).

_____Footprints of Gautama the Buddha, Being the Story of Portions of his Ministerial Life (London, 1957).

_____Journey into Burmese Silence (London, 1962).

Caiger, George, Tojo Say No: Japanese Ideas and Ideals (Sydney, 1943).

Cambridge, Ada, A Woman's Friendship, 1889, Elizabeth Morrison, ed., (Sydney, 1989).

_____Thirty years in Australia, London, 1903, Louise Wakeling, Margaret Bradstock introd., (Sydney, 1989).

Cameron, Clyde, China, Communism and Coca-Cola (Melbourne, 1980).

Carter, Isabel R., Alien Blossom: A Japanese-Australian Love Story (Melbourne, 1965).

Carter, Norman, G-string Jesters (Sydney, 1966).

Cass, S., R. Cheney, D. Malouf, M. Wilding, eds., We Took Their Orders and are Dead: An Anti-war Anthology (Sydney, 1971).

Choi, C. Y., Chinese Migration and Settlement in Australia (Sydney, 1975).

Chung, Helene, Shouting from China (Melbourne, 1988, 1989).

Clark, Axel, Christopher Brennan—A Critical Biography (Melbourne, 1981).

Clark, Gregory, In Fear of China (Melbourne, 1967).

Clark, Manning, Occasional Writings and Speeches (Melbourne, 1980).

_____A History of Australia, 6 vols., (Melbourne, 1962–1988).

_____A Short History of Australia (Melbourne, 1969).

Clarke, Hugh V., Last Stop Nagasaki! (Sydney, 1984).

Clarke, Marcus, The Future Australian Race (Melbourne, 1877).

Clift, Charmian, The World of Charmian Clift, (Sydney, 1970).

Clunies-Ross, Ian, ed., Australia and the Far East: Diplomatic and Trade Relations (Sydney, 1935).

Coleman, Peter, ed., Australian Civilization: A Symposium (Melbourne, 1962).

Cronin, K., Colonial Casualties: Chinese in Early Victoria (Melbourne, 1982).

Croucher, Paul, Buddhism in Australia 1848–1988 (Sydney, 1989).

Crowley, Frank, A Documentary History of Australia, 5 vols., (Melbourne, 1978–80).

Darlington, Robert, Sudan to Vietnam (Sydney, 1987).

Davis, A. R. ed., Search for Identity: Modern Literature and the Creative Arts in Asia, proceedings of the 28th International Congress of Orientalists, Canberra, January 1971 (Sydney, 1974).

D'Cruz, J. V., The Asian Image in Australian History: Episodes in Australian History (Melbourne, 1973).

Dermody, Susan, John Docker, Drusilla Modjeska, eds., Nellie Melba, Ginger Meggs and Friends: Essays in Australian Cultural History (Melbourne, 1982).

Diamond, Marion, The Seahorse and the Wanderer (Melbourne, 1989).

Donaldson, Ian, ed., Australia and the European Imagination, HRC, ANU (May, 1981).

Dower, John W., War Without Mercy: Race and Power in the Pacific War (New York, 1986).

Drewe, Robert, 'A Cry in the Jungle Bar: Australians in Asia', Meridian 5, 2, 1986.

Dugan, Michael, Josef Szwarc, There Goes the Neighbourhood! Australia's Migrant Experience (Melbourne, 1984).

Durnell, Hazel, Japanese Cultural Influences and American Poetry and Drama (Tokyo, 1984).

Dutton, Geoffrey, Snow on the Saltbush: The Australian Literary Experience (Melbourne, 1984).

_____Kenneth Slessor: A Biography (Melbourne, 1991).

_____ed. The Literature of Australia (Melbourne, 1964, 1976).

_____The Innovators: The Sydney Alternative in the Rise of Modern Art, Literature and Ideas (Melbourne, 1986).

_____Australian Verse from 1805: A Continuum (Adelaide, 1976).

Elder, Bruce, Jacqueline Kent, Keith Willey, Memories: Life in Australia Since 1900 (Sydney, 1988).

Elkin, A. P., Aboriginal Men of High Degree (Brisbane, 1946, 1977).

Elkin, A. P., and C. H., R. M. Berndt, *Art in Arnhem land* (Melbourne, 1950).

Evans, R., K. Saunders, R. Cronin, *Race Relations in Colonial Queensland: A History of Exclusion, Exploitation and Extermination* (Brisbane, 1975, 1988).

Ewers, John K., sel., *Modern Australian Short Stories* (Melbourne, 1965).

Fabian, Suzane, *Mr Punch Down Under* (Melbourne, 1982).

Falkiner, S., L. Graham, *Australians Today*, (Sydney, 1985).

Fitzgerald, C. P., *Why China? Recollections of China 1923–1950* (Melbourne, 1985).

FitzGerald, Stephen, 'Australia: The Lazy Country', *Sunday Herald*, 4 Nov. 1990, 13.

_____ 'Australia's China', unpublished paper, Nov. 1989.

Flood, Josephine, *Archaeology of the Dreamtime* (Sydney, 1983, 1989).

Flynn, Errol, *Beam Ends* (London, 1937).

_____ *My Wicked, Wicked Ways* (New York, 1959).

Foster, David, 'Aggression in Sleepy Hollow', ABR, Oct. 1984, 9–10.

_____ 'The Quandary of an India Addict', TOS, 8 March 1987, 24.

Fox, J. J., and others, *Indonesia: Australian Perspectives* (Canberra, 1980).

Fox, Len, *Friendly Vietnam* (Hanoi, 1958).

Frei, Henry P., *Japan's Southward Advance and Australia: From the Sixteenth Century to World War II* (Melbourne, 1991).

_____ 'Japan Discovers Australia: The Emergence of Australia in the Japanese World-view, 1540s–1900', MN, xxxix, 1 (Spring 1984), 66–81.

Frizell, Helen, 'The Asian Interface', H, 28, 2, Dec. 83, 108–15.

Fuller, Peter, *The Australian Scapegoat* (Perth, 1986).

Gelder, Ken, Paul Salzman, *The New Diversity: Australian Fiction 1970–1980* (Melbourne, 1989).

George, Margaret, *Australia and the Indonesian Revolution* (Melbourne, 1980).

Gerster, Robin, *Big-noting: The Heroic Theme in Australian War Writing* (Melbourne, 1987).

Gilmore, R. J., Denis Warner, eds., *Near North; Australia and a Thousand Million Neighbours* (Sydney, 1948).

Grant, Bruce, *Indonesia* (Melbourne, 1967).

_____ *The Crisis of Loyalty* (Sydney, 1973).

_____ *The Australian Dilemma: A New Kind of Western Society* (Sydney, 1983).

_____ *What Kind of Country? Australia and the Twenty-first Century* (Melbourne, 1988).

Grant, James, Geoffrey Serle, *The Melbourne Scene, 1803–1956* (Sydney, 1957).

Gray, Robert, Geoffrey Lehmann, sel., *The Younger Australian Poets* (Sydney, 1983).

Green, Dorothy, 'A Candle in the Sunrise', *The Eastern Buddhist*, new series, XIV, 2, Autumn 1981.

Greenwood, Gordon, ed., *Australia, A Social and Political History* (Sydney, 1955, *1978*).

_____ *Approaches to Asia: Australian Postwar Policies and Attitudes* (Sydney, 1974).

Gullett, Henry, *Not As a Duty Only: An Infantryman's War* (Melbourne, 1976, *1984*).

Hall, Rodney, ed., *Collins Book of Australian Poetry* (Sydney, 1984).

Halliday, Jon, Bruce Cummings, *Korea: The Unknown War*, 1988 (London, 1990).

Harries, Owen, chairman, Committee on Australia's relations with the Third World, *Australia and the Third World* (Canberra, 1979).

Harris, Stuart, *Review of Australia's Overseas Representation* (Canberra, 1986).

Harrison, Kenneth, *The Brave Japanese* (Adelaide, 1962, 1968) (*The Road to Hiroshima*, 1983).

Harrison-Ford, Carl, sel. and introd., *Fighting Words: Australian War Writing* (Melbourne, 1989).

Hassall, Anthony J., 'Interview with Randolph Stow', ALS, 10, 3, 1982, 311–325.

_____ *Strange Country: A Study of Randolph Stow* (Brisbane, 1986, *1990*).

Hazzard, Shirley, *Coming of Age in Australia*, ABC Boyer Lecture, 1984 (Sydney, 1985).

Hearn, Lafcadio, *Glimpses of Unfamiliar Japan* (Boston, 1894).

_____ *Out of the East: Reveries and Studies in New Japan* (Boston, 1895).

_____ *Japan: An Attempt at Interpretation* (New York, 1904).

_____ *Writings From Japan: An Anthology Edited with an Introduction by Francis King* (Melbourne, 1986).

Hergenhan, Laurie, gen. ed., *The Penguin New Literary History of Australia* (Melbourne, 1988).

Hewison, Robert, *Too Much: Art and Society in the Sixties, 1960–1975* (London, 1986).

Hicks, Neville, '*This Sin and Scandal*,' *Australia's Population Debate 1891–1911* (Canberra, 1976).

Higham, Charles, Michael Wilding, eds., *Australians Abroad* (Melbourne, 1967).

Hooker, John, *Korea: The Forgotten War* (Sydney, 1989).

Hood, John, *Australia and the East, Being a Journal Narrative of a Voyage to NSW in an Emigrant Ship, with a Residence of Some Months in Sydney and the Bush, and the Route Home by Way of India and Egypt in the Years 1841 and 1842* (London, 1843).

Hopkirk, Peter, *Foreign Devils on the Silk Road* (London, 1980).

Horne, Donald, *The Lucky Country* (Melbourne, 1964, 1971): *Australia in the Sixties* (Sydney, 1978).

_____ *The Next Australia* (Sydney, 1970).

_____ *The Australian People: Biography of a Nation* (Sydney, 1972).

_____ *Ideas for a Nation* (Sydney, 1989).

Hornadge, Bill, *The Yellow Peril: A Squint at Some Australian Attitudes Towards Orientals*, 2nd. ed. (Dubbo, 1976).

Hughes, Robert, *The Fatal Shore: The Epic of Australia's Founding* (New York, 1986).

Idriess, Ion, *Gold Dust and Ashes: The Romantic Story of the New Guinea Goldfields* (Sydney, 1941).

_____ *Trapping the Jap* (Sydney, 1942).

Ingleson, John, 'Australian Images of Asia', *Australia in Asia, The Next 200 Years*, UNSW symposium, 10 Nov. 1987.

Ingleson, John, David Walker, 'The Impacts of Asia', unpublished paper, UNSW (Sydney, 1988).

Inglis, Amirah, *An Un-Australian Childhood* (Melbourne, 1983).

Iriye, Akira, ed., *Mutual Images: Essays in American–Japanese Relations* (Cambridge, USA, 1975).

Isaacs, Jennifer, ed., *Australian Dreaming: 40 000 Years of Aboriginal History* (Sydney, 1980).

Jefferis, James, 'Australia's Mission and Opportunity', *Centennial Magazine* 1, Aug. 1888–July 1889.

Johnston, George, *War Diary, 1942* (Sydney, 1985).

_____*Australians at War* (Sydney, 1942).

_____*New Guinea Diary* (Sydney, 1943).

Johnston, Sheila K.. *The Japanese Through American Eyes* (Stanford, 1989).

Jordens, Ann Mari, 'A Dream Turns Sour. Official War Artists: Vietnam', unpublished paper, Official History Unit, AWM, 1987.

_____'The Cultural Influence of the Vietnam War on Australia since 1965', unpublished paper, Official History Unit, AWM, 1986.

Kabbani, Rana, *Europe's Myths of the Orient*, (London, 1986).

Kiernan, Brian, *David Williamson: A Writer's Career* (Melbourne, 1990).

_____*Burchett: Reporting the Other Side of the World 1939–83* (London, 1986).

King, Jonathan, *Stop Laughing, This is Serious: A Social History of Australia in Cartoons* (Sydney, 1978).

_____*The Other Side of the Coin: A Cartoon History of Australia* (Sydney, 1976).

King, Peter, ed., *Australia's Vietnam* (Sydney, 1983).

Kirkby, Joan, ed., *The American Model: Influence and Independence in Australian Poetry* (Sydney, 1982).

Koch, C. J., *Crossing the Gap: A Novelist's Essays* (London, 1987).

_____'Crossing the Gap: Asia and the Australian Imagination', *Quadrant*, Jan.–Feb. 1981

_____'Literature and Cultural Identity', *The Tasmanian Review*, 4, 1980.

Kramer, Leonie, ed., *The Oxford History of Australian Literature* (Melbourne, 1981).

Kramer, Leonie, Adrian Mitchell, eds., *The Oxford Anthology of Australian Literature* (Melbourne, 1985).

Krauth, Nigel, ed., *New Guinea Images in Australian Literature* (Brisbane, 1982).

_____'PNG in Recent White Fiction', in Chris Tiffin, ed., *South Pacific Images* (Brisbane, 1978).

Lach, D. F., *Asia in the Making of Europe* (Chicago, 1965).

Laffin, John, *Digger: The Story of an Australian Soldier* (Melbourne, 1959).

_____*Digger: The Legend of an Australian Soldier* (Melbourne, 1968, 1990).

LaNauze, J. A., *Alfred Deakin* (Melbourne, 1962, 1979).

Lane, John, *Summer Will Come Again* (Fremantle, 1987).

Larkins, John, *101 Events that Shaped Australia* (Adelaide, 1979).

Lepervanche, M., *Indians in a White Australia*, (Sydney, 1985).

Lett, Lewis, *Papuan Gold: The Story of the Early Gold Seekers* (Sydney, 1943).

_____*Sir Herbert Murray of Papua* (Sydney, 1949).

Levi, Werner, *Australia's Outlook on Asia* (Sydney, 1958).

Lockwood, Douglas, *The Front Door, Darwin 1869–1969* (Adelaide, 1974).

Lohrey, Amanda, ed., *Australian Studies Overseas: A Guide* (Canberra, 1988).

Long, Gavin, *To Benghazi* (Canberra, 1952, 1986).

Lord, Mary, *Hal Porter* (Melbourne, 1974).

_____ed. *Hal Porter* (Brisbane, 1980).

Lunn, Hugh, *Vietnam: A Reporter's War* (Brisbane, 1985).

Mackerras, Colin, *Western Images of China* (Hong Kong, 1989).

_____, *Cambridge Handbook of Contemporary China* (Cambridge, 1991).

Mackerras, Colin, Neale Hunter, *China Observed, 1964–67* (Melbourne, 1967).

Mackie, J. A. C., *Indonesia: the Making of a Nation* (Canberra, 1980).

Macknight, C. C., *The Farthest Coast: A Selection of Writing Related to the History of the Northern Coast of Australia* (Canberra, 1969).

_____'Macassans and Aborigines', *Oceania* 42, pp. 283–321.

_____*The Voyage to Marege* (Melbourne, 1976).

_____'Outback to Outback: the Indonesian Archipelago and Northern Australia', in Fox and others, 1980.

_____'Macassans and the Aboriginal Past', photocopy, Department of History, ANU, 1987.

Mahood, Marguerite, *The Loaded Line: Australian Political Caricature 1788–1901* (Melbourne, 1973).

Maloney, William, *Flashlights on Japan and the Far East* (Melbourne, 1905).

Malouf, David, *The Poetry of Judith Wright* (Sydney 1972).

Mandle, Bill, *Going it Alone: Australia's National Identity in the Twentieth Century* (Melbourne, 1977).

Marks, E. George, *Watch the Pacific! Defenceless Australia* (Sydney, 1924).

Martin, Ged, ed., *The Founding of Australia: the Argument about Australia's Origins* (Sydney, 1973).

McAulay, Lex (David Alexander, pseud.), *Contact: Australians in Vietnam* (Sydney, 1989).

_____*The Battle of Long Tan* (Melbourne, 1986).

_____*The Battle of Coral* (Melbourne, 1988).

_____*Blood and Iron: The Battle for Kokoda 1942* (Sydney, 1991).

_____*The Fighting First: Combat Operations in Vietnam 1968–69* (Sydney, 1990).

McCabe, Graeme, *Pacific Sunset* (Hobart, 1946).

McDonald, Hamish, *Suharto's Indonesia* (Melbourne, 1980).

McGregor, John, *Blood on the Rising Sun* (Sydney, 1943, *1980*).

McKie, Ronald, *We Have No Dreaming* (Sydney, 1988).

McKinley, Brian, *Australia 1942: End of Innocence* (Sydney, 1985).

McLaren, John, *Australian Literature: An Historical Introduction* (Melbourne, 1990).

McLeod, A. L., ed., *The Pattern of Australian Culture* (Melbourne, New York, 1963).

McQueen, Humphrey, *A New Britannia? An Argument Concerning the Social Origins of Australian Radicalism and Nationalism*, (Melbourne, 1970, *1978*).

_____ *Japan to the Rescue* (Melbourne, 1991).

McVitty, Walter, *Authors and Illustrators of Australian Children's Books* (Sydney, 1989).

Meaney, Neville, ed., *Under New Heavens: Cultural Transmission and the Making of Australia* (Melbourne, 1989).

_____ *Australia and the World* (Melbourne, 1975).

_____ *The Search for Security in the Pacific, 1901–14* (Sydney, 1976).

Miyoshi, Masao, H. D. Harootunian, eds., *Postmodernism and Japan* (London, 1989).

Modjeska, Drusilla, *Exiles at Home: Australian Women Writers 1925–1945* (London, Sydney 1981, *1984*).

Moore, Peter, Trevor Pleace, comp., *Vietnam Lives: Works by Australian Vietnam Veterans from the Sixties to the Eighties*, ex 5RAR, South Vietnam (n.d.)

Moore, T. Inglis, *Social Patterns in Australian Literature* (Sydney, 1971).

Moorehead, Alan, *The Fatal Impact: The Invasion of the South Pacific 1767–1840* (London, Sydney, 1966, *1987*).

Morimoto Junko, *My Hiroshima* (Sydney, 1987).

Morrison, G. E., *An Australian in China, Being the Narrative of a Quiet Journey across China to British Burma* (Sydney 1895, *1972*).

Morrison, Hedda, *Sarawak* (Singapore, 1957).

_____ *Life in a Longhouse* (Kuching, 1962).

_____ *A Photographer in old Peking* (Hong Kong, 1987).

_____ *Travels of a Photographer in China* (Hong Kong, 1987).

Morrison, R. H., ed., 'Vietnam Voices', *Overland* special issue, Spring 1973.

Morton, Leith, 'The Chrysanthemum and the Wattle: The Japanese Influence on Modern Australian Poetry', LS, 7 May 1988.

Mudie, Ian, comp., *Poets at War: An Anthology of Verse by Australian Servicemen* (Melbourne, 1944).

Mulvaney, D. J., *The Prehistory of Australia* (London, 1969, Melbourne, *1975*).

Munro, Craig, *Wild Man of Letters: The Story of P. R. Stephensen* (Melbourne, 1984).

Murdoch, James, *Australia Must Prepare: Japan,*

China, India: A Comparison and Some Contrasts University of Sydney, 3 Dec. 1919 (Sydney, 1919).

_____ *History of Japan*, 3 vols. (Sydney, 1903–1926).

Murray, Les A., *The Australian Year: The Chronicle of our Seasons and Celebrations* (Sydney, 1985).

_____ *Persistence in Folly: Selected Prose Writings* (Sydney, 1984).

_____ *Block and Tackles: Articles and Essays* (Sydney, 1991).

Narogin, Mudrooroo, *Writing from the Fringe: a Study of Modern Aboriginal Literature* (Melbourne, 1990).

National Trust of Australia (NSW), *William Hardy Wilson: A Twentieth Century Colonial 1881–1935* (Sydney, 1980).

Nelson, Hank, *POW: Australians Under Nippon* (Sydney, 1985).

Nelson, Hank, Tim Bowden, Helen Findlay, Nina Riemer, *Taim Bilong Masta: the Australian Involvement with Papua New Guinea* (Sydney, 1982).

Neville, Richard, Julie Clark, *The Life and Crimes of Charles Sobraj* (Sydney, 1979).

Nicholls, Bob, *Bluejackets and Boxers: Australia's Naval Expedition to the Boxer Uprising* (Sydney, 1986).

Parkin, Ray, *The Sword and the Blossom* (London, 1968).

_____ *Out of the Smoke: The Story of a Sail* (London, 1960).

_____ *Into the Smother: A Journal of the Burma–Siam Railway* (London, 1963).

Paterson, A. B., *Happy Dispatches: Journalistic Pieces from Banjo Paterson's Days as a War Correspondent* (Sydney, 1980).

Phillips, A. A., 'The Cultural Cringe', *Meanjin*, 4, Summer 1950.

_____ *The Australian Tradition: Studies in a Colonial Culture* (Melbourne, 1958).

Pierce, Peter, 'Perceptions of the Enemy in Australian War Literature', ALS 12, 2, Oct. 1985, 166–81.

_____ 'The Australian Literature of the Viet Nam War', *Meanjin* 39, 3, Oct. 1980, 290–303.

_____ ed. *Oxford Literary Guide to Australia* (Melbourne, 1987).

Pierce, Peter, Jeff Doyle, Jeffrey Grey, eds., *Vietnam Days: Australia and the Impact of Vietnam* (Melbourne, 1991).

Pike, Douglas ed., *Australian Dictionary of Biography* (Melbourne, 1966–).

Porter, Hal, *The Watcher on the Cast-iron Balcony* (London, 1963).

_____ *The Paper Chase*, (Sydney, 1966; Brisbane, *1980*).

_____ *The Actors: an Image of the New Japan*, (Sydney, 1968).

_____ *The Right Thing* (Adelaide, 1971).

_____ *The Extra* (Melbourne, 1975).

_____ 'Post-war Japan', in Higham, Wilding, eds., 1967.

_____ ed., *It Could be You* (Adelaide, 1972).

Pratt, Ambrose, *War in the Pacific* (Melbourne, 1914).

_____ *Magical Malaya* (Melbourne, 1931).

_____ *Wolaroi's Cup* (Sydney, 1914).

Price, Charles A., *The Great White Walls are Built: Restrictive Immigration to North America and Australia, 1830–1888* (Canberra, 1974).

Pringle, J. D., ed., *The Best of Ethel Anderson*, (Sydney, 1973).

_____ *Australian Accent* (Sydney, 1958).

Pulvers, Roger, *The Japanese Inside Out* (Tokyo, 1982).

Reid, Ian, *Fiction and the Great Depression* (Melbourne, 1979).

Reischauer, Edwin O., *The United States and Japan* (Cambridge, USA, 1950, *1965*).

Renouf, Alan, *The Frightened Country* (Melbourne, 1979).

Rickard, John, *Australia: A Cultural History* (Melbourne, 1988).

Ritchie, John, *Australia as Once We Were* (Melbourne, 1975).

Rivett, Rohan, *Behind Bamboo: An Inside Story of the Japanese Prison Camps* (Sydney, *1945, 1991*).

Rix, Alan, *W. Macmahon Ball: A Pioneer of Australia's Asian Policy* (Brisbane, 1987).

Roberts, S. H., 'History of the Contacts between the Orient and Australia', in I. Clunies-Ross, ed., 1935.

Roe, Jill, *Beyond Belief: Theosophy in Australia 1879–1939* (Sydney, 1986).

Rorabacher, Louise E., ed., *Two Ways Meet: Stories of Migrants in Australia* (Melbourne, 1969).

Ross, Jane, *The Myth of the Digger: the Australian Soldier in Two World Wars* (Sydney, 1985).

Rowlands, Graham, 'Preserving the New Past: Australian Vietnam War Poetry', *Island*, 6 March 1981, 35–6.

Said, Edward, *Orientalism* (New York, 1978, *1985*).

Seidensticker Edward, *Low City, High City: Tokyo from Edo to the Earthquake* (New York, 1983).

Sergeant, Harriet, *Shanghai: Collision Point of Cultures 1918/1939* (New York, 1991).

Serle, Geoffrey, *The Creative Spirit in Australia: A Cultural History*, (*From The Deserts the Prophets Come*, 1973), (Melbourne *1987*).

Serle, P., ed., *Dictionary of Australian Biography*, 2 vols. (Sydney, 1949).

Shaw, Basil, *Times and Seasons: An Introduction to Bruce Dawe* (Melbourne, 1974).

Sherington, Geoffrey, *Australia's Immigrants 1788–1988* (Sydney, 1990).

Simons, Jessie, *While History Passed, (In Japanese Hands): The Story of the Australian Nurses who were Prisoners of the Japanese for Three and a Half Years* (Melbourne, 1985).

Sinclair, James, *Kiap: Australia's Patrol Officers in Papua New Guinea* (Sydney, 1981).

_____ *Last Frontiers: The Explorations of Ivan Champion of Papua* (Brisbane, 1988).

Sissons, D. C. S., 'Australian–Japanese Relations: the first phase, 1859–1891', unpub. paper, Dept. of International Relations, ANU, 3 Oct. 1978.

_____ 'Immigration in Australian–Japanese relations, 1871–1971', in J. A. A. Stockwin, ed., *Japan and Australia in the Seventies* (Sydney, 1972).

_____ 'Australia's First Professor of Japanese: James Murdoch 1856–1921', ms, 1982.

_____ 'Karayuki-san: Japanese Prostitutes in Australia 1887–1916', I, II, *Historical Studies* 17: 68, 69, 1977, pp. 321–341 , 478–488.

_____ 'Early Australian Contacts with Japan', H, 16, April 1972, p. 15.

_____ *Episodes: A Glimpse of Australia–Japan Relations 1859–1979* (Canberra, n.d.).

_____ 'Attitudes to Japan and Defence, 1890–1923', MA thesis, University of Melbourne, 1956.

_____ 'The Japanese in the Australian Pearling Industry', *Queensland Heritage*, 3, 10, 1979, 9–27.

Sladen, Douglas, *A Japanese Marriage* (London, 1895).

_____ *Queer Things About Japan* (London, 1903).

_____ *More Queer Things About Japan* (London, 1904).

Souter, Gavin, *New Guinea: The Last Unknown* (Sydney, 1963).

_____ *A Peculiar People: the Australians in Paraguay* (Sydney, 1968).

Spearritt, Peter, David Walker, eds., *Australian Popular Culture* (Sydney, 1979).

Spry-Leverton, Peter, Peter Kornicki, *Japan* (London, 1987).

Stargardt, A. W., *Australia's Asian Policies: The History of a Debate 1839–1972* (Hamburg, 1977).

Stephens, F. R., ed., *Racism: The Australian Experience: A Study of Race Prejudice in Australia*, 2 vols. (Sydney, 1971, 1972).

Stephens, F. R., Edward P. Wolfers, eds., *Racism: The Australian Experience*, vol. 3, (Sydney, 1977).

Stephens, J., 'The Female Coloniser: gender-inscribed language and the discourse of orientalism', PhD thesis, Indian and Indonesian Studies, Melbourne University, 1986.

Stephensen, P. R., *Foundations of Culture in Australia* (Gordon, 1936).

Suzuki Daisetz Teitaro, *A Brief History of Early Chinese Philosophy* (London, 1914).

_____ *Essays in Zen Buddhism*, 2nd series (London, 1933).

TCN Channel 9 and *The Bulletin*, *The Greats: the 50 Men and Women who Most Helped to Shape Modern Australia*, Leonie Kramer, editorial board, and others (Sydney, 1986).

Terrill, Ross, *The Australians: In Search of an Identity* (London, 1987).

Thomas, Tony, *Errol Flynn: The Spy Who Never Was* (Citadel, New York, 1990).

Tiffin, Helen, 'Asia and the Contemporary Australian Novel', ALS, 11, 4, Oct. 1984, 68–79.

_____ 'Asia, Europe and Australian Identity: the Novels of Christopher Koch', ALS, 10, 3, Oct. 1982, 326–35.

_____ '*Tourmaline* and the *Tao Te Ching*: Randolph Stow's *Tourmaline*', in K. G. Hamilton, ed., *Studies in the Recent Australian Novel* (Brisbane, 1978) pp. 84–120.

Tranter, John, ed. and introd., *The New Australian Poetry* (Brisbane, 1979).

Vickers, Adrian, *Bali: A Paradise Created* (Melbourne, 1989).

Wakefield, E. G., *A Letter from Sydney, the Principal Town of Australasia—Other Writings on Colonization* (London, 1929).

Waley, Arthur, *The Way and its Power: A Study of the Tao Te Ching and its place in Chinese Thought* (London, 1930).

_____ *The Nō Plays of Japan* (London, 1931, 1957).

_____ *Oriental Art and Culture* (London, 1924, New Delhi 1981).

_____, tr., *Chinese Poems* (London, 1976).

_____, pref., in B. de Zoete, W. Spies, *Dance and Drama in Bali* (London, 1938, *1952*).

Walker, David, ed., *Australian Perceptions of Asia*, ACH, 9, 1990.

_____ *Dream and Disillusion: A Search for Australian Cultural Identity* (Canberra, 1976).

Walker, Shirley, *The Poetry of Judith Wright: a Search for Unity*, (London, 1980).

Wallace-Crabbe, Chris, ed., *The Australian Nationalists: Modern Critical Essays* (Melbourne, 1971).

Wallace-Crabbe, Chris, and Peter Pierce, eds., *Clubbing of the Gun-fire: 101 Australian War Poems* (Melbourne, 1984).

Walter, James, ed., *Australian Studies: A Survey*, (Melbourne, 1990).

Ward, Russel, *Australia Since the Coming of Man* (Sydney 1982, *1988*).

_____ *The Australian Legend* (Melbourne, 1958, 1966, *1985*).

_____ *Australia, A Short History* (Sydney, 1975).

Ward, Russell, John Robertson, *Such Was Life: Select Documents in Australian Social History, 1788–1850* (Sydney, 1969).

Warner, Denis, *The Last Confucian: Vietnam, South-East Asia and the West* (Sydney, 1964).

Warner, Denis, Peggy Warner, *The Sacred Warriors: Japan's Suicide Legions* (Melbourne, 1982).

_____ *The Tide at Sunrise: A History of the Russo–Japanese War 1904–05* (New York, 1974).

Watt, Alan, *The Evolution of Australian Foreign Policy 1938–1956* (London, 1967).

Watts, Allan W., *The Spirit of Zen: A Way of Life, Work, and Art in the Far East* (London, 1958).

White, Osmar, *Green Armour* (Sydney, 1945).

_____ *Time Now, Time Before* (Melbourne, 1967).

_____ *Parliament of a Thousand Tribes: A Study of New Guinea* (London, 1965).

White, Richard, *Inventing Australia: Images and Identity 1888–1980* (Sydney, 1981).

_____ '"Combating cultural aggression": Australian opposition to Americanisation', *Meanjin* 39, 3, Oct. 1980, 275–89.

Whitecross, Roy, *Slaves of the Son of Heaven: A Personal History of an Australian Prisoner of the Japanese During the Years 1942–1945* (Sydney, 1951, *1988*).

Wigmore, Lionel, *The Japanese Thrust* (Canberra, 1957).

Wilde, William H., Joy Hooton, Barry Andrews, *Oxford Companion to Australian Literature* (Melbourne, 1985).

Wilding, Michael, Charles Higham, eds., *Australians Abroad* (Melbourne, 1967).

Willard, Myra, *History of the White Australia Policy to 1920* (Melbourne, 1923, *1967*).

Williams, Harold S., *Tales of the Foreign Settlements in Japan* (Tokyo, 1958).

_____ *Shades of the Past, or Indiscreet Tales of Japan* (Tokyo, 1959).

Williams, Maslyn, *Faces of My Neighbour: Three Journeys into East Asia* (Sydney, 1979).

_____ *In One Lifetime* (Melbourne, 1970).

_____ *The East is Red: The Chinese—A New Viewpoint* (Melbourne, 1967, 1969).

Wilson, Charles, *Australia: The Creation of a Nation 1788–1988* (London, 1988).

Wilson, W. Hardy, *Instinct* (Wandin, 1945).

_____ *Grecian and Chinese Architecture* (Melbourne, 1937).

_____ *Atomic Civilization* (Melbourne, 1949).

_____ *Solution of Jewish Problem* (Wandin, 1941).

_____ *Cultural War*, typescript, 1947.

_____ *Eucalyptus* (Wandin, 1941).

Wingrove, Keith ed., *Norman Lindsay on Art, Life and Literature* (Brisbane, 1990).

Winks, Robin W., James R. Rush, eds., *Asia in Western Fiction* (Honolulu, 1990).

Wright, Judith, 'The Upside-down Hut', AL, III, 4, 1961, pp. 30–4.

_____ *Preoccupations in Australian Poetry* (Melbourne, 1965).

_____ *Phantom Dwelling* (Sydney, 1985).

Wu, William F., *The Yellow Peril: Chinese Americans in American Fiction, 1850–1940* (Hampden, Connecticut, 1982).

Yarwood, A. T., *Asian Migration to Australia: The Background to Exclusion 1896–1923* (Melbourne, 1964).

_____ ed. and introd., *Attitudes to Non-European Migration* (Melbourne, 1968).

Yarwood, A. T., M. J. Knowling, *Race Relations in Australian History* (Sydney, 1982).

Yu Beongcheon, *The Great Circle: American Writers and the Orient* (Detroit, 1983).

III DRAMA, DANCE, FILM

Date alone refers to year of first performance.
Date and place refer to publication.

Drama, dance

Abbott, Elisabeth, John Jenkins, Tina Stubbs, Gordon Williams, *Dustoff Vietnam*, photocopy (Darwin, 1988).

Asche, Oscar, *Chu Chin Chow: A Musical Tale of the East* (London, 1931).

Barr, Margaret, *A Day in the Life of Mahatma Gandhi: 1869–1948* (1982).

_____ *Climbers* (1976).

_____ *A Small People* (1969).

Bedford, Randolph, *White Australia: or, the Empty North* (1909).

Beynon, Richard, *The Shifting Heart* (1957, London 1960).

Blair, Ron, *Kabul* (1973).

Brand, Mona, *Strangers in the Land: Two Plays about Malaya* (1954).

———*Here Under Heaven* (Melbourne, 1948, 1989).

Buzo, Alex, *Norm and Ahmed* (Sydney, 1967).

———*Makassar Reef*, 1978 (Sydney, 1979).

———*The Marginal Farm* (1983, Sydney, 1985).

Casimiro, Maria Alice, Jose Mateiro, Graham Pitts, *Death at Balibo* (photocopy, Darwin 1988).

Chan, Kai Tai, *Two Women* (1980).

———*Midday Moon* (1984).

———*One Man's Rice* (1982).

———*The Cheated* (1982).

———*Six Chapters of a Floating Life* (1988).

———*Ah Q Goes West* (1984).

———*Turn of the Tide* (1987).

———*The Shrew* (1987).

———*Dancing Demons* (1991).

de Groen, Alma, *The Rivers of China*, 1986, (Sydney 1988).

Duggan, Edmund, *My Mate* (1911).

Elliott, Sumner Locke, *Rusty Bugles* (1948, Sydney 1980).

Ellis, Bob, Michael Boddy, *The Legend of King O'Malley* (1974, Sydney, 1979).

———, Anne Brooksbank, *Down Under* (Sydney, 1977).

George, Robert, *Sandy Lee Live at Nui Dat* (1981, Sydney, 1983).

Helpmann, Robert, *Sun Music* (1968).

———*Yūgen* (1965).

Herbert, Bob, *By the Billabong* (n.d.)

Hoenig, Ron, Jon Firman, *The Living Room War*, (1985).

Holt, Bland, *The Great Rescue* (1909).

Hopgood, Alan, *Private Yuk Objects* (1966).

Hopkins, F. R. C., *Reaping the Whirlwind: An Australian Patriotic Drama for Australian People* (Sydney, 1909).

———*The Opium Runners: Tales of Australia* (Sydney, 1909).

John, Rosemary, *The Luck of the Draw* (1985, Sydney, 1986).

Keene, Daniel, Dal Babare, Boris Conley, *Chō Chō San*, 1978, 1984 (Sydney, 1987).

Kellaway, Nigel, *House of Awa* (1984).

———*Fantastic Toys* (1986).

Keneally, Thomas, *Childermas* (1986).

Kim, Don'o, *The Love System of Madame Amilah*, radio play (1967).

Lee Joo For, John, *Sarong Aussies*, typescript, (1979).

———*The Propitious Kidnapping of a Pampered Daughter* (typescript, 1978).

———*The Satay Shop in Perth* (typescript, n.d.).

MacIntyre, Ernest, *Let's Give Them Curry: An Austral-Asian Comedy in 3 Acts* (Melbourne, 1985).

———*The Education of Miss Asia* (n.d.)

Mico, Domenic, *Contact*, typescript (Canberra, 1986).

Moore, T. Inglis, *We're Going Through, A Radio Verse Play of the AIF* (Sydney, 1945).

Nowra, Louis, *Sunrise* (Sydney, 1983).

———*The Precious Woman*, 1980 (Sydney, 1981).

Porter, Hal, *The Professor, or Toda-San, A Play in Three Acts* (London, 1966).

Pulvers, Roger, *Three Goals to Nhill*, (in Japanese: Tokyo, 1986).

———*General MacArthur in Australia* (1978).

———*Yamashita*, (in Japanese, 1970; in English, 1981).

Radic, Leonard, *Sideshow* (1971).

———*Now and Then* (1982).

Romeril, John, *The Floating World* (1974, Sydney, 1975).

———*Top End*, typescript (Melbourne, 1988).

———*Lost Weekend*, typescript (1988).

Seymour, Alan, *The One Day of the Year*, 1960, in H. G. Kippax, introd., *Three Australian Plays* (Melbourne, 1963).

———*The Gaiety of Nations* (London, 1965).

Shearer, Jill, *Shimada* (1987, Sydney, 1989).

Sheil, Graham, *Bali: Adat* (1991).

Smith, Jo, *The Girl of the Never-never* (1910).

Strachan, Tony, *The Eyes of the Whites* (Sydney, 1983).

Summons, John, *Lamb of God* (Sydney, 1979).

Triffitt, Nigel, *The Fall of Singapore* (1987).

Upton, John, *The Hordes from the South* (typescript, 1988).

Watkins, Dennis, *Pearls Before Swine* (Sydney, 1986).

Willett, F. J., *Baggy Green Skin* (1979).

Williamson, David, *Jugglers Three*, 1973, in Williamson, *Three Plays* (Sydney, 1974).

Film, video

Abbreviations for countries concerned:

Australia	[A]
China	[C]
Cambodia	[Ca]
Hong Kong	[HK]
India	[Ia]
Indonesia	[I]
Japan	[J]
Korea	[K]
Malaysia	[M]
Philippines	[P]
Papua New Guinea	[PNG]
South Pacific	[SP]
Thailand	[T]
Vietnam	[V]

Ansara, Martha, Mavis Robertson, *Changing the Needle* (1981) [V].

Asch, Patsy, *The Medium is the Massage* (1980) [I].

Bennetts, Don, *Donald Friend, the Prodigal Australian* (1990) [A,I].

Bindley, Victor, *The Devil's Playground* (1928). [A,SP]

Bourke, Terry, *Sampan* (1967–68) [HK].

_____ *Noon Sunday* (1970) [HK].

Bradbury, David, *Frontline* (1979) [T,V,Ca].

_____ *Public Enemy Number One* (1980) [J,C,K,V].

Bretherton, Di, Christina Pozzan, *As the Mirror Burns*, 1990 [V].

Bruce, Jack, Noel Monkman, *Typhoon Treasure* (1938) [A,SP].

Burns, Bob, *One People, One Soul* (1987) [I].

Burstall, Tim, *Attack Force Z* (1979).

Cahill, David, *You Can't See Round Corners* (1969) [A,V].

Cameron, Ken, *Bangkok Hilton* (1989) [T].

Capon, Edmund, *Travels in Chinese Art with Edmund Capon* (1989) [C].

Carson, Michael, *Cassidy* (1989) [HK].

Chase, Graham, *Bitter Rice* (1989) [P].

Chauvel, Charles, *In the Wake of the Bounty* (1933) [SP].

_____ *Uncivilised* (1936) [PNG].

Connolly, Bob, Robin Anderson, *First Contact* (1983) [PNG].

_____ *Joe Leahy's Neighbours* (1989) [PNG].

_____ *Funeral at Kilima* (1991) [PNG].

Cowan, Tom, *Wild Wind* (1975) [Ia].

Darling, John, *Bali Hash*, 1989 [I].

_____ *Bali Triptych*, 1987 [I].

_____ *Master of the Shadow*, 1984 [I].

_____ *Lempad of Bali* (1980) [I].

_____ *Five Faces of God*, n.d. [I].

Davidson, Robyn, *Mail-order Bride* (1964) [P].

Davis, Eddie, *That Lady from Peking* (1970) [C].

Dawn, Norman, *The Adorable Outcast* (1928) [A,SP].

Duigan, John, *The Trespassers* (1976) [A,V].

_____ *Far East* (1981) [P].

_____, Chris Noonan, *Vietnam*, 1986 [A,V].

Edols, Michael, Jack Bellamy, *Tidikawa and Friends* (1973) [PNG].

Film Australia, *The Human Face of China* (1979) [C].

_____ *The Human Face of Japan* (1982) (J).

_____, David Roberts, David Haythornthwaite, *The Human Face of Indonesia* (1985) [I].

Freeman, Warwick, *Demonstrator* (1971) [V].

Freney, Denis, James Kesteven, Mandy King, *The Shadow over East Timor* (1987) [I].

Gerrand, James, *Cambodia/Kampuchea* (1986) [Ca].

_____ *The Prince and the Prophecy* (1986) [Ca].

_____ *The Eagle, the Dragon, the Bear and Kampuchea* (1988) [Ca].

_____ *The Prince and the Prophecy* 1988 [Ca].

_____ *It's a Good Day if Nothing Happens*, 1979 [I]

Gurr, Tom, *Jungle Patrol* (1944) [PNG].

Hall, Ken G., *Lovers and Luggers* (1937) [A,SP].

Hardy, Alan, *Embassy* (1990–91) [Ragaan].

Harwood, A. R., *Sea of Intrigue* (1931) [SP].

Hexter, Ivan, *East Meets West* (1984) [A,V].

Hoaas, Solrun, *Waiting for Water* (1981) [J].

_____ *There's Nothing That Doesn't Take Time* (1981) [J].

_____ *The Priestess, the Storekeeper* (1983) [J].

_____ *Green Tea and Cherry Ripe* (1987) [J].

_____ *Sacred Vandals* (1983) [J].

_____ *Effacement* (1980) [J].

_____ *In Search of the Japanese* (1980) [J].

_____ *Aya* (1990) [A,J].

Holmes, Cecil, *Gentle Strangers* (1972) [A].

Howes, Oliver, *Do Your Utmost* (1987) [J].

_____ *Japan at Work* (1988) [J].

_____ *Indonesia, Pressure and Population* (1986) [I].

_____ *Pacific Paradise* (n.d.) [SP].

Hughes, Bill, *Lost Islands* (1975) [SP].

Hurley, Frank, *Pearls and Savages* (1921) [A,SP].

_____ *With the Head-hunters in Papua* (1923) [PNG].

_____ *Hound of the Deep* (1926) [Thursday Is.]

_____ *Jungle Woman* (1926) [PNG].

Ingleton, Sally, *For Better or Worse* (1988) [P,A].

Ivens, Joris, *Indonesia Calling* (1948) [I].

Jackson, William J., *In New Guinea Wilds* (1929) [PNG].

Jeffrey, Tom, *The Odd Angry Shot* (1979) [V].

Joffe, Mark, *Shadow of the Cobra* (n.d.) [T,Ia].

Johnson, Peter, *The Korean War—Australia Remembers* (1977) [K].

Kildea, Gary, *Celso and Cora* (1983) [P].

_____ *Valencia Diary* (filmed 1986) [P].

Kuyululu, Ayten, *The Golden Cage* (1975).

Lamond, John, *Felicity* (1979) [HK].

Landon, Jerry, *A Long Way from Home: Barlow and Chambers* (1986) [M].

Lavery, Hugh, Ken Taylor, *Messengers of the Gods: cranes in the life of man* (1985) [J,K,A].

le Mesurier, Simon, *Sword of Honour* (1985) [A,V].

Levy, Curtis, *Breakout* (1984) [A,J].

_____ *The White Monkey* (1987) [P].

_____ *Riding the Tiger* (1991) [I].

Longford, Raymond, *Australia Calls* (1913).

Macdonald, Alexander, *The Unsleeping Eye* (1927) [SP].

_____ *Mystery Island* (1937) [SP].

McCullough, Christopher, *Avengers of the Reef* (1972) [SP].

Merson, John, David Roberts, *Roads to Xanadu*, (1989) [C].

Mora, Philippe, *Mad Dog Morgan* (n.d.) [A,C].

Mueller, Kathy, *Every Day, Every Night* (1983) [A,V].

Nash, Chris, *Philippines, My Philippines* (1988) [P].

Noonan, Chris, Phil Noyce, *The Cowra Breakout* (1984) [A,J].

Noyce, Phil, Shadows of the Peacock (1987) [I].

Oehr, Jane, *Tamu* (the guest) (1972) [I].

O'Rourke, Dennis, *The Good Woman of Bangkok* (1991) [T].

_____ *Half-life* (1986) [SP].

_____ *Cannibal Tours* (1988) [PNG].

Parer, Damien, *Moresby under the Blitz* (1942) [PNG].

_____ *Kokoda Front Line* (1942) [PNG].

_____ *Jungle Warfare on the Kokoda Front* (1942) [PNG].

Parer, Damien, Frank Hurley, others, *Sons of the Anzacs*, (1943) [PNG].

Parer, Damien (jr), *The Legend of Damien Parer*

(1963) [PNG].

Penn, Patricia, *Once Upon a War* (1970) [V].

Petty, Bruce, Phillip Adams, *Hearts and Minds* (1968) [A,V].

Pike, Andrew, Hank Nelson, Gavan Daws, *Angels of War* (1981) [PNG].

Pilger, John, *The Quiet Mutiny* (1971) [V].

_____*Other People's Wars* (1988) [A].

Porter, Eric, *Marco Polo junior versus the Red Dragon* (1972) [C].

Robinson, Lee, *King of the Coral Sea* (1954) [A/SP].

Roper, Myra, Melbourne State College, *The Cultural Revolution* (1980) [C].

Schultz, Carl, *Which Way Home?* (1990) [V].

Scrine, Gil, *Buried Alive: The Story of East Timor* (1989) [I].

Shirley, Graham, *Prisoners of Propaganda* (1987) [A,J].

Smith, Brian Trenchard, *The Man from Hong Kong*, (1975) [A,HK].

Smith, Peter, *Children of the Dragon* (1991) [C].

Smith, Peter, *Sign of the Snake* (1991) [C].

Tan Teck, *The Chinese Diggers* (1988) [A,C].

Thomson, Chris, *The Last Bastion* (1984) [A,J].

Thomson, Chris, Bob Markowitz, *A Dangerous Life* (1989) [P].

Vickers, Roger, *Farang Monk* (1980) [T].

Wallace, Stephen, *Blood Oath* (1989) [A,J].

_____*Giants at Dawn* (1992) [A,J].

_____*Turtle Beach* (1991) [M].

Walsh, Phil, *The Birth of White Australia* (1928) [A].

Ward, Jack, *Australia's Own* (1919) [PNG].

_____*Death Devils in a Papuan Paradise* (1924) [PNG].

Weir, Peter, *Michael*, (1970) [A].

_____*The Year of Living Dangerously* (1981) [I].

West, T. J., *Welcome to Our Gallant Allies—the Japanese* (1906) [A,J].

Wilkinson, Marion, *Allies* 1983 [A,V].

IV PERFORMING ARTS HISTORY, CRITICISM

Adair, Gilbert, *Vietnam on Film from The Green Berets to Apocalypse Now* (New York, 1981).

Adamson, Judith, *Australian Film Posters 1906–1960* (Sydney, 1978).

Balough, Teresa, ed., *A Musical Genius from Australia: Selected Writings By and About Percy Grainger*, Music monograph 4, UWA (Perth, 1982).

_____*A Complete Catalogue of the Works of Percy Grainger*, Music monograph 2, UWA (Perth, 1975).

Baxter, John, *The Australian Cinema* (Sydney, 1969).

Bertrand, Ina, ed., *Cinema in Australia: a Documentary History* (Sydney, 1989).

Best, Alleyn, comp., *Directory of Australian Multicultural Films and Videos: A Resource Guide for Community Groups, Teachers, Film-makers, Researchers, librarians*, Australian Institute of Multicultural Affairs, 1985.

Bird, John, *Percy Grainger* (Melbourne, 1982).

Breen, Marcus, *Our Place, Our Music* (Canberra, 1989).

Brown, Ian F., *The Australian Ballet* (Melbourne, 1967).

Callaway, Frank, David Tunley, eds., *Australian Composition in the Twentieth Century* (Melbourne, 1978).

Cargher, John, *Opera and Ballet in Australia*, (Sydney, 1977).

Clément, Cathérine, *Opera, or the Undoing of Women* (tr. Betsy Wing, Minneapolis, 1988).

Clifford, Phil, *Grainger's Collection of Music by Other Composers*, Percy Grainger Music Collection, Grainger Museum (Melbourne, 1983).

Covell, Roger, *Australia's Music: Themes of a New Society* (Melbourne, 1967).

Fitzpatrick, Peter, 'Images of Asia in Recent Australian Plays', ASAL conference, unpublished paper, Aug. 1984.

_____*After 'the Doll': Australian Drama Since 1955* (Melbourne, 1979).

Dermody, Susan, Elzabeth Jacka, *The Screening of Australia: Anatomy of a National Cinema*, 2 vols., Sydney 1987, 1988.

Dreyfus, Kay, ed., *The Farthest North of Humanness: Letters of Percy Grainger 1901–1914* (Melbourne, 1985).

Drummond, Philip J., ed., *Australian Directory of Music Research* (Sydney, 1978).

Formby, David, *Australian Ballet* (Sydney, 1976).

Garling, Jean, *Australian Notes on the Ballet* (Sydney, n.d.).

Gleason, James, *Australian Music and Musicians* (Adelaide, 1968).

Grainger, Percy, notes, *Summary of Percy Grainger's Lectures at New York University*, Department of Music, College of Fine Arts, Sept. 1932–May 1933.

_____'The Aims of the Grainger Museum', *A Guide to the Grainger Museum* (Melbourne, 1955, *1975*).

_____'Music: A Commonsense View of All Types,' a synopsis of lectures delivered for the ABC, Dec. 1934.

Griffiths, Helen, catalogue, *Percy Grainger and the Arts of the Pacific* (Melbourne, 1979).

Gyger, Alison, *Opera for the Antipodes: Opera in Australia 1881–1939* (Sydney, 1990).

Hall, Ken, *Directed by Ken G. Hall: autobiography of an Australian Film-maker* (Melbourne, 1977).

Hannan, Michael, *Peter Sculthorpe: His Music and Ideas 1929–1979* (Brisbane, 1982).

Hayes, Deborah, *Peggy Glanville-Hicks: A Bio-Bibliography* (New York, 1990).

Hetherington, Norman, *Puppets of Australia* (Sydney, 1974).

Holloway, Peter, ed., *Contemporary Australian Drama: Perspectives Since 1955* (Sydney, 1981, 1987).

Irvin, Eric, *Dictionary of the Australian Theatre 1788–1914* (Sydney, 1985).

Jenkins, John, *Twenty-two Contemporary Australian Composers* (Melbourne, 1988).

Lisner, Charles, *The Australian Ballet: Twenty-one Years* (Brisbane, 1984).

Malm, William P., *Music Cultures of the Pacific, the Near East and Asia* (New Jersey, 1967).

MacCallum, Mungo, ed., *Ten Years of Television* (Melbourne, 1968).

McCredie, Andrew D. *Musical Composition in Australia* (Canberra, 1969).

McFarlane, Brian, *Australian Cinema 1970–1985* (Melbourne, 1987).

McPhee, Colin, *Music in Bali* (New Haven, 1966).

Moran, Albert, Tom O'Regan, *The Australian Screen*, (Melbourne, 1989).

Murdoch, James, *A Handbook of Australian Music* (Melbourne, 1983).

———*Australia's Contemporary Composers*, (Melbourne, 1972, *1975*).

Murray, Scott, ed., *The New Australian Cinema* (Melbourne, 1980).

Palmer, Helen, Jessie Macleod, *The First Hundred Years of Australia, As Seen by the People Who Lived In It* (Melbourne, 1956, 1981).

Palmer, Vance, *Louis Esson and the Australian Theatre* (Melbourne, 1948).

———*The Legend of the Nineties* (Melbourne, 1954).

———'The White Australia Policy', *Queensland Worker* (16 Aug. 1917).

Pike, Andrew, Ross Cooper, *Australian Film 1900–1977: A Guide to Feature Film Production* (Melbourne, 1980).

Radic, Leonard, *The State of Play: The Revolution in the Australian Theatre Since the 1960s* (Melbourne, 1991).

Reade, Eric, *Australian Silent Films: A Pictorial History of Silent Films from 1896 to 1928*, (Melbourne, 1970).

———*History and Heartburn: The Saga of Australian Film 1896–1978*, (Sydney, 1979).

———*The Talkies Era: A Pictorial History of Australian Sound Film Making 1930–1969*, (Melbourne, 1972).

———*The Australian Screen: A Pictorial History of Australian Film Making* (Melbourne, 1975).

Leslie Rees, *Australian Drama 1970–1985: A Historical and Critical Survey*, (Sydney, 1987).

———*Australian Drama in the 1970s: A Historical and Critical Survey* (Sydney, 1978).

———*The Making of Australian Drama: A Historical and Critical Survey from the 1830s to the 1970s* (Sydney, 1973, *1978*, 1982).

———*Towards an Australian Drama: From the 1830s to the Late 1960s* (Sydney, 1978).

———*Australian Radio Plays* (Sydney, 1946).

———*Mask and Microphone* (Sydney, 1963).

———*Danger Patrol: A Young Patrol Officer's Adventures in New Guinea* (Sydney, 1954).

Reeves, Helen, 'A Universalist Outlook: Percy Grainger and the Cultures of Non-Western societies', *Studies in Music*, Percy Grainger centennial volume, 16 (Perth, 1982).

Shirley, Graham, Brian Adams, *Australian Cinema: The First 80 Years* (Sydney, 1983).

Sitsky, Larry, 'New Music in Australia', H, 13, 11, Nov. 1969, 9–13.

Stewart, John, *An Encyclopaedia of Australian Film* (Sydney, 1984).

Stratton, David, *The Last New Wave: The Australian Film Revival* (Sydney, 1980).

Thoms, Albie, *Polemics for a New Cinema* (Sydney, 1978).

Treole, Victoria, ed., *Australian Independent Film* (Sydney, 1982).

Tulloch, John, *Legends on the Screen: The Australian Narrative Cinema 1919–1929*, (Sydney, 1981).

———*Australian Cinema: Industry, Narrative and Meaning* (Sydney, 1982).

Tunley, David, 'A Decade of Musical Composition in Australia 1960–1970', *Studies in Music*, 5, UWA (Perth, 1971).

Vella, Maeve, Helen Rickards, *Theatre of the Impossible: Puppet Theatre in Australia* (Sydney, 1989).

Williams, Margaret, *Australia on the Popular Stage 1829–1929: An Historical Entertainment in Six Acts* (Melbourne, 1983).

———*Drama* (Melbourne, 1977).

V VISUAL ARTS, ARCHITECTURE, CERAMICS: HISTORY, CRITICISM

Abbott-Smith, Nourma, *Ian Fairweather: Profile of a Painter* (Brisbane, 1978).

Adams, Brian, *Sidney Nolan: Such is Life: A Biography* (Melbourne, 1987).

Adamson, Judith, *Australian Film Posters 1906–1960* (Sydney, 1978).

Allen, Traudi, *Clifton Pugh, Patterns of a Lifetime* (Melbourne, 1981).

Ambrus, Caroline, comp., *The Ladies' Picture Show: Sources on a Century of Australian Women Artists* (Sydney, 1984).

Astbury, Leigh, *City Bushmen: The Heidelberg School and the Rural Mythology* (Melbourne, 1985).

Badham, Herbert. *A History of Australian Art* (Sydney, 1949).

Bail, Murray, *Ian Fairweather* (Sydney, London 1981).

Barnett, Percy Neville, *Colour Prints of Hiroshige* (Sydney, 1937).

———*Japanese Colour-prints* (Sydney, 1936).

———*Figure Prints of Japan* (Sydney, 1948).

———*Japanese Art: A Phase in Colour Prints* (Sydney, 1953).

Berndt, R. M., ed., *Australian Aboriginal Art* (Sydney, 1964).

Berndt, R. M., C. H. Berndt, J. E. Stanton, *Aboriginal Australian Art: A Visual Perspective* (Sydney, 1982).

Bickel, Lennard, *In Search of Frank Hurley* (Melbourne, 1980).

Bonyhady, Tim. *Images in Opposition: Australian Landscape Painting 1801–1890*, (Melbourne, 1985).

Bonython, Kym, *Modern Australian Painting and Sculpture* (Adelaide, 1960).

———*Modern Australian Painting 1950–1975*, Laurie Thomas introd., (Adelaide, 1980).

Boyd, Robin, *New Directions in Japanese Architecture* (London, 1968).

———The Great Great Australian Dream (Sydney, 1972).

———Living in Australia (Sydney, 1970).

———Australia's Home: Its Origins, Builders and Occupiers (Melbourne, 1952, 1968).

———Kenzo Tange (New York, 1962).

———The Australian Ugliness (Melbourne, 1960).

Bradley, Anthony, Terry Smith, eds., Australian Art and Architecture, Essays Presented to Bernard Smith (Melbourne, 1980).

Brown, Glenn, 'The Impact of Traditional Japanese Architecture on Sydney Architecture', B.Sc.(Arch) honours thesis, University of Sydney.

Burke, Janine, Australian Women Artists 1840–1940 (Melbourne, 1980).

Butel, Elizabeth, Margaret Preston: The Art of Constant Rearrangement (Melbourne, 1985).

Butler, Roger, The Prints of Margaret Preston: A Catalogue Raisonné (Melbourne, 1987).

———Melbourne Woodcuts and Linocuts of the 1920s and 1930s (Ballarat, 1981).

———Australian Prints in the Australian National Gallery, Canberra (Canberra, 1985).

Carr, W. H., 'The Japanese House, New Farm, Brisbane', Architecture in Australia, Dec. 1964.

Carroll, Alison, East and West: The Meeting of Asian and European Art (Adelaide, 1985).

———Out of Asia (Melbourne, 1990).

———The Centre: Works on Paper by Contemporary Australian Artists (Adelaide, 1984).

Catalano, Gary, An Intimate Australia: The Landscape and Recent Australian Art (Sydney, 1985).

Chaloupka, George, From Paleoart to Casual Paintings: the Chronological Sequence of Arnhem land Plateau Rock Art (Darwin, 1984).

Chanin, Eileen, ed., Contemporary Australian Painting (Sydney, 1990).

Clark, Jane, Bridget Whitelaw, Golden Summers: Heidelberg and Beyond (Melbourne, 1985).

Clark, John, Papers 1987–1988, typescript, Power Research Library, Sydney University.

———Japanese–British Exchanges in Art 1850s–1930s, papers and research materials, typescript, ANU, 1989.

———The Art of Modern Japan's Three Wars, typescript, 1990.

———'Once again, the East', Art Monthly Australia, May 1990.

Clark, Kenneth, Colin MacInnes, Bryan Robertson, Sidney Nolan (London, 1961).

Clark, Tony, Chinoiserie Landscape, catalogue, Institute of Modern Art, Brisbane, 4 Aug.–6 Sept. 1989.

Conder, Josiah, Landscape Gardening in Japan (London, 1893).

Cooke, Glenn R., Carl McConnell: Master Potter (Brisbane, 1986).

Cooke, Lynne, Reorienting: Looking East (London, 1990).

Courthion, Pierre, Impressionism, tr. John Shepley (New York, 1977).

Croll, R. H., Smike to Bulldog (Sydney, 1946).

Deutscher, Chris, Roger Butler, A Survey of Australian Relief Prints 1900–1950 (Melbourne, 1985).

Dobson, Rosemary, Focus on Ray Crooke (Brisbane, 1971).

Docking, Gil, Desiderius Orban: His Life and Art (Sydney, 1983).

Draffin, Nicholas, Australian Woodcuts and Linocuts (Melbourne, 1976).

Drury, Nevill ed., New Art One: New Directions in Contemporary Australian Art (Sydney, 1987).

———New Art Two (Sydney, 1988).

———New Art Three (Sydney, 1989).

———New Art Four (Sydney, 1990).

Dupain, Max, Max Dupain's Australia (Melbourne, 1986).

Dutton, Geoffrey, The Innovators: The Sydney Alternative in the Rise of Modern Art, Literature and Ideas (Melbourne, 1986).

Dwight, Alan, 'The Asian Interface', Arts of Asia, 14, 2 , 1984, 130–5.

Eagle, Mary, 'The Mikado Syndrome: Was There an Orient in Asia for the Australian 'Impressionist' Painters?' Australian Journal of Art, VI, 1987, 45–63.

———Australian Modern Painting: Between the Wars 1914–1939 (Sydney, 1990).

———The Art of Rupert Bunny (Canberra, 1991).

Edwards, Robert, Bruce Guerin, Aboriginal Bark Paintings (Adelaide, 1969).

Elkin, A. P., C. H. Berndt, R. M. Berndt, Art in Arnhem Land (Melbourne, 1950).

Ewington, Julie, Political Postering of Australia (Sydney, 1978).

Fabian, Suzane, ed., Mr Punch Downunder: A Social History of the Colony from 1856 to 1900 via Cartoons and Extracts from Melbourne Punch, (Melbourne, 1982).

Feltham, H. B., In the Eastern Manner: The Effects of Direct Western Trade with China and Japan (Sydney, 1980).

Flower, Cedric, The Antipodes Observed: Prints and Printmakers 1788–1850 (Melbourne, 1974, 1983).

Fink, Elly, The Art of Blamire Young (Sydney, 1983).

Freeland, J. M., Architecture in Australia: A History (Melbourne, 1968, 1981).

Friend, Donald, Donald Friend in Bali (Sydney, 1972).

———Save Me from the Shark: A Picaresque Entertainment (London, 1973).

———Art in a Classless Society and Vice Versa (Sydney, 1985).

———Birds from the Magic Mountain, (Bali, 1979).

———Gunner's Diary (Sydney, 1943).

———Painter's Journal (Sydney, 1946).

Frizell, Helen, 'The Asian Interface', H, 28, 2, Dec. 83, pp. 108–15.

Fry, Gavin, Colleen Fry, Donald Friend, Australian War Artist 1945 (Melbourne, 1982).

Fry, Gavin, Anne Gray, Masterpieces of the Australian War Memorial (Adelaide, 1982).

Fuller, Peter, The Australian Scapegoat (Perth, 1986).

Fullerton, Peter, ed., Norman Lindsay's War Cartoons

(Melbourne, 1983).

Galbally, Ann, *The Art of John Peter Russell* (Melbourne, 1977).

_____*Arthur Streeton* (Melbourne, 1969, *1979*).

Galbally, Ann, Anne Gray, comps. and eds., *Letters from Smike: The Letters of Arthur Streeton, 1890–1943* (Melbourne, 1989).

Garnsey, Wanda, *China, Ancient Kilns and Modern Ceramics: A Guide to the Potteries* (Canberra, 1983).

Germaine, Max, *Artists and Galleries of Australia and New Zealand* (Sydney, 1979).

Gibson, Frank, *Charles Conder, His Life and Work, With a Catalogue of Lithographs and Etchings by Campbell Dodgson* (London, 1914).

Gleeson, James, *Modern Painters 1931–1970*, (Melbourne, 1976).

_____*Impressionist Painters 1881–1930* (Sydney, 1976).

_____*William Dobell: A Biographical and Critical Study* (London, 1964, 1969, 1971).

_____*Masterpieces of Australian Painting* (Melbourne, 1969).

_____*Ray Crooke* (Sydney, 1972).

Haese, Richard, *Rebels and Precursors: The Revolutionary Years of Australian Art* (Melbourne, 1981).

Hall, Rodney, *Focus on Andrew Sibley* (Brisbane, 1968).

Hammond, Victoria, ed., *Australian Ceramics* Shepparton Art Gallery (Melbourne, 1987).

Hawley, Janet, 'Australia and the Asian Connection: How Ginger Meggs Turned Japanese', *The Age*, 23 Sept. 1983.

Helmer, June, *George Bell: The Art of Influence* (Melbourne, 1985).

Henshaw, John, *Godfrey Miller* (Sydney, 1965).

Herman, Morton, *The Early Australian Architects and Their Work* (Sydney, 1954).

Hersey, April, *Women in Australian Craft* (Sydney, 1975).

Hetherington, John, *Australian Painters, 40 Profiles* (Melbourne, 1963).

Hodgkinson, Frank, *Sepik Diary* (Melbourne, 1982).

Hoff, Ursula, *Charles Conder* (Melbourne, 1972).

_____*The National Gallery of Victoria: painting, drawing, sculpture* (Melbourne 1968, London 1973).

_____*Charles Conder: His Australian Years* (Melbourne, 1960).

Holmes, Jonathan, *Les Blakebrough, Potter* (Sydney, 1989).

Honour, Hugh, *Chinoiserie: The Vision of Cathay* (London, 1961).

Hood, Kenneth, *The Arts in Australia: Pottery* (Melbourne, 1961).

Hood, Kenneth, Wanda Garnsey, *Australian Pottery* (Melbourne, 1972).

Hughes, Robert. *The Art of Australia* (Melbourne, 1966, *1970*).

_____*The Shock of the New*, rev.ed., (New York, 1990).

Hutchings, P. A. E., Julie Lewis, *Kathleen O'Connor, Artist in Exile* (Fremantle, 1987).

Impey, Oliver, *Chinoiserie: The Impact of Oriental Styles on Western Art and Decoration* (Oxford, 1977).

Ioannou, Noris, *Ceramics in South Australia 1836–1936: From Folk to Studio Pottery* (Adelaide, 1986).

Irving, Robert, comp., *The History and Design of the Australian House* (Melbourne, 1985).

Irwin, Robert, *The Orientalists: Delacroix to Matisse* (London, 1984).

Ives, Colta Feller, *The Great Wave: The Influence of Japanese Woodcuts on French Prints* (New York, 1974, *1979*).

Johnson, Donald, *Australian Architecture 1901–1951: Sources of Modernism* (Sydney, 1980).

Johnson, Heather, *Roy de Maistre: The Australian Years 1894–1930* (Sydney, 1988).

Kempf, F., *Contemporary Australian Printmakers* (Melbourne. 1976).

King, Anthony, *The Bungalow: The Production of a Global Culture* (London, 1984).

King, Jonathan, *Stop Laughing, This Is Serious: A Social History of Australia in Cartoons*, (Sydney, 1978).

_____*The Other Side of the Coin: A Cartoon History of Australia* (Sydney, 1976).

Kupka, Karel, *Dawn of Art: Painting and Sculpture of Australian Aborigines* (Sydney, 1965).

Lambert, Amy, *The Career of G. W. Lambert: Thirty Years of an Artist's Life* (Sydney, 1938).

Langer, Karl, 'Subtropical housing', *Papers*, Faculty of Engineering, University of Queensland, 5, 1, 7, May 1944.

Leach, Bernard, *Beyond East and West: Memoirs, Portraits and Essays* (London, 1978).

_____*A Potter's Book* (London, 1940, *1970*).

_____*A Potter in Japan, 1952–54* (London, 1960).

_____*Kenzan and his Tradition: The Lives and Times of Koetsu, Sotatsu, Korin and Kenzan* (London, 1966).

_____*Hamada, Potter* (London, 1976).

Legg, Frank, *The Eyes of Damien Parer* (Adelaide, 1963).

Lindesay, Vane, *The Inked-in Image: A Survey of Australian Comic Art* (Melbourne, 1970).

Lindsay, Lionel, *Norman Lindsay's Pen Drawings* (Sydney, 1931, *1974*).

Lindsay, Robert, *The Seventies: Australian Paintings and Tapestries from the Collection of the National Australia Bank* (Melbourne, 1982).

Lindsay, Robert, Memory Holloway, *George Baldessin: Sculpture and Etchings: A Memorial Exhibition* (Melbourne, 1983).

Littlemore, Alison, Kraig Carlstrom, *Nine Artist Potters* (Sydney, 1973).

Lynn, Elwyn, *The Australian Landscape and Its Artists* (Sydney, 1977).

_____*The Art of Robert Juniper* (Sydney, 1986).

_____*Sidney Nolan, Myth and Imagery* (Melbourne, 1967).

_____*Tom Roberts, The Man and His Art* (Sydney, 1978).

_____'Sidney Nolan,' in TCN 9 and *The Bulletin, The Greats* (Sydney, 1986).

Macainsh, Noel, *Clifton Pugh* (Melbourne, 1962).

Mansfield, Janet, *A Collector's Guide to Modern Australian Ceramics* (Sydney, 1988).

McCarthy, F. D., *Australian Aboriginal Rock Art* (Sydney, 1958, *1979*).

———*Australian Aboriginal Art*, catalogue introd. State Art Galleries, 1960–1.

———*Aboriginal Decorated Art and Aboriginal Rock Art* (Sydney, 1938).

———'The Cave paintings of Groote and Chasm islands', *Record of American–Australian scientific Expedition to Arnhem Land*, 1948, 2, pp. 297–414.

McCaughey, Patrick, *Fred Williams* (Sydney, 1980).

———*Australian Painters of the Heidelberg School: The Jack Manton Collection* (Melbourne, 1979).

———*Australian Abstract Art* (Melbourne, 1969).

———*Daryl Jackson, Architecture, Drawings and Photographs* (Melbourne, 1984).

McCaughey, Patrick, Jane Clark, *Sidney Nolan: Nolan Landscapes and Legends* (Melbourne, 1987).

McCulloch, Alan, *Encyclopaedia of Australian Art*, 2 vols. (Melbourne, 1968, *1984*, 1991).

———preface, *Jorg Schmeisser etchings 1974–1979* (Tokyo, 1980).

McGrath, Sandra, *Brett Whiteley* (Sydney, 1979).

McGrath, Sandra, John Olsen, *The Artist and the Desert* (Sydney, 1981).

McKay, Ian, Robin Boyd, Hugh Stretton, John Mant, *Living and Partly Living in Australia* (Melbourne, 1971).

McMeekin, Ivan, *Notes for Potters in Australia*, (Sydney, 1967, *1985*).

McPhee, John, *Australian Decorative Arts in the Australian National Gallery* (Canberra, 1982).

McQueen, Humphrey, *The Black Swan of Trespass: The Emergence of Modernist Painting in Australia to 1944* (Sydney, 1979).

Meech, Julia, Gabriel Weisberg, *Japonisme Comes to America: the Japanese Impact on the Graphic Arts 1876–1925* (New York, 1990).

Mendelssohn, Joanna, catalogue notes, *The Yellow House 1970–72*, AGNSW, (Sydney, 1990).

———*The Art of Sir Lionel Lindsay* (Sydney, 1982).

Menpes, Mortimer, *Whistler As I Knew Him*, (London, 1905).

———*Japan—A Record in Colour by Mortimer Menpes Transcribed by Dorothy Menpes* (London, 1901).

———'A Letter from Japan', *The Studio*, XII, 1898, pp. 21–26.

———'A Personal View of Japanese Art', *Magazine of Art*, 1888, pp. 192–199, 255–261.

Menzies, Jackie, catalogue, *The Calligraphic Image*, Project 13 exhibition, AGNSW, 24 April–23 May 1976 (Sydney, 1976).

———catalogue, *The Asian Interface, Australian Artists and the Far East*, ASAA/AGNSW exhibition, 3 Sept.–2 Oct. 1983 (Sydney, 1983).

Millar, Ronald, *Civilized Magic: An Interpretive Guide to Australian Painting* (Melbourne, 1974).

Mollison, James, Albert Tucker, A Retrospective (Melbourne, 1990).

———*Fred Williams, Etchings* (Sydney, 1968).

———*A Singular Vision: The Art of Fred Williams* (Canberra, 1989).

Mollison, James, Nicholas Bonham, *Albert Tucker* (Melbourne, 1982).

Moore, Felicity St John, *Vassilieff and His Art* (Melbourne, 1982).

Moore, William, *The Story of Australian Art from the Earliest Known Art of the Continent to the Art of Today*, 2 vols. (Sydney, 1934).

Motion, Andrew, *The Lamberts, George, Constant and Kit* (London, 1986).

Munsterberg, Hugo, *Zen and Oriental Art* (Tokyo 1971).

———*The Folk Arts of Japan* (Tokyo, 1958).

National Museum of Western Art, Tokyo, Galeries Nationales du Grand Palais, Paris, *Japonisme*, 17 May–15 Aug. 1988, Paris, 23 Sept.–11 Dec. 1988, Tokyo 1988 (Tokyo, 1988).

National Trust of Australia (NSW), *William Hardy Wilson: A Twentieth Century Colonial* (Sydney, 1980).

Newton, Gael, *Shades of Light: Photography and Australia 1839–1988* (Canberra, Sydney, 1988).

North, Ian, *The Art of Dorrit Black* (Adelaide, 1979).

North, Ian, Humphrey McQueen, Isobel Seivl, *The Art of Margaret Preston* (Adelaide, 1980).

Olsen, John, *My Complete Graphics 1957–1979* (Sydney, 1980).

Paroissien, Leon, Michael Griggs, eds., *Old Continent, New Building* (Sydney, 1983).

Parr, Lenton, *The Arts in Australia: Sculpture* (Melbourne, 1961).

Pearce, Barry, *Donald Friend* (Sydney, 1990).

———*Swiss Artists in Australia 1777–1991* (Sydney, 1991).

———*Terra Australis to Australia* (Sydney, 1988).

Pearl, Cyril, 'Norman Lindsay,' in TCN 9 and *The Bulletin, The Greats* (Sydney, 1986).

Pearson, H., *The Man Whistler* (London, 1952).

Pryor, Denis, *Focus on Milton Moon* (Brisbane, 1967).

Radford, Ron, *Outlines of Australian Printmaking* (Ballarat, 1976).

Reid, John, *Australian Artists at War: Compiled from the Australian War Memorial Collection*, vol. 2 (Cedric Flower, ed.) (Melbourne, 1977).

Rewald, John, *The History of Impressionism* (London 1961, *1973*).

———*Post-impressionism: From Van Gogh to Gauguin* (London, 1956, 1978).

Richards, J. M., 'Missionary of Japan: An Exhumation of Josiah Conder', *Architectural Review*, 136, 196–198.

Roskill, Mark, *Van Gogh, Gauguin and the Impressionist Circle* (New York, 1970).

Rothenstein, John, *The Life and Death of Conder* (London, 1938).

Rowe, Ron, *Modern Australian Sculpture: Multimedia with Clay* (Adelaide, 1977).

Sadler, A. M., *A Short History of Japanese Architecture* (Rutland, 1962).

Saini, Balvant Singh, *Architecture in Tropical Australia* (Melbourne, 1970).

_____ *The Australian House: Houses of the Tropical North* (Sydney, 1982).

Salter, Elizabeth, *The Lost Impressionist: A Biography of John Peter Russell* (London, 1976).

Sanders, Herbert, *The World of Japanese Ceramics* (Tokyo, 1967).

Saunders, David, ed., *Historic Buildings of Victoria* (Brisbane, 1966).

Sayers, Andrew, *Drawing in Australia: Drawings, Watercolours, Pastels and Collages from the 1770s to the 1980s* (Canberra, 1988).

Scarlett, Ken, *Australian Sculptors* (Melbourne, 1980).

_____ *The Sculpture of John Davis: Places and Locations* (Melbourne, 1988).

Seidel, B., *The Arts in Australia: Printmaking* (Melbourne, 1965).

Selz, Jean, *Foujita* (Paris, 1981).

Sladen, Douglas, *Japan in Pictures* (London, 1896).

_____ *The Japs at Home* (London, 1892).

Smith, Bernard, *Australian Painting 1788–1970*, 1971; *1788–1990*, (Melbourne, *1991*).

_____ *European Vision and the South Pacific, 1768–1850: A Study in the History of Art and Ideas* (Oxford, 1960, New Haven 1985, Melbourne 1986).

_____ *Place, Taste and Tradition: A Study of Australian Art since 1788* (London 1944, Sydney *1945*).

_____ *The Antipodean Manifesto: Essays in Art and History* (Melbourne, 1959).

_____ ed., *Documents on Art and Taste in Australia. The Colonial Period 1770–1914*, (Melbourne, 1975).

_____ ed., *Concerning Contemporary Art: The Power Lectures 1968–1973* (Oxford, 1975).

Smith, Sydney Ure, ed., *Margaret Preston's Monotypes* (Sydney, 1949).

Sparke, Penny, *Design in Context* (Sydney, 1988).

Spate, Virginia, *Tom Roberts* (Melbourne, 1972).

_____ *John Olsen* (Melbourne, 1963).

Specht, Jim, John Fields, *Frank Hurley in Papua: Photographs of the 1920–23 Expeditions* (Bathurst, 1984).

Splatt, William, Dugald McLellan, *The Heidelberg School: The Golden Summer of Australian Painting* (Melbourne, 1986).

Statler, Oliver, *Modern Japanese Prints, An Art Reborn* (Rutland, 1959).

Sturgeon, Graeme, *The Development of Australian Sculpture, 1788–1975* (London, 1978).

_____ *Australia, The Painter's Vision* (Sydney, 1987).

Sullivan, Michael, *The Meeting of Eastern and Western Art from the Sixteenth Century to the Present Day* (London, 1973).

_____ *The Arts of China (London, 1962).*

Sutton, Peter, ed., *Dreamings: The Art of Aboriginal Australia* (New York, 1988).

Tanner, Howard, *Australian Housing in the Seventies* (Sydney, 1976).

_____ *Architects of Australia* (Melbourne, 1981).

Taylor, Jennifer, *An Australian Identity: Houses for Sydney 1953–63* (Sydney, 1972, *1984*).

_____ *Australian Architecture since 1960* (Sydney, 1986).

Thomas, Daniel, *Sali Herman* (Melbourne, 1971).

_____ ed., *Creating Australia: 200 Years of Art, 1788–1988* (Adelaide, 1988).

_____ *Outlines of Australian Art: The Joseph Brown Collection* (Melbourne, 1973, *1989*).

Thomas, Daniel, Renee Free, Geoffrey Legge, *Tony Tuckson* (Melbourne, 1989).

Thomas, Laurie, introd. in Kym Bonython, ed. *Modern Australian Painting, 1950–1975* (Adelaide, 1980).

Timms, Peter, *Australian Studio Pottery and China Painting* (Melbourne, 1986).

_____ *Australian Pottery 1900–50* (Shepparton, 1978).

_____ *Sir John Longstaff 1862–1941* (Melbourne, 1975).

Tipping, Marjorie, *An Artist in the Goldfields: The Diary of Eugene von Guérard* (Melbourne, 1982).

Topliss, Helen, *Tom Roberts 1856–1931: A Catalogue Raisonné* (Melbourne, 1985).

Uhl, Christopher, ed., *Albert Tucker* (Melbourne, 1969).

Van Erp, R., *Ukiyoe: Japanese Woodcuts: An Appreciation of the Art of the Japanese Woodblock Print with a Catalogue of Works in the Collection of the Queensland Art Gallery* (Brisbane, 1975).

Van Gogh, Vincent, *The Complete Letters*, 3 vols, (New York, 1958).

Watson, Ann, David Ward, *Etheleen Palmer: Printmaker of the 1930s* (Sydney, 1980).

Weisberg, Gabriel P., *Ukiyo-e Prints and the Impressionist Painters*, catalogue, Dec. 1979–Feb. 1980, Committee for the Year 2001 (Tokyo, 1979).

_____ *Japonisme in Art: An International Symposium* (Tokyo, 1980).

Welsh, Lionel, *Vermilion and Gold: Vignettes of Chinese Life in Ballarat* (Melbourne, 1985).

Whiteley, Brett, *Another Way of Looking at Vincent Van Gogh 1888–1889, 1968–1983*, (Melbourne, 1983).

Whitford, Frank, *Japanese Prints and Western Painters* (London, 1977).

Wichmann, Siegfried, *Japonisme: the Japanese Influence on Western Art in the 19th and 20th Centuries* (New York, 1980).

Williams, Donald, *In Our Own Image: The Story of Australian Art 1788–1986* (Sydney, 1987).

Wilson, W. Hardy, *Grecian and Chinese Architecture* (Melbourne, 1937).

_____ *Atomic Civilisation* (Melbourne, 1949).

Wolseley, John, *Nomadism: Twelve Years in Australia—Paintings and Drawings* (Melbourne, 1988).

_____ catalogue notes, *From Bendigo to Kyoto*, (July, 1984)

_____ catalogue notes about the installation 'Deep time shallow time: journey from Ewaninga to Gosse Bluff' (Melbourne, 24 June 1991).

_____, others, *Orienteering: Painting in the Landscape* (Melbourne, 1982).

Yanagi Soetsu, *The Unknown Craftsman* (Tokyo, 1972).

Index